1999

Imperial Objects

Essays on Victorian Women's Emigration and the Unauthorized Imperial Experience

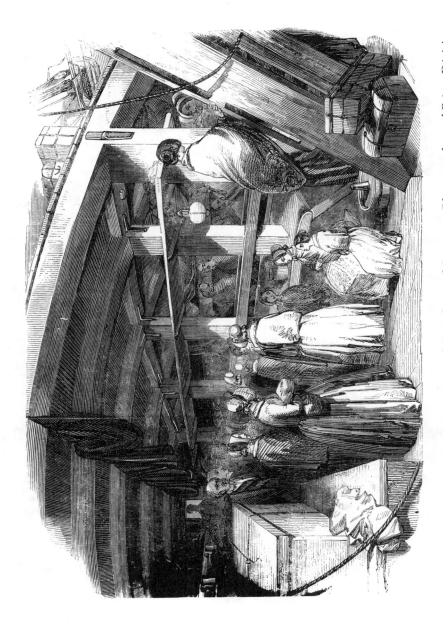

Emigrant ship, between decks. *Courtesy of the Library of Congress, Photographs and Prints Division.*

Imperial Objects

*Essays on Victorian Women's
Emigration and the
Unauthorized Imperial Experience*

edited by
RITA S. KRANIDIS

Twayne Publishers
An Imprint of Simon & Schuster Macmillan
New York
Prentice Hall International
London Mexico City New Delhi Singapore Sydney Toronto

Twayne Publishers
An Imprint of Simon & Schuster Macmillan
1633 Broadway
New York, New York 10019

Library of Congress Cataloging-in-Publication Data

Imperial objects : essays on Victorian women's emigration and the
 unauthorized imperial experience / edited by Rita S. Kranidis.
 p. cm.
 Includes bibliographical references and index.
 ISBN 0–8057–1627–0
 1. Women immigrants. 2. England—Emigration and immigration—
 History—19th century. 3. Women—England—History—20th century.
 I. Kranidis, Rita S.
 JV6347.I47 1997
 304.8′2′0820941—dc21 97-31199
 CIP

The paper used in this publication meets the minimum requirements of American National Standard for Information Sciences—Permanence of Paper for Printed Library Materials. ANSI Z39.48–1984. ⊚ ™

10 9 8 7 6 5 4 3 2 1

Printed in the United States of America

For Sandra

Contents

CONTENTS

Illustrations

Acknowledgments

I would like to thank the contributors to this collection for sharing their work with us and for persisting in their explorations of these important questions. Working with them has been a pleasure. Thanks also go to Jennifer Farthing, editor at Twayne, for her invaluable help with this project, and her support.

At Radford University, colleagues Moira Baker, Scott Christianson, and Tim Poland have provided an intellectual community that is essential and enriching, while the Radford Foundation has supported this project in practical, necessary ways.

Finally, I owe a great deal of gratitude to Helen Cooper at SUNY–Stony Brook for continuing to graciously and generously share her insights and expertise.

Introduction:
New Subjects,
Familiar Grounds

Rita S. Kranidis

The past ten or more years have witnessed the production of innovative scholarship on British imperialism, much of it authored from what has been termed a "postcolonial" perspective, that is, a perspective that seeks to transcend conceptual limitations relevant to nationality and cultural identity. Interest in the latest developments in such scholarship arises in large part from the state of our world today. Boundaries of all kinds are being collapsed, a universal process greatly facilitated by developments in information technology that have produced a broad-based and loosely regulated sharing of information. It is no longer always feasible to determine the physical boundaries of places and the social boundaries of populations, as economic exploitation has joined with information sharing to enact a dramatically extensive and insidious cultural appropriation of Third World nations. The ability of people from different cultures to make contact with one another instantaneously and share information, perspectives, and to some extent, experience, urges renegotiation of the traditional distinctions between nations and cultures. Clearly, the field of Cultural Studies owes much of its impetus to these developments.

Amid such fundamental changes, the subjects of colonial emigration and emigrant women's relation to the Victorian imperial project surface as significant analogues to our present preoccupation with cultural boundaries. Specifically, the study of Victorian women's emigration to the colonies and dominions contributes to present examinations of how cultural boundaries get negotiated by calling into question their very existence. To appreciate the high incidence of general emigration from England to the colonies and dominions, we need to consider both the social significance of the "trend" of emigration and the actual numbers involved. The available sources offer some statistics but are inconclusive and often contradictory. In A Woman of Good Character, Charlotte Macdonald suggests that the number of women emigrants was enormous:

1

nearly 108,000 women were shipped to New Zealand between the years 1853 and 1880.[1] Furthermore, James Hammerton notes that 156,606 women were sent from England to the colonies between the years 1899 and 1911.[2] Beginning with the 1834 Poor Law Amendment Act, which instigated the first systematic efforts to "export" English subjects to the colonies, the number of emigrants sent to the colonies and dominions continued to rise well into the twentieth century, so that virtually all national populations are still experiencing the effects of nineteenth-century emigration.

As Stephen Constantine notes in his introduction to *Emigrants and Empire*, the formation of the Colonial Land and Emigration Commissioners dramatically increased the number of people emigrating. Whereas by 1860 only 26,000 had emigrated, increased efforts culminated in the emigration of more than 370,000 English citizens by 1869.[3] Likewise, David Thompson notes that "[b]etween 1853 and 1880 Britain sent out some 2,466,000 emigrants to destinations including the colonies and dominions, of whom an unknown but probably small proportion returned."[4] However, Dudley Baines estimates that these figures constitute "only seven per cent of all emigrants at that time" because only "about a quarter of the emigrants were helped by friends or relatives and only some ten per cent were officially assisted."[5] Given these statistics, it would seem that, indeed, one of the "commonest non-governmental responses [to national economic depressions was] mass emigration."[6]

While the practical implications of these large numbers of emigrants are startling, the numerical details of general emigration also suggest that in the nineteenth century, leaving England may be said to have been a trend, a national condition, and a state of mind that pertained most significantly to the lower classes. Emigration was also, however, very closely tied to Victorian imperialism, and emigrants were encouraged to view themselves as serving the empire. Hobsbawm observes that, as a tool to enforce conformity, "imperialism encouraged the masses, and especially the potentially discontented, to identify themselves with the imperial state and nation" (*Age* 70). As a substantial segment of the imperial project, then, emigration to the colonies and dominions emerges as something more than a series of distinct acts and events; the information available suggests a pattern of national events that translates into a radically revised national subjectivity and an alternative mode of "Englishness." These cultural and political considerations allow Victorian emigration to be perceived as a system, perhaps even as a national institution not unlike the traditions of vocational apprenticeship, marriage, and educa-

tion. In fact, as the essays collected here suggest, emigration from England to the colonies and dominions permeates many facets of the Victorian social arena. Ultimately, emigration mediates the Victorian symbolic economy by intervening and commenting upon—even changing—normative cultural traditions and ideologies.

Emigration was always problematic within England, either as a topic or as a process. Specifically, arguments both for and against systematically assisted emigration make persistent critical reference to socioeconomic conditions within England. Victorian arguments against the trend of emigration as a solution to domestic problems reveal a concern that the empire could not continue to deposit its problems into other spaces indefinitely, and suggest that the way to accommodate England's poverty and social strife was to deal with them *within* England. An 1828 article from *Blackwood's* discusses the harm of the emigrant's "disregard[ing] the feelings of home, cross[ing] the ocean, and bury[ing] himself in the wildernesses of the United States or Canada, and submit[ting] to every desperate privation."[7] Regarding the private ownership of land as a cure to England's poverty problem, this same article recommends a "scheme of settling" within England that would offer everyone a plot of land and self-sufficiency; this plan would be more likely to yield the desired results, since "the emigration scheme is utterly impossible" (192). Even arguments that reject emigration schemes recognize the need to refigure geographic boundaries, and nonetheless advocate internal migration as a solution. Antiemigration arguments such as these indicate that cultural and political implications were very much a conscious concern attending the emigration process at the moment of its execution.

Rationales for the desirability of emigration were generally based on totally different, although not less meaningful, grounds. Arguments in defense of emigration as a solution to domestic problems primarily served to valorize the empire and were made in the name of extending England's global influence. Whether deliberately or inadvertently, exchanges concerning emigration were ultimately deliberations about existing problems *within* England and served to initiate explicit discussions of gender's relation to the empire. The imperial discourse concerning women's emigration to the colonies and dominions exposes the problems of gender in the context of the nation and comments on the emigrant women's "place" in the imperial context. When the issue of female emigration is discussed, unmarried women's problematic status within England is revised so that it is linked to the broader imperial agendas as an integral component of imperialism in general. Such argu-

ments obscure the significant role of gender in women's colonial emigration and reveal the extent to which an explicit commodification of women as national property had to be invented before they could be incorporated into the empire's imperatives and interests. Women's excessively problematic place in the hegemony had to be refigured and their cultural value renegotiated: "When female emigration has done its work, and drained away the excess and the special *obviousness* of the redundance; when women have thus become far fewer in proportion, men will have to bid higher for the possession of them, and will find it necessary to make them wives instead of mistresses" (original emphasis).[8]

In glancing at female emigration rhetoric, it becomes apparent that introducing the problem of gender into the study of Victorian colonial emigration complicates matters enormously. The main paradox one encounters is how it was that women, the cultural emblems of sacrosanct domesticity (figuratively and symbolically extending to England's national culture), were removed from England *en masse* during the period. The question arises, How was such a transfer effected and justified? Many of the women wishing to emigrate were unmarried and often referred to as "superfluous" or "redundant." The concern most often projected onto them was, Where shall I be of use to the world? and got as macabre as, Where shall lonely women die?

To the extent that unmarried women constituted a problem within England, they were also such in the colonies and dominions. England's "superfluous" women constituted a hegemonic contradiction in that they problematized institutionalized gender prescriptions by being culturally excessive at the same time as they remained ideologically valued by virtue of their biological sex. However, despite the many allusions to the problem of "excessive" and "superfluous" women, the discrepancy in male and female populations does not explain the rigor of the emigration efforts; emigration was also mobilized as a solution to the limitations of women's employment imposed by gender restrictions. More broadly, women's emigration was a response to the economic conditions and trade practices that ultimately situated England's wealth, finances, and brighter prospects for men in the "Elsewhere" of the colonies and dominions. Viewed in historical context as the "dustbins of [England's] unwanted and unsuccessful," as Hobsbawm has termed them, the colonies and dominions become England's "Elsewheres" and serve to mark the intersection between national definition and its exclusionist counterpart, cultural nonexistence.[9]

The rhetoric surrounding Victorian emigration to the colonies and dominions reveals an extensive reciprocity between England and the

4

colonies, mainly manifested in the close bonds between those still in England and the colonists. In the emigration rhetoric, the colonies are represented as places that are specifically not England but that are nonetheless defined by Victorian culture and politics in their subordinate relation to British national culture and its practices at home and abroad. Patrick Brantlinger's *Rule of Darkness* (1988) and David Spurr's *Rhetoric of Empire* (1993) enhance our appreciation of the different and often conflicting imperial functions the colonies are asked to serve, both materially and symbolically. Extending these findings to how the dominions are refigured into suitable destinations for women, we encounter an argument that has broader ramifications for the political relations between England and its dependent territories. When asked to accommodate the "superfluous" or "excessive" women of England, the colonies assert their rights to self-determination and self-rule, explicitly defying England's stated prerogatives. In the ongoing debate, the women themselves become commodified in the domestic realm, a practice that is then extended to England's relation to the colonies and that highlights the question of colonial autonomy in trade practices.[10] Established colonists invariably acknowledge female emigration's implications for broader imperial politics and turn this issue into a battleground for self-determination. In their arguments, the emigrant spinster becomes a figure of speech, signifying the empire's imposition on the colonies. Both sides, those opposing and those advocating female emigration, acknowledge the spinster's symbolic value as a national commodity. In the crude and harsh words of an Australian colonist critical of female emigration schemes,

> We have heard of a state being the father of its people, but is there not some risk in its undertaking the duties of the people's father-in-law? We may bring the young women here, but what if they do not suit the young men? What shall we do with the articles which don't "move off," and the goods which are found unsaleable?[11]

Likewise, an Australian supporter of female emigration notes the very base gender economy in which the emigrant spinster figures as an item of exchange:

> It cannot be said ... that the number of educated women in the colony is already in excess of the demand; or that there is a surplus of this sort of imports over and above what the capitalists are able to consume. It may be difficult to fix any rule by which to measure

the supply with the demand of a commodity of this nature, but we may safely assume generally that there is no prospect whatever of the market being glutted with educated women, let the immigration as it can be, with our existing social arrangements.[12]

The problem of gender becomes the most volatile point in the colonies' argument with the mother country, eliciting powerful questions of initiative and self-sufficiency. Emigrant spinsters emerge as one of the most contentious commodities over which the issue of colonial autonomy was fought. When they converge on the issue of Victorian female emigration in this manner, colonial relations with England and with the British gender economy emerge as a new discursive and analytical space. British imperialism and gender relations come under scrutiny in a way that renders both questionable and problematic.

The status of *undesirable* English women in the colonial context disturbs many of our preconceptions about gender and the empire. Most such preconceptions allow only for stereotypical understandings of colonial women as memsahibs (official wives), bush women, and missionaries (whether cultural or religious). Most recently, the woman traveler has originated as one who intersects all of the prior identifications and literally floats about in her critical importance. While it is valuable to acknowledge the relevance of these categories, most of which are definitively descriptive of the main roles assigned to women outside England's geographic borders, it may also be important to question and transcend them. This promise is encompassed in the problematic national identities of the unmarried emigrant women, the gendered political dynamics of their leaving England, and their places abroad.

Were we to begin our investigation of Victorian female emigration with some of the earlier critical sources, we would consider the important collection of essays edited by Martha Vicinus in *Suffer and Be Still* (1972) and her book *Independent Women* (1985). These two texts foreground the complex status of uncommon women in Victorian society and examine the ways in which unmarried Victorian women may be understood to have been "independent" of specific institutional restrictions. Initiating an implicit connection between female emigration and the domestic spinster, Vicinus considers the social status of women who did not easily fit into the normative gender categories because they remained unmarried. Another early study, Nina Auerbach's *Communities of Women* (1978), considers the literary manifestations and broader implications of

6

Victorian women who are not attached to men and thus constitute a distinct class of social subjects. Although there is a good amount of current critical scholarship on the Victorian spinster, there is little analysis of the circumstances that shaped and indeed created the middle-class spinster as a social and cultural category, nor are there enough accounts of the connection between emigration, empire, and gender.[13] Possibly because they arose outside the moment of postcolonial criticism, such works evidence no sense of urgency to consider the spinster's cultural value in the imperial context.

It is not surprising that much of the original research on the subject of Victorian female emigration has come out of Australia, New Zealand, and England. Half of the essays in this collection come from outside the United States, from England and Australia. To date, the main historical studies of Victorian emigration, apart from Una Monk's early *New Horizons* (1963, originally issued by the HMSO), are those by James Hammerton (1979), Patricia Clarke (1985), and Charlotte Macdonald (1990).[14] It is those researchers whose homelands have been most directly affected by the long-standing patterns of emigration from the English Empire to the colonies, and for whom those practices have had enormous daily repercussions, who have concerned themselves the most with this subject. For them, the study of colonial emigration has constituted a genealogy of sorts, tracing the origins and constructing a history of their countries' present populations and cultural compositions.

In the United States, recent postcolonial scholarship has emphasized the general categories and processes of imperialism and colonization, specifically acknowledging the significance of gender and the problems of representation. Notable among recent works are Margaret Strobel's *European Women and the Second British Empire* (1991), Mary Louise Pratt's *Imperial Eyes* (1992), Deirdre David's *Rule Brittania* (1995), and Anne McClintock's *Imperial Leather* (1995). The subject has been compartmentalized further into subcategories that investigate Victorian women's travel writings and the relationship of Western women to imperialism. While most such studies forge enlightening connections between colonialism, gender, and the literary, very few have thus far noted the correspondence between emigration and nationhood as part of the imperial project. It is also meaningful that in recent scholarship more has been written about Victorian women's established presence in the "Elsewhere" as privileged colonists or as travelers than about the particulars of their removal there, permanently and *en masse*. That is, not enough attention has been devoted to the disenfranchised emigrant

working women. Feminist studies by Sara Mills (1991), Laura Donaldson (1992), Laura Brown (1993), and Jenny Sharpe (1993) concentrate exclusively on travel and privileged women colonists. The latter are well-documented phenomena and concrete discursive areas to investigate, whereas emigrant women represent somewhat more difficult conflicts in cultural identity, cultural and symbolic function, and intricately complex—albeit repressed—ideological strife. However, in considering the ways in which gender served the imperial project, much of this scholarship may conceive of gender's agency too narrowly. Concentrating on authorized British males in the colonial context, the gender identity of the empire builders, and gender relations between colonizer and colonized, these works pose questions (although not always explicitly) concerning woman's role in the imperial effort and investigate her alterity and relative cultural disempowerment. Amid these observations, colonial women are often described as complicitous in the imperial endeavor, although they were "ambiguously placed" in the colonization process.[15] That is, they are implicated in perpetuating the imperial agenda even as they are clearly *not* the empire official agents.

The most compelling feminist studies on Victorian colonialism examine the role of women and the category of gender in the imperial context and conclude that gender prescriptions were systematically instituted in the colonies to "acculturate" native peoples and places. Specifically in relation to the *gendering* of the colonial project, McClintock makes a powerful argument for an apparent "masculinity" to the imperial endeavor. In *Imperial Leather* she notes that colonial women "experienced the process of colonialism very differently from colonial men" and appear to have held a different relationship to imperialism than did men, mainly by virtue of women's positioning in the domestic gender ideology (6). Concentrating on the ways in which colonized places were "domesticated" in an English fashion by employing the main available model, Victorian domestic ideology and its accompanying prescriptions of gender, McClintock notes that "colonialism took shape around the Victorian invention of domesticity and the idea of the home" (36). Her study is especially important because it amply illustrates the complicity between domestic trends in gender commodification and their service to the imperial project. McClintock's thesis, that imperialism relied on both intra- and extracultural commodification, illuminates the reciprocal relationship between foreign cultures and Victorian England, between the "Elsewhere" and the ramifications and material and symbolic transformations its appropriation prompted within the English nation.

It has been established that the colonies figured instrumentally in conceptions of the "domestic" space, both geographically and ideologically, and that the imperial project was very much assisted by a cultural agenda based on a strictly prescribed gender ideology of domesticity. However, although this innovative scholarship sets the stage for thinking about female emigration to the colonies, there is still a lingering sense that women as social subjects are an entirely separate concern from gender ideology in the pattern of imperial exchanges and impositions, and also that, however subtly, colonial women served to acculturate and domesticate the colonies at the same time as they themselves were utilized as imperial instruments.[16] This schematization does not immediately allow the possibility of a yet more fascinating and instructive model of the relationship between the colonies and England, one that forces us to think more extensively about the relationship between oppressor and oppressed. Victorian female emigration resists such categorization because as imperial subjects, women emigrants defy our categorical distinctions between colonizer and colonized, public and private, and ideology as opposed to social practice.

The problems one encounters in attempting to mark the intersections between gender and racial/imperial oppression in regard to emigrant women (and spinsters in particular) are suggested by some important studies on women and imperialism. Margaret Strobel's fascinating history of women and the empire, *European Women and the Second British Empire*, astutely analyzes the problematic status of "authorized" women in the colonial context, illustrating the extent to which these women exercised a particularly different kind of imperial power. Her discussion of the "incorporated" wife, which accounts for the memsahibs' status as "derived from their relationship to a man, usually a husband" (13), appears to exempt such women from imperial agency, initiative, and ultimately complicity toward cultural dominance. As this passage suggests, accounting for the privileged colonial women's social conduct becomes difficult: "[T]he apparent pettiness of dependent women's lives is explained by their position as incorporated wives. . . . An incorporated woman's derived position in a hierarchy limited the extent to which she could express intimacy and solidarity across rank or status lines, hence her apparent competitiveness with other women" (13–14). While it is crucial that women's imperial authority was of a particular kind in the colonial context, as Strobel emphasizes, it may be more important to recognize the ways in which this uniquely defined and limited power was instrumental in the women's colonial positionings in relation to the

empire. Moreover, Strobel's analysis suggests that the disempowerment of women on the domestic front may have extended to their positioning in the colonies. In this sense, the patriarchal control exercised over women in England could be said to extend quite unilaterally to Victorian English women abroad. Once this essential observation is made, further inferences may be drawn concerning women's role in the imperial effort, but most important, in relation to colonial "others" and to foreign places. As Strobel surmises, "In comparison with accounts by Victorian men, women's travel narratives incline less toward domination and more toward discovery," thus ascribing to colonial women a disinterested and nonimplicating form of power (36).

Although these observations are quite valid and in some respects necessary, we may do better than to deliberate the extent of women's complicity in the imperial effort. "Exonerating" colonial women may not ultimately be the most productive tactic, as exempting women from responsibility also negates their agency. Rather, the question to address is, "[W]hat is the relationship . . . between any single text or person . . . to the discourse or discourses that frame it?"[17] That is, how are particular classes of women and their texts situated contextually in the colonies and within the imperial agenda? And what is their status in relation to domestic gender ideologies in the colonial context? This question needs to also incorporate political and material practice so that, in our attempt to appreciate the complexity of gender's place in the imperial project, the notion of "discourses" doesn't come to negate the materiality of culture, or those "concrete historical conflicts and contradictions that characterize the formation and development of social relations."[18]

Considerations of "unauthorized" colonial women reveal a gap between the historical narratives produced by scholars in the ex-dominions and the theoretical work that is being produced in England and the United States. Although theory is also being produced in other places and contexts, the gap between historical information and theory has not yet been significantly bridged; the connection between Victorian women's emigration and postcolonial analysis, and the attendant theoretical implications for gender studies of the empire, has yet to occur. This gap cannot be ignored, since it contributes to the increasing incidence of misunderstandings and inadequacies in postcolonial approaches, of which we are hearing more and more.

In connection to these concerns, a final point I want to address is this collection's relation to *postcolonial* scholarship. Materialist critics Aijaz

Ahmad and Michael Sprinker express an important reservation concerning the label *postcolonial* and its applications. They criticize the ways the term is applied to studies that do not effectively engage questions of historical specificity. In its essence, theirs is also an argument against postmodernist approaches that dehistoricize the concepts, practices, and ramifications of imperial appropriation by positing that such relations transcend specific cultural moments and contexts. In the introduction to the recent volume *Late Imperial Culture*, Sprinker identifies the main problem with the current trends in postcolonial studies as the "comparative neglect of any, even provisional, periodization of imperialism itself. The consequences for understanding the real effects wrought by the European colonial empires have been far from negligible, and most often quite damaging."[19] Postcolonial scholarship, we must understand, needs to be rooted in the concrete, the specific, the historical moment and sociopolitical context that it purports to address.

This argument is illustrated most powerfully in Ahmad's principal essay in the same volume, while possible means of rectification are illustrated by the majority of the volume's contributors. In arguing for the necessary specificity of postcolonial studies, Ahmad rightly criticizes "the frequent *inflation* of the term [postcolonial], both spatially and temporally. In some usages, especially in much writing emanating from Australia, the terms 'colonial' and 'postcolonial' ... are applied not just to what is generally called the 'Third World,' but also to the United States, Canada, New Zealand, Australia itself" (30). According to this argument, in charting the emigration of middle-class women to many different destinations at different historical moments, we may be guilty of overgeneralization and hence a grander kind of misrepresentation and misunderstanding. Analogously, we are warned not to apply the label *colonial* and hence the practice of "postcolonial" theory to inappropriate political and cultural scenarios. Ahmad emphasizes that, in effect, "constructing this globalized trans-historicity of colonialism is to evacuate the very meaning of the word and disperse that meaning so widely that we can no longer speak of determinate histories of determinate structures" (31). We risk confusing some essential elements, we are told, when we apply the politics of postcolonial and liberatory analytic tools to populations such as the Australians and other mainly white emigrant colonials.

One other compelling assertion by Ahmad concerning the problematics of postcolonial studies (and one illustrated in this anthology) is that the colonial subject can occupy a number of situations or positions within power categories such as gender, race, and class, in the colonial

11

context and also in relation to the empire. Most instrumentally, colonial subjects can sometimes occupy a number of positions simultaneously. Hence, efforts toward the historical specificity of imperial events and processes require that we examine distinct movements in light of the shifting cultural positioning of imperial subjects. The treatment one gives colonial subjects such as Victorian emigrant women is thereby complicated even further, not only because they were only nominally agents for the empire but also because of their positioning(s) both within *and* without the Victorian cultural economy.

These criticisms and precautions clearly implicate the objectives and politics of the following essays on emigrant women. They do so mainly in pointing to the problem of colonial identity in the sense that Australia and the ex-dominions, the main destinations for emigrant women, cannot be said to hold the same cultural and political significance as do the colonies whose populations featured a majority of nonwhite natives and where colonials constituted a small portion of the general population. Indifferentiating between the dominions and other colonies, it would not be prudent to view or represent the dominions as already colonized and appropriated spaces. The infiltration and acculturation of those spaces and cultures must instead be seen as an active, ongoing process of occupation similar to that which occurred in South Africa and India, else we obscure a significant segment of the imperial agenda.

Ahmad's position concerning the practice of postcolonial study does not quite account for yet one more grey area, the place in-between occupied by the female emigrant, who cannot be said to have participated officially in the imperial project and whose role in that effort is still nebulous and uncharted. Trinh Minh-ha's exploration of the subjectivity of the nonwhite, disenfranchised female explains the extent to which emigrant women may be seen to constitute a distinct imperial category:

> Can knowledge circulate without a position of mastery? Can it be conveyed without the exercise of power? No, because there is no end to understanding power relations which are rooted deep in the social nexus—not merely added to society nor easily locatable so that we can just radically do away with them. Yes, however, because in-between grounds always exist, and cracks and interstices are like gaps of fresh air that keep on being suppressed because they tend to render more visible the failures operating in every system.[20]

As a class and as a population, emigrant women hold a distinctly different relationship to power and hierarchical structures but also to knowl-

edges—both those that exist now as historical record and those that were circulated, articulated, and delineated in the Victorian context. The contingent connection of emigrant women to the nation and to the imperial project rests on their ineligibility to participate in its products, knowledge being one of these. As marginal and disenfranchised subjects for whom England had no use and no defined domestic "place," emigrant women must perforce occupy some other "place" in the imperial endeavor, although predicting what that may be is a precarious position at best. As my earlier examples suggest, attempts to maintain and reassign the oppressor/oppressed binarism could not succeed in this instance. For example, Patricia Clarke's work on emigrant women's letters suggests that emigrant spinsters often expressed condescension not only toward the colonies as Other places but also toward the established colonists and the natives. Even so, these women did manage to successfully effect the necessary cultural transitions and to appreciate the shifts in their own cultural status once they were placed in the colonies. As one emigrant woman stated, "[I]n my new home I shall make acquaintance with a new class of people—'the nouveaux riches'—but I may consider myself now 'colonized' so it will be only viewing a new phase of life."[21]

Victorian gender prescriptions need to be viewed very differently now to account for those that were devised specifically for colonial uses. By extension, the terms *colonizer* and *colonized* are themselves problematic because they dichotomize the tense and complex relationships involving subjects who are situated very differently in terms of power. Fanon reminds us of two important features relevant to imperialism and colonialism: first, that the family is a microcosm for the nation, and second, that contrary to the processes of colonialism, "to understand something new requires that we make ourselves ready for it, that we prepare ourselves for it; it entails the shaping of a new form."[22] The "new form" here is represented in the colonial discourse by women who are no longer subsumed by the English nation because they have left their home country permanently. The critical revision of the imperial economy that is facilitated by studying emigrant women also produces such a new cultural form. The emigrant women's own "understandings" of their new cultures and homes is in fact a distinctly material engagement, since their level of "preparation" for emigration and their colonial adjustment are actual and experiential. More radically, Fanon's definitions of the "colonized" may be said to apply to the emigrant women, who, as with "every colonized people," "find [themselves] face to face with the language of the civilizing nation" and neither oppose nor submit to it (18).

For, the emigrant woman is both of and outside the nation, both a constituent and an exile in relation to the empire.

The issue of unmarried emigrant women facilitates such an analysis because it bridges the conceptual gap between the domestic Victorian gender ideology and the social category of "woman" in the imperial context. Therefore, single women's emigration to the colonies becomes a fruitful ground for investigating conceptions of nationhood in relation to the unmarried women, who may be seen to fall somewhere outside *and* beyond the prescribed margins of the dominant gender ideology. Edward Said's directive for postcolonial analysis, which points out the complexities of reading across cultures and times, states that "[t]he problem for the contemporary cultural critic is how to bring [different cultural versions] together meaningfully."[23] It is precisely this analysis of the "different cultural versions" of both the authorized *and* the subordinate cultural subjects such as single women that needs to be undertaken.

Female emigration opens other areas to analysis, such as the applicability of identifying emigrant women as "agents" for the empire and the extent to which they were effective in "acculturating" the spaces they were to inhabit, the latter being one of the main arguments for assisting in their emigration. The presence of undesirable, "superfluous" English women in the colonies and dominions confounds many of our preconceptions about gender and the empire. Victorian emigrant women constitute a different imperial category. They were not engaged in colonial "travel" nor did they have a *practical* assignment of imperial duty in the colonies—they were being exported as surplus commodities. The mass emigration of unmarried and mainly middle-class women to the colonies reinvestigates and challenges the extant findings and conclusions. It does so mainly by questioning both the gender identity *and* the imperial value of emigrant women, thus implicating their symbolic and transcultural place in the colonization process. Exploring the emigration of British subjects to England's corollaries is so intricately important to investigating colonizing processes that it is surprising that so little postcolonial scholarship has deemed it worthy of inquiry.

The emigrant women are neither colonizer nor colonized, yet they may be said to be both. Insofar as they manifest the nation's perpetually expanding cultural borders, they are national subjects who are simultaneously not integral, legitimated parts of the empire. In order to understand how unmarried women were revalued and commodified into appropriate items of exchange with the colonies (in exchange for cultural privilege and for material goods), and to then contrive a meaning of

that commodification, we must note the ways in which commodities conceal social relations.[24] We must also entertain the possibility that emigrant unmarried women were in fact "traded" or "circulated" *within* the domestic ideal, first at home and then abroad. Therefore, we are compelled to rethink the traditional binary oppositions and to investigate, instead, the significant space between England and other places, as well as women's national roles and positioning in places other than England. A final ingredient of such critical analysis must be the emigrant women's relation to the broader cultural economy, to see the Victorian hegemony as inclusive of the multivalent exchanges between England and the colonies.

In this introduction I suggest that the main importance of the subject of emigrant middle-class women lies in its inclusiveness and in the problems it both exposes and introduces to postcolonial studies. In studying nineteenth-century British emigration history, one delves not only into the practical matters attendant to the emigration process but also into the internal, domestic politics and dynamics that compelled England to transport so many of its subjects to other places. The statistics on Victorian female emigration are rather startling, as are the means by which such transports were facilitated. Hence, on a universal scale, the issue of emigration links the citizens of England to those notions of nationhood that prompted them to emigrate and thus forge a link between England and the colonies and dominions.

The essays in this volume address the issue of Victorian women's emigration from a number of different perspectives. They produce new knowledge on the subject of female emigration to the colonies and dominions and contribute greatly to the extant scholarship on the subject. Their specific areas of investigation involve many of the colonies and both the political and private realms, including investigations into the literary realm, as is the case with the bulk of the essays. They take historically based approaches and implicate the national categories of power (culture and gender among them) as well as the distinctions between authorized and "unauthorized" colonial women. Mark Bevir's essay on Annie Besant, for instance, unsettles some of the standard assumptions concerning these delineations and complicates the figure of the female missionary, as well.

While focusing on unauthorized colonial women and female emigration, the essays discuss and chart some new critical terrain on the intricacies of Victorian women's presence abroad. Eva-Lynn Jagoe's essay

locates the practices of Victorian imperial emigration in a geographic place that has been written about very little by Victorian scholars. In examining the presence of emigrant women in South America, this essay also investigates the role of the Victorian bourgeois class in areas other than the domain of the British Empire. Marion Diamond's essay on Maria Rye concentrates on a different aspect of the emigration issue, the colonists' responses to assisted female emigration. It discusses the role of female emigration within the imperial contest by examining the conflicts over assisted emigration, the discrepancies between emigrant and colonial needs, and the contradictions that were mediated in the process. Nupur Chaudhuri's essay on the assisted emigration of children complements the historical portrait of organized assisted emigration and exposes some of its challenges within England.

Posing some new questions for our consideration and for further study, A. James Hammerton's essay undertakes a retrospective analysis of his highly influential *Emigrant Gentlewomen* (1979) and considers the kinds of issues it would need to address today, in light of recent critical and theoretical developments. Specifically, he notes the areas of investigation that have been slighted thus far, both in his own earlier work and in general. He considers misrepresentations, both in the emigration scholarship and in the original emigration discourse, that place middle-class, "genteel" women at the center of inquiry, despite the fact that the overwhelming majority of female emigrants were working-class. This timely sequel to what has been a very important study facilitates a necessary examination of what Hammerton presents as gaps in the emigration scholarship. It also promotes further study of emigration along the lines of class and gender.

The cultural, national, and international relations contrived during the Victorian period continue to distinguish national boundaries today. In this most important respect, the subject matter of this book concerns the present moment as it does the past. In that spirit, this collection is intended as an introduction to a field of inquiry that would both complement and reshape postcolonial study. The essays that follow initiate a series of discussions that, it is my hope, will continue for some time to come.

Notes

1. Charlotte Macdonald, *A Woman of Good Character: Single Women as Immigrant Settlers in Nineteenth-Century New Zealand* (Auckland, NZ: Williams, 1990) 21.

2. A. James Hammerton, *Emigrant Gentlewomen: Genteel Poverty and Female Emigration, 1830–1914* (London: Croom, 1979) 177.

3. Stephen Constantine, ed., *Emigrants and Empire: British Settlement in the Dominions between the Wars* (Manchester, Eng.: Manchester UP, 1990) 2–3.

4. David Thompson, *England in the Nineteenth Century: 1815–1914* (New York: Penguin, 1978) 163–64.

5. Dudley Baines, *Emigration from Europe, 1815–1930* (London: Macmillan, 1991) 36, 50.

6. Eric Hobsbawm, *The Age of Empire: 1875–1914* (New York: Pantheon, 1987) 36–37. Hereafter cited in text as *Age*.

7. George Croly, "Mr. Wilmot Horton and Emigration," *Blackwood's Edinburgh Magazine* Feb. 1828: 191–94, 192.

8. William R. Greg, "Why Are Women Redundant?" *National Review* 28 (Apr. 1862): 434–60, 452. There are several important Victorian texts that negotiate the cultural value of unmarried women, some of which also defend female emigration. Among these are Hatton (1884), Greg (1862), Oliphant (1858), Grey (1875), and Ross (1882). An article by Tregear (1888) makes a compelling argument against emigration on nationalist grounds. Also, see Chapman (1874) for an incisive discussion of emigration practices. Most important among the pro-emigration texts are a pamphlet issued by the Women's Branch of the Oversea Department in 1897 (reissued in 1929) and a later study by G. F. Plant (1951).

9. Eric Hobsbawm, *Industry and Empire: From 1750 to the Present Day* (1968; New York: Penguin, 1990) 84.

10. If the problem for Victorians was how to provide for "superfluous" women, its solution was seen to lie in a desired scarcity. The colonies and dominions thereby become the most suitable nonplaces in which to deposit these women. Their removal would in turn render those who stayed in England more precious and valuable. It is in these terms that unmarried women surface as "surplus" commodities, as the literature of the period acknowledges.

11. This discussion is taken from Maria Rye, "Middle-Class Female Emigration Impartially Considered," *English Woman's Journal* 10.56 (1862): 73–85, 81.

12. Rye 80. Rye repeatedly used letters from colonists and new emigrants to construct arguments in favor of her mission, considering first-person narratives the most reliable sources, even above government statistics.

13. Among existing studies that do not go far enough in analyzing the cultural politics of the spinster are Laura Doan, ed., *Old Maids to Radical Spinsters: Unmarried Women in the Twentieth Century Novel* (Urbana: U of Illinois P, 1990) and Dea Birkett, *Spinsters Abroad: Victorian Lady Explorers* (London: Blackwell, 1989).

14. Monk's thoroughly researched study exhibits especially interesting affiliations both for the imperial project and for the single women's predicament. By and large, it is a project that works to endorse the imperial objectives of colonial emigration.

15. Anne McClintock, *Imperial Leather: Race, Gender, and Sexuality in the Colonial Contest* (New York: Routledge, 1995) 6.

16. An extreme instance of this miscategorization is Ronald Hyam's *Sexuality and Empire* (Manchester, Eng.: Manchester UP, 1990), which dissociates gender politics from the category of sex and sexual practice. Criticizing feminist critics for what he perceives as their oversimplification of the sex and gender dynamic, Hyam

nonetheless manages to discuss sexual practice in the colonial context without paying adequate attention to the ways in which sexual practice, gender politics, and imperial strategies intersected.

17. James Buzard, "Victorian Women and the Implications of Empire," rev., *Victorian Studies* 36.4 (1993): 443–53, 447.

18. We are reminded of Michele Barrett's early caution in *Women's Oppression Today* (London: Verso, 1986) against placing exclusive emphasis on discourse in cultural analysis. The grounds on which Barrett objects are that "analys[es] of 'social and discursive practices' appear ... to deny that gender differences, as a set of historically constructed and systematic categories, can be predicted with any confidence within a given historical conjecture" (87). Insofar as Victorian gender relations and categories are historically specific and systematically instituted, it is also important to note how these categories are renegotiated in the imperial context. The "site of struggle," in Barrett's words, must be seen as resting with those institutions and not with discourse.

19. Aijaz Ahmad, "Postcolonialism: What's in a Name?" (1981), *Late Imperial Culture*, ed. Roman de La Campa, E. Ann Kaplan, and Michael Sprinker (New York: Verso, 1995); Michael Sprinker, introduction to *Late Imperial Culture*, 1. See also Aijaz Ahmad, *In Theory: Classes, Nations, Literatures* (London: Verso, 1992).

20. Trinh Minh-ha, *Woman, Native, Other: Writing Postcoloniality and Feminism* (Bloomington: Indiana UP, 1989) 41.

21. Quoted in Patricia Clarke, *The Governesses: Letters from the Colonies, 1862-1882* (London: Hutchison, 1985) 87.

22. Franz Fanon, *Black Skin, White Masks* (New York: Grove, 1982) 141, 95.

23. Edward Said, *Culture and Imperialism* (London: Vintage, 1994) 128.

24. Karl Marx, *Capital*, vol. 1 (New York: Penguin, 1990). For an elaborate explanation of the "mystery" of commodities, see especially pages 149–77.

"Who Will Help the Girls?":
Maria Rye and Victorian Juvenile
Emigration to Canada, 1869–1895

Nupur Chaudhuri

In the mid-1870s the *Colonies*, a periodical published in London, often printed the following advertisement:

> Miss Rye's Home for the Emigration of Destitute Little Girls, between the ages of eight and thirteen. Mission and Bible women, and other benevolent persons, are invited to communicate any case they might think eligible to the Secretary, Avenue House, High Street Peckham. Funds are greatly needed to carry on the above good work, where by poor neglected little girls may be removed from wretchedness and vice, and placed in happy Christian homes in Canada, where they may be properly trained and cared for.

An additional note in the advertisement was that the "cry of the charitable has too long been boys, boys, who now will help the girls?"[1]

Maria S. Rye (1829–1903) was a leading figure of the nineteenth-century English juvenile emigration program. She was a major architect in organizing a program to take primarily female children of the destitute poor, whether in or out of the workhouse, from England to Canada from 1869 to 1875 and again from 1877 to 1903. Her emigration project created controversy across the nation, eventually leading to temporary suspension of her program from 1875 to 1877. Rye's work for juvenile emigration was both praised and criticized by her contemporaries in England and Canada. The critics of her undertaking blamed her mostly for inadequate supervision of these children upon their arrival in Canada and for failure to ensure that the children were under the proper care of their Canadian adoptive parents or employers. The critics cited a few instances of abuse occurring in the juvenile emigration program while Rye was trying to provide a better life for pauper juvenile girls.

A brief setback in Rye's plan of female juvenile emigration to Canada fueled her enthusiasm of caring for the destitute little girls. Her problem

with the Local Poor Law Board has received some attention in a few recent scholarly works. Ivy Pinchbeck and Margaret Hewitt, while describing in detail the transportation and emigration of children to the colonies from 1717 to 1920, touched on Rye's involvement in juvenile emigration and the resultant controversy.[2] Gillian Wagner, Philip Bean, and Joy Melville, in their descriptions of the migration of British children during the nineteenth and twentieth centuries, argue that Rye's insensitivity toward the children's needs lead to the dispute.[3] Wesley Turner analyzed the attitude of the press toward Rye's juvenile emigration scheme and the debates surrounding it.[4] These works have captured well the full depth of the controversy surrounding Rye's work on juvenile emigration to Canada. The value of Rye's lifelong work in this area lies in the revelation of attitudes of women in some segments of the British society during much of the nineteenth century, which is a central focal point of this article. The responses to her work give another dimension to the Victorian attitude about the emigration of children to colonies.

In nineteenth-century Britain many were concerned about children's plight, which citizens believed was a serious problem for the state. The long-established workhouse schemes were apparently failing, as in the early nineteenth century thousands of children and young adults swarmed London's streets and alleys as beggars, thieves, and even prostitutes, often working for unscrupulous parents and other individuals. In 1848, approximately thirty thousand children or "street arabs" in London used arches, porticoes, sheds, carts, and iron rollers in Regent's Park as shelter.[5] These children, like Oliver Twist, fell in with "kidsmen" such as "Fagin" who trained these children to be thieves.[6] Some people believed that beggary and more vile activities were instigated by exploiters. Regardless of the source of the children's plight, most people saw a need for some form of parliamentary intervention to control the rising tide of children's misfortune.

In 1834, the report of the Royal Commission on the Poor Laws offered assistance to those who were totally dependent on public relief and spent nights in workhouses.[7] The second largest group in the workhouses was the children.[8] The 1834 Poor Law Amendment Act was enacted to permit the children to be separated from adults in the workhouses, and to provide children with a basic education so they would find employment and leave the workhouses. As many individual workhouses were found incapable of providing basic education to the children, legislation was passed in 1844 that permitted parishes and unions to combine to form residential district schools. But the concept of the district school was slow

to break ground, as it was not until 1849 that a school district surfaced. Limitations on the finances and the size of each district, including sparsely populated areas, coupled with opposition from local boards of guardians that wished less authority in this matter and were reluctant to bear the cost of the operation, drastically dimmed the prospect of the act's adoption.

Social reformers like the earl of Shaftesbury saw emigration as a means to save these children from criminal life. Shaftesbury moved adoption of the Pauper Children Emigration Bill in the Lords on 26 June 1852. According to this bill, parishes or boards of guardians would raise funds to send children abroad. Lord Shaftesbury also wanted to send younger girls "in order to fit them by an education of not less than a year to become useful servants and eligible wives." But the bill was defeated by the opposition led by Lord Derby (Bean and Melville 37). This defeat marked the end of the movement for a state-organized juvenile emigration program.

In 1855, the Education of Poor Children Act, forbidding any relief to parents sending their children to be educated, permitted local boards of guardians to pay for schooling for only the outdoor pauper children. In the ensuing few years, evidence arose that pauper populations among the children increased and that the majority of girls brought up at some major workhouses had turned to prostitution, signaling a nearly total failure in the arrangements for basic training and religious education of vast numbers of destitute children.[9] The failure of the Poor Law to eradicate child pauperism and to help the children become self-supporting, useful citizens, triggered the support of voluntary societies around the second half of the nineteenth century. Caring for the pauper children shifted from a large, institutionally based drive to small, family systems such as "boarding out," "family cottages," "cottage homes," and others. In such homelike atmospheres, it was believed, the pauper children would grow up with affectionate family ties, love, and religious upbringing and would learn many different household tasks that would enable them to find a productive means of livelihood in the future. All of these factors led the British to agree that the environment of workhouses would be detrimental to a child, but they did not agree on the best means of removing a child from that environment. Some thought a child should be educated in a special industrial school, whereas others believed that she or he should be boarded out with working-class families. Children aged between seven and fourteen years and charged with vagrancy were sent to industrial schools. In 1861, there were nineteen industrial

schools seeking to prevent crime by caring for the orphans. These schools also provided shelter for the destitute children who did not fit into the more specialized voluntary orphanages.[10]

The Poor Law Board had responsibility for orphans and vagrant children; it did not seek out the children for whom care was needed but provided help whenever assistance was sought. The Poor Law authorities tried to accommodate many orphans in the workhouses, but no provisions were made for neglected children whose parents worked in factories, begged, or even turned to crime. These neglected, deserted children, whose numbers continued to increase, began to spend their lives on the streets. Failure to take care of many orphans in the workhouses and inability to cope with the swelling numbers of neglected and deserted children on the streets forced society to seriously consider programs devised by private charitable foundations and philanthropists to prevent these children from joining the underworld. Juvenile emigration appeared to many philanthropists and charitable organizations an attractive means of curbing the rising problem of juvenile delinquency. The attraction of juvenile emigration originated in the first half of the nineteenth century when numerous children, especially boys, were sent to Australia. But the home country seriously questioned emigration after receiving information about the loneliness and isolation of these child migrants and the lack of facilities offering them any formal education, vocational training, or religious instruction. Furthermore, people feared that the Australian gold rush of 1853 would be harmful to children sent there. The Committee of the Ragged School Union believed that in addition to contamination from the diggings, "many of the boys would be susceptible to the contagion of those moral diseases which have broken out in the train of gold fever."[11]

Critics of juvenile emigration argued that young, unprotected children with no aftercare provision should not be sent abroad. This provision was deemed necessary even when opportunities for juvenile emigration to Canada emerged around the middle of the nineteenth century. Canada now began to replace Australia as the primary destination of emigration, in part because the cost of passage to Canada was less than that to Australia.[12]

Although orphans of both sexes faced the physical hazards of poverty and risked being led into criminal life, girls were in additional danger of entering prostitution. Poorly paid factory jobs or the lowest "maid-of-all" domestic employment was the only source of income for girls over the

age of twelve.[13] It was the dreariness of their lives that probably led many young girls into prostitution.[14] To save these children from poverty and a life of crime, the organized juvenile emigration movement to Canada gained imomentum in the late 1860s. Maria Rye played a leading role in this movement.

A few observers of emigration issues became concerned that destitute boys were favored over equally threatened girls. The *Englishwoman's Review,* a feminist periodical, published a letter in January 1867 in which a correspondent wrote,

> Take as examples the excellent refuges of St. Giles and St George, Bloomsbury, where according to last year's report, there had been admitted, up to the close of 1865, 1016 boys against 659 girls. . . . [A] distinction in favor of boys prevails. . . . Would it not be well to endeavour earnestly to establish more refuge for *girls?* They might be trained with a view to their emigration to the Colonies. . . . Emigration seems specially suitable to those who have no family ties in the old country.

The author of this letter strongly believed that "the neglected and forsaken children who wander about our streets, with nothing before them but misery and vice, these it is to whom we should extend a rescuing hand, and help them to reach those fields of honest and happy labour which lie open to them beyond the seas."[15]

The emigration of orphan girls to colonies during the nineteenth century was promoted most vigorously by Maria Rye, who devoted herself from 1869 to 1875 to supervising the emigration of 202 boys and 1,102 girls to Canada, the latter ranging in age from six months to fourteen years.[16] Her work was suspended from 1875 to 1877 because of a controversy but was then resumed until her retirement in 1895. Born in London in 1829, she became involved in improving the lives of young single women and at the age of thirty opened a law-copying office in Lincolns Inn Fields as a branch of the Employment Society. The office employed a large number of single women. She also established the Victoria Printing Press and in 1860 set up a telegraph school to employ women as telegraph clerks. To offer single women other opportunities in life, she independently advised and assisted applicants to emigrate to different colonies.[17] In 1865 she shifted her attention solely toward juvenile emigration to Canada and began to seek the betterment of the lives of destitute female children. She explained that

about fourteen years ago, Lord Shaftesbury had a conversation with her about getting homes in Canada for young children. She had borne the matter in mind for some time, and in 1869 a gentleman from New York ... had visited London and explained what was done in New York and neighbourhoods with poor children—sending them from the over crowded Eastern cities to the far West, and finding for them good homes for life. (qtd. in Turner 173)

Rye was apparently familiar with Charles Loring Brace's work with Children's Aid Society in placing children in the midwestern states. In 1868 Brace commented that his work in placing children had reached its limits. Thus it appears that, coincidentally, the placing of children became a dying movement in the United States when it began in Britain.[18]

In 1869 Rye wrote a lengthy letter to the (London) *Times* entitled "Our Gutter Children," in which she referred to juvenile emigration as "a fresh branch of my work, which I believe may prove even more beneficial than anything I have attempted. I allude to the emigration of our street children to Canada and the Western States of America." Reflecting on the apparent success of programs that allowed homeless boys from New York City to be adopted in the western states, she remarked, "Why not attempt the same thing for the 'gutter children' of London, Manchester, Birmingham, Bristol and Liverpool?" To gain support for her plans on juvenile emigration, she argued: "What treatment will they receive from the cold, the starvation, the temptation they meet with our gutters; what justice will they receive at our hands when the police, the gaol, the hospital, and the Magdalene receive them? Can anything I introduce them to in Canada or America, be worse than that to which they are doomed if we leave them where they are now ?"[19]

Rye's juvenile emigration program focused largely on female children. She wrote:

As the boys have more "home" and "reformatory" accommodation than the girls, and have also the army and navy by which to earn their bread, besides innumerable trades, while the girls are confined almost exclusively to domestic service and needlework, I propose taking only female children, and they are to be—I. Orphans; 2. Children who have been deserted for five years; 3. Foundlings, also deserted; and all to be of the age from five to ten years.[20]

She claimed that since she understood girls better than boys, the migration of boys should be left to Annie Macpherson (Bean and Melville 51).

To get her project going, Rye needed one thousand pounds to buy two houses to shelter the children: one house in London to keep the children until they left for Canada, and the other house in Canada where they would stay until families willing to accept them could be located. She appealed generally for contributions, assuring potential contributors that the children would be properly supervised. Rye wrote in the (London) *Times* of 12 April 1869: "Local committees of ladies and gentlemen in the different towns can easily be formed, who will from time to time — say quarterly — report to the central home at Niagara the progress and condition of the children living in their own immediate neighbourhoods; at any rate, I shall do all I can to secure the safety of the children" (11). Although she agreed that her plan might be open to many objections, she assumed that "it is very easy to object, and suggest difficulties. The thing is to do something."

To accommodate 120 children in 1869, Rye bought and renovated a house that had been Niagara-on-the-Lake's second jail and courthouse in Canada. This residence was formally opened on 1 December 1869 and was named "Our Western Home" (Turner 173). Even before the Canadian house was formally opened in 1869, she took one hundred servant girls (working-house girls) to Canada in the summer of 1868, and she quickly placed them with families.[21] The children Rye collected came from the poorhouses and also from various sections of present-day London and Birmingham. By repeated appeals through the (London) *Times*, Rye raised enough funds in 1872 to buy the second house (Avenue House) in Peckham, where she established the Home for the Emigration of Little Girls; the earl of Shaftesbury and the chairman of the St. George's Board of Guardians were members of the advisory committee.[22] In the meantime, to get support for the cost of collecting the children from the streets and to provide them with a certain amount of training prior to their emigration, she contacted William Rathbone, a wealthy Liverpool merchant and member of Parliament, who contributed two hundred pounds to her cause and helped her to receive additional support of two hundred pounds from Liverpool Poor Law Union.[23] The archbishop of Canterbury supported her undertakings (Turner 173).

Nearly a year after she established Our Western Home in Canada to provide temporary shelter for children to be settled in Canada, and while still raising funds for the house in London, Rye sought the approval of her activities from the Poor Law Board. She also requested to the board that she be allowed to take orphans and deserted pauper girls

ages seven to thirteen chiefly from the London workhouse schools to Canada, assuring the board and the public that children up to eighteen years of age would be placed under proper legal protection, in respectable families in British North America. Rye also requested permission to use her own discretion to place children with any respectable American family that requested such a child. The Poor Law Board gave official sanction to Rye's juvenile emigration scheme and commended her and others for the "satisfactory arrangements made by these ladies, not only for proper superintendence during the voyage but also for the support and treatment of the children on their arrival in the colony" (Pinchbeck and Hewitt 565).

To collect deserted pauper girls for emigration to Canada, Rye sent out letters such as the following to different poorhouses: "I am prepared to take from your Union any fresh cases of pauper girls, of from seven to thirteen years of age, whom your board may think it wise and kind to start afresh in a new country." Her arrangements offered "departure by the mail steamers from Liverpool," and the unions were to pay eight pounds for passage and an outfit, transit to the home in Canada, and support costs while the child lived in the home. The unions would also pay the child's travel to Liverpool, fare from London at the time being 12s. 6d. for adults and 6s. 3d. for children under twelve.[24]

Rye required that all unions provide particulars about the girls selected for emigration, as requested in the following application form:

> Female Emigration—Orphans—Canada
> State child's full name. State her age. Has she been baptized? Into what communion ? Where is she living? How long has she lived there? Are her parents dead? Has she any relations living? Where do they live? Are you (the applicant for a passage to Canada for this child) in any way related to her? Give your full name and address.
> MEMORANDUM.—Children who have been deserted three years to be considered orphans. If the child in whom you are interested is taken to Canada she will go to "Our Western Home," Niagara, Canada, West, and will be taken care of until she can be placed out into some respectable farmer's or tradesman's family, and be looked after until she is eighteen years of age.[25]

Although Rye did not accept children over thirteen years of age for her emigration program, in the case of an orphan with family tie, she would accept a sister a little older or younger instead of breaking up the family. Furthermore, before removing a child from a parent's care, she obtained

consent from both the parent and the child, given before two magistrates. The children were at least consulted about their willingness to emigrate—even if the question was only *pro forma*.

Any person who wished to have a child from Rye's Canadian home was required to give her or his name, address, length of stay at that address, marital and job status, religious preference, number of children, and two character references. This individual also had to state the future status of the orphan in the family.[26] Rye placed all the children in her home at Niagara under the following categories: adoption, apprenticeship by indenture, and ordinary service. Children who were not being adopted were bound out to serve until the age of eighteen on the following terms: up to fifteen years of age they were fed, clothed, taught, and sent to a place of worship and Sunday school (if possible); from fifteen to seventeen, instead of being clothed they were paid twelve shillings (estimated to about $3.00) a month as wages; and from seventeen to eighteen (the last year of apprenticeship) they received fourteen shillings ($3.50) a month as wages. Under no circumstances would a child "be passed on to another family without first consulting Rye, and in case of the death of persons (husband or wife) taking children, it [was] particularly requested that an immediate notice of the fact be sent to the Home."[27] These benefits were secured to each child by legal indentures binding the master to treat the child properly and were jointly signed by him, Rye, and two justices of peace for Canada. At the end of the apprenticeship, the young women were free to make their own terms and chose their own employers. The young children were not expected to work hard. No more than ten percent of the total number of emigrants were little children, and they were adopted by the families who took them as boarders.

Rye's efforts in Niagara, Canada, were sustained by help from local leaders like the Reverend. Dr. McMurray, anglican rector of Niagara; Robert N. Ball, justice of peace; George P. M. Ball, member of a locally prominent family; and J. M. Lowder, a local judge. Rye did not have sufficient resources to open temporary homes elsewhere in Ontario, but she was able to place children in different parts of Ontario with the help of influential local citizens. Rye herself was a member of the Church of England. In Canada she found homes for her destitute children with members of the Church of England, Presbyterians, Wesleyans, Congregationalists, and several other Protestants. She did not accept Roman Catholic children for fear of religious opposition of the Catholics to the project, saying, "As I am a Protestant myself, and am anxious that there should be no difficulty raised at any future time on this point, I desire to

say that all children committed to my care will be placed under or within the influence of clergymen of our National Church." She also relied on the support of evangelical ministers of other denominations "who will supply quarterly reports of the welfare of the little ones living in their prospective neighborhoods, and with members of their congregations."[28]

From 1869 to 1874, Rye transported more than 1,377 children to Canada. Rye estimated that two hundred of the children were from orphanages and the rest from workhouses.[29] The *Englishwoman's Review* of October 1872 reported that since December 1869 Rye had taken six hundred children to Canada, ninety-eight percent of whom were female. In April 1874, the same periodical noted that 490 farmers, 159 tradesmen, and 252 people from other professions took children from the home at Niagara, and quoted the Liverpool *Daily Post* that "the rule with respect to these children, is that they become practically the adopted of those to whom they are sent (101–02).

Rye's emigration program apparently ran smoothly until 1871, when she began facing mounting criticisms of the goals and management of her programs. In 1871 the Local Government Board replaced the Poor Law Board, and soon after its formation, this new board decided to review the emigration programs for children to Canada, since emigration of the children from the Poor Law workhouses was paid partially from Poor Law rates. Rye's free and easy management style laid her open to criticism, and rumors were already circulating in the press about her work when, in 1874, the Islington Board of Guardians received written requests from Allendale Grainger to review the emigration program. Grainger complained that the work of a servant in Canada was almost triple that in England and that orphans were also scattered all over the country, where they could not be monitored by Rye. He urged the board to investigate whether the ratepayers and general public were paying too much for Rye's service (Wagner 50–51). This letter prompted some board members to voice their dissatisfactions with Rye's juvenile emigration project. A member of Islington's Local Government Board remarked, "Mr. Fairbank said the children were brought up and educated, and when fit to go to service were drafted off to Canada. There was a great scarcity of labour in this country, which would be increased by sending away the strong and healthy and leaving the weak and sickly." Mr. Young, another board member, claimed that many families in Islington would like to keep two servants but had to put up with only one because it was difficult to get servant girls. He further commented that "servants in England got better wages and were more comfortable than

those in Canada, implying that the children were not best served by emigration. Young added that "Miss Rye did not take the poor destitute children from the streets, but the best from the workhouses." However, another board member reminded the others that the guardians themselves, not Rye, selected the children.[30] Members of the Local Government Board also questioned Rye's ways of spending the money she received and doubted her assurances regarding treatment of the children in Canada. Rye successfully defended her program to the Islington Board of Guardians (Wagner 52).

The Local Government Board's inquiry into the juvenile emigration scheme attracted the attention of high-ranking officials of the British administration. In 1873, both Colonial Secretary Kimberley and Governor General Duffarin discussed the questions regarding management of this project (Turner 174). In 1874, a member of the British Parliament asked Mr. Sclater-Booth, the president of the Local Government Board in the House of Commons,

> whether, considering the large number of children sent out to
> Canada by the Poor Law Guardians of various Unions, it was the
> intention of the Government to exercise any inspection of the tem-
> porary homes or refuges provided for such children, both in this
> country and Canada ... [and to inquire] generally into the system
> adopted in the latter country whereby the children were placed out
> in different trades and employment.[31]

Sclater-Booth responded that "it is the intention of the Government to make inquiry into results which have attended this particular form of emigrants.... [T]he arrangements [of investigation] are on the verge of completion."[32]

To counter criticisms, Rye published in the (London) *Times* of 6 March 1874 two letters that she claimed were typical of those she had received over the years. One letter was written by an eleven-year-old orphan girl who had lived with some old maiden aunts, who were supported by charity. This little girl wrote to her aunts: "i [sic] have got sent to Canada, and i [sic] have got good home, i am with a lady and gentleman.... the gentleman is a rich farmer, he own 200 acres of land, he is his own landlord, this is a free country, much better than were you be." She continued, "i like my new home well, i have had good health ever since I have been hear [sic].... i have got as fat as pig.... i have plenty of every thing that is good to eat and drink.... i have a quarter of a mile to go to Sunday school every Sunday" (4). The second letter was written by

a family that adopted a seven-year-old orphan girl. In this letter, the family wrote that they had spent money to give the child music lessons and that they were happy with their adopted child.

In 1874 the review board for the Poor Law Unions finally recommended that Andrew Doyle, one of their most experienced inspectors, be sent to Canada to investigate juvenile emigration systems carried out not only by Maria Rye but also by Annie Macpherson. However, Doyle was not in favor of the juvenile emigration scheme. Since 1858, Doyle had openly opposed plans for juvenile emigration and had argued that it would be cheaper instead to provide a suit of clothing at fourteen years for Poor Law children and to assist them in finding employment. He also argued against the "boarding-out" system of pauper children and defended their training in the great district schools and workhouses.[33] In February 1875 Doyle reported his findings to the Local Government Board. This report was printed in *British Parliamentary Papers* and was also dispatched to Canada by the colonial secretary "with a request that it should receive the particular attention of the Canadian Government" (Turner 175).

True to his predisposition against child migration, Doyle objected to several points in both Rye's and Macpherson's systems, and he was particularly hard on Rye for her loose managerial style. Doyle complained that he himself observed at Liverpool, from where Rye brought a group of 150 children to Canada, that the parties of children sent out were too large and the number of supervisors were too few to look after the physical needs and personal hygiene of these children. Doyle preferred that each group be of no more than fifty children and reiterated that accommodations at the intermediary homes fell short of the official requirements of an ordinary English workhouse. Doyle further charged that Rye failed to fulfill the promise she made to the Board of Guardians in 1870 that additional security would be provided not only "for the proper superintendence [of children] during the voyage but also for the support and treatment of the children on their arrival in the colony, where suitable situations are found for them" (Doyle, "Report" 6). He claimed that Rye did not supervise her children properly and that they were badly treated in Rye's home at Niagara. He related one girl's description of her punishment at Our Western Home for having displayed bad temper: "She was placed in a room at the top of the house and kept there in a solitary confinement for 11 days upon bread and water, without book or work to divert her thought. The only person she saw during that time was the child who brought her bread and water allowance" (18).

In 1870 the Poor Law Board of England wrote that "experience has conclusively proved that unless the homes are carefully selected by persons who have intimate knowledge of the locality, and who at the same time take a responsible interest in the children to be placed out, great abuses are quite certain to ensue" (20). Doyle argued that some of Rye's children worked in the United States, where they could not be supervised, and that even in Canada she did not have any regular or organized means of supervising these children once they were placed with families. Local persons voluntarily assisted Rye in placing the children in service and visiting them afterward. Unless Rye heard an unfavorable report regarding any particular child, she assumed that the child was doing well and did not require any attention from her. However, she maintained lengthy correspondence with the employers. Doyle commented that "Miss Rye trusts to the accident of being able to find persons in different districts who will relieve her from the responsibility not only of finding suitable homes but of looking after the children when they are placed in them" (14, 20). Rye apparently lost track of about twenty-five persons for lack of supervision.

Doyle noted that Rye placed all her children under one of the following categories: adoption, apprenticeship by indenture, and ordinary service (Doyle, "Report" 11). A large number of children were placed without any formal indenture of service but simply upon a verbal agreement that after a certain age the child should receive, either in addition to clothing or in lieu of clothing, so many dollars a year. Doyle found several cases of "adoption" in which the indenture of adoption had not been signed by the employers. Doyle felt that a large number of people adopted children "on account of their services, and ... willingly [took] them on account of their future usefulness" (12). Doyle also believed that the English children had become objects of pity and were sometimes taken into service as much for charity as for what their labor was worth. Sometimes the older children were placed in isolated rural communities. They were poorly paid, as wages in Canada were lower than those in England, and their working conditions were miserable. Doyle commented, "Some of these places indeed, are worse than a Board of Guardians would consent to place a child in England." To escape from wretched situations, several girls left their employment and went to the nearest town. A number of these girls were left destitute with illegitimate babies by the time they were sixteen or seventeen, and since Canada had nothing resembling the Poor Law at the time, they were in more serious trouble than they would have been in England. Doyle

commented, "[I]t would surely be better to keep them at home, letting them take their chance of what Guardians can do for them amongst their own people" (21).

Doyle further suggested that Rye and others might be profiting from this scheme. He wrote in his report that with several thousand pounds a year of private contribution and financial assistance by the Governments of the Dominion and of the Province of Ontario, in addition to a payment of eight pounds and eight shillings for every pauper child taken out by Rye, "there would be a clear gain of 5 £. per head upon every pauper child taken by these ladies as emigrants to Canada" (34–35). Despite this estimate he could not make any formal charge because he did not receive any detailed financial statements from Rye, nor did she respond to his inquiry as to the amount of aid she received from the Ontario and Dominion governments (Turner 175).

Rye was perhaps most vulnerable in the area of management. She did, however, respond publicly to Doyle in letters and speeches beginning around March 1875. Publication of Doyle's report led the Immigration Committee of the Canadian House of Commons to interview Rye on 22 March of that year, at which time she claimed that Mr. Doyle's comments were unjust and without foundation. Rye was in no haste to defend herself because she believed the Canadian Parliament was working on the matter and would report to the British Parliament in due time. However, to reassure the British public of her program, she countered the charges on Doyle's report. She wrote from Montreal two letters to the (London) *Times*. In the first letter, published on 22 April 1875, she noted that in Canada she had ten centers for placing children but that Doyle went to only four. She underscored that Doyle met 140 out of her 400 children and that he admitted that those 140 were doing well (13). In the second letter to the (London) *Times*, published 23 April 1875, she emphasized that every Canadian man lived on his own property and had lived there either all of his life or for a long time, in contrast to "the poor cottager with whom the children are boarded out in England, to whom the child's weekly pay is a matter of most serious moment, and who, should any unforeseen trifle put him out of work, would find very great difficulty in retaining the child in his cottage at all." She also mentioned that within the previous five years two hundred "rebellious, obstinate, and unmanageable children" came back to her Niagara home for whom she had to find new places. She complained about Doyle's omission of this fact. Finally, she wrote:

I have asked the Government here to make a house-to-house visitation of the children, in common justice to myself and to the work.... I now ask that the Local Government Board shall in England, at the same time, order house-to-house visitation of the same number of girls taken from the same workhouses during the same dates, and let the public compare the fates of the children left in England with the fates, or perhaps, I might even say with the fortunes, of the children, taken to Canada.

Throughout the controversy contemporary Canadian newspapers praised Rye's work (Turner 179).

During the controversy, the *Englishwoman's Review* also supported Rye, writing that "[t]hose poor children have been rescued from [a life] in England, of vice, ignorance, pauperism, and unfriendliness, [so] we must deprecate any reactionary feeling on the part of the magistrates which should put a check on juvenile emigration."[34] To prove that her girls were doing well in Canada, Rye offered photographs she had collected of four hundred children. Some of these girls who emigrated in 1869 were no longer children. In June 1876 she held an exhibition of six hundred pictures at her Peckham home. After seeing this exhibit the *Englishwoman's Review* commented:

It was almost impossible to believe in looking over the albums filled with the portraits of healthy looking, well dressed girls, that they could have been taken from the workhouses of St. Pancras, Lambeth, Stepney, Chelsea ..., as also from our London streets. The photographs have been sent from Canada to Miss Rye, some by the girls themselves, others by the adopted parents and mistresses of the children, and in every case it has been done voluntarily.[35]

In December 1876, Rye wrote a letter to the president of the Local Government Board, answering Doyle's charges. She pointed out that after reviewing her books, the Canadian government was satisfied that she did not profit from her juvenile emigration scheme.[36] Rather, on 6 December 1875, in response to her request for a grant of two thousand dollars to keep Western Home open, the secretary of Department of Agriculture, Canada, had sent an official check of one thousand dollars (16). She also mentioned that the Department of Immigration, Toronto, had written her a letter stating that she would be receiving six dollars (£1

4s.) for each child she brought to Canada. In response to Doyle's comment on her lack of supervision, Rye claimed that the class of Canadian men and women who took English children were a "substantial, orderly, comfortable, and well established class of people," and for that reason she thought "inspection of the children of comparatively so small moment, [that she had] largely used correspondence as a means of oversight of the young people" (1–2). In response to Doyle's accusation that she failed to secure the affections of the children, Rye described the difficulty of one woman becoming the center of thousands of young children and pointed out that many girls required several placements before they settled down to lifework, which would cause the children to look upon her unfavorably. She wrote that "Mr. Doyle's great cruelty consisted in quoting these cases as representative, and not as exceptional."

Rye argued that if her scheme was so disastrous, then others, like Dr. Middleton with his Birmingham and London, Ontario, Receiving Houses, and Mrs. Burt with her Liverpool and Nova Scotia workings, would not have imitated her. However, she admitted that in six years (1869–74) she lost track of twenty-eight children under fifteen years of age. She claimed that she wished to devote her time, if allowed to go on with her emigration work, exclusively to the girls. Drawing attention to the large number of female prisoners committed to the House of Correction, Westminster, Manchester, and Liverpool during the years 1875 and 1876, she emphasized that the Kirkdale, Bristol, St. George's, and Hanover-Square School Committees had publicly acknowledged that her work saved the ratepayers as much as two to three thousand pounds a year (3–8). She concluded her letter by saying "that the following Unions, all of whom have previously committed their young people to my care, have again requested me to carry more children to Canada, viz., Fareham, Chichester, Oxford, Stepney, and I believe I may also add Bristol" (9).

On 14 May 1877, Doyle wrote a lengthy letter to the president of the Local Government Board emphasizing that "Miss Rye has lost sight of only 28 children *of the age of fifteen and under.*" Then he caustically asked, "How many children lost sight of are *above the age of fifteen and under eighteen?*" He answered his own question by stating that "the number of that age who are 'lost sight of,' Miss Rye does not think it necessary to state. It appears, however, to be no fewer than 100."[37] Most accurate in his criticisms of Rye's managerial style, Doyle more pointedly betrays his classicism and sexism in his other complaints about Rye's program. A recurrent theme in Doyle's report was Rye's failure to separate "gutter arabs" from pauper children taken from the homes and industrial

schools. Doyle claimed that he enquired about "the character of a large class of the children who are sent out as emigrants and [about] the way in which they were collected" by Rye. He visited four hundred children, arabs and pauper, placed throughout the provinces of Quebec and Ontario. He corresponded with several employers and also visited Rye's Western Home in Niagara (Doyle, "Report" 3). He emphasized that although the proportion of "gutter children" distributed by Rye was quite low, she did not make any distinction between the pauper children from workhouses and reformatory and industrial schools and the "street children" whom she rescued. These children were simply known as "Maria Rye's children" in Canada, but Doyle asserted that the distinction should have been maintained. These "waifs and strays" were "from the very lowest class—the semi criminals of our large cities and towns." Hence, lack of class distinction would enable these "gutter children" to corrupt the pauper children. Furthermore, the pauper children "usually have had some few years preliminary education and industrial training," whereas street children were sent out without much industrial training and preliminary education and did not receive any training in their Canadian home (4).

Doyle emphasized that "if the emigration of pauper children to Canada is to continue, it should be wholly disconnected with the emigration of arab children." He argued that "to gather children off the streets, or to accept them from the guardians without satisfactory assurance of their fitness for service, and to take them out to take their chance of finding those 'splendid homes' in Canada that are written about, is to really do serious injury to the children and permanently prejudice a system of emigration that might do infinite good" (Doyle, "Report" 16, 34–35). By their attitude and behavior, the street children were tarnishing the imperial image of Great Britain and Canada. Furthermore, Doyle's English pride was apparently offended by what seemed patronizing behavior by Canadians who took children into service out of pity rather than out of need for their labor. Doyle implied that Canadian homes and family life were not necessarily better than English and were not automatically superior to those in orphanages and other institutions.

Besides economic factors, there were political reasons for child migration, such as the desire of the English to populate the colonies and the desire of the colonies to increase the number of the British in that part of the world. Juvenile emigration was perceived as counteractive to rebellion in the colonies, since young children could be molded into good colonists and could thus strengthen the empire.[38] Charity for needy chil-

35

dren, such as those from the streets, was therefore less important than the political motive for sending suitable children to the colony. Rye responded by emphasizing that the only difference between the street arabs and the pauper children was that the latter could read and write, but the street children had "quicker intelligence, greater gratitude and infinitely more affection."[39] Rye seemed to have overcome the classism of her culture to some extent. According to Doyle, Rye followed "a very loose and informal way" of obtaining the consent of the legal authority over the street children and did not get the required consent of the street children themselves, given before two magistrates, as she had with the pauper children.

Given Doyle's resistance to sending street children to Canada, one must assume his point here is not to defend the rights of children he saw as a disgrace to the empire but rather to invent an obstacle to their emigration. Why did Rye herself discriminate in her manner of handling the consent? Perhaps she felt the moral danger that tempted the gutter children on a daily basis, and chose a more authoritarian intervention to effect their rescue. Criticizing the religious upbringing of these emigrant children, Doyle wrote: "[E]very pauper child that Miss Rye has taken from this country, being a member of the Church of England would, if kept at home, be brought up in communion with the Church of England." He maintained that this was the child's legal right and that the guardians in England would have been careful to protect that legal right of the child. He emphasized that "under Miss Rye's system the security of the 'Creed Register' is set at nought, and the provision of the law, completely disregarded" ("Reply" 14). Given that the private philanthropic sponsors of the program in England and many of the supervisors in Canada were connected with some Protestant church, indeed were in some cases members of the clergy, this complaint seems another of Doyle's attempts to invent obstacles to emigration. Defense of the establishment of the Church of England was an easy chime to ring at this time, but the needs of the poor clearly outstripped what the church was providing.

The discrepancies in education and training noted between street children and paupers and the question of their suitability to become colonists raise the issue of children's place in the Victorian labor market. The children most suited to be good colonists were also the ones potentially most useful to provide cheap labor in Britain. Doyle concluded in his report that only girls younger than seven or eight years old should be sent to Canada. When girls between the ages of nine and fif-

teen were sent to Canada, they were hired as domestics. He raised the question that "if they be reasonably well prepared for service, it is difficult to understand why they should be sent out of a country in which one hears from every household complaints of the dearth of domestic servants, and of the want of young hands in various branches of industry." Once Rye had begun her vigorous defense, Doyle appealed again to this argument of the labor market. Later in the dispute, he stated again that the terms of service were unfair to English children because "in no other way can one account for the eagerness of the Canadian employers to get them, and the unwillingness of the working people in Canada to send their own children into service upon the same terms." He continued, "Nor is it easy to understand why managers do not avail themselves of those 'splendid homes' that are spoken of for the children who may be found in such numbers with in the various charitable institutions of the chief cities of the Dominion" ("Reply" 14). It was apparently the economic motive that prevailed in the minds of the men who made the decisions.

Doyle's report convinced the Local Government Board to recommend in 1875 that "it is not desirable to encourage the emigration of pauper children to Canada, except in special cases."[40] The board further decided that should the girls educated in workhouse and district schools in the south of England or in the agricultural districts become unsuccessful in finding proper employment on their own, the board would then consider other arrangements for obtaining employment for these girls in other parts of the country. Following the newly adopted policy, the Local Government Board declined to sanction the sending out of eleven little pauper girls from St. George's, Hanover Square, to Canada. The grounds against the sanction were that "they were too old, that wages offered were too low, and that the girls were wanted in England. Why should girls be sent to work at 10 in Canada when the law protects them up to 12 in England?" In response, the guardians of St. George's Union approached Mr. Sclater-Booth, president of the Local Government Board. They emphasized that "Miss Rye's system was in the interest of the children and the rate payers. So far as was known, these children in Canada became useful members of the society, and lost the taint of the pauperism of home, and were infinitely better off than they were in England."[41] Responding to this request, Mr. Sclater-Booth stated that the girls' services would be valuable in England and suggested that "Miss Rye might profitably employ her time in providing young married people who had lost their own children with children for adoption."[42] Thus,

the new policy of the board in 1875 marked the beginning of the decline of juvenile emigration.

Rye remained undaunted by Doyle's criticism, and though she was forced to suspend her work from 1875 to 1877 while the controversy over Doyle's report raged, she eventually resumed helping children from the workhouses, although a smaller number of children. When the Board of Guardians of St. George's found out that the Canadian government had decided to inspect and report upon the condition of children sent to Canada, they immediately asked Rye to take twenty girls to Canada.[43] The Board of Guardians intended to save money for the state, as child migration was economically beneficial to England. The cost to equip, transport, and place a child in Canada was less than that to maintain a child for a year in a workhouse or perhaps for several years in a home before finding employment (Bean and Melville 39). The majority of the Victorians did not believe in a social welfare state caring for the poor and the destitute. Doyle emphatically stated that "no pauper children ought to be sent to Canada under Miss Rye's present system of emigration ("Reply" 1). Rye, however, paid little attention to Doyle's recommendations and continued in much the same way as before (Pinchbeck and Hewitt 571). She continued to send children from the workhouses to Canada until 1893. Pinchbeck and Hewitt claim that "Rye's arrogant dismissal of all criticisms and her blank refusal to accept the necessity for adequate inspection and supervision only underlined how limited a conception Miss Rye had of her work, and how unfortunate this could be for the children" (572). In perceiving Doyle as sympathetic to destitute children and Rye as callous toward them, these two authors have missed Doyle's profound class consciousness.[44]

In some of his assertions, Doyle was accurate. Rye's organization lacked proper management, and her placements of children were not always appropriate. However, the very success of her scheme is what led to this problem. Since she succeeded in placing children, more and more workhouses and other voluntary organizations sent her children for emigration. With limited help, she could not manage to place so many children properly (Pinchback and Hewitt 570). This failure justifies some of Doyle's criticisms.

Maria Rye's work for girls' emigration and her debate with Doyle offer us a better understanding of English attitudes toward juvenile emigration during the latter half of the nineteenth century. Scholars of juvenile emigration agree that the proponents of child migration did not concern

themselves with the children's feelings. Victorians believed that, though curable, pauperism was threatening to society (Rose 64). Therefore, children should be removed from pauperism. The second evangelical revival in 1859 also created strong religious and moral pressures on society to remove children from the bad environment of urban life. People interested in the welfare of the children believed that juvenile emigration would save children from lives of crime and prostitution. Novelists like Charles Dickens and evangelical writers like Hesba Stretton praised juvenile emigration as a means for these children to escape life in workhouses or gaols. Settling orphans and workhouse children in the colonies became a favorite writing topic.[45]

Rye strongly believed that destitute girls had fewer opportunities to escape from pauperism and that their poverty could be cured by emigration. Her work was praised by other women of her time. On 8 January 1870, the *Queen*, an upper-middle-class periodical, wrote, " Miss Rye has found her way to the heart of a good many people in Canada as well as in England." Supporting Rye's work, in March 1875, the *Englishwoman's Review* wrote, "These poor children have been rescued from [a life] in England, of vice, ignorance, pauperism, and friendlessness, [so] we must deprecate any reactionary feeling on the part of magistrates which should put a check on juvenile emigration."[46] On 3 May 1884, the *Girl's Own Paper*, a penny weekly published by the Religious Tract Society, wrote, "Altogether, no one who has seen the Home and the children in London, and the children at Niagara, can for one moment doubt that the change made in their fortunes by removal under Miss Rye's care has been the means, under Providence of ensuring for them a useful, healthy, and happy life." It further added, "All thanks and honour then to Miss Rye, for her ceaseless care in promoting so sure a condition of improvement! In stead of two or three of such institutions as hers, there should be a thousand of them."[47] Thus it seems women in general approved the emigration of little girls because women believed that emigration gave these girls the opportunity to escape poverty and prostitution.

Victorian attitudes toward caring for destitute, neglected children were essentially bimodal: some strove to improve the condition of the poor by traditional means with continued modifications affordable within the limits in the home country; others attempted to embrace bold opportunity that continued to emerge with the territorial expansion and development in the colonies. These two different approaches clashed at times, perhaps most intensely from 1875 to 1877, when Rye became embroiled in the dispute with Doyle. The view shared by Doyle, Lord

Derby, and others of curing pauperism through home-based programs rooted its antiemigration schemes for juveniles to cultural values that can be best offered with proper controls in an environment within the home-land. These cultural values continued to separate pauper children from street children. In contrast, promoters of colony-based programs for uplifting the lives of destitute children found a potential means of establishing closer ties between the colony and the mother country. By capturing the spirit of colonial expansionism, they wanted even the poorest children to participate in colonial enterprise, paying little attention to the dividing line between the pauper children and the street children. Maria Rye, Charles Dickens, Lord Shaftesbury, and many advocates of women's interests represented such a view.

The controversy between Maria Rye and Andrew Doyle did not continue after 1877. Despite Doyle's criticism, Rye continued her emigration work till 1895. She donated her homes to the Church of England Waifs' and Strays' Society and retired to Hemel Hempstead, where she died on 12 November 1903. After Rye's retirement, Dr. Barnardo, a philanthropist, and various religious organizations continued the emigration work till the 1930s. But none of these organizations would address the question, "Who will help the girls?"

Notes

The author would like to thank Rita Kranidis for her many helpful suggestions in the preparation of this essay.

1. *Colonies* 16 Sep. 1873: 643; 2 Apr. 1874: 99, 115.
2. Ivy Pinchbeck and Margaret Hewitt, *Children in English Society*, vol. 2 (London: Routledge, 1973) 564–73.
3. Gillian Wagner, *Children of the Empire* (London: Weidenfield, 1982) 50–55; Philip Bean and Joy Melville, *Lost Children of the Empire: The Untold Story of Britain's Child Migrants* (London: Unwin, 1989) 61–72.
4. Wesley B. Turner, "Miss Rye's Children and the Ontario Press, 1875," *Ontario History* (1976): 169–203; hereafter cited in text.
5. Lionel Rose, *"Rogues and Vagabonds": Vagrant Underworld in Britain, 1815–1985* (London: Routledge, 1988) 37.
6. Kellow Chesney, *Victorian Underworld* (London: Temple, 1970) 145–46; Edna Bradlow, "The Children's Friend Society at the Cape of Good Hope," *Victorian Studies* 27 (1984): 155–56.
7. Michael E. Rose, "The Disappearing Pauper: Victorian Attitudes to the Relief of the Poor," *In Search of Victorian Values: Aspects of Nineteenth-Century Thought and Society*, ed. Eric M. Sigsworth (Manchester: Manchester UP, 1988) 57.

8. James Walvin, *Victorian Values* (Athens: U of Georgia P, 1987) 17, 21.

9. In 1861, the published report of the Royal Commission on the Education of Neglected Children (the New Castle Commission) claimed that the majority of girls and boys brought up in workhouses turned to prostitution and criminal life (Pinchbeck and Hewitt 512–13).

10. Jean S. Haywood, *Children in Care: The Development of the Service for the Deprived Children*, 3rd ed. (London: Routledge, 1978), 47–48; Pinchbeck and Hewitt 526–29.

11. Wagner 33 and Bean and Melville 38–39. Many of the boys came from "Ragged Schools," which opened in 1840 to provide free religious instruction to pauper children.

12. Thomas E. Jordan (" 'Stay and Starve, or Go and Prosper!': Juvenile Emigration from Great Britain in the Nineteenth Century," *Social Science History* 9.2 [Spring 1985]: 146–51) has analyzed the motivations of the British authorities to send children to the colonies. Edna Bradlow has described early unsuccessful attempts by the Children's Aid Society to place poor British children in South Africa (155–77).

13. For a detailed account of the way in which young girls entered domestic service in one geographical area in the 1880s, see Flora Thompson, *Lark Rise to Candleford* (London: Oxford UP, 1945), especially chapter 10; Garreth Stedman Jones, *Outcast London: A Study in the Relationship between Classes in Victorian Society* (Oxford: Clarendon, 1971), especially chapter 4.

14. Deborah Gorham, "The 'Maiden Tribute of Modern Babylon' Re-examined: Child Prostitution and the Idea of Childhood in Late-Victorian England," *Victorian Studies* 21 (1978): 373–74.

15. *Englishwoman's Review* Jan. 1867: 121.

16. N. Sutherland, *Children in English-Canadian Society* (Toronto: Toronto UP, 1976) 5.

17. For a full account on Rye's involvement with female emigration to Australia, see A. James Hammerton, *Emigrant Gentlewomen: Genteel Poverty and Female Emigration, 1830–1914* (London: Croom, 1979) 126–29, 131–33; Charlotte Macdonald, *A Woman of Good Character: Single Women as Immigrant Settlers in Nineteenth-Century New Zealand* (Auckland, NZ: Williams, 1990); Una Monk, *New Horizons: A Hundred Years of Women's Migration* (London: HMSO, 1963).

18. Thomas Bender, *Toward an Urban Vision: Ideas and Institutions in Nineteenth-Century America* (Lexington: U of Kentucky P, 1975) 136–47.

19. Maria Rye, "Our Gutter Children," *Times* [London] 29 Mar. 1869: 8. The children from the streets were sometimes called "arab" or "gutter children," while those from the workhouses were usually called "pauper children."

20. Rye, "Gutter Children" 8.

21. *Englishwoman's Review* Oct. 1868: 73.

22. *Colonies* 2 Apr. 1874: 99, 115.

23. Maria Rye, letter, *Times* [London] 12 Apr. 1869: 11.

24. *Times* [London] 12 Jan. 1874: 7; *Woman's Opinion* 21 Feb. 1874: 34.

25. "Form of Queries to be Answered by Applicants to Miss Rye on behalf of Children to be sent out to Canada," from "Report to the Right Honourable the President of the Local Government Board by Andrew Doyle, Esquire, Local Government Inspector, as the Emigration of Pauper Children to Canada with Appendix," *British Parliamentary Papers* 63 (8 Feb. 1875): 37; hereafter cited as Doyle, "Report."

26. *Englishwoman's Review* Oct. 1872: 280.
27. "Circular distributed in Canada by Miss Rye," in Doyle, "Report" 37.
28. Rye, "Gutter Children" 8.
29. Turner 174. For a full account of Canadian attitude toward Rye's emigration activities, see Turner and Sutherland.
30. *Times* [London] 12 Jan. 1874: 7.
31. *Times* [London] 6 June 1874: 6.
32. *Times* [London] 6 June 1874: 6.
33. Patricia T. Rooke and R.L. Schnell, "Imperial Philanthropy and Colonial Response: British Juvenile Emigration to Canada, 1896–1930," *Historian* 46 (1983): 61.
34. *Englishwoman's Review* Mar. 1875: 133.
35. *Englishwoman's Review* 15 June 1876: 273–74.
36. Maria Rye, letter to the president of the Local Government Board, *British Parliamentary Papers* 71 (1877): 14–16.
37. "Reply of Mr. Doyle to Miss Rye on the Emigration of Pauper Children to Canada," *British Parliamentary Papers* 71 (1877): 11; hereafter cited as Doyle, "Reply."
387. Bean and Melville 33; Wagner xiv.
39. Maria Rye, letter, *Times* [London] 22 Apr. 1875: 13.
40. *Englishwoman's Review* 15 June 1877: 283.
41. *Englishwoman's Review* 14 July 1877: 324; *Queen* 7 July 1877: 3.
42. *Queen* 7 July 1877: 3.
43. *Englishwoman's Review* Aug. 1878: 376.
44. Wagner, Bean, and Melville also described Doyle as sympathetic toward the children and Rye as cold and uncompassionate toward the children.
45. Margaret Nancy Cutt, *Ministering Angels: A Study of Nineteenth-Century Evangelical Writing for Children* (London: Five Owls, 1979) 141.
46. *The Queen* 8 Jan. 1870: 20; *Englishwoman's Review* Mar. 1875: 133.
47. K.T., "Miss Rye's Girls' Homes," *Girl's Own Paper* 3 May 1884: 490.

Recycling the Poor and Fallen: Emigration Politics and the Narrative Resolutions of *Mary Barton* and *David Copperfield*

Shannon Russell

The thought of Mrs. O'Gall and Bitternutt Lodge struck cold to my heart; and colder the thought of all the brine and foam, destined, as it seemed, to rush between me and the master, at whose side I now walked; and coldest the remembrance of the **wider ocean**—wealth, caste, custom intervened between me and what I naturally and inevitably loved.

—Charlotte Brontë, *Jane Eyre*

We are their slaves as long as we can work; we pile up their fortunes with the sweat of our brows; and yet we are to live as separate as if we were in two worlds; ay, as separate as Dives and Lazarus, with a great **gulf** betwixt us.

—Elizabeth Gaskell, *Mary Barton*

"That sort of people. Are they really animals and clods, and beings of another order? I want to know *so* much."

"Why, there's a ***pretty wide separation*** between them and us," said Steerforth, with indifference.

—Charles Dickens, *David Copperfield*

I am very glad to hear that your poor girl is safe, so far. Let me caution you about the Cape. She *must be* profoundly silent there, as to her past history, and so must those who take her out. Miss Coutts and I, are just now in the receipt of reliable intelligence from that quarter (we have sent three girls there) which assures me that this caution is imperative, or she will either be miserable or flung back into the **gulf** whence you have raised her.

—Charles Dickens to Mrs. Gaskell, 5 Feb. 1850,
with reference to Mrs. Gaskell's attempts to
assist Pasley, a young and "fallen" girl, to emigrate to Australia.

(My emphases on all quotations.)

> When Jane Eyre is forced to contemplate the shock of exile from
> Rochester, her mind makes a speedy metaphorical association
> between the necessity for this journey across the Irish sea and that
> "wider ocean" of wealth, caste, and custom that separates her from
> Rochester. These literal and figurative "gulfs" relate to both emo-
> tional and physical starvation; the political events of the hungry for-
> ties in England, the potato famine in Ireland, and the plight of the
> poor, "redundant" woman are enmeshed in Jane's struggle for
> romantic and domestic fulfillment. If this threatened banishment to
> Ireland is Rochester's teasing joke, his later proposal that Jane
> abscond with him to France as his mistress is not. Jane evades the
> ostracism associated with this channel crossing through her refusal
> to become a fallen woman. Appropriately, she flees this fate and
> Thornfield under the warning counsel of her dead mother—that
> most-conventional Victorian figure of righteous influence and sex-
> ual safeguarding. Jane's moral triumph entitles her to stay at home
> in the "healthy heart of England,"[1] and by the time she decides to
> reunite with Rochester, an important process of equalization has
> occurred. Through the women and wealth of the West Indies,
> Rochester falls to humility and virtual estatelessness while Jane rises
> to become a woman of independent means, so that the other ocean
> of class and convention is bridged as well.[2]

Such fantasies of equalization do not come true in *Mary Barton*, how-
ever.[3] If Jane Eyre is saved from exile, Gaskell's characters are not. In
fact, the terms are completely reversed in *Mary Barton*, as salvation
comes in the form of emigration—a rustic homestead in the clearing of
the Canadian woods, the substitute for the enclosed haven of the cottage
at Ferndean. This reversal is significantly a matter of class, for as a lower-
middle-class governess Jane is more entitled to view a departure from
England and Rochester as a fate worse than death. But for the working
classes, outcasts, prostitutes, or fallen women, exile must be received
gratefully as the happy alternative to domestic misery.

The poor are believed to be more suited to emigration, for as Steer-
forth tells Rosa Dartle in *David Copperfield,* there is a "pretty wide sepa-
ration" between them and the rich. He claims that the poor have "not
very fine natures" and "coarse rough skins," which leads Rosa to the com-
forting conclusion that "when they suffer, they don't feel!"[4] Steerforth
voices this popular perception of the poor just before he sexually corrupts

Emily. Once callously discarded by him, Emily's only refuge will be emigration to Australia. Steerforth's characterization of the poor as uncivilized and insensitive may rebound on him in the novel, but such stereotypes pervade contemporary discussions of emigration and ease the justification for the expulsion of the poor to new and untamed colonies. Dickens's use of emigration as a narrative solution in *David Copperfield* exposes his adherence to perceptions of the colonies as the place for those who cannot be morally or materially accommodated in the Old World. He sanctions the view that some people should be kept separate.

Gaskell's idyllic Canadian ending, too, is no mere "tying up" of loose ends.[5] Though postscript in style, this culmination is less a failure of her form than a failure of her society; or rather, an endorsement of contemporary rerouting of that society's ills (class and social problems) to conform to evolving notions of progress and imperial expansion.[6] A healthy environment is no longer available in the heart of England—at least as far as the poor are concerned, for when not starving themselves, they are viewed as contributing to home pollution. To preserve and protect middle-class domesticity and its imperial agenda, the burdensome poor at home were asked to leave England to become more productive in the colonies. Excluded from the domestic ideal at home, they were nevertheless enticed to the New World by the promise that *there* it was attainable. In a novel in which Gaskell seemingly works to establish sympathy across the gulf of class, her use of the physical gulf between England and the colonies to resolve personal and public tensions must be read as her endorsement of emigration to manage the poor and to better serve home interests. The popular debates about the efficacy of emigration as a means of both solving Britain's complex problems at home and consolidating its imperial position abroad render a certain inevitability to the colonial resolutions of both *David Copperfield* and *Mary Barton*.

Disposing of Industrial Waste:
The Emigration "Cure" to Population "Dis-ease"

Just as the fiction frequently portrayed the colonies as "a convenient dumping-ground for social outcasts," the debates about emigration focused on the management of the poor as just so much industrial waste.[7] At the time Gaskell and Dickens were writing their novels, emigration was discussed almost solely as a response to the pressing problem

of the superabundant population. Gershom writes of ill-fitted emigrant ships carrying a "cargo of human rubbish" or of the necessity to open the "sluices of emigration" for Irish paupers—"this vampire [that] will eat up the resources of the mother country to its inevitable ruin."[8]Like carcinogenic pesticides, the poor were seen to be draining the life out of England. The language of Victorian sanitary reform and the rhetoric of modern-day green politics are appropriate tools for understanding the politics of emigration. The emigrant's "second chance for a new life" was promoted as his or her moral and social "recycling," with the benefit of a corresponding environmental cleanup at home once this "shovelling out of paupers" had occurred.[9] With the health of the nation at issue, the contemporary discourse was also dominated by the medical metaphor of emigration as the only "remedy" or "cure of the social disorders" of British and Irish society.[10]

Women occupied a significant position in the debates about the moral and material cleanup of England, as *Punch* comically observed in 1850: "The daughters of England are too numerous and if their Mother cannot otherwise get them off her hands, she must send them abroad into the world.... All our difficulties arise from a superabundance of females. The only remedy for this evil is to pack up bag and baggage and start them away."[11] The failure of the mother country to marry off her daughters, like her failure to find employment for her sons,[12] was "a sad waste of material."[13] It was also a worrying sign of the disintegration of the separate-spheres model and of social order and progress. The "alarmist view," again according to *Punch*, expressed the worry that these overabundant women would "reduce our free and glorious constitution to that most degrading of all despotisms, a petticoat government."[14] Emigration promised to reverse this "dangerous" situation by reinstituting women in the acceptable roles of wife and mother to colonists.

How much this notion of superabundant women was a sign of popular discomfort with the idea of working women and how much a necessary myth for the redirection of female usefulness to imperial goals is suggested by the failure of demographic evidence to support the superabundant-female myth. However, as Cecillie Swaisland has pointed out, "from the 1850s onwards" this myth was neatly partnered with a parallel "strong belief" in the "imbalance of the sexes overseas."[15]A few contemporary writers, like George Sala in *Household Words*, disputed the statistical evidence for the redundant female, but the perception that she existed went relatively unanalyzed, and for good reason.[16]

Whatever the numbers, the colonies were in need of women, both as workers and as peoplers of the empire, so that the promulgation of this myth of the redundant female was necessary for the fulfilment of British destiny both materially, and, as the domestic ideology stressed, morally. Those, like Dickens and Caroline Chisholm, involved in the burgeoning industry of female emigration societies quite shamelessly worked to make women sexual commodities in an exchange that partnered them with poor men or, in some cases, reformed criminals previously sent to the penal colonies. Virtually every emigration manual attempted to lure women to the colonies by promising a two-step career of abundant and well-paid work followed rapidly by marriage. Gershom writes of "the greater part of a consignment" of single females being *asked in church* to marry the week after arriving.[17] *David Copperfield* supports this perception, for all of the single women who emigrate receive proposals of marriage—even, as is so amusing to Mr. Peggoty, the old and widowed Mrs. Gummidge.

By shipping women off, Britain could defuse some of the anxiety surrounding the woman question. Restoring woman to her "proper place" as a dependent within the home not only diminished female competition in the marketplace but kept the threat of revolution at bay. It was felt that women's influence would hold disgruntled workingmen in check so that the social order would be secured. At the same time the dream was kept alive that the sexuality of women, like their socioeconomic roles, would be contained and controlled through marriage and motherhood and made to serve worthy national interests.[18] The ambiguous conceptions and debates surrounding female emigrants tell the story of how the Old and New Worlds were building or reconstructing themselves.

The management of women to serve the national agenda is most evident in W. R. Greg's "Why Are Women Redundant?" Though written in the early 1860s, Greg's article exhibits the same anxieties about women and emigration that prevailed in the forties and fifties. Greg accepts the statistical evidence of the redundant single woman and demonizes her, for she is shown to be a sign of "an unwholesome social state."[19] Presuming that woman's only "natural" role in life is that of dependent wife and mother, he believes it is a social crime for women to "have to earn their own living, instead of spending and husbanding the earnings of men" (436). Importing the health metaphor that also characterized the contagion of the redundant poor, he speaks of woman as a cancerous "disease" to be cured—a Sphinxian riddle, which "society must solve or die"

(437). He proposes marriage as the "despotic law of life" that can right this wrong and advocates female emigration as the means of effecting this remedy (443). Greg's writing betrays his view of single women as goods to be exchanged through the economic mechanism of "supply and demand." Unashamedly, he writes that "the vast reduction in the redundant numbers" that emigration would effect "could not fail to augment the value, and the demand for, the remainder." Here again, life in the homeland would improve once the unoccupied were exported.

Greg anticipates objections to his scheme by admitting that the redundancy of women in England "is not in the emigrating class." The kind of women "wanted in the colonies" and "adapted to colonial life" are lower-class women because they are "hardy and well-trained for the severe labours" (446). However, the redundant women of England are said to be those just above the laboring poor—the distressed needlewomen, milliners' apprentices, and daughters of unfortunate tradesmen, clerks, and curates. They present a problem because it is they who "have a position to maintain and appearances to keep up, who are too proud to sink, too sensitive to contrive, too refined or too delicate to toil, or too spoiled to purchase love at the expense of luxury" (445–46). It is just this kind of woman, who clings to the "pauperism o' the needle ... because it's 'genteel,'" that Eliza Meteyard aims to convert in her emigration propaganda masquerading as novella, *Lucy Dean: The Noble Needlewoman*.[20] Similarly, Greg attacks the "morbid LUXURY" (446) of the age throughout his article because this luxury is presumed to inhibit marriage. Greg attempts to reconcile the emigrant woman to her derogation of status by suggesting that even women who do not emigrate need to lower their standards and expectations: "[A]s they become less costly articles of furniture, they will find more numerous and more eager purchasers" (453). Some contemporary thinkers felt that emigration suited this class of women because their fall in status would not matter so much in the colonies. For "those obliged to seek a subsistence; their delicacy would rather find it among strangers than among neighbours."[21] Greg is aware that the colonial market will not tolerate any womanly article with an inflated view of her own value. As Hammerton writes, women like the "governess who might not be prepared to turn to less genteel employment could quickly become a colonial liability."[22]

Although there was some limited effort to encourage emigration across classes, this sense that thinkers as opposed to workers were useless in the colonies can be seen to be reflected in the way the governess was often discouraged from emigrating. A perpetual figure of ridicule, she

stood for a kind of educated indolence and "fine ladyishness" that made her loathsome to settlers.[23] The association of loss of caste with colonial life reinforced the impression that colonial life was both freer in some respects than life at home yet also less "civilized."[24]

Emigration often involved a negotiation about status in terms of both class *and* gender. There was a significant reluctance among British women to emigrate, in part because a Victorian woman's identity and virtue were bound up with home and England. Although this feeling may have been more prevalent amongthe middle classes than the poor, *they*, too, made sacrifices to attain the cultural status conferred by a separate-spheres lifestyle.[25] The adventurousness, initiative, and independence necessary for the prospective emigrant were not appropriate qualities for a respectable woman.[26] Many who did leave England for a new life in the colonies did so in conformity with their domestic conditioning, out of "obedience and duty" rather than desire. Certainly Mary Barton and Little Emily ascribe to a belief in their subordinate gender status when dutifully acquiescing to the wishes of the paternal figures in their lives who want them to emigrate.

The association of emigration with the poor Irishwoman[27]—a figure immortalized by Carlyle, among others, as a member of a lower and contaminating race—could not help but mar the thought of emigration for the English woman who believed herself to be culturally superior.[28] Resisting emigration, then, could be viewed as holding on to national as well as personal status, given that an English woman's domestic character was so strongly allied with her, and her nation's, comparative virtue and moral standing. Poems like "Song of Emigration" published in *Blackwood's* in 1827 dramatized this feminine opposition and reinforced the notion of woman's sentimentalized attachment to home.[29] The poem enacts stereotypical gender roles: the masculine voices of the poem are overtly imperial and outward reaching as they speak of leaving the mark of "their fearless race" on the colonial geography, whereas the feminine voices are directed inward to the emotional and domestic life of the family and express concerns about the inability to nurture the favored flowers from home in the colonial soil.[30] The homesickness of these women reflects a proper English value and foretells their desire to transplant, if not the flowers, the sacred domestic values of the Old World into the New.[31] Of course, the anxiety that home values, like home flowers, would not grow in an alien and inferior soil also haunts these women, as it did their culture.

Women had to be reconciled to their position in the colonies, as the success and survival of the emigrant family depended largely, as so many

pamphlets and manuals cautioned, on the cooperation and industriousness of the wife. To try to offset cultural concerns about loss of status, promoters of female emigration enlisted the icon of the woman with a civilizing mission. Female emigrants were advised to regard "themselves as social missionaries, labouring worthily in a place where they are wanted, and remembering that their dignity cannot be really lessened by their position so long as they are actuated by Christian principles."[32] In *The Emigrants*, a maid about to leave home to join her lover in the colonies departs with the blessing that her "nursing hand" and "loving heart" will "win to arts of peace a savage race, / And their rude vices gradually efface."[33] Still, such a balance between the image of mission and menial labor was difficult to maintain, as most of the literature emphasized the need for female bodies over female heads.

Sexual Servants of Empire

Contemporary literature too openly unveiled the sexual dimension, if not sexual exploitation, inherent in female emigration schemes. Questions of sexual suitability dominated the list of requirements for the ideal female emigrant. Colonists required healthy, young bodies capable of working and breeding. They were as unashamed to ask for them as Britain was to oblige. Over and over again, particularly in the literature about Australia, requests are made for young, single women to work as servants.[34] The concomitant requisition for sexual service was clear, as there were often restrictions imposed concerning age and attractiveness.

Colonists hoped to entice these women with incentives like "free" passage. Single men were only encouraged to come if they were matched in number by single women.[35] The *Illustrated London News* reported the following about the cargo of an emigrant ship bound for Australia: "The apartment of the unmarried females was rather dark, but still there was light enough to show several really handsome countenances and good figures, whose departures from Old England seemed to cast a reflection upon the bachelors they left behind. If there is any gallantry in Sydney, many that we beheld cannot be long after their arrival without husbands. There was not the remotest indication of want or pauperism amongst the whole."[36] As these "bodies" and "hands" were encouraged to leave England while the "heads" stayed behind, subtle hierarchical relationships between home and colony were reinforced.[37] The colonies could be constructed as morally inferior and subject to the superior reason and

rule of the mother country— a viewpoint replicated in much of the contemporary fiction.

Advocates of female emigration argued that it was, in part, a means of saving poor young women from falling again because the colonies would house them. This perception was applied repeatedly to the case of the distressed needlewoman, who was, like Gaskell's Ruth, often forced out onto the streets on Sundays as a condition of her apprenticeship. Many held the view that her poor living conditions and pecuniary circumstances could not help but drive her to prostitution, as dramatized in "The Needlewoman's Farewell":

> And so we strove with straining eyes, in squalid rooms, and chill;
> The needle plied until we died—or worse—oh, Heaven, have pity!—
> Thou knowst how 'twas oftener for want we sinned, than will—
> Oh, nights of pain and shameful gain, about the darkling city![38]

Similarly, in his poem "The Emigrant-Ship: The Sempstress's Tale," James Lister Smith describes a needlewoman without family support who considers selling her "last loved friend," her Mother's bible: "Twill but prolong my fate a time, / And then comes death—or, worse, comes crime."[39] She is rescued from the streets by philanthropists who "[g]ave me to sail o'er foaming tide, / And this dear Bible is ever my guide!"—an obvious symbol of the Christianizing mission embedded in emigration schemes.[40] Seen as an overworked drudge without a home and family to tend, the needlewoman symbolized the potential falling away from domestic duties and virtues that lent so much to national identity.

The lack of a proper womanly domestic life was not the only thing that made the middle classes uncomfortable about the needlewoman. Her alienation from home life signified the deeper societal alienation resulting from the industrial revolution. Managing her sexuality became a way of controlling and obscuring the latent dangers and anxieties represented by her type. Her exploitation in the marketplace allied her with the masses of disgruntled and poor male workers.[41] The idea of "want" over "will" driving women to prostitution dramatizes the popular Victorian need to contain female sexuality within the constraints of the image of the helpless victim. One senses in this emphasis the fear of independence, rebellion, and social instability so associated with a woman's sexual freedom and desire.[42] Just as the ghost of a revolutionary or violent Chartist lurked behind the image of the male emigrant, a fallen woman lay dormant in every female emigrant, threatening to equally undermine

the status quo.[43] Her poverty, like his, indicated potential immorality and a threatening criminal nature. By casting suspicion on her sexuality or by conceiving her revolutionary nature in terms of her sexuality "run riot,"[44] Victorians deflected attention from the horrors embedded in her labor or class grievances. In part, this deflection was easily accomplished because of the ambivalent attitude Victorians had about the working woman. Class and gender ideology were often at odds in terms of this figure, for she made middle classes uncomfortable at the same time as she labored for their comforts.

The predominance of novels that describe how rich men seduce poor women through false promises convey the exploitation of the working poor but also their dangerous ambition. The poor woman's temptation to rise socially is almost always a matter of falling sexually. Mary Barton's Aunt Esther is an example of this type, and Little Emily, too, is said to have been beguiled by Steerforth's promises to make her "a lady." Mary Barton herself is faced with this inducement. She fantasizes about her life as a wealthy women or "non-worker,"[45] until she discovers that Harry Carson's plans do not include marriage. Despite her innocence, Mary *is* contaminated by her aspirations. She bears the blame for Jem's inability to find work after he is falsely accused of the murder of his rival. Jem accepts his unwarranted shunning by his fellow workers because he knows that "character" is the poor man's only "capital."[46] Ultimately, however, it is *Mary's* loss of character that is responsible for their emigration to Canada.

Such ambition, whether in the poor woman or the disgruntled Chartist, had to be suppressed because it carried with it the fear of revolution, the transference or sharing of power and privilege, and the disintegration of a known culture. By reinstituting the needlewoman in her proper place through marriage in the colonies, it was somehow believed that the problems presented by the masses of poor, too, would be contained. Emigration offered the cure for her sexual and her nation's social pathology.[47] It is not surprising that philanthropists embraced emigration as a method of saving the needlewoman from the streets and domesticating her rather than as a means of improving her conditions as a working woman. The same chivalric aspect of paternalism that placed this woman in a victimized and dependent position was asserted to stem the danger posed by exploited women, reinforcing the hierarchical order of society at home. Gender ideology effectively kept the female worker subservient to the will of the masters. The containment of her sexual nature through colonial marriage was a means of channeling lower-class ambi-

tion to benefit Britain. Thus what seemed a potentially explosive situation could be defused and transformed into profit.

Anxiety about Possessing and Retaining the Profits of Empire: Who Is to Blame?

Victorian anxiety about luxury is reflected in the obsession with the needlewoman's potential corruption. Wealthy women with an appetite for elegant clothing are frequently chastised for inciting the needlewoman's emulation of that love of fashion and finery, the symbolic prelude to her fall at the hands of their sons or brothers.[48] Both Dickens and Gaskell are guilty of this subtle abdication of male responsibility through their endorsement of women's influence in their novels.[49] Proud of yet uneasy about their wealth, Victorians approached it both as a validation of their imperial position and as a sign of its potential decline. The debauchery associated with the opulence of the rich suggested a worrying Roman-style excess that Victorians understood to be the harbinger of imperial demise. Speaking of the increased "inclination for strong drink among our fairest and most refined," one promoter of emigration proclaims: "So was it in the days of the fall of Rome."[50] The popular figuration of Britain's imperial wealth in terms of oriental excesses also conveyed this insecurity and signified a disturbing tendency toward unchristian behavior. Gaskell writes to explain to these "people on Turkey carpets, with their three meat meals a-day ... why working men turn Chartist and Communists."[51] This cultural critique of the rich is evident in Thomas Hood's popular "Song of the Shirt," in which the needlewoman's exploitation transforms her into the harem slave.[52] Given the ways in which Christianity and providential design were enlisted to support imperial expansion and dominance, any falling away from those cultural ideals could foretell decline.[53]

Despite Victorian anxiety about the fallen woman, she possessed qualities that seemingly made her an ideal emigrant. Accustomed to a rough life, familiar with perceiving her body as part of an economic exchange, and ostracized at home, the fallen woman or prostitute was, in many respects, just what the colonist ordered.[54] With a driving need to rid herself of her shame and accustomed, at least in theory, to doing penance, as Ruth does for her guilty past, the fallen woman could have no grounds for complaint in the New World. In *David Copperfield*, Emily is stigmatized into blessed subservience in Australia, while the prostitute, Martha,

is considered hardened enough to withstand happily the vicissitudes of life in the bush. Similarly, Lucy Dean negotiates a marriage for her fallen sister, Nelly, to Ben— a colonist from her village in England who is from the class she should not have thought of rising above. This marriage, like Ben's adoption of her illegitimate daughter, is tidily arranged without Nelly's consent and is described as something she must aspire to "deserve" (377). The ambition and industry that were supposed to have instigated the fall of the fallen woman were qualities valued in the pioneer settler. By rerouting the fallen woman's desire to "get on" in the world, Victorians transformed her potential evil to advantage.

If the fallen woman was as useful to the imperial project as her opposite, the civilizer, she was also a type whose influence had to be regulated. Her recycling required deft handling. As Britain shipped her worst social problems to the colonies, the contaminating influence of the fallen woman became a cause for complaint. Some settlers expressed dismay that the introduction of the corrupted female body into the New World was bringing down the moral tone of the colony.[55] One writer blames female emigration schemes for "the frightful increase of drunkenness, of profligacy, [and] of crime" in the colony.[56] Another claims that there was a "refusal of the colonists any longer to send funds, in return for which they are burdened with the half-savage and wholly untaught and unskilled population of the wilds of Ireland and Scotland."[57] How much these complaints were grounded in moral concern and how much in material is difficult to assess. The colonists did not want inferior goods, nor did they want to support these women or their children once they had landed.[58] There was a movement to abolish female emigration ships in the colonies even as there was growing enthusiasm for them in England.[59]

Given the material and cultural expectations inherent in female emigration, it is not surprising that the actual colonial passage was a concern to many. The truth was that when safely on board a female emigrant ship, the single woman could be anything but secured from a sexual fall. A provocative literature with some of the sexual overtones of Victorian views of harem culture,[60] the stories of female behavior on ships endorsed the connection between the emigrant and the fallen woman, as well as the idea that female sexual behavior was associated with a rebellious or mutinous spirit: "The women (of whom there were not a few of the most depraved characters on board) broke out into open rebellion; the crew became mutinous; and ultimately the ship became little better than a complete brothel, no restriction whatever being interposed on the

intercourse of the crew with the women."[61] Many writers suggested that if a woman was innocent when she boarded these ships, by the end of her voyage she would have been fortunate to evade the corrupting influence of her fallen female, never mind her male companions. Miss Coutts's scruples about aiding Elizabeth Gaskell with passage for her protégé, Pasley, are based on these grounds, for Dickens describes how inclined these women are to their old ways during the journey.[62] "Floating brothels," inhabited by "vicious young men who seem to have no occupation ... read Tom Paine aloud, and assail the Holy bible with clumsy jests,"[63] these ships seemed to signify a world in revolution.

Not surprisingly, most reports expressed anxiety about the loss of authority of the male captain or, even worse, his complicity in the activities on board. As these stories spread, interest increased in the regulation of ships, and the morality of the carrier as well as the passenger. Married captains were more desirable than single captains because it was assumed that they would be morally restrained and susceptible to the civilizing influence of their wives.[64] Strict separation of the sexes, whether married or not, and the installation of a matron to guide the passage of the young women under her care were all instituted and discussed at length in the literature.[65] Upon departure, emigrant tracts were often distributed that offered detailed instructions as to how young women and men should comport themselves in relation to each other once on board ship.[66]

Regulation of the sexuality of female emigrants manifested itself in concern about housing and thus policing of the female body.[67] As Michie writes, such thinking promulgated the moral split between the public and private woman.[68] Many accounts of the care and maintenance of single women preparing to emigrate, fallen or otherwise, involves their institution within a home as a means of reform or of keeping them safe and pure from contamination.[69] There were also places in which domestic skills were developed, where there was education, again, "not so much of the head as of the heart and hands."[70] That these "homes" were a type of criminal incarceration is evident from one woman's account of how she and the other single women, upon landing in Brisbane, "were marshalled in order and marched straight up to the depot, under the convey of three gentlemen, who delivered us into the safe keeping of the matron."[71] She describes the rows of iron bedsteads round the walls and writes that "all the windows were guarded by thick iron bars, which gave it a dismal prison-like look."[72] The resemblance borne between Dickens's Urania House or these government waiting

places in the colonies and prisons betrays both the belief that potential criminality lay inherent in women's sexuality and the belief that women, as carriers of cultural forces, were worth protecting at all costs.[73]

However concerned the English were about the single emigrant, the colonists, too, worked to ensure that these women arrived as usable commodities. Instead of female emigration ships, they favored a system whereby single women journeyed under the protective paternal care of a male guardian or family.[74] It was felt that this method minimized corruption on board and increased the likelihood that the single woman would maintain her good character once she had landed. Both this father figure and the "homes" in which these single women were ensconced bore disturbing resemblances not just to prisons and prison keepers but to brothels and pimps, as these institutions existed solely to provide men with desirable sexual partners.[75] Again, by instituting control over female sexuality, it could be turned to colonial gain.

However ambiguous and hypocritical the attitudes surrounding the emigration of the single woman, Victorians justified her sexual exploitation and cattlelike exportation through their sanctification of the role of motherhood. As one emigrant tract put it: "While ... we would deprecate the practice of sending out young women as a species of merchandise as was the case a few years ago in India, we would yet assert that there cannot be a holier or purer mission than that of preparing our young emigrants for the important duties of wives and mothers.... [O]n the character of these wives depends much of the future prosperity of the country."[76]

To become a married mother was to be redeemed—to participate in a higher calling. Rhetorically elevated into images of "new graces for a New Maternity" and "Mother[s] of the World," Meteyard's prospective emigrants in *Lucy Dean* achieve a kind of nobility (331). By constructing colonization as a divine mission, Victorians eased the passage for both those who went and those who stayed behind. Women were assisted in overcoming their resistance to emigration, while philanthropists at home felt good about the departure of these colonists. Undoubtedly, women could benefit as much as men from the much vaunted freedom and "independence" of colonial life: the relaxation of rigid social codes, the release from sexual frustration, and the promise of plenty. Indeed, Erikson argues that colonial life modified gender roles slightly, so that if they were "separate" they were at least "permeable."[77] Whatever the reality of colonial life for women, the ideology surrounding the emigrant woman constructed her value solely in terms of national utility.

Victorians felt that it was necessary to institute her sexual release in the appropriate role of the mother, not only as a sign that colonial freedom did not imply decadent license but as a symbol of the promised fertility of the new world and, with it, the improvement of the old. Maternity symbolized a woman's colonization—her identification with the new land and its desired treasures, for as one emigrant manual advised, pioneering men were to "ally themselves to the new region as to a bride, to abide with it for good and evil."[78] In Wakefield's conceptualization of imperial expansion, the salvation of England would come once the colonies were turned into "an immense nursery."[79] With their emphasis on domestic service and maternity as carriers of the ultimate good into the New World, both novels and emigration tracts expose how the labors of the female body as much as female morality were harnessed to the attainment of imperial dreams.

Punch's cartoon of the "Needlewoman at Home" and the "Needlewoman Abroad" concisely illustrates this point.[80] An obvious advertisement for the amelioration promised to the single woman emigrant, the woman's salvation is pictured as her institution into the proper role of domestic wife and mother. The English setting delineates a vision of want and potential corruption as the poor needlewoman is driven into the streets and is figured between the gin palace, a starving child, and a wealthy man who stands both as moral judge and potential defiler. The adjacent illustration of the needlewoman in the colonies depicts her off the streets and off her feet, sitting as a well-clothed mother within the protective confines of a home, surrounded by healthy children with bread in their hands. The robust figure of a gentleman farmer who surveys her as his possession and dependent stands in for the moral reformer/defiler who took her measure at home. It is just such an idyllic vision as *Mary Barton* presents to the mind's eye in the Canadian epilogue of Gaskell's novel. The poor and potentially fallen woman has been rescued from a moral and social abyss to be recycled through an ocean passage. What was waste in England develops into a serviceable and fertile body in the colonies.

Notes

1. Charlotte Brontë, *Jane Eyre*, ed. Jane Jack and Margaret Smith ([1847]; Oxford: Clarendon, 1979) 459.
2. Similarly, in Disraeli's *Sybil*, "the gulf is impassable" that separates the lovers until the fairy tale resolution in which Sybil's true aristocracy is discovered, enabling

their union. See Benjamin Disraeli, *Sybil; or, The Two Nations*, ed. Thom Braun (1845; London: Penguin, 1985) 336–37.

3. Elizabeth Gaskell, *Mary Barton*, ed. Stephen Gill ([1848]; Harmondsworth: Penguin, 1985). All subsequent references to the novel will be cited from this edition and incorporated within the text.

4. Charles Dickens, *David Copperfield*, ed. Nina Burgis ([1849–50]; Oxford: Clarendon, 1981) 251. All subsequent references to the novel will be cited from this edition and incorporated within the text.

5. Duncan Bythell, "The Working Man's Paradise? Myth and Reality in Australian History, 1850–1914," *Durham University Journal* (1988): 1.

6. See Gillian Beer, "Can the Native Return?" *Open Fields: Science in Cultural Encounter* (Oxford: Clarendon, 1996) 31.

7. Bythell 1. See also Daniel Bivona, "Postscript: Disposing of the Surplus: Capitalism and Empire," *Desire and Contradiction: Imperial Visions and Domestic Debates in Victorian Literature* (Manchester, Eng.: Manchester UP, 1990) 113–27.

8. Gershom, *Emigration for the Millions: Being the Digest of a Plan for More Equally Locating the Population of Great Britain and Ireland throughout the British Empire* (London: Pelham, 1849) 17–18.

9. Edward Gibbon Wakefield refers to this coined phrase in *A View of the Art of Colonization, with Present Reference to the British Empire; in Letters between a Statesman and a Colonist* (London: Parker, 1849) 138. See H. J. M. Johnston, *British Emigration Policy, 1815–1830: Shovelling Out Paupers* (Oxford: Clarendon, 1972).

10. "Highland Destitution," *Blackwood's Monthly Magazine* 62 (1847): 633. See also John Crawford, who writes of combining British labor and colonial land to restore wealth and health to Britain in *Employment for the Millions; or, Emigration and Colonization on a National or Extended Scale: The Remedy for National Distress; in a Letter Addressed to Her Majesty's Ministers* (London: Smith, 1842) 5.

11. "Our Female Supernumeraries: In a Series of Views," Punch's Holidays, *Punch* 18 (1850): 13.

12. "The Needlewomen's Farewell" describes England as a "Hard step-mother" to the needlewomen and "niggard of thy care," *Punch* 18 (1850): 14.

13. "On the Cause of the Distress Prevalent among Single Women," *English Woman's Journal* 12 (1864): 401.

14. "Our Female Supernumeraries" 15.

15. Cecillie Swaisland cites evangelization as a "powerful motivation" behind female interest in emigration in *Servants and Gentlewomen to the Golden Land: The Emigration of Single Women from Britain to Southern Africa, 1820–1939* (Oxford: U of Natal P, 1993) 3. An advocate of the abolition of female emigration ships to Australia also disputes "the alleged disparity of sexes in our population (unless the unmarriageable prisoners, and the chaingangs are included)"; in [By the Superintendent of the Layton Emigrant Ship], *A Few Copies and Some Remarks upon Sundry Documents on the Subject of Female Emigration* (Sydney: Williams, 1836) 21.

16. George Sala, "Numbers of People," *Household Words* 10 (1854): 221–28.

17. Gershom 19. Other promoters write of shipping another "larger 'consignment' *next spring*" of young women to Canada. In the language of environmental waste management, too, they speak of the "disposal" of the redundant woman to the colonies,

where it is hoped she will be used to promote home prosperity. See Isa Craig, "Emigration as a Preventive Agency," *English Woman's Journal* 2 (1851): 297, 292.

18. See Anna Davin, "Imperialism and Motherhood," *History Workshop* 5 (1978): 9–65. See also Charles Dickens and Caroline Chisholm, who write that "a wife and children are precisely the encumbrances which, in a new country, chain a man to hard work and to probity"; in "A Bundle of Emigrants' Letters," *Household Words* 1 (1850) 20.

19. W. R. Greg, "Why Are Women Redundant?" *National Review* 28 (Jan. and Apr. 1862): 436. Hereafter cited in text.

20. Eliza Meteyard [Silverpen], *Lucy Dean: The Noble Needlewoman*, serial novel publ. in *Eliza Cook's Journal* 2 (1850): 315. Hereafter cited in text.

21. Hyde Clarke to B. Hawes, 23 June 1849, *Parliamentary Papers* 1850, XL [1163]: 98–101. Clarke's proposals to the Colonial Office for the National Benevolent Emigration Fund for Widows and Orphan Daughters of Gentlemen, Clergymen, Professional Men, Officers, Bankers, and Merchants is excerpted in A. James Hammerton, *Emigrant Gentlewomen: Genteel Poverty and Female Emigration, 1830–1914* (London: Croom, 1979) 94.

22. Hammerton 92.

23. See Gershom's satirical portrait of the pretentious governess with her "useless" education: "They know all the latitudes and longitudes of the British Colonies, although they still remain to them as a 'terra incognita' for any practical beneficial purposes, which I wish them to realise." Despite their unpopularity, Gershom believes that even "these ladies are sure to get what is commonly called settled in the colonies, and all except the very *passé* will glide into the noose of matrimony" (32).

24. On the other hand, Caroline Chisholm argued that the shortage of women in the colonies only served to enhance their value so that they were treated with greater kindness and respect than European women. See E. Mackenzie, *The Emigrant's Guide to Australia. With a Memoir of Mrs. Chisholm* (London: Clarke, 1853) 128.

25. Charlotte Erickson cites evidence that textile workers in Lancashire were willing to accept a reduced standard of living in favor of male breadwinners and home-based wives in *Leaving England: Essays on British Emigration in the Nineteenth Century* (Ithaca: Cornell UP, 1994) 255.

26. Hammerton 92. Hammerton deals only with lower-middle-class women, but the ideal of the domestic woman concerned the poor, as well. There are many poems and writings, including Gaskell's *Mary Barton*, that argue that married women should be at home, rather than at work, to keep men from the gin palace.

27. Erickson 244.

28. John Hood describes the women on board an emigrant ship as follows: "Some were tolerable in appearance; but the majority, chiefly Irish, were of the coarsest fabric of woman kind"; in *Australia and the East: Being a Journal Narrative of a Voyage to New South Wales in an Emigrant Ship: With a Residence of Some Months in Sydney and the Bush, and the Route Home by Way of India and Egypt, in the Years 1841 and 1842* (London: Murray, 1843) 4.

29. For fond recollections of English cottage home life, see the incomplete *The Emigrant's Daughter: A Tale that is Told. Descriptive of Victoria during the stirring times that followed the discovery of gold* (Tasmania: Daily News Office, 1856).

30. F. H., "Song of Emigration," *Blackwood's Edinburgh Magazine* 22 (1827): 32.
31. Maria Rye, like Meteyard in *Lucy Dean* uses the metaphor of the emigrant woman as plant when she writes that "amidst the many homesteads of our wonderful colonial possessions, some, at least, of our many worthy, industrious, poor, young countrywomen may be safely planted." See Maria S. Rye, "The Colonies and Their Requirements," *English Woman's Journal* 8 (1861): 171.
32. L. C. Merryweather, "Letters on Australia and New Zealand," *English Woman's Journal* 9 (1862): 409. In the poem *Emigration Realized*, the author writes of those who emigrate to New Zealand as "Losing caste, being cast here ashore" and "On the land tied to stake, / Slave your wife you must make, / Serf your son, with the surface of Maori; / Your daughter—ah! shocking, / From wild men you must lock in,— / Or her spring-time will soon become show'ry;" in S. C. C., *Emigration Realized: A Poem* (London: Saunders, 1855) 47, 35.
33. H[arriet] G[oodall], *The Emigrants; A Tale of Truth: By the Rector's Wife* (Eton: Williams, n.d.) 49.
34. See Bob Reece, "Australia, the Beckoning Continent: Nineteenth Century Emigration Literature," *The Trevor Reese Memorial Lecture, 1988* (London: U of London, Inst. of Commonwealth Studies, Australian Studies Centre, 1988) 6.
35. *The Emigrant's Guide to the Gold Fields: Containing, Among other information, The fullest details as to their past and present position, their future prospects etc.* (London: Piper, 1853).
36. "Emigration to Sydney," *Illustrated London News* 8 Apr. 1844; as excerpted in Leonard DeVries, comp., *Panorama, 1842–1865: The World of the Early Victorians As Seen through the Eyes of the Illustrated London News* (London: Murray, 1967) 29.
37. See the preface to S.C.C.'s *Emigration Realized*, iv, which discourages emigration for everyone but the "right sort—hands, not heads."
38. "Needlewoman's Farewell." See also the article "Female Penitentiaries," *Quarterly Review* 83 (1848): 366; in which it is argued that "poverty has a large, if not the largest, share in the original mischief—that under-paid needlewomen, and so forth, furnish perhaps the majority of the recruits" to the Magdalene hospitals.
39. James Lister Smith, *The Emigrant-Ship, and Other Poems* (London: Hope, 1851) 49.
40. Smith 50.
41. For evidence of female protest, see Malcolm I. Thomas and Jennifer Grimmett, *Women in Protest, 1800–1850* (London: Croom, 1982). Thomas and Grimmet acknowledge the importance of female protest while identifying certain habits of subjection to gender ideology that limited this protest.
42. As Beth Kalikoff writes, "[B]oth popular fiction and nonfiction barely conceal a genuine dread of female sexual, social, and economic autonomy"; in "The Falling Women in Three Victorian Novels," *Studies in the Novel* 19.3 (1987): 357.
43. John Murray describes the common perception of the male emigrant as a "rash or discontented mortal" in *The Emigrant and Traveller's Guide to and through Canada* (London: Smith, 1835) 7.
44. In "The Black Country" the natural outgrowth of a factory girl's lack of a proper domestic upbringing is "unwomanly and unbecoming" conduct, or sexuality "run riot"; in the *English Woman's Journal* 8 (1861): 85.

45. W. E., rev. of *Mary Barton*, *Westminster and Foreign Quarterly Review* 51 (1849): 56.
46. Character and labor were the emigrant's only property, too, and the traits that supposedly distinguished him as English, as many emigration tracts emphasize (Crawford 5, 10). Crawford writes that "the emigrant embodies in himself his own capital stock" (16).
47. John Kucich writes that Gaskell understands sexual disorder as "pathological . . . rather than as a liberation" in her novels; in Kucich, "Transgression and Sexual Difference in Elizabeth Gaskell's Novels," *Texas Studies in Literature and Language* 32.2 (1990): 196.
48. Mariana Valverde discusses the predominance of servants coveting the cast-off clothing of their mistresses in Victorian novels as evidence of class anxiety in "The Love of Finery: Fashion and the Fallen Woman in Nineteenth-Century Social Discourse," *Victorian Studies* 32.2 (1989): 182. Katherine Retan argues that the fallen Ruth is sacrificed to tame the middle-class Jemima in "Lower Class Angels in the Middle Class House: The Domestic Woman's 'Progress' in *Hard Times* and *Ruth*," *Dickens Studies Annual* 23 (1994): 194 .
49. Gaskell mediates Barton's guilt in the novel by tying his criminal degradation to the absent good and the present bad woman. Not only does Mrs. Barton's death fatally deprive him of one of the civilizing influences of his life, but Esther is culpable for that death, in his eyes. Part, if not all, of the blame for Steerforth's defilement of Emily is projected onto the corrupting influence of his bad mother and the inadequate sister/lover figure of Rosa Dartle. Until David is properly taken care of through his marriage to his angelically domestic sister and housekeeper Agnes, he, too, is portrayed as having suffered and gone wrong through the absence of a strong mother or a useful wife. The ideology of women's influence infantilizes men in both novels, as responsibility for their actions and morality ultimately resides with women.
50. [Signed by an Australian colonist], *Emigration! Where shall I go?* (London, 1869) 19.
51. Rev. of *Mary Barton*, *Fraser's Magazine for Town and Country* 39 (1849): 430. In Gaskell's *North and South*, too, the extravagant display of Indian silk wedding shawls that opens the novel subtly conveys the disparity between the rich and poor, and its latent dangers. See Elizabeth Gaskell, *North and South*, ed. Patricia Ingham (1854–55; London: Penguin, 1995) 9–12.
52. [Thomas Hood], "The Song of the Shirt," *Punch* 5 (1843): 260. Hood writes: "It's O! to be a slave / Along with the barbarous Turk, / Where woman has never a soul to save, / If this is Christian work!"
53. Nina Auerbach, "The Rise of the Fallen Woman," *Nineteenth Century Fiction* 35.1 (June 1980): 29–52.
54. One advocate of the abolition of female emigration pointedly describes how settlers "have paid for the importation of concubines" and claims that honorable marriages are rare despite being "craftily held out as allurements before embarkation" ([Superintendent of the Layton Emigrant Ship] 22). Those who resisted emigration, then, could be seen to be protecting their reputations for sexual virtue, given that so many reformers looked to emigration as a means of disposing of British prostitutes. See Elsie B. Michie, *Outside the Pale: Cultural Exclusion, Gender Difference, and the Victorian Women Writer* (Ithaca: Cornell UP, 1993) 87–88.

55. T. B. Wilson, *Narrative of a Voyage Round the World; Comprehending an Account of the Wreck of the Ship 'Governor Read,' in Torres Straits; a Description of the British Settlements on the Coasts of New Holland, more particularly Raffles Bay, Melville Island, Swan River, and King George's Sound, also, the Manners and Customs of the Aboriginal Tribes; with An Appendix, containing Remarks on Transportation, the Treatment of Convicts During the Voyage, and Advice to Persons Intending to Emigrate to the Australian Colonies* (London: Sherwood, 1835) appendix: 348.

56. [Superintendent of the Layton Emigrant Ship] 8.

57. [S. C.], "Emigration for Educated Women," *English Woman's Journal* 7 (1861): 2.

58. Complaints were made about the arrival of "the worst cargo for the Colony ... so young, so utterly helpless and useless to this colony" that they have to be kept like "our own orphans ... at the public expense" ([Superintendent of the Layton Emigrant Ship] 7).

59. One report cites the "local legislature of the colony" voting for the "total discontinuance" of female emigrant ships ([Superintendent of the Layton Emigrant Ship] 3).

60. Even the respectable ships, which separated single women from men, did so in harem fashion, by placing the women provocatively behind "wooden grating." John Hood describes how one man is so titillated by these arrangements that he makes an attempt to enter the women's quarters, only to be ostracized for the rest of the trip because of the violation (Hood 11, 19–20).

61. [Superintendent of the Layton Emigrant Ship] 4.

62. Charles Dickens to Mrs. Gaskell, 9 Jan. 1850, *The Letters of Charles Dickens*, vol. 6, ed. Graham Storey, Kathleen Tillotson, and Nina Burgis (Oxford: Clarendon, 1988) 6–7. For further evidence of Dickens's awareness of the dangers of emigrant ships and the problems of female emigration, as well as documentation of relevant articles published in *Household Words*, see Alan S. Watts, "Dickens and Emigrant Ships: A Matter of Whitewashing?" *Dickensian* 85 (1989): 167–75.

63. John Davies Mereweather, *Life on Board an Emigrant Ship: Being a Diary of a Voyage to Australia* (London: Hatchard, 1852) 8, 33.

64. Mereweather 7–8.

65. A matron was also responsible for training women to be neither "ignorant of household duties" nor "disinclined for labor" to ensure that they would not "lose their character and become a burden to the colony." See Maria S. Rye, "Emigrant-Ship Matrons," *English Woman's Journal* 5 (1860): 29.

66. *Emigrant Tracts* (London: Soc. for Promoting Christian Knowledge, 1850).

67. Many female philanthropists worked to replace the workhouse with household institutions in which women would get domestic training. See F. K. Prochaska, *Women and Philanthropy in Nineteenth-Century England* (Oxford: Clarendon, 1980) 178.

68. Michie 9–82.

69. As late as 1860, Bessie Rayner Parkes was still writing of the need for "homes" to ensure the safety and respectability of the middle-class woman's emigration in "A Year's Experience in Woman's Work," *English Woman's Journal* 6 (1860): 119–20.

70. "Black Country" 86. See also the case history of a girl trained and sent to Tasmania in [L. N.], "Our Emigrant," *English Woman's Journal* 9 (1862): 181–86.

71. L. C. Merryweather, "Letters on Australia and New Zealand," *English Woman's Journal* 9 (1862): 407.

72. "Letters on Australia" 407.
73. Loveless, as well as others, spread concern about the single female emigrant by detailing how in 1835, young girls unable to find immediate employment were driven to prostitution to survive; in *The Victims of Whiggery* (1837; London, 1969) 24. See also J. E. Lewin, "Female Middle-Class Emigration," *English Woman's Journal* 12 (1864): 314.
74. See *Emigrants Guide to the Gold Fields.* Under "Qualifications of Emigrants" it was specified that "[s]ingle women under eighteen cannot be taken without their parents unless they go under the immediate care of some relative or relatives. Single women with illegitimate children can in no case be taken" (n.p.).
75. Amanda Anderson draws two parallels between Urania House and a brothel: [t]he Monochie system paid women to please, and like brothel keepers, the wardens of the house maintained ownership and control over the clothing of these women; in *Tainted Souls and Painted Faces: The Rhetoric of Fallenness in Victorian Culture* (Ithaca: Cornell UP, 1993) 78.
76. *Emigrant Tracts* 7.
77. Erickson 254.
78. R. Howitt, *Impressions of Australia Felix, during Four Years' Residence in That Colony; Notes of a Voyage Round the World; Australian Poems, &c.* (London: Longman, 1845) 170.
79. Wakefield 413.
80. "Our Female Supernumeraries" 14.

"Waste Not, Want Not": Even Redundant Women Have Their Uses

Carmen Faymonville

After 1850, female emigration to the supposedly "empty" lands of Australia, Canada, and other parts of the British empire emerged as a possible solution to so-called female redundancy and the growing political dissatisfaction of many women regarding their status in nineteenth-century British society.[1] Female emigration became regarded, from a wide variety of political perspectives, as a way of easing the overcrowded inner cities, decreasing unemployment, and improving the social mobility of women from all classes. By midcentury, female emigration propaganda, couched in terms of social reform and charity but also in terms of nationalism and imperialism, began to appear with some frequency in articles, advertisements, and editorials in the popular media and literary discourse. Especially in the 1860s and 1870s, those Victorian periodicals specifically directed at a female readership, such as the *English Woman's Journal, Eliza Cook's Journal,* and Charles Dickens's *Household Words,* played a significant role in shaping public opinion about the female emigration debate. Through these forums, feminists and nationalists, social conservatives and imperialists advanced female emigration.

These advocates of emigration made various arguments that the perceived surplus of women that neither the labor nor the marriage market was capable of absorbing "wasted" fine women's potential and energy. During the same period, however, different classes of women had also become increasingly vocal about what they wanted: the vote, economic possibilities, and gender equality. One way of dealing with the potential social and political "waste" that "redundant" women presented, however, was not to give these women what they wanted but to engage them instead in the consolidation of the British empire.

This essay explores how Charles Dickens, Elizabeth Gaskell, and a relatively unknown Victorian novelist named Eliza Meteyard, a frequent contributor to *Eliza Cook's Journal,* positioned themselves within this

64

discourse on Victorian emigration. These three authors believed that the so-called "fallen women," working-class women, paupers, and even impoverished middle-class gentlewomen, might profit from emigration assistance. One way of helping women to forge new, morally responsible lives and to escape marginalization in Britain, they thought, was to help them set up house elsewhere. Regardless of their political differences — including their acceptance or rejection of feminist arguments — the three authors subscribed to the view expressed by William Greg, the author of the 1862 essay "Why Are Women Redundant?": "[W]omen who are condemned to celibacy, struggle, and privation here [Britain], might, if transferred to the colonies or the United States, find in exchange a life, not indeed of ease, but of usefulness, happiness, domestic affection, reasonable comfort, and ultimate prosperity (438).

Meteyard and Gaskell, for their part, strongly sympathized with economically deprived working-class and middle-class single women, who, contrary to the idealization of domesticity in middle-class Victorian culture, had no family or marital support. Meteyard published a serialized novel, *Lucy Dean: The Noble Needlewoman*, to advocate emigration for women unable to make a living by their trade in Britain. Gaskell helped a young woman, an ex–prison inmate, to emigrate to Australia. Similarly, in his Urania House, Dickens attempted to reform "fallen women" and personally helped many of them to buy a passage to Australia.

Although the grounding of British discourses of emigration in colonialism is the larger context in which I write, this essay explores the internal differences in attitudes toward female emigration in Victorian Britain. Situating the female emigration debate in demographic and cultural history, I show the disparity between feminist and conservative views and then examine Meteyard's, Dickens's, and Gaskell's engagement in that debate.

The Background for the Female Emigration Debate

Because Britain's overall population nearly doubed between 1801 and 1851, in the early decades of the nineteenth century, political and economic arguments in favor of emigration to the British colonies initially focused on dislocated laborers and working-class men, displaced by the growing competition for resources (Lewandoski 9). The increased attention to the question of female emigration, however, can be attributed to the publication of the 1851 census, which suggested that Britain suffered

from a dramatic oversupply of women: out of the total population, at that time about twenty-seven million, there were about 650,000 more women than men. The underlying causes were a naturally high male-infant mortality, numerous wars that had afforded great casualties, and the economically motivated migration of young men. Of the estimated 200,000 British citizens emigrating each year, males outnumbered females by a ratio of three to two (Jackel xv). In addition, many men were enlisted in the military or occupied in other government enterprises abroad. Further, statistics for the period between 1840 and 1870 also suggest that the median age of men at marriage was twenty-eight or twenty-nine, whereas women were seeking husbands in their early twenties (Dreher 6).

But neither could "redundant" women simply enter the labor force. Working-class women, accustomed to supporting themselves, however marginally, already worked in the expanding urban industrial centers or in domestic service, whereas middle-class women often had no relevant, marketable skills. Competition for white-collar jobs was even more intense, and professions requiring university education were simply not accessible for women at the time because of gender discrimination. Moreover, class consciousness associated with their "gentility" prevented many middle-class women from seeking "inferior" positions. Consequently, many poor middle-class women attempted to earn their bread as governesses, but competition raised the standards of qualification so high that many prospective governesses could not afford the necessary costly education. Thus, by 1861 the surplus of women had risen to about 800,000, and in 1911 government statistics documented that there were over 1.3 million more women than men in the United Kingdom.[2]

But the meaning and effect of this statistical surplus of women, I argue, depended heavily on the Victorian prescription of marriage and the inability to imagine single women in charge of their lives. From a twentieth-century feminist point of view, the debate about "redundancy" and emigration was not really about numbers or economics. Instead, the notion of "redundancy" actually reveals competing definitions of femininity. If it had not been for Victorian social codes and myopic gender role expectations, a mere surplus of women would not have posed as big a problem.

Partly in reaction to the surplus debate, between 1899 and 1911 about one and a quarter million British women left their homeland.[3] Despite the social stigma associated with the colonies, emigration offered to some "redundant" middle-class women the possibility of maintaining their class status. They could uphold a facade of gentility by relocating to Aus-

tralia, South Africa, or Canada, where they supposedly would either find "acceptable" work or husbands.

Special colonization societies were formed by various private sponsors and organizations in addition to governmentally sponsored emigration schemes to help middle-class women, in particular, who were not eligible for free emigration. These included Caroline Chisholm's Family Loan Colonization Society and the Female Middle Class Emigration Society (FMCES) established by Maria Rye. With the help of Jane Lewin, prominent suffragists and feminists Maria Rye and Barbara Bodichon also raised funds to educate prospective emigrants and formed reception committees to place the new immigrants after their arrival (Herstein 142–44). In 1890 the British Women's Emigration Association even founded a school to train women from all walks of life for colonial positions as servants (158–89). The Fund for Promoting Female Emigration, organized by Sidney Herbert, financed the emigration of London's distressed needlewomen, but Herbert's interest soon shifted to women of a "superior class." Apparently, by 1853 middle-class emigration had become a more respectable proposition (99–110).

British economic expansionism and aggressive imperialism during the second half of the nineteenth century encouraged emigration as a way of gaining new markets by setting up British institutions in its military and trade conquest outposts. To these ends, Thomas Wakefield, the most prominent conservative Victorian propagandist for emigration, tries to invoke female bourgeois patriotism. He writes:

> [I]n trade, navigation, war, and politics, — in all business of a public
> nature, except works of benevolence and colonization — the
> stronger sex alone take an active part; but in colonization, women
> have a part so important that all depends on their participation in
> the work. (137)

In 1850, an editorial writer of the *Times* (London) also encouraged public assistance for female emigrants and attacked the shortsightedness of past policy that discouraged single women from emigrating:

> Just at the moment that colony after colony is threatening indepen-
> dence it strikes the British public, as a novel thought, that it has
> made the great mistake of creating a settlement at the Antipodes
> with twice as many men as women instead of that equality which
> Heaven has ordained. And this is the accumulated error of half a
> century. Year after year we have witnessed its development with stu-
> pid indifference.(4)

Clearly, the primary motive for the argument here is not assisting women but utilizing women in colonial power consolidation through the interpellation of Christian gender orthodoxies. Female emigration was thus destined to result in the female civilizing mission and the domesticization of British male colonists through traditional marriage. Conveniently, this would also eliminate women's "redundancy." Women's participation in the civilizing mission, fueled by their supposed "natural" moral disposition, would, the conservatives figured, strengthen the British empire as a whole while alleviating some of the pressure at home. British women, increasingly vocal about their dissatisfaction with legal and social powerlessness, were invited to help the "future growth of an indigenous colonial population, springing from the purest British stock and raise them to the highest standard of British discipline, loyalty, and refinement," (Jackel xvii). As these examples suggest, conservative proponents of female emigration wanted to contain the unrest and the increasingly militant feminist activism by redirecting middle-class women who were either "redundant" or dissatisfied with their condition.

Prominent Victorian feminist intellectuals and social activists advocated female emigration schemes as solutions to their own definition of the problem of redundancy (Bodichon 141–42). Redundancy, they claimed, was not caused by sheer numbers or the absence of men but by women's restricted social sphere. They saw that emigration just for the purpose of marriage to colonial white men did not enlarge women's sphere, such as by providing more education and better job opportunities. Therefore, emigration as a means of enabling economic advancement was advocated, for instance, by suffragist Isa Craig, whose 1859 essay in the *English Woman's Journal*, "Emigration as a Preventive Agency," argues that the colonies should be considered an economic opportunity for unemployed and impoverished women.[4]

More cautious about the efficacy of female emigration, some feminist advocates of emigration saw it as a short-term aid for individual women but questioned its long-term efficacy. Rye and Bodichon, for example, still insisted that long-term reforms of the British education system and a political campaign to stop gender discrimination were more imperative than emigration propaganda. Bessie Parkes, a well-known Victorian feminist, thus challenged the usefulness of the export of women to the colonies by asking, "[A]re we trying to assist the female population of this country over a time of difficulty, or are we seeking to develop a new state of social life?" (Hollis 201). Clearly, in her view, the short-term solution

of emigration would not result in a "new state of social life" but rather in the strengthening of existing societal structures.

But feminists advocating emigration, even if cautiously and only temporarily, had to counter a barrage of antifeminist arguments that were clothed in a seeming concern for the welfare of women. A pertinent example of a conservative advocate of female migration is Mr. Minwaring, a colonial mining explorer in Meteyard's *Lucy Dean*, who presents his misogyny as charity:

> If one fraction of our middle class women could ... but act up to the half of such thoughts, they might be the newer Ann Hutchinsons of this age, instead of being what Wakefield too truly calls them, 'or countless miserable nuns"; ... and instead of wearing out a wretched existence here, as ill-paid governesses, musicians, artists, or else wasting life in the mean frivolities, and half starvation of 'gentility,' they would go forth with brave and fearless hearts to teach to sew, to cook, to be wives and mothers, and to be mighty examples to the less taught of their sex. (343–44)

Granted that he is honestly appalled at the sheer despair of many Victorian women, Minwaring represents a solution that would perpetuate the traditional functions of women in patriarchal societies. Clearly, his sexist language, his charges of cowardice as well as his implicit accusation that middle-class women had class interests to protect, places him in opposition to the feminists.

Exactly because emigration still carried the stigma of disreputability, feminists generally addressed female emigration schemes as legitimate and respectable avenues of social mobility. Thus Rye, the cofounder of the Female Middle Class Emigration Society, in "On Assisted Emigration," tries to counter the fears associated with Victorian women emigrating and thus leaving the domestic sphere, with a nationalistically inspired mock despair. It is difficult to understand, she writes, how "any nation possessing such magnificent colonies as ours should hold such varied views and display such apathy on the subject of emigration as is shown in England."[5] In advocating emigration for charitable reasons, however, Victorian feminists also participated in imperialist discourse by not questioning the political conditions associated with colonization and the notion of "empty space," which rendered native inhabitants invisible or even nonhuman. Rye, for instance, found that "the colonies, quite as much our

own though they are thousands of miles away, remain year after year uninhabited wastes without man or beast."[6] Female emigration, to Rye as to her contemporaries, was simply a "benevolent" and self-evident part of colonization in response to the exploitation of British women at home. Other feminists bought into the imperialist values of a society that thought women's supposed "moral superiority" as the gentler, more refined sex would be well applied to "civilizing" the natives and its own male "race" abroad.

Eliza Meteyard

Meteyard's *Lucy Dean*, published in 1850 in six installments in *Eliza Cook's Journal* under the pseudonym "Silverpen," illustrates the rising interest in emigration after 1849. Wakefield's *Art of Colonization* had just been published, and the unsavory image of emigration had begun to give way to a more positive attitude, in part fueled by the census reports. Written by a fairly conservative feminist and oriented at a female audience, the narrative recognizes the crisis of economic deprivation caused by an economy unable to absorb women who had to support themselves by their labor. In sentimental style, *Lucy Dean* conveys the plights of the pitifully poor yet respectable seamstress Lucy, age thirty and single. We are told the story of how Lucy, at the lowest point in her life, is "rescued" by emigration advocates, including Mary Austen, a virtuous woman who organizes large-scale female emigration out of a feeling of feminine solidarity, and a male benefactor, Robert Fortescue, who assists with the funding. As a didactic narrative, the novel expresses the moralizing forces that emigration promised to conservatives and feminists alike. As the apparent purpose of Lucy's emigration is self-support through work, not marriage to a colonist, Meteyard falls within the feminist propaganda efforts I have described. Other rigid class, race, and gender distinctions, however, are upheld in this text, reflecting perhaps the inherent conservatism that also pervaded female-oriented agendas.[7]

In *Lucy Dean*, female emigration takes on unique importance because the title character, a strong and virtuous woman fallen on hard times, is made weak and sick by the conditions in Britain but flourishes abroad. The underlying message is that poor women like her are not virtueless or inferior, as the proponents of racial eugenics would have it, but that their living conditions cause their debasement. Initially characterized by her "corpselike, ... wasted fingers," Lucy is so terribly poor

that she tries to sell even her last belonging, a little bird. The novel opens as she meets Mr. Twiddlesing, a bird dealer, and his friend O'Flanagan, the servant of benefactor Robert Fortescue. These two men recommend that she emigrate to Australia instead of waiting for help at home, since they, like other reformers of the Victorian era, are convinced that "those who have been helped, only ... feel poverty more sorely when need came again" (313).

Singling out Lucy as a respectable and hardy wench, the bird dealer introduces her to a respectable matron, emigration sponsor Mary Austen, who, modeled after Caroline Chisholm, is reputed to have done "more to put at heart in things such as this than half the men in the country" (315).[8] Motivated by female solidarity, Mary Austen first gives Lucy work to secure her immediate survival then solicits the help of the rich benefactor, Robert Fortescue, modeled after Sidney Herbert, to send Lucy to Australia. At first Lucy conceives of emigration as "dreary voyages and desert countries at the end," but she soon becomes convinced that her only escape from starvation and exploitation in the slopwork business is to leave home. The solution to the problem of genteel poverty is not charity toward women at home, Meteyard suggests, because

> charity will never heal woeful misery like yours, not if it be the charity of half a nation; for it is but lifting a bucket out of a big ocean. (313)

Instead, a different course of action, supposedly both economically and morally more advantageous, is suggested:

> [S]ome must brave the perils of the ocean to these far lands, must lay aside the beggared needle and its lazy bread, must cook and bake, wash and iron, sweep the house and trim the garden, become mothers, and nurse their offspring into good men and women. And some of you must get money, and collect money in that country, and come back to this, and spread the knowledge wide and far that there are blessed lands in this wide world, for them as'll strive and work, and not cling to the pauperism o'the needle ... because it's 'genteel.' (313)

As a next step, Austen takes charge of Lucy's moral education. She cross-examines Lucy to find out if she meets the standards of chastity and religious fervor, including a clean reputation, and requisite cooking, nursing, and cleaning abilities. Verifying Lucy's chastity is imperative for

Austen's own reputation and that of her emigration scheme, but also for Lucy herself because "she well knew that all power over these men, lawless as perhaps they might be, depended on the sense they would have of her moral worth" (363). Stressing the civilizing mission of women exercised through religion, Austen asks Lucy if she would "enforce faith and duty in your household that should teach your lisping children by your knees, those prayers, which men go back to in their after years, for penitence, for faith, for hope, for good" (330). In this, Meteyard echoes Chisholm's and Wakefield's views on the civilizing mission of women exercised through religion. Chisholm, for example, a Roman Catholic convert, wife, and mother, adamantly stressed women's function as "God's police."[9] Similarly, Wakefield argued in the *Art of Colonization* (which Meteyard clearly had read) that "if you persuade religious women to emigrate, the whole country will be comparatively virtuous and polite" (72).

Nevertheless, the advancement and organization of female emigration is defined as a specifically female and liberal feminist task in *Lucy Dean*. Meteyard appeals repeatedly to the power of women and implicitly, of course, to women readers. "If we women," Meteyard admonishes, "despair of helping our sister woman what can men do? No! it is only through labour—honest self-help, that those standing can raise the fallen—and this you may do—this is what I have to do—this is what the strong in will, and what the untempted of our sex have to do" (331). The help of women readers, in particular, is solicited here because the author perceives that "charity, and love, and faith, within the heart of woman, have not yet accomplished the millionth part of their duty, nor scarcely yet foreshadowed their destiny in the progress of the ages." In very glorifying prose, both Austen and Lucy symbolize for the author "new graces for a New Maternity, ... which Nature, truer and diviner than man's laws, has decreed shall be the sign of woman's great prerogative, as Mother of the World" (331). This grounding of woman's identity in nature, motherhood, and caring was characteristic of essentialist feminist discourses of the period.

After Lucy has saved some of the money needed for the passage, she receives additional financial aid from her benefactors, sails to Australia, and finds work as a housekeeper in a mining town. Able to support herself, she is one of the period's "new women" who use their initiative and intelligence to carve out a space for themselves outside the traditional system. In her initial interview with her employer, she assures him that she has "no thoughts, at least at present, about marriage" (331). Aware of the shortage of women and keen on social mobility, Lucy eventually

Emigration agent's office (1856).
Courtesy of the Library of Congress, Photographs and Prints Division.

73

marries her boss. After becoming self-sufficient, thereby meeting the expectations of the feminist emigration proponents, she sees even greater benefit in becoming a "mother of the race." As expected by the conservative emigration proponents, she cultivates both the land and the men in the mining camp and, as her most important duty, brings order to the wilderness. Designated as redundant—as "waste"—at home, Lucy finds a larger purpose in life via her role in the civilizing mission. The narrator thus conveys to readers that it was

> a touching, sacred thing, as their rude nature [the men's] visibly softened under the pure and blessed influence of this noble woman, and indirectly under the blessing of a nobler influence still, ... to see them alone or in bands go to her neat room after the day's labour was over, to beg a book, to ask advice, to talk with her, or to take her some little offering—a rare mineral from the mine, a flower from the woods, a piece of furniture of their own constructing; or to ask her, where they were poor scholars, to read to them, or write for them, "home" letters. (378)

Here we see a woman put to "good use": Lucy has become the mother of the nation in the outposts of the empire. In comparison to the masculinist-conservative proponents of female emigration, Meteyard's text seems indeed inspired by feminist notions of female friendship and solidarity, especially in the emphasis that is placed on women's duty and privilege to work and to help her sisters. Yet the traditional female roles and feminine civilizing mission that Lucy is made to follow at the end of the novel negate many of the text's more radical notions.

Charles Dickens

Dickens supported female emigration to the colonies as a charitable scheme aimed at fallen women and prostitutes after they had been reformed in so-called refuges or lodging houses.[10] In his article "Home for Homeless Women," published in *Household Words* in 1853, Dickens targets as possible emigrants the "starving needlewomen of good character, poor needlewomen who have robbed their furnished lodgings, violent girls committed to prison for disturbances in ill-conducted workhouses, poor girls from Ragged Schools, destitute girls who have applied at Police offices for relief, [and] young women from the streets ..." (169)

Dickens was so attracted to the idea of female emigration as a "simple safety valve" that he dedicated ten years of his life, the period roughly between 1846 and 1856, to his Urania House, which served to reform and prepare its female prostitute inhabitants for emigration to Australia. In 1847, Dickens had rented a building to serve as a home for former prostitutes in behalf of his collaborator and friend, Angela Burnett Coutts, with whom he extensively corresponded on the plan and its execution over a period of years (Dickens, *Letters* 181, 425, 462, 507). Emigration, Dickens believed, provided these reformed prostitutes with a fresh start and the possibility of a lasting reintegration into respectable society. Dickens himself took great interest in the lives of these women and often personally supervised arrangements to send them to the colonies.

Dickens had witnessed sexual exploitation and male violence toward women across class divisions, and he found that women's downfall through seduction was often the result of male irresponsibility.[11] Yet, lest we might perceive Dickens as a feminist, it is important to add that Dickens "had no desire to make women economically independent of men and expressed no sympathy for efforts to establish vocational schools or working communities for women" (Kaplan 260–61). In consequence, Dickens's attitude to fallen women was essentially punitive, if superficially compassionate. Unlike Gaskell, Dickens believed that a woman's fall was an individual lapse in morals and that no larger restructuring of Victorian society was needed with respect to women. In fact, Nancy, his fallen woman character in *Oliver Twist*, as well as Lady Dedlock in *Bleak House*, have to die as part of the plot resolution, perhaps reflecting Dickens's problematic final dismissal of these women.[12]

It is in this light that we have to view Dickens's statement that "perfect penitence in these women" might express itself as "a kind of active repentance in their being faithful wives and the mothers of virtuous children" (261). Dickens still relegates women to the restrictive private sphere by defining women's subjectivity through biological determinism (anatomy as destiny). His intellectual companion is William Greg, another conservative proponent of emigration, who argues in his essay "Why Are Women Redundant" that the transportation of women to the colonies would eliminate prostitution. Greg imagines that "when female emigration has done its work, and drained away the excess ... men will have to bid higher for the possession of them, and will find it necessary to make them wives instead of mistresses" (qtd. in Dreher 4). Greg implies here that emigration could prevent prostitutes from engaging in

their professions in Britain, which would then further discourage the deterioration of British superior civilization.

Besides writing about the advantages of emigration in *Household Words* and in his letters, Dickens also incorporated the theme of female emigration into his major literary works. Two characters in Dickens's novel *David Copperfield*, for example, are literary representations of fallen women who redeem themselves through emigration. Emily is an orphan who lives with her uncle and is soon to be married to her cousin Ham when an evil character named Steerforth appears on the scene and seduces Emily. After their elopement Steerforth quickly tires of her, and it becomes clear that his intentions were never honorable. He treats Emily like a prostitute, and she finds herself in a serious predicament abroad.

Overcoming many difficulties, Emily eventually returns to Britain and meets Martha Endell, who herself is a fallen woman. Dickens makes it clear that there is no "respectable" life possible for Emily and Martha in Britain since their reputation is thoroughly ruined and their shame public and openly condemned. Emigration to Australia seems the only option. Dickens's removal of Emily to the colonies appears necessary because there she can escape the vicious pseudo-Christian propriety exhibited by Rosa Dartle, a woman who chastises Emily for her betrayal of "decent" womanhood. After Emily appeals to Rosa's solidarity on the basis of their shared womanhood, the latter denies that there is anything in common between them: "[Our sex] ... is so strong a claim, preferred by one so infamous, that if I had any feeling in my breast but scorn and abhorrence of you, it would freeze it up. Our sex! You are an honour to our sex!" (719). Martha, in spite of her past offenses to Victorian sexual mores, eventually marries a farm laborer in Australia, but Emily remains single and stays with Peggotty, who returns to Britain many years later to tell Copperfield what had happened to them in Australia.

Australia functions in the novel as a place of redemption since "[n]o one can't reproach my darling in Australia" (730). Yet, we have to ask ourselves what kind of solution Dickens offers here: Martha is able to live a "woman's life," defined in socially conservative fashion by Dickens through her marriage to an Australian beneath her social class (who was too desperate to have any wife at all to care about her past). Emily, however, never marries and stays with her uncle, who, according to Philip M. Weinstein, "doubles as father and lover" (84). Emily's escape to Australia is not an empowering solution; she seems to perceive Australia as a mere hiding place from her shame, as suggested by Rosa's cruel admonition that she should hide—a view perhaps shared implicitly by Dickens him-

self (722). Although Dickens apparently believed in the reformability of young fallen women, for Emily, the "fall" always remains. Emily's worn look, her sorrowful eyes and her "pritty head, leaning a little down," and her "quiet voice and way—timid a'most" inform the reader that emigration did not result in either emancipation or happiness.

One might even argue that for Dickens, emigration simply functions as a plot device to get rid of women characters at the end of a book without having to kill them off. Coral Lansbury explains that this decision might be motivated by Dickens's essentially conservative political identity. In *Arcady in Australia,* Lansbury claims that Dickens "enjoyed his growing reputation of being the conscience of the age," yet he emerges as a quintessential middle-class man, largely because "he desired the amelioration of the lower classes without disturbing the middle class" (94). Dickens's interest in the problem of fallen women and emigration as a means of reform can be seen as symbolic of his belief in the "potential for wider salvation, for the triumph of humanistic liberalism, for the confirmation of his ability as a man of action to accomplish something in the real world of social problems, for the re-affirmations of this own idealized image of the higher moral sentiments inherent in the female" (Kaplan 228.)

In contrast to Gaskell's feminist-liberal humanism, Dickens thought that change was to be accomplished "without the slightest tremor of revolution or social upheaval" (Lansbury, *Arcady* 94). Furthermore, in contrast to Victorian feminists, Dickens unabashedly advocated marriage as part of the narrative and real-life solution for reformed women: For Dickens, "Only the prospect of marriage in a context free of past associations could be sufficient incentive for former prostitutes to give up their long-learned and endured vices" (Kaplan 229). In his attitude toward female emigration and the solutions it provides to Victorian dilemmas, Dickens proves to be caught within a conservative web of reformism that ignores alternative solutions to social problems in the socioeconomic system of British society itself.[13] To many Victorians, including Dickens, emigration—"out of sight, out of mind"—was easier to accept.

Elizabeth Gaskell

A shared concern for helping fallen women through education and emigration brought Elizabeth Gaskell into her first contact with Dickens. The first letter that Gaskell ever received from Dickens, dated 9 January

1850, responded to her request for advice on a young woman whom Gaskell had met during one of her charitable prison visits and whom she deemed worthy of help. In her own letter, Gaskell asks Dickens how she might help this young girl, who "is in our New Bayley prison" and who was seduced "by a surgeon in the neighbourhood who was called in when the poor creature was ill" (Gaskell, *Letters* 98). Gaskell then needs to know " ... how Miss Coutts [Dickens's co-organizer of the Urania house] sends out *her* protegees?" In the rest of her letter to Dickens, she explains her concerns and emigration plans for the girl:

> I want her [the girl] to go out with as free and unbranded a charac-
> ter as she can; if possible, the very fact of having been in prison,
> etc., to be unknown on her landing. I will try and procure her
> friends when she arrives; only how am I to manage about the voy-
> age? and how soon will a *creditable* ship sail; for she comes out of
> prison on Wednesday and there are two of the worst women in the
> town who have been in prison with her, intending to way-lay her,
> and I want to keep her out of all temptation, and even chance of
> recognition.... I can manage all except the voyage ... and we can
> pay all her expenses etc. Pray don't say you can't help me.... She is
> such a pretty sweet looking girl. I am sure she will do well if we can
> but get her out in a *good* ship. (99)

Like Ruth, the title character of Gaskell's novel, the young girl, Miss Pasley, had been an orphan and seduced by an older, affluent man when she was very young; like Ruth she was a dressmaker apprentice working under demeaning conditions, and like the fictional figure, she was abandoned by the seducer.

Dickens promptly replied to Gaskell's request by putting her in touch with the right people in London. Miss Pasley left Britain two months later, financially assisted and outfitted by Gaskell and her friend Eliza Fox (Guérin 105). Convinced that the girl would redeem herself, Gaskell made sure that through her visits to the prison she would "keep up and nurse [the girl's] hopes and good resolutions." The author even found respectable prospective emigrants who promised to take care of her young charge (Gaskell, *Letters* 62–63).

In her novel *Ruth*, however, Gaskell chose a different path than emigration for the fallen woman. Ruth does not remove herself from the judgment of her society through emigration but decides, instead, to live with her shame and to redeem herself among those people that form the moral and societal backbone of Victorian Britain. In *Ruth*, Gaskell

shocked her contemporaries by creating a new type of heroine—a fallen woman different from those Dickens had portrayed. Unlike Dickens's emigrating women, Ruth is rescued and restored to society in Gaskell's world. A.B. Hopkins argues that Gaskell "had ventured to show in a plain realistic way, unhampered by the trappings of romance that an error made in ignorance may be the very means of a girl's rehabilitation, ... [and] that it is possible, though very difficult, to win back, even without marriage, the respect of her own community, the very community that had cast the first stone" (131).

Thus, in *Ruth*, Gaskell exposes the hypocritical attitudes of Victorian society, who chastised the woman but silently condoned male behavior. Guérin explains that Gaskell wanted to affect "the moral outlook of all educated strata of Victorian society" that "left the others, the untaught and often destitute poor, with no other recourse than to break both divine and man-made law," and that her larger goal was "to inform and touch her readers as to arouse their social conscience and pity, knowing that these are the preliminaries to any effective movement of reform" (127–28).

Gaskell's position is so remarkable because emigration as an answer to the "woman question"—at least conceived in Victorian middle-class terms—failed. The emigration of middle-class women never reached high enough numbers to actually solve the problems of redundancy and limited access to the professions. Employment possibilities in the colonies were only good for skilled servants, who were much sought after in Britain as well. In fact, other political changes in Britain, such as the opening of relatively low-paying white-collar jobs to women with education, opened the doors for more unmarriageable women than emigration did.

The relatively small number of middle-class women who emigrated with the help of the Female Middle Class Emigration Society that Maria Rye had founded also demonstrates that no effective large-scale, pro-feminist emigration of single women took place. The FMCES was only able to help 302 women between the years 1862 and 1882. This does not mean, of course, that no women emigrated with their families or went abroad temporarily. Of the two million British citizens that emigrated to Canada and Australia between 1830 and 1899, fifteen to twenty percent were single women (Dreher 5–6). One has to keep in mind, however, that all of the aforementioned societies helped only an estimated twenty thousand women—across all classes—to emigrate during the 1850s to 1880s.

Conclusions

As these examples and various perspectives show, there were many differ-
ent responses to the dilemma of the Victorian middle-class woman and
general female redundancy, and consequently, ideologically different
arguments emerged in support of emigration as a viable solution to Vic-
torian dilemmas. Encouraging fallen, redundant and poor unemployed
women to emigrate had several seemingly good purposes: Many Victori-
ans were convinced that emigration promoted women's general welfare
since women of all classes could make a living in the colonies. Further,
helping fallen women and prostitutes to go abroad might promote social
hygiene and prevent them from falling back into a life of crime.

Whether advocated by the progressive reformers, conservatives, or
feminists, female emigration perhaps preserved Victorians from engaging
critically with their own complicity in the dismal position of women.
One could argue that the emigration of redundant, fallen, and unem-
ployed women may have effectively maintained the social structure in
Britain and proved in many ways counterproductive to reform. Since
these "problem women" were supposedly "taken care of," those that
remained were supposed to tolerate their continued exclusion from
many areas of life. In addition, from a late twentieth-century point of
view, the coinciding of feminist discourse on emigration with British
imperialism must be seen as highly problematic and, in retrospect, as a
political choice detracting from the liberating and solitary impulse
underlying feminist goals.

That the fundamental ideologies of female emigration also sometimes
produced quite averse backlashes can be discerned, perhaps, from the
following example. Emigration societies that helped women seeking
work in the colonies had to realize that women often deserted "service"
for marriage once they had acculturated. Perhaps based on these frustra-
tions, the British Women's Emigration Association (BWEA) soon
promised women both employment in "higher" domestic service and
potential marriage (whereas before they had insisted that women should
emigrate to enter the workforce and had warned prospective emigrants
not to become dependent on men). By the 1890s the BWEA also openly
identified its emigration schemes in ideological terms as women's oppor-
tunity to safeguard British interests and advance British cultural projects
in the "uncivilized" colonies (Hammerton 148–49, 162–63).

I have tried to show what comprises the spectrum of views on female
emigration that these prominent and not so well-known Victorians held

and how their rhetoric and actual life activities reflected differing ideologies of emigration. This is to say that emigration might have been abused by some of these authors to solve—and paradoxically to avoid solving—problems in Britain itself by exiling the problem makers or even by transporting the problems themselves elsewhere. As the title of my essay suggests, even redundant women had their uses. Meteyard saw no other means of relieving female poverty than by sending starving needlewomen to the colonies as laborers, mothers, and missionaries of civilization. For Dickens, redundant women had yet another use: since he conceived of prostitution as something that was contagious and could be prevented from spreading in Britain if the bearers of the disease were removed, these redundant women could be used to reform a morally corrupt culture. Only Gaskell was aware of the many potential drawbacks that female emigration held for British society if similar transformation did not occur at home. Moreover, given the problematic participation of British women in the institution of race and class barriers in the colonies, emigration was perhaps not a morally "clean" choice in the first place. In light of recent postcolonial critiques, it gets harder and harder for social and literary critics to be entirely sympathetic to the educated, distressed gentlewomen seeking their luck abroad as white matrons in racially stratified societies.

Notes

1. Redundancy is, of course, relative. Victorian society saw any abject other, including poor and sexually promiscuous women, redundant to the well-ordered, bourgeois civic space it envisioned. Below, I cite some figures reflecting the supposed redundancy of women, but I want to stress from the start that these data do not reflect the construction of that redundancy in Victorian popular discourse. Empirical data do not adequately represent how cultural ideologies circulate and act on the psyches and bodies of people.

2. See *Annual Abstract of Statistics, 1899–1914*. Van-Helten and Williams provide evidence in their article " ' The Crying Need of South Africa' " that by 1911 "there were in the United Kingdom 1,329,000 more females than males and in the self-governing dominions 762,000 more males than females" (21).

3. Hammerton 146–48. The total number of female emigrants between 1850 and 1899 is not known, but Sidney Herbert and Caroline Chisholm's combined efforts helped more than 1,300 women to emigrate between 1850 and 1853 (Hammerton 111). Maria Rye independently helped about 400 women; the FMCES helped about 302 women; and the Women's Emigration Society (WES), which operated from 1880 to 1884, helped approximately 200,000 women. Between 1906 and 1914, the BWEA assisted 6,700 women in emigrating to Canada.

4. See Lacey 295.

5. Maria Susan Rye, "On Assisted Emigration, *English Woman's Journal* (1860): 338; qtd. in Lacey. The imperialist language of her argument shows the implication of Victorian feminism in imperialist designs. As Inderpal Grewal also argues in *Home and Harem*, "[T]he space in which English feminism could resonate at the turn of the nineteenth century was that of nationalism and imperialism" (11). Grewal's postcolonial analysis reveals that

> those nineteenth-century Englishwomen who fought for their rights were not against the project of empire. For most of them, empire was a matter of pride as well as a policy that did not need contestation. It was important to see themselves as part of a "civilizing" nation, for that could imply a nation that would not subjugate or exploit its own people. Being part of the empire also gave them a sense of racial superiority that enabled them to feel their own worth and equality with men.... As a consequence, they did not extend their protest to a critique of industrial economy or patriarchal systems, nor did many of them protest the interrelated notions of class and race hierarchies that supported the culture of colonialism in England. (66–67)

Despite Grewal's rigorous analysis, however, it would be quite ahistorical to view English feminists' implication in imperialism as identical to that of the ruling-class patriarchy.

6. Rye 337; qtd. in Lacey 295.
7. Meteyard uses racial and anti-Semitic stereotypes in explaining Lucy's economic exploitation and reinforces essentialist gender stereotypes, including a distinction between "good" and "bad" women.
8. The *Times* had actually praised Chisholm in similar terms.
9. Hammerton 101. Like Wakefield, Chisholm argued that the colonies' loyalty to the empire depended on the integrative work of women: by giving men in Australia "help-mates, ... you make murmuring, discontented servants, loyal and happy subjects of the state" (Hammerton 30–31).
10. *Lucy Dean* exemplifies this "charitable scheme": Nelly, the sister of the protagonist, is rescued from a sinful life of single motherhood, poverty, and prostitution and is reformed. Although not as virtuous as Lucy, charity, trust, and hard work help Nelly to become repentant and respectable again so that she can go off to Australia to marry a laborer who will have her in spite of her stained reputation.
11. Kaplan, Dickens's biographer, explains the complex but nonfeminist sympathy Dickens had for such women:

> For those who have been unlawfully seduced, the collapse of self-esteem, he believed, almost inevitably led to self-destructiveness. Fallen women embodied the perversion of the true, high nature of women. If they could be caught before their natures had been brutalized and provided with a disciplined supportive environment, their essential goodness and attraction to purity, and the naturalness of marriage and motherhood as well, would assert itself. Since society offered few economic opportunities for women outside the home, those who had been deprived, by accident, by drunkenness, by poverty, by seduction, by crime, by the immoral elements within

patriarchy, of an appropriate domestic environment inevitably turned to prostitution once their alternatives had been exhausted. (260)

12. Although, through Nancy, Dickens challenges the madonna-whore paradigm, his empathy for fallen women is not all-comprehensive or particulary sympathetic to feminist concerns about prostitution. For a different, more positive evaluation of Dickens's attitude toward fallen women, see George Watt's *Fallen Woman in the Nineteenth-Century English Novel*.

13. Ironically, there is considerable evidence that prostitution continued to grow by the influx of British and other white women in the colonies. Margaret Strobel reports that in South Africa in 1899 about ten percent of white women over age fifteen were prostitutes (28).

Works Cited

Annual Abstract of Statistics, 1899–1914. London: Kraus, 1966.

Bodichon, Barbara. "Open Council." *English Woman's Journal* 12 (Oct. 1863): 141–42.

Chisholm, Caroline. "The A.B.C. of Colonization." 1850. *Women in Public, 1850–1900: Documents of the Victorian Women's Movement*. Ed. Patricia Hollis. London: Allen, 1977. 35.

Dickens, Charles. "Home for Homeless Women." *Household Words* 23 Apr. 1853. Rpt. in *The Uncollected Writings of Charles Dickens: Household Words, 1850–1859*. Ed. Harry Stone. Vol. 7. Bloomington, IN: Allen, Penguin, 1968.

———. *The Letters of Charles Dickens, 1847–1849*. Ed. Graham Storey and K. J. Fielding. Vol. 5. Oxford: Clarendon, 1981.

———. *The Personal History of David Copperfield*. Oxford: Oxford UP, 1987.

———. *The Uncollected Writings of Charles Dickens: Household Words, 1850–1859*. Ed. Harry Stone. Vol. 1. Bloomington, IN: Allen, Penguin, 1968.

Dickens, Charles, and Caroline Chisholm. "A Bundle of Emigrants' Letters." *Household Words* 30 Mar. 1850.

Dreher, Nan. "Women and Emigration." *Victorian Periodicals Review* 26.1 (Spring 1993): 1–7.

"Emigration for Educated Women." *English Woman's Journal* (Mar. 1861): 1.

Gaskell, Elizabeth. *The Letters of Mrs Gaskell*. Ed. J. A. V. Chapple and Arthur Pollard. Manchester, Eng.: U of Manchester P, 1966.

———. *Ruth*. London: Penguin, 1986.

Greg, W. R. "Why Are Women Redundant?" *National Review* 28 (Apr. 1862): 434–60. Rpt. in *Women in Public, 1850–1900*. Ed. Patricia Hollis. London: Allen, 1977. 12, 39–40.

Grewal, Inderpal. *Home and Harem: Nation, Gender, Empire, and the Cultures of Travel*. Durham: Duke UP, 1996.

Guérin, Winifred. *Elizabeth Gaskell: A Biography*. Oxford: Clarendon, 1976.

Hammerton, A. James. *Emigrant Gentlewomen: Genteel Poverty and Female Emigration, 1830–1914*. London: Croom; Totowa, NJ: Rowman, 1979.

Herstein, Sheila R. *Mid-Victorian Feminist Barbara Leigh Smith Bodichon*. New Haven: Yale UP, 1985.

Hollis, Patricia. *Women in Public, 1850–1900: Documents of the Victorian Women's Movement.* London: Allen, 1977.

Hopkins, A. B. *Elizabeth Gaskell: Her Life and Work.* New York: Octagon, 1971.

Jackel, Susan, ed. *A Flannel Shirt and Liberty: British Emigrant Gentlewomen in the Canadian West, 1880–1914.* Vancouver: U of BC P, 1982.

Kaplan, Fred. *Dickens: A Biography.* New York: Morrow, 1988.

Lacey, Candida Ann, ed. *Barbara Leigh Smith Bodichon and the Langham Place Group.* New York: Routledge; London: Kegan, 1987.

Lansbury, Coral. *Elizabeth Gaskell: The Novel of Social Crisis.* New York: Barnes, 1975.

———. *Arcady in Australia: The Evocation of Australia in Nineteenth-Century English Literature.* Carlton, Austral.: Melbourne UP, 1970.

Lewandoski, Ken. "A New Transportation for the Penitentiary Era: Some *Household Words* on Free Emigration." *Victorian Periodicals Review* 26.1 (Spring 1993): 8–17.

Meteyard, Eliza [Silverpen]. *Lucy Dean: The Noble Needlewoman.* Serial novel publ. in *Eliza Cook's Journal* 2 (1850): 312–16, 329–31, 340–44, 360–65, 376–79, 393–96.

Strobel, Margaret. *European Women and the Second British Empire.* Bloomington: Indiana UP, 1991.

Times [London] 2. Jan. 1850: 4.

Van-Helten, Jean Jacques, and Keith Williams. " 'The Crying Need of South Africa': The Emigration of Single Women to the Transvaal, 1901–1910." *Journal of Southern African Studies* (Oct. 1983): 17–38.

Wakefield, Thomas. *The Art of Colonization.* London: 1849. Repr. 1954.

Watt, George. *The Fallen Woman in the Nineteenth-Century English Novel.* Totowa, NJ: Barnes, 1984.

Weinstein, Philip M. "Mr. Peggotty and Little Emily: Misassessed Altruism?" *Modern Critical Interpretations: Charles Dickens's David Copperfield.* Ed. Harold Bloom. New York: Chelsea, 1987.

Without Artificial Constraint: Gentility and British Gentlewomen in Rural Australia

Emma Floyd

British gentlewomen played a major role in the transference of gentility to Australia, but their experiences and their unique culture have thus far been either ignored or misrepresented. Much emphasis has been placed upon the analysis of promotional literature and published accounts of the migration experience. These sources theorize about the need to transfer the culture of gentility to the colonies, but they do not explore the ways in which that culture was to manifest itself. A combined analysis of letters, diaries, and published accounts as well as material culture, including dress and homes, would allow a more comprehensive interpretation of the British gentlewoman's understanding of gentility and the ways in which she sought to recreate it in her new environment. This is the aim of the following essay. First, however, it is important to understand why the genteel migrant experience has been so misconstrued.

Emigration has long been associated with the move of the working class, particularly the working-class male.[1] This emphasis follows a historical tradition that has presented migration as a positive experience, associated with improvement of and benefit to the individual. Within this context, improved working conditions, wages, and living standards are highlighted as the means by which the working class is "liberated" in the New World. Recently, more attention has been given to those migrants of other classes who may not have experienced these "liberating" aspects.[2] Recognition has been given to the many emigrants for whom emigration implied financial or social failure and psychological trauma. But, despite their scholarly efforts, these pioneering works have failed to completely dispel the idea of the "workingman's paradise," particularly in Australia.

Gentility has been viewed by many as in conflict with more dominant ideas of egalitarianism and is thus dismissed as less significant within the national culture.[3] But this is a misconception. In the Australian context,

one historian, John Hirst, has argued that democracy and gentility have been compatible. Once the newly wealthy achieved their financial goals, Hirst argues, they sought not to challenge the prejudices and old-world notions of the genteel but to emulate them and adopt the attitudes that would allow them to become the excluders rather than the excluded.[4] Gentility thus takes on a new significance, which deserves to be addressed.

Some have sought to address the issue of gentility in Australia, but they have failed to recognize women as the main arbiters of the genteel culture. In *Pounds and Pedigrees*, Paul de Serville looks at "the operation of gentility in the colony" of Victoria, Australia. De Serville admits that the bias of his work is "inevitably masculine" and encourages other scholars to delve into the "private and domestic face of polite society," by which he presumably means the "feminine."[5] Yet, in so doing he denies the power of woman in the genteel world and fails to recognize that the private/public dichotomy was an ideological construction, not an immutable physical reality.[6] He continually denigrates the strength of women's roles in the marking of genteel boundaries, stating that "convention hemmed them in," and belittles their "limited" domestic circle and "few" charitable involvements.[7] A year after the publication of de Serville's book, Cambridge University Press published Sharon Morgan's *Land Settlement in Early Tasmania: Creating an Antipodean England*. Like de Serville, Morgan explains that her work concentrates largely on men because they were the only "legal settlers," the only ones granted land. Yet the work claims to analyze the re-creation of the English world as "the yardstick of civilisation and beauty," an aim that cannot be achieved without the recognition of the influence of women.[8] Female emigrants are given scant attention, a bias that is not excused by Morgan's statement of intent, and once more the British gentlewoman is denied the recognition warranted by her position as a social arbiter.

Other studies of gentility that do look at the role of women have concentrated almost entirely on the urban experience, ignoring rural Australia. Such studies assume that "society" cannot exist outside major cities, in areas where distances are greater and populations are sparser. This assumption has created an image of the cult of gentility as nothing more than a public performance, an external display that would collapse when moved to rural areas beyond the gaze of an audience. Gentlewomen themselves are presented as shallow observers of an insignificant set of social rules.

But the cult of gentility was much more than a performance; it was an internalized cultural force with a powerful hold on the psyche of its

adherents. Gentility endured in the Australian bush, carried there by British emigrant gentlewomen. These women had deep-seated ideals of gentility, and whether or not they were willing adherents of its tenets or able to meet its financial demands, they could not easily relinquish its web of mores and cultural expectations. The public performance might dwindle in the bush, but the private maintenance of genteel notions would not be so easily renounced. British gentlewomen had been invested with these notions, and the guarding of them was, for many, simply a matter of self-respect. Thus, it is at least as important to analyze gentility in rural Australia as it is in the cities, for such an analysis would illustrate the strength of gentility as an internalized ideal and the agency of emigrant gentlewomen in promoting its precepts.

One of the most obvious, external aspects of the genteel culture, which is analyzed by those concerned purely with its public display, is, of course, dress. Most contemporary and historical observers of gentility in Australia have given a great deal of attention to this external signifier. Recent studies have emphasized how dress affected "perceived notions of respectability in terms of appearance, beauty and etiquette," particularly with regard to women.[9] In Britain, gentlewomen were certainly "preoccupied with dress," every aspect of their attire being symbolic of a particular status category.[10] From a very early age, British girls were inculcated with the symbolic associations of dress with gender and status differences.[11] In the colonies, it has been argued, this preoccupation was intensified as gentlewomen sought to distinguish themselves from the rising numbers of nouveaux riches, who were able to buy the external symbols of gentility. But this problem of distinguishing between the genteel and the parvenu created difficulties when using dress as a criteria for defining status. Many could now afford to dress as the genteel without possessing any other discernible genteel qualities.

A study of British gentlewomen and dress in rural Australia testifies that while clothing was important to these women, it was of trivial significance when compared to more internalized signifiers of status—one's demeanor and behavior. In a land where a former servant, simply because of her outfit, could be mistaken for a lady, the issue of dress became a questionable marker of status. Dress codes could be relaxed, providing other areas of genteel existence were attended to, and while recognizing the necessity of display in public, British gentlewomen welcomed the lapsed attitude toward their attire without feeling a loss of status.

In rural Victoria, one British gentlewoman, Annie Baxter Dawbin, had slowly begun to move into the realm of men in the bush, working with horses and cattle. For this she had to adopt alternative clothing, including her husband's "red shirt & straw hat."[12] A few months later in April 1845, Annie and her friend Mrs. Connolly agreed that they would ride in gentlemen's pantaloons. Thus Annie altered "a pair of Baxter's for the purpose—they only require taking in, in the waist—otherwise they fit well."[13] In the same entry in which she described the adoption of her husband's shirt, Annie also commented on making "a pretty cuff." The image she creates of a gentlewoman sewing fancywork while dressed in her husband's clothing is not only amusing but also indicative of the freedoms found in isolated areas of the bush, and the delicate balance between colonial necessity and gentility. Annie did not totally abandon the ways of the genteel. Indeed, once back in Melbourne Annie behaved according to expectations, as her biographer Lucy Frost notes: "[A] woman of her class gained self-respect by being a lady, and ladies were admired for being decorative, fragile, passive. Annie lay on the drawing-room sofa, and waited for people to come to her."[14] The public performance was resumed in the city, but its laxity in the bush did not result in a loss of status.

Other gentlewomen recognized the less strict fashion "rules" in the bush, although most did not go to Annie's extreme. On Victoria's goldfields, for example, Martha Clendinning saved her fashionable clothes only for special occasions. On one such occasion she went to get her husband's license in her "go-to-meeting clothes," which consisted of "a black cashmere dress, with two deep flounces with velvet folds on the edges, a Paisley shawl, and a straw bonnet, trimmed with white ribbon."[15] Clendinning prided herself on being careless with her appearance and felt no compunction in stating as much in her memoirs, but she admitted sometimes that the strength of genteel codes of behavior could not be suppressed. She recalled an event that demonstrated this almost unavoidable bowing to British genteel social mores. On this particular day, Clendinning's sister was talking to two gentlemen of her acquaintance when her husband arrived from the Wet Flat, covered with mud and looking quite "a miserable figure":

> He threw down his tools and leaned against the tent post. He looked at his wife and her two companions, but she took not the slightest notice of him. The visitors seemed surprised at the free and easy demeanour of the dirty digger who so coolly availed himself of

the tent pole without a word of apology. After a few minutes they said, "Good evening," and departed. My sister turned to address her still silent husband, with a remark that he was not fit to be introduced to the strangers. She found, however, he was most indignant with her for being ashamed of him.[16]

Clendinning's sister might well have introduced her husband to less-discerning visitors, but in front of gentlemen she would not, it seems, degrade herself by admitting that the base-looking character was in fact her husband and a gentleman. Nonetheless, in private, Clendinning's sister would not have considered her husband any less of a gentleman, despite his degraded appearance. Ultimately, a well-dressed maid was still a maid and a shabbily dressed gentleman was still a gentleman.

> In addition to dress, another external indicator of status was the gentlewoman's home. But "home" had a far deeper significance for these women than mere bricks and mortar or wooden slats. The physical appearance of the home was certainly very much under public scrutiny by those who considered themselves of society, particularly other women.[17] Social intercourse, argues Elizabeth Windshuttle, "centred on the private home," making the private public.[18] But it was also a private sanctuary, ideologically and psychologically a feminine place of respite and refuge. The gentlewoman, as wife and mother, was glorified as the guardian of the home, the "secular temple." She became its "priestess ... stemming the amoral and irreligious drift."[19] And with the gentlewoman firmly instituted in her ideal domestic and moral role, the home was viewed as a sanctuary, a moral haven, and a bastion against the harsh, competitive world outside.[20] Thus "home," not just in the sense of Britain but in the sense of one's personally constructed domestic space, consumed many pages of gentlewomen's diaries and letters.

The creation of a domestic "home" space was as important to gentlewomen in the bush as it was to gentlewomen in the cities of Australia, particularly in terms of providing a psychologically "comfortable" space in unfamiliar surroundings. The recreation of old home ways and the demarcation of space did not necessarily ensure an exact replication of the past "home," but, argues Gina Buijs, it allowed women to "construct a meaningful identity in the context of life in alien ... circumstances."[21] Many colonial homes, particularly in the early days of settlement, were rudimentary and much smaller than those to which British gentle-

women were accustomed. It was thus imperative for these women to counter this unfamiliar lack of space and the raw and functional physical structure with a familiar genteel ambience.

On visiting her sister's rural home in 1854, Mary Spencer wrote in her journal that it was a "peaceful abode, where harmony reigns." Moreover, it far exceeded her "most sanguine expectations," with its "pretty verandah, the posts covered with evergreens. The sitting-room is so cool and pretty, with its piano, books and flowers."[22] Spencer's description revolved around the ornamental aspects of the house: its aesthetic qualities and its genteel paraphernalia. Its functional aspects were something of which she made no note; these were not as important to her as the refined atmosphere that emanated from the house.

Even the more simplistic of abodes could be adorned to reflect the gentility of its owner. On the goldfields in the 1850s, Martha Clendinning, her sister, and their respective husbands had to make the best of their canvas accommodations. Having brought some simple furniture with them, their tents were then beautified with "articles that had formerly belonged to comfortable times in the far-off land over the sea." Clendinning was quite proud of the "comfortable domicile" they had created and noted in her reminiscences that "the diggers mostly were contented with very rough shelters. It was generally where they had respectable wives (and they were very few in numbers in those early days) that an effort was made to have their tents tolerably comfortable."[23] Here the meaning of "comfort" goes beyond purely physical boundaries. Gentlewomen attempted to ease their sense of social upheaval by creating a familiar and ornamental world to counter the physical hardships and practical nature of colonial life. In Britain the home was a refuge of femininity contrived to shelter its residents from the realities of public life. In the raw atmosphere of the Australian bush, this role of home as refuge was even more vital for the "protection" of its unworldly occupant. But ornamentation alone could not comfort the "exiled" British gentlewoman. The subtle but clear demarcation of domestic space also helped her define the apparently conflicting areas of her emigrant life and provided a key strategy for maintaining some level of gentility against the odds.

In her work on America's southern plantation mistress, Catherine Clinton has captured the essence of this fragile maintenance of gentility in an often unworkable situation. She recounts a tale of a visitor to the home of a southern planter, where the hostess was the model of a southern lady, "warm, gentle, and refined in her manner." While strolling around the plantation, the visitor inadvertently caught the mistress hard

at work, her clothing disarrayed and her hands deep in a salting barrel. The visitor had, says Clinton, "essentially caught his hostess behind the scenes, accidentally violating the rules by wandering backstage." Realizing the delicacy of the situation, the gentleman bypassed the mistress, without a glance, an action that would have caused offense under normal circumstances. Yet, if he had acknowledged his hostess he would have caused her great discomfort and embarrassment. "Exalted imagery," concludes Clinton, "and an unwillingness to cope with reality when it conflicted with the ideal created this eccentric world."[24]

A similar creation of a "backstage" can be detected in the rural areas of colonial Australia. It was not uncommon in Australia for even the simplest of slab huts to have a kitchen built away from the house. Annie Drysdale's cottage, for example, was very "comfortable & nice," having a number of rooms and a parlor and kitchen separated by a "little passage."[25] This separation had practical advantages, such as sheltering living areas from the heat and smells of a busy rural kitchen, but the physical separation of kitchen chores from the more sociable aspects of the home may have also been made deliberately to reinforce the psychological separation.

One British gentlewoman, Ellison Westgarth, wrote of visiting a cottage built of wood with a drawing room and veranda, and a kitchen built outside. This observer noted the strategies her hostess used to complete necessary physical chores with a genteel air: "Elizabeth is such an excellent housewife, she has always her children so neat & tidy, superintends most of the cooking, as her present servant altho' giving herself out as a good plain cook understands as much about it as a porridge ladle, she also looks after a great stock of poultry and chickens and is able to go about to receive her visitors as if she had nothing at all to do."[26] Appearing to have "nothing at all to do" was of supreme importance to the woman conscious of an audience, and it was also a key coping mechanism for the "leisured" gentlewoman undertaking unfamiliar menial tasks. Creating an area for the pursuit of more leisurely activities was also of importance to many British gentlewomen. The McCrae home in Arthur's Seat, Victoria, included a room of particular importance to Georgiana. Her private sanctum, though physically small, gave Georgiana the freedom to write, paint, and correspond with family and friends in Britain, thus maintaining "her sense of connection with her former world."[27]

The surroundings of the gentlewoman's home in the bush marked a mediation between the private genteel ambience of the interior and the

hostile landscape of rural Australia. These surroundings consisted of the veranda and the garden. The veranda was not only seen as an important architectural marker of British heritage—verandas were first adopted by the British in their colonial outposts, such as India—but it also had symbolic importance. For women, argues Jennifer Craik in her study of Queensland homes, the veranda marked the barrier between public and private, between home activities and the world outside.[28] This division of space allowed the etiquette-conscious British gentlewoman to maintain a veneer of gentility while fulfilling her domestic role.

Gardens were also of great significance to the British gentility. As Leonore Davidoff and Catherine Hall argue, the garden was a symbolic extension of the genteel domain in which women and men could fulfill their specific gender roles in tranquillity. Women were associated with the nurturing of delicate flowers, for which they were deemed to have a particular affinity. The relative seclusion of the British garden, with its hedges and high walls, also allowed gentlewomen to "engage in brisk physical activity."[29]

From early settlement, argues Robert Dixon in the Australian context, colonists were encouraged to follow the example of Britain in creating a landscape of taste and beauty around their homes, a symbol of the unity of civilization and wilderness.[30] Gardens were not simply for utilitarian purposes—that is, for providing vegetables—but were for display and pleasure. Settlers carried many plants and flowers from Britain to be nurtured in the new environment. Gentlewomen, in particular, found gardening to be a therapeutic and enjoyable activity, for it helped them "face life in a country which was not only strange and lonely, but often bewildering."[31] Before actually seeing her first home in rural New South Wales, British gentlewoman Elizabeth Leighton was encouraged on hearing that her cottage was not only very pretty but also had an excellent garden, something that might prove a pleasant distraction rather than a practical necessity.[32] Annie Drysdale also took great pride and pleasure in her garden, growing both vegetables and flowers.[33]

Gentlewomen in rural areas not only disguised their necessary chores by undertaking them "backstage," they also countered them by retaining the genteel pursuits that had marked a leisurely existence in Britain, a strategy exemplified by Georgiana McCrae's "sanctum," which was created specifically for pursuing "ladylike" activities. If the home and garden were used to escape a hostile environment, genteel activities were

used to escape the rigors of arduous chores. Such activities also helped distinguish the gentlewoman from the "lower" orders of working women in the more volatile social climate. In her reminiscences of growing up in Queensland, Rosa Praed noted the ways in which many gentlewomen undertook domestic and farm tasks while sustaining a "semblance of genteel standards, educating their children in manners and skills appropriate to their class."[34] The genteel D'Alton sisters were renowned in the Victorian Grampians for their accomplishments. Susan wrote poetry and songs; Henrietta painted wildflowers, some of which were submitted to colonial and international exhibitions; and all played the family piano, which had been brought from Ireland. Indeed, although the D'Alton's biographer claimed that their life in the colonies was a "strange contrast to their elegant and lively life in Ireland," at least their genteel activities somewhat counterbalanced their domestic work.[35]

Mrs. Caughey in Traralgon, Victoria, also combined necessary domestic chores with more leisurely activities. In various diary entries she gave descriptions of picnics and noted the books she had been reading, such as the novel *Frank Farleigh*. However, Caughey also spent her time doing housework, milking cows, weeding the strawberries, and, more philanthropically, helping to teach Sunday school.[36] In Britain it was expected that gentlewomen would channel their passions into philanthropic works, demonstrating their role as mothers of society.[37] Time, however, was something precious to Caughey, as to other gentlewomen, and on occasion she felt pressured to fulfill her duties. In September 1882, for example, Caughey was visited by two ladies who were seeking help in organizing a Wesleyan bazaar. Although reluctant to volunteer because of the constraints of time and all her other work, Caughey felt obliged to help her charitable "sisters."[38] Eliza Chomley had felt a similar obligation when she moved to Sale, Victoria. Perhaps away from the hectic social whirl of Melbourne's city life, Chomley found herself with more time on her hands and looked for an outlet in which to channel her energies. For many gentlewomen philanthropy provided an escape from "'the isolation, self-abnegation, and ... [became] a means of expressing their personality, fulfilling their abilities, and gaining satisfaction from their achievements."[39] Chomley became secretary to the local Ladies Benevolent Society and "took life more seriously, accepting more responsibilities and duties."[40]

Church attendance and observation of the Sabbath remained central concerns to the genteel in rural Australia. Religious practice helped reaffirm their gentility. As Leonore Davidoff and Catherine Hall have

argued in *Family Fortunes*, gentlewomen were seen as more naturally religious than men or their more lowly sisters, for they occupied the secluded domestic sphere that "gave a proper basis for a truly religious life."[41] Moreover, church attendance provided the ideal opportunity for gentlewomen, with their propensity for moral guidance, to reinforce their superiority over the lower orders. In 1853 Emily Tolhurst was rather impatient to go to the "House of God," especially to give thanks for her safe arrival in the colonies, but she had been taken to rural Glenferrie, five miles outside of Melbourne, where there was no church.[42] Other districts in rural areas also lacked a formal church building, a real problem in a land of such scattered settlements and vast distances.[43] But so important was attendance, and the concomitant display of respectability, that many makeshift churches were erected. On the goldfields of Victoria in the 1850s, Martha Clendinning attended church service held in the commissioner's tent, which had been turned into "a little canvas house of God."[44] In the 1880s Georgina Graham's genteel sensibilities were horrified by the apparent lack of piety in the rural New South Wales home in which she was employed. Her diary entry for 22 January 1882 indicates her resort to the private observance of her faith:

> There is no Sunday here. The boys are flying about on their bicycles and all is noisy and anything but Sabbath-like. . . . So long as I am working and teaching I prefer it but in quiet moments it comes to me my life is not what it should be and I am far from happy. If Mr. C. were only different and did not scoff at everything good and pure! I was praying all the time he was speaking that I might be kept from saying anything hasty. It makes my blood rise with intense scorn and anger when I hear the Bible and God's Word attacked.[45]

Another important genteel pursuit, without which this research would not have been possible, was the continued practice of diary and letter writing. These literary forms played an important role in the cultural construction of gentility and reinforce the argument that the observance of gentility was more than simply a bowing to public pressure. Letters were an extremely powerful medium through which one could determine and define genteel associations and also served as personal expressions of gentility. In her 1897 etiquette guide, *Manners for Women*, Mrs. Humphrey devoted a whole chapter to "Correspondence" and opened discussion of the topic with these words of caution:

In forming our estimate of an unknown person from whom we receive a letter, we judge her, first by the character of her note-paper, the neatness or otherwise of the lettering composing the address, and even more than all, by the composition of the note itself. It needs some practice to say in a letter exactly what has to be said, with no more discursiveness than may be necessary to avoid an appearance of abruptness.[46]

Journal writing was also a well-accepted aspect of gentlewomen's lives, a literary outlet that did not contravene codes of propriety. The skills necessary for the art form, for it was truly considered art, were passed down through generations of gentlewomen in various ways. Cynthia Huff's bibliographical work on nineteenth-century female diaries reveals that women were often selected as family historians, painstakingly copying family diaries. Gentlewomen also often shared their diaries and read them aloud as they did other literary works.[47] Indeed, in an 1854 letter, emigrant gentlewoman Rachel Henning recorded reading her sister Annie's journal aloud to the rest of the family.[48] Mary Mowle also noted in 1853 that her friend Elizabeth "generally reads me to sleep every night—sometimes extracts from old diaries & at other times, letters etc."[49]

Diaries, letters, and memoirs also reveal some of the strategies that gentlewomen adopted when faced with the migration experience and challenges to their status. The words of these women and the manner in which they are written give many clues as to how these women constructed themselves as "gentlewomen" and determined the extent to which others fell into that category. Even in private these women could not fully escape the strength of Victorian social codes. As Alain Corbin argues, the quest for self deepened with the insecurity that accompanied social mobility. "Diarists questioned their own position and speculated about the judgements of others," he continues. "Society's mute presence haunted the private and solitary life of the journal author."[50] Emigration deepened the social insecurity of gentlewomen, and social mores "haunted" every aspect of their lives.

Certainly these sources are more introspective than many, but it would be extremely naive to suggest that they provide some kind of truth or reality. Instead, they provide the historian with what Harriet Blodgett has called "subjective versions of reality" and "tell one what women take to be true about themselves, their world and its representability."[51] These literary devices were not completely "private" in the sense of being oblivious to external examination, nor were their writers free of societal

restrictions and accepted codes of behavior. The division between "private" and "public" was complex and rhetorical. Whether conscious or not, the internalization of gentility ensured that in their "private" writings, gentlewomen were still aware of external perusal. Moreover, constructions of gentility were as much under contest in these private worlds as they were in the public arena. Memoirs were obviously written with some audience in mind; the very nature of letter writing implies readership; and even the very "private" mode of diary keeping is often questioned as a purportedly personal, reader-free, and uninhibited medium.

Diary writers were as much a product of their society as letter writers, and constructed, whether consciously or not, "a fictional persona, a version of the self" that they wished to project.[52] However, this does not detract from their value as source material. On the contrary, their value is twofold. The explicit contents of diaries, letters, and memoirs obviously provide valuable historical information. Moreover, the implicit and unstated, as well as the reasons for writing, provide clues about the extent to which these women had internalized ideals of gentility. "The motivation for their writing," states Gayle Davis, a historian of American pioneering women, "is just as important a consideration as is the particular content."[53]

For British gentlewomen the emigration process itself strengthened the psychological attachment to writing, in whatever form. In *Recording Angels*, a study of women's diaries, Sarah Gristwood questioned why so many overburdened rural women would add journal writing to their already extensive list of duties. Was it, she asked, because of loneliness, boredom, or the "burning desire that their efforts should not slip into oblivion"?[54] An analysis of numerous writings of British gentlewomen suggests that their motivation for putting pen to paper lay in all three of these aspects, and indeed others. One of the most important functions of the diary, which is crucial in analyzing constructions of gentility, was its ability to preserve some sense of continuity. Historian Gayle Davis recognized that on the American frontier, diary keeping became a significant coping mechanism for women. Journals became mediators, linking the old and the new, the familiar and the strange, thus aiding adjustment.[55] In a similar argument, Paul Rosenblatt claimed that in describing their experiences on paper, women were attempting to control and delineate their lives, which had been upset by a particularly traumatic or unsettling event.[56]

Emigration certainly fell into the category of a major life change. By continuing their journal writing, gentlewomen, many of whom kept diaries from girlhood, could retain some of their British genteel existence

in the colonies, a sense of their identity as gentlewomen. The more that their identity seemed threatened by the experience of emigration and the strangeness of rural Australia, the more precious their diary writing became. Many diaries depend upon pattern and repetition, "using the basic technique of daily reportage as a strategy for controlling disturbances in individual lives."[57] The diaries of emigrant gentlewomen reveal that these women maintained that daily routine for their own self-preservation, overcoming many obstacles that might have hindered their writing.

A comment in the 1883 diary of A. Caughey reveals the extent to which diary writing was internalized, inseparable from the existence of the gentlewoman. Claiming that she never had time to do anything but work, Caughey, nevertheless, ensured that time was given to the precious task of updating her journal, particularly at a time of apparent homesickness. The entry reads: "I wonder what is the use of always working? [O]ne seems to never have time for anything here.... How I would like to see my dear sister again ... although I hardly ever mention her name, there is not a day passes but I think of her."[58] Mary Allport suffered from bad eyesight and often felt the strain of reading, but this did not prevent her from writing her journal. "My eyes are still very bad," she noted in February 1853, "so I did nothing but cook today." Again this illustrates the extent to which diary keeping had become internalized.[59] Even if it were to record that nothing had happened, or "every day much the same," as Emily Tolhurst wrote in 1852, the journal was essential to the gentlewoman's daily routine and her maintenance of some familiar level of gentility.[60]

Another reason for addressing a diary to a reader, whether known or not, was perhaps that it became another companion. Female companionship was particularly important in the cultural life of British gentlewomen, but these women had little recourse if these channels of communication were closed to them, as they often were during the emigration experience and more particularly in isolated areas of rural Australia. Diaries, often addressed to women, became the companions of gentlewomen cut off from personal contact with female family members and friends. Diaries became substitutes for personal contact, mediating between isolation and communication and replacing longed-for conversation.[61]

Jane Henty enjoyed the society of her three brothers-in-law, but she severely "felt the want of a woman's company."[62] Katherine Kirkland was delighted in the 1840s to go, temporarily, to Melbourne for the birth of

her child. Her delight lay in being able once more to associate with "ladies," for she had "not seen a lady in eight months." Her yearning was not for the company of women per se, as she did have a female servant in the bush, but rather for the company of female gentility, a role her servant could not fill.[63] Grimshaw and Willet have noted the "definite social limits of sisterhood," which kept female servants at a "proper" distance.[64] Kirkland's comment again exemplifies the significance of maintaining gentility even in the isolation of the bush.

Others showed a similar concern for maintaining only genteel relationships, even through periods of loneliness. Rachel Henning was not only discerning in her choice of female company but also with gentlemen. "On the whole," she wrote, "we are very well off in having such a gentlemanly set in the house, for some of the sons of the bush are very rough." Fortunately, for the sake of her genteel sensibilities, Rachel did not believe that her brother, who had been in the colonies since 1853, would allow anyone of "vulgar manners or habits" into his home.[65] Indeed, it was perhaps his retention of disgust for the sons of the bush that accounted for his not being in "the least roughened or colonialised by his long residence in the bush." His manners and appearance, it seems, continued to be " 'first rate,' so very simple and yet so very gentlemanly."[66] In the 1880s, Georgina Graham also desired to have as little as possible to do with her rural neighbours, who showed "little of the refinements of life." Two saving graces were a Mr. Grainger and a Mr. Brown, who as gentlemen afforded "a little intellectual conversation ... on progress, books and many things."[67]

Thus, clothing, homes, and evidence of the "proper" social skills could serve as indicators of gentility. However, in rural Australia, perhaps even more so than in the public cities, such indicators were not always present—as discussed earlier, shabby clothes often masked a genteel nature, but many would not dare go so far as to explore the conversational dexterity of a shabbily dressed person. Gentlewomen thus sought to discern true gentility by looking at subtleties of behavior and innate physical characteristics that went beyond mere external appearances, indeed often despite appearances. In *Ella Norman*, a fictional account written in 1864 of a British gentlewoman's plight in Australia, one of the major characters, the stockman Jock Davies, is immediately recognized as a gentleman by the heroine, despite his rough colonial appearance and occasionally coarse language. Indeed, Ella is convinced by his very step that he had been in the British cavalry, a deduction that proves cor-

rect and verifies his status as gentleman. But this apparent ability to see breeding beyond the surface was not exclusive to fiction. Martha Clendinning recalled that while looking for water she encountered a man in a clump of bushes, whom she recognized immediately "by his voice and manner" as a British gentleman, despite his digger's dress.[68] In the 1890s, Eliza Chomley also recalled meeting members of the impoverished gentility in a small community outside of Wangaratta, Victoria. These included the mysterious Mr. and Mrs. T., of whom she wrote:

> She also, was obviously of our own class, with an easy, natural manner, and the eagerness with which she at once seized on the *Punches* and Magazines on the drawing room table won my sympathy and a sort of pity, for she and he were both shabbily dressed and their present occupation did not seem a lucrative one.... [V]arious odd coincidences placed her as undoubtedly the daughter of a well known reputable Londoner, a professional man.[69]

Another much more publicly announced tale of gentility detected beneath a shabby veneer appeared in the *Times* in June 1863. Believing that the gentlefolk of Britain had formed very romantic notions of life in the colonies, a *Times* reporter who had recently visited the Australian bush decided to give public air to his experiences and one incident in particular. While taking a stroll in the country outside a Victorian township, the reporter had heard, to his rear, thirty head of approaching cattle. Such an event would certainly not have been unusual in that environment, but as far as the reporter was concerned, the leaders of that herd certainly were. His description of them read:

> a sort of gentleman in his shirt sleeves, and well mounted, kept them together on the one side, and a woman, also on horseback, was rounding them up on the other side. As she galloped after some errant animal, her habit gracefully flying behind her, and her seat (as she jumped logs and little creeks) safe and assured from long practice, she looked like Die Vernon turned useful; and any one would have pronounced her a lady, and an elegant lady too, had she not been driving cattle, which to my prejudiced eye rather complicated her personal appearance with a touch of Smithfield.

On returning to his accommodation the reporter had been honored with a tale of the young couple he had just witnessed at work, as told by his landlord, who considered it one of the most romantic little stories of the

neighborhood. The gentleman leading the cattle had once been in the navy and had married, against the judgment of friends, "a delicately nurtured lady," the very same who now rode horseback by his side. They had arrived in Victoria very poor. However, "Mr D— —, the husband, nearly related to a noble family in England, nevertheless, with honourable strength of will worked hard with his hands, and his delicate young wife was a devoted and self-denying partner in his hardships." They soon bought a few head of cattle, and Mr. D— — declared that he was happier than if he had "the command of the best ship in Her Majesty's navy."

The couple, we are told, had three children and apparently lived happily. In the evening Mrs. D— — "solaces herself and little circle with the piano, and gives an hour or so to the education of her little ones." All appeared a happy mixture of refinement and domestic work. The rumor, however, was that Mrs. D— — was not as contented as her husband. Curiosity got the better of the *Times* reporter, and he determined to discover the reason for her apparent discontent. His conclusion, based on the "cross-examination of various witnesses," appeared thus:

> At the bottom of all the lady's rural felicity is a something which poisons it somewhat—human pride. She is often addressed as a common milkwoman, when she knows she is not a common milkwoman, and she shrinks from the vulgar but extremely natural mistake. A woman who serves milk, were she a Princess in disguise, is still a milkwoman to the eyes of the flesh; and suppressed accomplishments can hardly secure recognition.

Perhaps to this roving reporter and his genteel readership, it seemed natural that such an existence would be a mistake for a woman delicately nurtured. "They are a misfit in the social scheme," declared the observer, and cannot possibly be happy. For who would publicly announce that they are contented with a life that denies them association "with those with whom they are fit to associate" and throws them in company with "the ignorant and vulgar"? Convinced of the propriety of this observation, the reporter thus concluded, rather sarcastically, that

> the troubled pride therefore of Mrs D— — is, after all, only the involuntarily expressed consciousness of the unappreciated lady. She is playing a part in the midst of serious life, and is perhaps unreasonably indignant that the life does not applaud the little drama and admire the milkwoman and the lady so gracefully rolled into one.[70]

In the comfort of their own gentility, many *Times* readers might well have found the bush lifestyle distasteful and quite contrary to all that was proper and refined. The apparent contradiction between "milkwoman" and "lady" also reinforced the rampant hostility toward opening more employment opportunities to educated women, whether in Britain or the colonies.[71] However, the reaction of the gentlewoman herself, Mrs. D— —,presented quite another perspective.

In a letter dated 15 August 15 1863, Henrie Dugdale responded sharply to the *Times* report. The eagerness with which she awaited that most respectable of British newspapers, and the rapidity with which she responded to attacks on her lifestyle, can easily be determined by the date of her letter, which marked only eight weeks from the first report. During the 1850s the new circle route and the faster clipper ships had reduced the voyage from Britain to under seventy days.[72] Consequently, the *Times* report can only just have arrived at Dugdale's door when she took pen to paper.

Recognizing the description of her own life and "little nest in the bush," Dugdale sought to rectify an error that she felt might "subject me to unmerited annoyance, and, what is worse, cause dear ones in England to blush for the littleness of mind your correspondent so mercilessly ascribes to me." Dugdale showed her distaste for the words of the reporter and her anger that he did not even pay her the honor of a "visit of inspection" before making her history so public. If he had but inter-viewed her, she claims, he would know, contrary to his report, that she had no " 'troubled pride,' only gratitude that I am able to be a milk-woman, and that my husband's society is amply sufficient for my happi-ness." Her concluding statement is poignant and disclaims all that the *Times* reporter had suggested about her character. She wrote "that I have pride I confess, but only the pride of being loved by my good and truly noble husband; and so long as I can assist to earn our bread by his side no one will ever find me ashamed of any occupation that is not dishon-ourable."[73]

Dugdale defied the suggestion that gentility and manual work were incompatible. For her, work was empowering. In later years she became a prominent feminist and wrote in 1883 that the greatest obstacle to human advancement and sexual equality was "the fiercest and most powerful of our world's monsters—the only devil—MALE IGNORANCE."[74] Perhaps she had the *Times* reporter of twenty years earlier in mind when she made that statement. Yet, having attacked the prejudices against work, Dugdale still observed some of the codes of gentility. She was, after

all, aware of the ever scrutinizing eyes of "dear ones in England" and sensitive to the distaste they might have felt in reading of their relative in such an apparent state of decline. Whether this was the reason for publicly declaring herself happy, we may never know, but it is certainly interesting to consider how different her private thoughts might have been.

Six years after this public airing of the sensitivities that defined gentility, another British gentlewomen, Elizabeth Townbridge, described her own emigration experiences. Seemingly oblivious to the contradictions that she betrayed, Townbridge wrote: "I am at work for them [her husband and sons], most unsentimentally too, not working slippers, or embroidering braces, as delicate ladies are apt to do in the old country, but—I only write it in a whisper—making their cloth caps and trousers."[75] At face value, Townbridge's statement that "I only write it in a whisper" implies a sense of shame that she is not fulfilling the role of a delicate lady. Yet this apparently private comment was published, with her acknowledgment, in *Sharpe's London Magazine* of 1869. The whisper thus became something of a stage whisper, a device that signified recognition of the distinction between gentility and colonial necessity but that challenged the ideal division between "public" and "private." Thus while Townbridge appeared privately ashamed of her work, she displayed those same achievements for public perusal and acknowledgment. Dugdale, however, declared herself privately unashamed, yet she resented public exposure of her change of life.

Dugdale and Townbridge highlight the troubled issue of balancing gentility and necessary work in rural Australia, and the strategies used to cope with the apparent conflict therein. We have seen attempts to "backstage" work and to counter it with genteel activities, but these two women illustrate a different strategy—the adaptation of genteel ideals. An attachment to the ideals of gentility remained in their heads, just as an attachment to Britain lingered in their hearts, but as absence loosened the ties of affection to their native home, necessity loosened the constraints that gentility preached.

But the isolation of rural Australia and the concomitant lack of "spectators" to observe the "performance" did not result in the total abandonment of gentility. British gentlewomen could not, even willingly, relinquish all the ideals of gentility that had informed their lives from such an early age, but these women individually adapted those ideals in the new colonial environment. Mary Fullerton remembered her mother hoarding scraps of all the pretty dresses from her "betterdays." They were,

recalled Fullerton, "Silky, Satiny, and lovely patterned pieces," and each had its own history that her mother loved to share.[76] What Mary's mother did with these pieces is unknown, but perhaps she stitched them together into a patchwork, creating a functional colonial cloth out of symbolic pieces of her genteel past. Therefore, these "scraps" were not useless but simply needed to be reconstructed in a more resourceful way. In a similar manner, British gentlewomen did not discard the "scraps" of their genteel existence but selected the appropriate "pieces" to reshape their lives in a new colonial environment.

Notes

1. For example, W. S. Shepperson, in his *British Emigration to North America* (Oxford: Blackwell, 1957), devoted only five pages of an extensive work to women, in a chapter rather disparagingly entitled "The Emigration of Vagabonds and Children" (122–26). Eight years later in W. A. Carrothers' *Emigration from the British Isles* (London: Cass, 1965), female emigrants appear in the index whereas males do not, the assumption being that men are the default by which others are categorized. The experience of women is separated from the norm in a twelve-page chapter entitled "Special Emigration Problems: Women, Children and Juveniles" (274–86).
2. In the last twenty years a number of works have been published, in several countries, that look beyond the working-class migration experience. For example, in Canada, Patrick Dunae's 1981 *Gentleman Emigrants* and Susan Jackel's 1982 *A Flannel Shirt and Liberty* looked, respectively, at the experiences of ex-public-school British gentlemen and single and married British gentlewomen on the Canadian frontier. The plight of the single British gentlewoman who traveled under the guidance of specifically constructed emigration societies has also been recorded by historians of the 1970s, 1980s, and 1990s. A. James Hammerton, in his 1979 work *Emigrant Gentlewomen*, added scholarly analysis to earlier, more general works on specific female emigration societies, successfully challenging the destructive and monolithic image of the passive, helpless, and "redundant" British gentlewoman. In 1982, Patricia Clarke enhanced this work with *The Governesses: Letters from the Colonies, 1862–1882*, a more specific look at governesses in Australia, New Zealand, and South Africa, as revealed in the letters of the Female Middle Class Emigration Society.
3. In her 1983 master's thesis, for example, Margaret Sales wrote of English middle-class female migrants: "Their consciousness of class hindered their acceptance in colonial society, creating conflict between English concepts and the emerging democratic ideals of the Australian colonies" (" 'Redundant Women' in the Promised Land: English Middle Class Women's Migration to Australia, 1861–1881," thesis, U of Wollongong, 1983, 2).
4. John Hirst, "Egalitarianism," *Australian Cultural History* 5 (1986): 12–31.
5. Paul de Serville, *Pounds and Pedigrees: The Upper Class in Victoria, 1850–1880* (Melbourne: Oxford UP, 1991) ix.

6. The recognition of the public/private divide has been well-established, particularly by Leonore Davidoff and Catherine Hall, who argue that "public was not really public and private not really private despite the potent imagery of 'separate spheres.' ... [They were] products of a particular historical time" (*Family Fortunes: Men and Women of the English Middle Class, 1780–1850* [London: Century, 1988] 33). More recently, P. Grimshaw, M. Lake, A. McGrath, and M. Quartly developed this argument in *Creating a Nation, 1788–1990* (Melbourne: McPhee, 1994), which speaks of the "fiction of separate spheres" (118).

7. de Serville 31.

8. Sharon Morgan, *Land Settlement in Early Tasmania: Creating an Antipodean England* (Cambridge: Cambridge UP, 1992) 2.

9. Margaret Maynard, " 'A Great Deal Too Good for the Bush': Women and the Experience of Dress in Queensland," *On the Edge: Women's Experiences of Queensland,* ed. G. Reekie (St. Lucia: U of Queensland P, 1994) 52. See also Maynard, "Australian Dress: Perceptions and Stereotypes," *Journal of Australian Studies* 41 (June 1994): 1–11.

10. L. Davidoff, *Best Circles: Society, Etiquette and the Season* (London: Croom, 1973) 93.

11. D. Gorham, *The Victorian Girl and the Feminine Ideal* (London: Croom, 1982) 70.

12. Lucy Frost, *A Face in the Glass: The Journal and Life of Annie Baxter Dawbin* (Melbourne: Heinemann, 1992) 65.

13. Frost 70.

14. Frost 134.

15. Martha Clendinning, "Recollections of Ballarat: Lady's Life at the Diggings Fifty Years Ago," bay 18, ms. 9762, p. 11.

16. Clendinning 16.

17. As John Field argues in his discussion of Portsmouth's middle class, while the home was ostensibly private it was concurrently part of the public world: "[G]uests carefully selected, were permitted entry at specific times.... [M]uch might count on the home, and on the impression significant others gained from it" ("Wealth, Styles of Life and Social Tone amongst Portsmouth's Middle Class, 1800–1875," *Class, Power and Social Structure in British Nineteenth-Century Towns,* ed. R. J. Morris [Leicester, Eng.: Leicester UP, 1986] 95).

18. Elizabeth Windshuttle, "The New Science of Etiquette," *Push from the Bush* 7 (Sep. 1980): 71.

19. W. Houghton, *The Victorian Frame of Mind* (London: Oxford UP, 1957) 348.

20. See J. Calder, *The Victorian Home* (London: Batsford, 1977).

21. Gina Buijs, ed., *Migrant Women: Crossing Boundaries and Changing Identities* (Oxford: Berg, 1993) 18.

22. Mary Spencer, "Aunt Spencer's Diary," written to her nephew Sebastian Waterhouse, La Trobe U Lib., Melbourne, Austral.: ms. 23801, p. 8.

23. Clendinning 15–16.

24. Catherine Clinton, *The Plantation Mistress: Woman's World in the Old South* (New York: Pantheon, 1982) 16.

25. Anne Drysdale, "Miss Anne Drysdale's Diary, 1841," *Clyde Company Papers,* ed. P. L. Brown, vol. 3: 1841–45 (London: Oxford UP, 1958) 79.

26. Ellison Westgarth, letter to her mother, 23 Oct. 1854, letters to her mother, 1854–1855, La Trobe Lib.: ms. 9152.

27. Brenda Niall, *Georgiana: A Biography of Georgiana McCrae, Painter, Diarist, Pioneer* (Melbourne: Melbourne UP, 1994) 179.

28. Jennifer Craik, "Verandahs and Frangipani: Women in the Queensland House," *On the Edge: Women's Experiences of Queensland*, ed. G. Reekie (St. Lucia: U of Queensland P, 1994) 155–56.

29. For a discussion of the practical and symbolic importance of the garden to the British gentility, see Davidoff and Hall 370–75.

30. Robert Dixon, *The Course of Empire: Neo-Classical Culture in New South Wales, 1788–1860* (Melbourne: Oxford UP, 1986) 154–57.

31. B. Bligh, *Cherish the Earth: The Story of Gardening in Australia* (Sydney: Ell, 1980) 9.

32. Elizabeth Leighton, letter to Dorothy White, 3 Nov. 1838. Leighton wrote eight letters to White, her friend in England, during the 1830s and 1840s. The Royal Historical Society of Victoria (RHSV) collection includes a letter of March 1923 by E. Denchar, Leighton's granddaughter from London, confirming the authenticity of the letters.

33. Drysdale 78.

34. Qtd. in Grimshaw et al. 121.

35. Gillison, "Henrietta D'Alton and her Family," paper delivered at the Royal Historical Society of Victoria, June 1983, RHSV: box 207/15, ms. 00725, p. 15.

36. A. Caughey, diary entries, 22 Sept. 1882, 18 Nov. 1882, written in Traralgon, Victoria, 12 Aug. 1882–June 1884, La Trobe Lib.: ms. 8735.

37. For details of "social maternalism," see J. Lewis, *Women in England* (Bloomington: Indiana UP, 1984) 92–97.

38. Caughey, 18 Sept. 1882.

39. J. Gerard, "Lady Bountiful: Women of the Landed Classes and Rural Philanthropy," *Victorian Studies* 30.2 (Winter 1987) 206.

40. Eliza Chomley, memoirs, 1920, La Trobe Lib.: box 912/5, ms. 9034, p. 40.

41. Davidoff and Hall 90.

42. Emily Sarah Tolhurst, diary entry, 14 Nov. 1852, from diary written during and after voyage to Australia from Gravesend on board the *Admiral*, 31 July 1852–7 Sep. 1853, RHSV Lib.: box 15/18, ms. 000031.

43. J. Barrett, *That Better Country: The Religious Aspect of Life in Eastern Australia, 1835–1850* (Melbourne: Melbourne UP, 1966) 3.

44. Clendinning 12.

45. Georgina Caroline Graham, diary entry, 22 Jan. 1882, in "Diary, 1882–1897," private possession of Marie Johnstone.

46. Mrs. Humphrey ("Madge of Truth"), *Manners for Women* (London: Bowden, 1897) 124.

47. Cynthia Huff, *British Women's Diaries: A Descriptive Bibliography of Selected Nineteenth-Century Women's Manuscript Diaries* (New York: AMS, 1985) xviii.

48. Rachel Henning, letter to her sister, Annie, 27 Feb. 1854, in *The Letters of Rachel Henning*, ed. David Adams (Middlesex: Penguin, 1969) 9.

49. P. Clarke, *A Colonial Woman: The Life and Times of Mary Braidwood Mowle, 1827–1857* (Sydney: Allen, 1991), 178.

50. Alain Corbin, "The Secret of the Individual," *A History of Private Life: From the Fires of Revolution to the Great War*, ed. M. Perrot (Cambridge: Harvard UP, 1990) 457–548.

51. Harriet Blodgett, *Centuries of Female Days: Englishwomen's Private Diaries* (New Brunswick: Rutgers UP, 1988) 18.

52. Judy Simons, *Diaries and Journals of Literary Women from Fanny Burney to Virginia Woolf* (London: Macmillan, 1990) 12.

53. Gayle R. Davis, "Women's Frontier Diaries: Writing for Good Reason," *Women's Studies International* 14.1 (1987): 11.

54. Sarah Gristwood, *Recording Angels: The Secret World of Women's Diaries* (London: Harrap, 1988) 180.

55. Davis 5.

56. Paul Rosenblatt, *Bitter, Bitter Tears: Nineteenth Century Diaries and Twentieth Century Grief Theories* (1983). Qtd. in Judy Nolte Lensink, "Expanding on the Boundaries of Criticism: The Diary as Female Autobiography," *Women's Studies International* 14.1 (1987): 42.

57. Simons 13.

58. Caughey, 22 Jan. 1883.

59. Mary Morton Allport, journal entry, 24 Feb. 1853, written for her son, Morton, typescript of Lucille Andel, Balwyn.

60. Tolhurst, 14 Nov. 1852.

61. Davis 8–9.

62. Jane Henty, "Old Memories," privately circulated pamphlet (Whitcomb, c. 1901), La Trobe Lib.: box 117/6, ms. 000312, p. 3.

63. Katherine Kirkland, "Life in the Bush by a Lady [1839–1841]," *Chambers' Miscellany of Useful and Entertaining Tracts* 1.8 (Edinburgh, 1845), rpt. in H. Anderson, *The Flowers of the Field, Together with Mrs Kirkland's Life in the Bush* (Melbourne: Hill of Content, 1969) 189.

64. Patricia Grimshaw and Graham Willet, "Family Structure in Colonial Australia," *Australia, 1888: A Bicentennial History Bulletin for the Study of Australian History Centred on the Year 1888*, no. 4 (May 1980): 12.

65. Henning, letter to Etta, 18 Oct. 1862, in Adams 111.

66. Henning, 15 May 1861, in Adams 63.

67. Graham, 13 Feb. 1882.

68. Clendinning 9.

69. Chomley 60.

70. *Times* [London] 15 June 1863.

71. Mary Poovey argues that "almost every advocate of expanding women's employment shared two crucial assumptions with her (or his) opponents: that women would work only out of necessity and that every occupation was appropriate to a specific class" (*Uneven Developments: The Ideological Work of Gender in Mid-Victorian England* [Chicago: U of Chicago P, 1988] 158.

72. R. Broome, *The Victorians: Arriving* (Fairfax, Austral.: Syme, 1984) 70.

73. Henrie A. Dugdale [Hermitage Dairy, Queenscliffe, Victoria], letter to editor, 15 Aug., in response to Broome [see note 73], *Times* [London] 16 Oct. 1863.

74. H. Radi, ed., *Two Hundred Australian Woman* (Broadway: Women's Redress, 1988) 25.

75. Elizabeth Townbridge, "A Year of Bush Life in Australia," *Sharpe's London Magazine* 1869: 264.
76. Mary Fullerton, unpublished autobiography, La Trobe U Lib., Melbourne, Austral., Moir Collection, box 77/4, p. 97.

The Return of the Native:
Hardy's Arabella, Agency, and Abjection

Michele Ren

> Your marrying that woman Arabella was about as bad a thing as a man
> could possibly do for himself by trying hard. But she's gone to the other
> side of the world, and med never trouble you again.
>
> Thomas Hardy, *Jude the Obscure*

The expanded colonial empire offered many British women the opportunity of empowerment through travel.[1] As the presence of British women was desired in the colonies, the strengthening of the empire and the empowerment of middle-class British women were often achieved in the same manner. This was not always the case, however. In Thomas Hardy's *Jude the Obscure*, Arabella Donn's emigration suggests quite a different form of female empowerment through travel. In this essay I discuss Arabella's emigration in terms of Victorian "abjection" and the colonies as a dumping ground for British misfits. Specifically, I look at Arabella Donn's removal from England as a result of the conflict between her working-class status and the middle-class gender ideology. Because she is outside the middle class yet still subject to its authority, Arabella occupies a border space. I will discuss the physical and social mobility that Arabella has within this space and the ways in which she uses it to consistently return from the margins of the Victorian abject.

Emigration as Abjection

As Great Britain's colonial possessions multiplied during the Victorian era and more and more British subjects traveled to and from the colonies, the imperial project of civilizing "others" took shape at home as well as abroad. British citizens who remained at home were subject to public scrutiny, and those who did not fit the moral standards of the proper British citizen were politely encouraged to leave for the colonies. The

colonies became not only a place where indigenous savages were "saved" but also a site of deliverance for British subjects who had strayed from the various (and cumbersome) middle-class value systems of the period. In *Industry and Empire*, E. J. Hobsbawm labels the colonies a "dustbin" for England.[2] The colonies provided England with a mythical dumping ground for its social misfits. The British were not merely expanding their economic base; with the help of exported Englishmen, they were expanding their social territory by converting heathen savages. This new territory provided a social space where native Brits could also be saved. If the moral wrongs of these human exports could not be righted, the colonies doubled as a dustbin, a place to deposit human refuse. The existence of this colonial dumping ground and its redemptive powers through "abjection" brought the white man's burden back home to England, as it keeps surfacing in the literature of the Victorian period.

By "abjection," I refer (broadly) to the construction and subsequent rejection of the negative. In *Imperial Leather*, Anne McClintock discusses the colonies as a site of British "abjection." McClintock uses Julia Kristeva's work on the processes of abjection within the subject to understand the processes that are employed to construct a nation.[3] McClintock posits that "abjection traces the silhouette of society on the unsteady edges of the self; it simultaneously imperils social order with the force of delirium and disintegration." She adds that the abject must be expelled to restore order, yet "the expelled abject haunts the subject as its inner constitutive boundary; that which is repudiated forms the self's internal limit. The abject is 'something rejected from which one does not part.' "[4] Assisted emigration was a part of the process by which Victorian society expelled its undesirables in an attempt to form a more perfect nation. Yet, as McClintock asserts, the abject never completely disappears from the national consciousness because its expulsion is what constitutes the society.

Victorian England, a historical site whose prudery has not gone unnoticed, was quite an active spot for abjection within the individual subject as well as within the nation. I have chosen Thomas Hardy's *Jude the Obscure* as a representative text of personal and national abjection. I see Arabella Donn as a woman upon whose character these Victorian discourses of abjection intersect. Arabella's refusal to abide by the standards set for middle-class ladies makes her the villain of Hardy's novel. Her emigration to Australia is but one example of a system of expulsion operating in the novel, as abjection through emigration was but one of the Victorian solutions to alleviating the nation's (im)morality problems.

Arabella represents the undesirable abject because her expulsion is never complete. Whether Arabella is rendered invisible, divorced, or shipped to Australia, she consistently returns like the clichéd bad penny to haunt the lives of Jude Fawley and Sue Bridehead. Within the space of Hardy's novel as well as the space of Victorian England, she represents that which must be expelled, but she is also "something rejected from which one does not part." To expel the undesirable, the abject must first be located and defined as dangerous to the constitution of the subject. Within the textual boundaries of *Jude the Obscure*, the process of expelling the undesirable—represented by Arabella—constitutes Victorian England, femininity, and the other characters in Hardy's novel. In McClintock's extended imperial metaphor, the abject is first constructed as a danger to the nation, much the way the working classes and single women were configured as national problems in the Victorian era.

The existence of the colonies made assisted emigration an attractive option in ridding England of its undesirable elements. One such element was the working class. In an 1859 article written for the *English Woman's Journal* entitled "Emigration as a Preventive Agency," Isa Craig proposes the use of emigration to prevent crime by exporting members of the working classes.[5] Craig feels that expelling certain working-class men, women, and children would result in "wiser laws, better education, better morals, sounder health, and a safer social standing [which] are this day sought by the voice of the nation for all its members."[6] Craig's proposal is "one mode of elevating the working-classes ... by strengthening their attachment to the country ... [thereby] strengthening those who remain."[7] By removing the negative element of the working classes to the colonies as imperial exports, the remaining body—those productive individuals fortunate enough to be characterized as the *noble* poor—would continue to function properly (and nobly) while elevating the nation and the empire. The colonies, for Craig, promised deliverance for Great Britain as well as its less productive (less desirable) citizens.

Contrary to Isa Craig's suggestions, the ignoble poor were not the only group of people considered to be cluttering up the empire and generally lowering its moral standards; there were also the hordes of single women formerly of the middle class, now seen as burdensome old maids, who needed to be properly housed. William Rathbone Greg was particularly concerned about the plight of these women. In an article published in 1862, Greg ponders the question, "Why Are Women Redundant?" He is concerned with the "increasing number of single women in the nation, a number quite disproportionate and quite abnormal."[8] Greg seems extra-

ordinarily preoccupied with the idea that many women may actually remain unmarried by choice, a choice that he feels is "one of the surest and most menacing symptoms of something gravely and radically wrong." The only solution to the abomination that single women represent to himself and to the nation is either "to transport the half million from where they are redundant to where they are wanted" or to employ them in domestic service. According to Greg, unmarried women employed as a maid or a governess "are in no sense redundant.... [T]hey fulfil both essentials of a woman's being; *they are supported by, and they minister to, men.*" The urgent tone of Isa Craig's plea for the deliverance of the nation is the same tone taken by Greg, who fears for the moral future of the nation's women.

The strength of the nation relied on the strength of its moral standards. As Victorian women were to exemplify these standards, Greg felt they must be married. The bond that united women to the nation was men. This fear of losing control of the nation's women by not marrying them off and/or placing them safely within the home of a man coexisted with the fear of losing control of the nation's colonial possessions. According to an article entitled "A New View of Imperial Federation," published in *Blackwood's Edinburgh Magazine* in 1890, there was a fear that "leaving [women] so much to themselves ... they might be allowed to forget the bond which united them to the mother country, until the tie between the two became so slender and shadowy that it would ultimately vanish out of sight altogether."[9] As more and more men left for the colonies (leaving British demographics lopsided with "superfluous women"), the question of what to do with these redundant women became an issue of vital national importance. Greg also feared that an important national bond—that of women to men—would become "so slender and shadowy that it would ultimately vanish out of sight altogether." Greg's idea of shipping middle-class British women to the colonies to marry was a way of cementing the bond between women and men as well as that between England and its colonies.

Victorian women were equally concerned about what was to become of their unmarried contemporaries. In 1843, *Blackwood's* published an article entitled "Woman's Rights and Duties" (written "By a Woman") that suggested women could acquire virtue only through marriage.[10] The unnamed woman informs us that only "from the dignified affections of the other sex [have women] gradually acquired some social rights, and some share of that freedom, without which virtue itself can scarcely exist."[11] The dangers of being unmarried are made apparent. A woman

without a husband has limited access to virtue and few social rights. To restore moral superiority to women and to the nation that binds them, it is necessary that they "minister to men." Given that there were not enough men to be ministered to in England, the solution was to ship the single women out to the colonies to find a husband, have a family, and secure the virtue that was supposed to come naturally to them.

At the heart of virtue for a Victorian woman is a husband and family; without these she has fallen without ever having stumbled. As women were supposed to be the more virtuous of the sexes in the first place, it was imperative that their ties to men not be loosened, as the entire nation would then crumble and decay. This fear of losing control when familial ties are broken is also exemplified by Great Britain's fear about the loss of her colonies. Allardyce wrote that "the most anxious problem of our time is how we are to knit [the colonies] to ourselves by ties that will prove indissoluble in the face of political change and chance."[12] Allardyce uses a decidedly feminine occupation as his metaphor for domesticating the empire: to "knit" the colonies to Great Britain, "the duty incumbent on us [is] to select the best man for the post."[13] The best man for the colonial post, according to Allardyce, has "an elevating influence [that] is spread abroad which exercises a beneficial counter-action to the 'rough-and-readiness' and *abandon* which the colonial mode of living is only too ready to promote."[14] John Ruskin also saw a need for an elevating influence abroad, but he saw it as women's work.

Although virtue was supposed to be natural to women, it still required some fine-tuning. In 1865, John Ruskin admonished women for not cultivating their natural attributes. In "Of Queens' Gardens" he informs women that it is their responsibility to use their natural virtue to civilize the world: "[W]hat the woman is to be within her gates, as the centre of order, the balm of distress, and the mirror of beauty, that she is also to be without her gates, where order is more difficult, distress more imminent, loveliness more rare."[15] The unnamed *Blackwood's* writer worries that single women will have no garden to cultivate, no space for their virtue to blossom. Greg's idea of exporting these women to the colonies and back into the domestic sphere appears to be the solution to the nation's redundant women problem, despite the foreign locale.

Constituting single women as a problem to be solved is a phenomenon discussed by Deirdre David in *Rule Britannia* as "the male writer's panic (expressed on behalf of late-Victorian imperialism) that British society was losing control of woman's laboring and reproductive body."[16] David sees this "panic" as a part of the imperial project because it coex-

isted with the fear of losing colonial control. Single women were constructed as a problem in England in order to be exported to "where they [were] wanted," thereby saving British women, the nation, and its colonies. David goes on to analyze women's roles in the colonies and finds women either contributing to the construction of the empire without realizing it or becoming passive victims of colonization. She says that "British women ... got 'grilled alive in Calcutta' without knowing what got them there in the first place, or, they were figures of Britannic rule without knowing the cost to themselves and to others of their gendered power."[17] David reads Victorian emigration in terms of how it may have affected individual women instead of the nation, a perspective that Ruskin, Greg, and Craig were not interested in offering in the Victorian era. Yet, in the cited passage, David represents women as either ignorant of their own imperial power — meager as it may have been — or as victims of the project.

Whether active or passive victims of imperialism, British women are inextricably "knit" to the building of the empire. However, the women that Greg encouraged to leave for the colonies, those women whom Ruskin asked to balm the empire's distress, were a specific type of women. Greg's women (and perhaps David's) were ladies who should have been married but, because of a lack of single middle-class men in England, were not. The women who were to go over on Isa Craig's theoretical ship were of quite a different brand. Greg's women were undesirable because they had no husbands. Isa Craig's intended exports were undesirable because they were poor. Single middle-class women could find a husband in the colonies and acquire their natural virtue; their moral wrongs could be righted. Working-class women could not be delivered in the same manner. They were sent to inhabit the dustbin.

Arabella Donn, who is not necessarily redundant but is certainly a member of the working class, is repeatedly rejected or expelled from Hardy's novel. Unlike the traveling British women whom David discusses, Arabella Donn cannot be said to have "contributed" anything to the construction of the empire, nor does she represent an innocent victim. Arabella's initial emigration may have led to the temporary cleansing of Wessex and the life of Jude Fawley, but Arabella's return suggests that she had no "gendered power" to contribute to the building of an empire. Her absence is the only thing she can contribute to the imperial cause. Whether in England or abroad, Arabella is caught between the colonizer and the colonized. Arabella's agency is not of an imperial variety. She is in no position to spread an "elevating influence" abroad, nor

is virtue accessible to her no matter how many husbands she manages to capture. Unlike the women Greg characterizes—women he reduces to a type of domesticated animal to be rounded up, branded, and shipped to market—Arabella decides to leave England (and to return) of her own accord. Although it is feasible that rhetoric such as Isa Craig's may have put the idea into Arabella's head that "a woman of her sort would have more chance over there than in this stupid country," Arabella, unlike Greg's women, ministers to no one but herself.[18] If the decision regarding Arabella's emigration had been left to others, "a woman of her sort" would have been given a one-way ticket on Isa Craig's refuse boat, straight to Hobsbawm's dustbin. Greg's ship filled with Ruskin's balms of distress would have left Ms. Donn and her false tresses standing on the docks.

Pork Products, Public Houses, Pedestrian Prayers

From the moment that she flings the remnants of a dismembered pig's masculinity at Jude Fawley, interrupting his "hoity toity" intellectual ramblings, Arabella Donne represents an impediment to his scholarly aspirations.[19] Arabella's sexuality and her material reality (i.e., slaughtering pigs and serving beer for a living) represent the undesirable elements that Jude hopes to leave behind in order to become an ordained minister and a true scholar. It is clear from the moment they begin to see each other that Arabella is beneath him. Even a local barmaid can see, just by observing the two together, that Jude "descended so low as to keep company with Arabella," which makes it quite clear that Arabella is intrinsically objectionable, even to her peers.[20] After Jude's initial lust is satisfied, he plans to leave Arabella behind and forget about sex altogether, telling her "it is never too late to mend."[21] In Jude's mind Arabella equals sex, and the only way to rid himself of his sexual desires is to rid himself of her.

Of course, Arabella has no intentions of letting Jude go and fakes a pregnancy to get him to stay. Arabella's relative freedom from middle-class morality allows her to make her own decision (with a little help from her friends) to seduce Jude. This freedom is relative because she is subject to middle-class morality—its influence is what makes the barmaid see her as lower than Jude—yet paradoxically removed from it because of this construction. Arabella cannot be the proper middle-class wife no matter how she chooses to adorn herself. Arabella's false hair, discovered by Jude on their wedding night, is indicative of her attempts at

emulating a middle-class lady. She tells Jude that "every lady of position wears false hair," but Jude sees the hair as indicative of Arabella's "instinct towards artificiality."[22] Jude makes several wedding night discoveries about Arabella's life: she left her father's home to work and take care of herself, her hair and her dimples are not natural, and she knows a good beer from a bad one because of her public-house experience. These revelations only strengthen his ideas about her relative value as a woman. In her own mind, Arabella is worldly, whereas in Jude's opinion (and that of the rest of her society), she's a worthless "specimen of womankind."[23] These early glimpses into Arabella's character and the opinions it inspires reveal the paradoxical life that she will lead throughout the novel. Arabella is unafraid to act on her desires, but she is repeatedly rejected or ridiculed for these actions. Perhaps more important is that she finds herself in both the role of barmaid and housewife but does not find either role agreeable.

Arabella Donn's "expulsion" from England is centered on the conflict between her social status and the predominant middle-class gender ideology of her time. "Expulsion" perhaps does not accurately describe Arabella's particular circumstances, for the decision to leave England is her own. What makes Arabella's emigration seem more like expulsion is her apparent inability to fit easily into any of the categories assigned to British women. As a barmaid, Arabella is somewhat free from the demands of domestic ideology, but as a housewife she is not free from the implications of having been a barmaid, nor is she free from being the pig breeder's daughter. Indeed, when they marry, Jude decides to "utilize her past experiences by letting her keep a pig." The pig and its slaughter and preparation are part of a commonplace reality for Arabella, whereas they are an affront to Jude's sensibilities. As Jude thanks God that the pig has finally died, Arabella says of its slaughter: " 'What's God got to do with such a messy job as a pig-killing, I should like to know! ... Poor folks must live.' "[24]

The "messy" jobs that Arabella has had to perform to live only set her apart as a woman and mark her as undesirable both as a wife and as a "lady of position." McClintock sees the cult of domesticity as a powerful force in shaping Victorian ideology and marking women such as Arabella. According to McClintock, "[T]he cult of domesticity was a crucial, if concealed, dimension of male as well as female identities—shifting and unstable as these were—and an indispensable element both of the industrial market and the imperial enterprise."[25] To successfully transport the cult of domesticity abroad to save the heathen native, it was

imperative that it remain strong at home. This (re)inscription of domestic ideology at home and abroad brought about an intellectual and cultural (re)examination of middle-class gender roles, which resulted in the policing of undesirables such as Arabella Donn. Arabella is both driven and defined by these "shifting and unstable" female identities, even as she tries to shift with them by wearing false hair, by contorting her face to produce dimples, by marrying Jude, or by traveling to the other side of the world.

Arabella's base nature is what makes her undesirable as a wife to Jude and objectionable to the general public. However, her "nature" is what attracted Jude in the first place. Mr. Fawley was not the only man attracted to the highly sexualized Ms. Donn. In his article "In Defense of Arabella: A Note on Jude the Obscure," Frederick McDowell calls Arabella "a natural force so strong that she produces strong effects upon others," while he speaks highly of her "animal nature."[26] Arabella's "animal nature" is imposed on her because of her working-class background. This imposition was necessary for the imperial project of exporting domesticity and, in the process, constructing the native. Exporting domesticity required the redundant women that Greg describes to travel abroad and cultivate Ruskin's imperial "gardens." The imperial construction of racism required the imposition of an animal nature upon those to be colonized. The two processes intersected in Great Britain, where the working classes were similarly defined as animal.

McClintock cites Friedrich Engels's use of race in his descriptions of the Victorian working classes in *The Condition of the Working Class in England*: "The working class is a 'race wholly apart,' so that it and the bourgeoisie are now 'two radically dissimilar nations, as unlike as difference of race could make them.' " Engels continues his analysis, describing the slums as an " 'unplanned wilderness' " and its inhabitants as " 'a physically degenerate race, robbed of all humanity, degraded, reduced morally and intellectually to bestiality.' "[27] As ugly as Engels's urban portrait appears, he at least attributes some intelligence to these workers. Engels posits a scale of intelligence for laborers with agricultural workers (i.e., pig breeders) positioned at the bottom of his scale: "[T]he degree of intelligence of the various workers is in direct proportion to their relation to manufacture; and that factory-hands are the most enlightened ... the miners somewhat less so, the agricultural labourers scarcely at all."[28] This hierarchy can perhaps account for Arabella's idea that because she has worked in town as a barmaid, she can describe herself as "a little more finished than I could have been by staying where I was born."[29]

What Arabella does not recognize about her "finishing" is that leaving home to learn about the world is a man's prerogative. For a woman, leaving home is socially lethal. Problems with women of all classes plagued Victorians such as Greg and Ruskin, as Deirdre David asserts: "[I]n the late-nineteenth-century questioning of British engagement abroad, worries about empire and race are inseparable from patriarchal worries about female cultural assertion."[30] To keep domestic ideology intact—for ladies to remain ladies—women who left the home and their natural roles were seen as fallen. Greg attempts to circumvent this notion by asserting that redundant women who leave England for the colonies to "minister to men" may still keep their femininity—and the empire—intact. Because she has worked as a barmaid and a pig breeder and because she repeatedly leaves the homes of her father and husbands, Arabella is seen as being "biologically driven to lechery and excess."[31] The popular notion that working women were, by nature, unvirtuous meant that they were not subject to the same rhetoric concerning femininity that many middle-class women struggled against. It also meant that they had limited access to virtue.

While working as a barmaid, Arabella would have had very little time to contemplate her role as a woman in society. And because she was a barmaid, society probably did not contemplate her, either. In a *Victoria Magazine* article entitled "A Barmaid's Work" (1876), a young woman describes her experience: "I live in a city house with six others, and we all work very hard, our hours being seventeen in a day.... We are supposed to have two hours rest each a day, but this we only get three days out of six, and the other three days we have but an hour. We are supposed to be allowed to go out every third Sunday. Several of us have asked to be allowed to go out in rest time to get a breath of fresh air, but we have been refused for fear we should exceed our time." Janet Horowitz Murray explains that not until 1913 were "their hours of work ... limited, in some cases, to a maximum of sixty-three hours a week."[32] As a barmaid, Arabella would have enjoyed the paradoxical life that most working women enjoyed: they were slave to their employers, but were free from the impositions of strict moral codes. Because of this relative "freedom," Arabella occupies a border space. Although she is subject to the rhetoric of feminine virtue, Arabella can never fully become a lady, a wife, a mother, or a proper British subject, but she is able to masquerade as all of these. As Jude tells Sue, "*You* haven't the least idea how Arabella is able to shift for herself."[33] Unfortunately, Arabella's various charades are often exposed as she does not respect the distinctions between the public and private realms.

While Ruskin was instructing women to be the "centre of order" within and without their "gates," Arabella could be seen from her garden gate slitting the windpipe of a pig. After the slaughter of the pig, Arabella and Jude have an argument that begins in the home when Arabella smears Jude's "dear ancient classics" with pig fat. The quarrel makes its way out into the public realm when Arabella storms out of the house into the street and begins to methodically remove the middle-class wife's costume that had already been mussed by Jude in the course of the argument: "Jude relinquished his hold, and she crossed the room to the door, out of which she went with a set face, and into the highway. Here she began to saunter up and down, perversely pulling her hair into a worse disorder than he had caused, and unfastening several buttons of her gown." This public display does not go unnoticed by the pedestrians exiting Alfredston this "fine Sunday morning": "These pedestrians turned to stare at tbe extraordinary spectacle she now presented, bonnetless, her disheveled hair blowing in the wind, her bodice apart, her sleeves rolled above her elbows for her work, and her hands reeking with melted fat. One of the passers said in mock terror: 'Good Lord deliver us!' "[34] The pedestrian's "mock terror" is no doubt caused by the public "spectacle" of Arabella as the housewife gone awry. The pedestrian's prayer is answered when Arabella—exposed as a fraud and not terribly unhappy about it—emigrates to Australia shortly thereafter.

Arabella's departure is obviously prompted by her failure to keep her bodice together in public. Her emigration is meant to provide deliverance for herself as well as the Alfredston churchgoers. McClintock writes of the process of emigration as salvation for the nation through "rituals that separate the marginal ones from their old status, segregating them for a time and then publicly declaring their entry into their new status."[35] Arabella never remains segregated long enough to allow a reintegration; her emigration is as short-lived as her other occupations or masquerades.

Because she hasn't the social status that would make her a real lady, Arabella's Alfredston display undermines the entire system of lady-making. By dressing as a lady while slaughtering pigs in her yard, Arabella presents a rather disturbing image. When she removes her ladies' clothing in public, the construct "lady" is further exposed. In "Of Mimicry and Man," Homi Bhabha writes, "[T]he discourse of mimicry is constructed around ambivalence; in order to be effective, mimicry must continually produce its slippage, its excess, its difference."[36] For Arabella to succeed as a lady would put middle-class ladies and the notion of breed-

ing (be it ladies or pigs) out of business. But, her failure, the "slippage" of her disguise, is also quite disturbing for the Alfredston churchgoers, for it suggests that ladies can be easily mimicked by pig killers. As Bhabha concludes, "The effect of mimicry on the authority of colonial discourse is profound and disturbing." It is Arabella's *failure* to adorn herself appropriately that causes the public disturbance and prompts her to take her act on the road.

Many Victorian women were actively recruited to emigrate in order to elevate the moral fiber of the colonies. These women, unlike Arabella, knew how to dress appropriately. In "Under Cover: The Paradox of Victorian Women's Travel Costume," Birgitta M. Ingemanson writes of "the women travelers of these times" that "for fear of demeaning their social status Victorian women travelers were unwilling to neglect the strict dress code to which they were accustomed at home." In other words, "they moved their 'clothing zone' with them."[37] These women, not unlike William Rathbone Greg's ideal emigrants, were of the middle class, and they took their class consciousness with them. David says of the same class of women, "In the case of the British woman, whose political identity [is] as subaltern assistant trusted with the moral management of empire ... there is a transformation signaled by an expanded purpose for female emigration to the colonies."[38] This expanded purpose did not include women such as Arabella.

In the late-Victorian era, the colonies were managed with the help of Greg's redundant women and their clothing zones. The dustbin was no longer a place for a woman of Arabella's "sort." In examining the colonization of women in Australia, Anne Summers says, "[F]emininity is a cultural imposition upon the female sex, an artificial contrivance designed to replace natural conduct and appearance with conventions which make their governing easier."[39] When Arabella removes her ladies' clothing in the course of her argument with Jude, it becomes obvious that she will not be governed. But as Summers has noted, the impositions of femininity will follow her no matter which British town or colony she chooses to run to, which is why she is never delivered or, as McClintock puts it, "reintegrated." The colonial dustbin, like England itself, was being cultivated by the middle classes. Arabella is certainly not "the British woman ... trusted with the moral management of empire," nor is her presence in Australia that of a desired colonial assistant. She is not wanted in Australia as Greg posits "redundant women" are. Because of her "dangerous, liminal" status, what is desired of Arabella is her absence from England.[40]

New [Good] Woman/
Old [Bad] Woman

Arabella's removal from England is not official; although Australia origi-
nated as a penal colony, she is not forced to emigrate there as many
before her were. However, a heightened sense of morality brought social
deviance and the responsibility for its correction to the hands of the pub-
lic in the Victorian era.[41] The hideous spectacle that Arabella presents
when her masquerade as a lady begins to unravel prompts the Alfredston
parish member to ask the good Lord to "deliver us." This type of public
display is enough to make Arabella socially undesirable and her depar-
ture inevitable. As Isa Craig proposes, Arabella's departure aids in
"strengthening those who remain," especially her husband.

Jude desires Arabella's absence so that he can get on with his religious
studies without the nagging interference of his sexual desires or the dis-
turbing spectacle of pig fat on his books. Acknowledging that just "by
caring for books he was not escaping the commonplace," Jude realizes
that he must expel his sexual desires. Jude associates these desires with
his lusty wife.[42] Arabella's commonplace sexuality—or her "animal
nature," as McDowell would have it—and her inability to keep it under
wraps are frequently the reason for her travels. Arabella's return indicates
that she did not fit in abroad, either. According to Summers, middle-class
British values were successfully transplanted with those British subjects
that colonized Australia: "[T]he specific aim in colonizing Australian
women is to ensure that they will marry and bear children, thus perpetu-
ating 'the family.' "[43] Arabella's commitment to the family and its values
is no stronger in Australia than it is in England. Arabella leaves her
father's house in Australia and has a child that is not fathered by the "hus-
band" she finds there.

If middle-class British women were as desperate for husbands as the
media would have us believe, then a woman who leaves two husbands
(and a son) to wander about the world would not have been very highly
regarded. Arabella's return to England is most likely prompted by the
same type of moral policing that persuaded her to leave in the first
place. If Isa Craig's idea of exporting the negative portion of the working
classes was to strengthen those who remained, then the return of this
negative element would have the opposite effect. In Arabella's case, the
return of the undesirable native brings disaster to the lives of those who
remain.

Because of her various professions and her sexual appetite, Arabella seems to bring an element of filth to Jude's otherwise clean existence. Her return signals doom for the entire Fawley-Bridehead family. Though branded as undesirable wherever she may go, Arabella has a certain amount of freedom, mobility, that her counterpart, Sue Bridehead—the novel's New Woman—does not possess. Arabella is able to move from occupation to occupation: she is a barmaid one week, a pig breeder the next, and a wife and mother after that. While Sue is labeled a fallen woman and is repeatedly thrown out of her various positions, Arabella continues to move about freely. When her divorce from Jude is granted, Jude recognizes that it is Arabella's relative social invisibility that makes it easier for her to elude the discriminating gaze of the moral police of Wessex.[44] Like the "messy business" associated with the work that she does, Arabella simply does not exist. Arabella remains anonymous until she crosses a moral line in public and offends the decent folks.

Arabella's existence, whether in England or Australia, is enough to thwart the decency of Jude and his beloved Sue Bridehead. Sue (who apparently has no sexual desires) and Jude (who tries to export the "commonplace" with his wife) share a platonic—albeit tense—relationship until Arabella returns. Upon seeing Arabella again, Jude's "commonplace" desires return with a vengeance. To Sue's accusation that Arabella "is too low, too coarse for you to talk to long, Jude, and was always!" Jude responds: "Perhaps I am too course too, worse luck! I have the germs of every human infirmity in me, I verily believe—that was why I saw it was so preposterous of me to think of being a curate. I have cured myself of drunkenness I think; but I never know in what new form a suppressed vice will break out in me!"[45]

Arabella's presence is likened to that of a virus that never completely leaves Jude's system. Her return causes Sue to be infected, as well. Sue finally gives in to Jude's sexual advances the night Arabella knocks at their door. Sue's acquiescence is based on her fear of Arabella's influence on Jude. Sue sacrifices herself to counteract Arabella's negative influence. Yet, Arabella's impact on Sue and her modesty is equally strong. When Sue visits Arabella in her room at the public house, Arabella springs "out of bed so suddenly that the soft parts of her person shook," causing Sue to jump "aside in trepidation."[46]

The "trepidation" that Arabella inspires in Sue is similar to the feelings of the Madonna toward the whore. The first time Sue sees Arabella in the light of day, she immediately begins to appraise herself in comparison: "Sue was wicked enough, despite her penitence, to wish for a

moment that Jude could behold her forerunner now, with daylight full upon her. She may have seemed handsome enough in profile under the lamps, but a frowsiness was apparent this morning; and the sight of her own fresh charms in the looking-glass made Sue's manner bright."[47] Sue evaluates herself in opposition to Arabella, who fares better under artificial lighting. Sue is not the only one who positions herself in a binary relationship to Arabella. Jude sees Sue and Arabella as opposites from the start. When he arranges his first meeting with Sue, Jude worries that he has asked her to meet with him outside, the way he first met with Arabella. Later, when Arabella returns, Jude tells Sue, "She is not like you, my darling, and never was."[48]

Arabella "never was" like Sue because Arabella must play the Old Woman to Sue's New Woman. In *Uneven Developments*, Mary Poovey describes the Old Woman "in eighteenth century texts like Swift's and Pope's poems" as being "associated with flesh, desire, and unsocialized, hence susceptible, impulses and passions."[49] Arabella the Old Woman is driven by her impulses and passions. By contrast, Sue the New Woman is defined by her lack of "commonplace" desires. The New Woman appeared in the Victorian era in conjunction with the feminist movements of the time. In *Consuming Fiction*, Terry Lovell sees the New Woman "in the literature of this period" as "a figure who belongs as much to anti-feminist reaction as to feminism."[50] Sue Bridehead is too complex a character to reduce to either feminism or antifeminism. However, in either case, class distinctions would have remained intact.

The majority of Victorian feminists were middle-class women. Lovell says of these feminists, "[I]n order not to lose caste it was essential that they maintained their standing as 'ladies' and to do this they must backhandedly affirm prevailing gender identities."[51] This meant that the Madonna/whore complex could not be resolved because merely questioning it would cause the New Woman to "lose caste." It also meant that the looking glass that Sue consulted to check her own image against that of Arabella was being held up to women all over England. Ruskin's "mirror of beauty" categorized women according to their relationship to nature. Whereas the mirror of beauty is shattered by the spectacle of Arabella and her ladies' clothing covered in pig fat, Sue's image remains fair. Even though she's labeled a "fallen woman," Sue's natural virtue shines through.

It seems that even human nature is set up along class lines. McClintock argues that "women as historical actors are disavowed and relegated to the realm of nature."[52] If women are relegated to the natural realm, as

McClintock suggests, then working-class women are doubly condemned. The New Woman set out to intervene in history and therefore had to disassociate herself from nature and the Old Woman. This division makes it necessary for Hardy's readers to see Arabella as old in order to define Sue as new (hence Frederick McDowell's reading of Arabella's "animal nature"). There is a dualistic hierarchy created between Sue and Arabella, with Sue and her mind on a pedestal and Arabella and her body down in the mud with the pigs. The abjection of this animal nature, represented by Arabella, is imperative in constituting Sue as a New Woman, a historical actor, a mind without a body. Like the traveling ladies of the Victorian era, Sue takes her clothing zone with her. Social standing affirms the authority of the "subaltern assistant" and the historical actor. If travel empowered Victorian women, so too did their middle-class status. Sue's reputation as the fallen woman indicates that status is precarious. The New Woman is as susceptible as the Old. Even as she reaffirms her own natural virtue, Sue is frightened by the sight of Arabella's shaking soft parts.

Sue's fear of Arabella's negative influence is confirmed with the murder of her children by "Arabella's boy." As Jude tells Sue, "[I]t was in his nature to do it."[53] The implication is that Arabella's infectious immorality was allowed to spread and the Fawley-Bridehead family is to pay the consequences. The murder of the children and Jude's subsequent death (after remarrying Arabella) suggest that Arabella's forays into the margins of British abjection deliver neither her nor her community. Traveling to the other side of the world and back while desecrating the ladies' clothing zone only strengthen Arabella's "natural force." Somewhere between the "rituals of domesticity" and the promise of deliverance lie the reasons for Arabella's departure.[54] Her emigration can be read as merely another attempt to escape the various animal labels that have been applied to her, to avoid being wrested from her natural state of savagery, or, perhaps, to perfect her masquerade as a lady. Arabella's departure can be likened to the removal of the working classes or redundant women, for she too poses a danger to public morals. Her emigration can also be interpreted as a failed attempt to find her own city upon a hill.[55] Read either way, her refusal to remain segregated, her return to England, and the "natural" behavior of her boy represent the spectacle prompted by the slippage of "the authority of colonial discourse." Its effect is, indeed, "profound and disturbing."

Notes

1. Caren Kaplan, " 'Getting to Know You': Travel, Gender, and the Politics of Representation in *Anna and the King of Siam* and *The King and I,*" *Late Imperial Culture*, ed. Roman de La Campa, E. Ann Kaplan, and Michael Sprinker (London: Verso, 1995) 33–52. Kaplan says, "[I]f colonial expansion brought unprecedented economic gain to the metropolitan centers of the West, a corresponding personal and political gain was won for Western women through the liberating activities and challenges of travel" (33).
2. Eric J. Hobsbawm, *Industry and Empire: From 1750 to the Present Day* (New York: Penguin, 1990) 84.
3. Kristeva sees abjection as a means by which individuals better themselves by repressing, denying, or merely expelling undesirable character traits.
4. Anne McClintock, *Imperial Leather: Race, Gender, and Sexuality in the Colonial Contest* (New York: Routledge, 1995) 71.
5. Isa Craig, "Emigration as a Preventive Agency," *English Woman's Journal* 2.11 (1859): 289–97.
6. Craig 289.
7. Craig 293.
8. William Rathbone Greg, "Why Are Women Redundant?" *National Review* 14 (1862): 436.
9. Alexander Allardyce, "A New View of Imperial Federation," *Blackwood's Edinburgh Magazine* 147 (1890): 708.
10. J. G. Phillimore, "Woman's Rights and Duties," *Blackwood's Edinburgh Magazine* 54 (1843): 373–97.
11. Phillimore 374.
12. Allardyce 709.
13. Allardyce 711.
14. Allardyce 714.
15. John Ruskin, "Of Queen's Gardens," *Sesame and Lilies unto This Last and the Political Economy of Art* (London: Cassell, 1910) 87.
16. Deirdre David, *Rule Britannia: Women, Empire, and Victorian Writing* (Ithaca: Cornell UP, 1995) 205.
17. David 215.
18. Thomas Hardy, *Jude the Obscure* (London: Penguin, 1985) 118.
19. Hardy 80.
20. Hardy 89.
21. Hardy 101.
22. Hardy 104.
23. Hardy 102.
24. Hardy 111.
25. McClintock 5.
26. Frederick McDowell, "In Defense of Arabella: A Note on *Jude the Obscure,*" *English Language Notes* (June 1964): 276.
27. McClintock 43.
28. Friedrich Engels, *The Condition of the Working Class in England* (London: Penguin, 1987) 64.

29. Hardy 106.

30. David 9.

31. As McClintock writes, "The Victorian splitting of women into whores and Madonnas, nuns and prostitutes has its origins ... not in universal archetype, but in the class structure of the household" (86).

32. Janet Horowitz Murray, ed.,"A Barmaid's Work," *Strong-Minded Women and Other Lost Voices from Nineteenth Century England* (New York: Pantheon, 1982) 362.

33. Hardy 333.

34. Hardy 115.

35. McClintock 25.

36. Homi K. Bhabha, "Of Mimicry and Man," *The Location of Culture* (London: Routledge, 1994) 86.

37. Birgitta M. Ingemanson, "Under Cover: The Paradox of Victorian Women's Travel Costume," *Women and the Journey: The Female Travel Experience*, ed. Bonnie Frederick and Susan H. McLeod (Pullman, WA: Washington State UP, 1993) 7.

38. David 159.

39. Anne Summers, *Damned Whores and God's Police: The Colonization of Women in Australia* (Melbourne: Allen, 1975) 238.

40. McClintock 25.

41. Les Johnson, *The Rebirth of Private Policing* (London: Routledge, 1992) 22. Johnson writes, "[A] relatively small number of police officers was able to maintain social order in late-nineteenth century England, only because populations were able to manage instances of anti-social behaviour without their intervention."

42. Hardy 112.

43. Summers 200.

44. "There is this advantage in being poor and obscure people like us—that these things are done for us in a rough and ready fashion. It was the same with me and Arabella. I was afraid her criminal second marriage would have been discovered, and she punished; but nobody took any interest in her—nobody inquired, nobody suspected it" (Hardy 322).

45. Hardy 331.

46. Hardy 336.

47. Hardy 334.

48. Hardy 332.

49. Mary Poovey, *Uneven Developments: The Ideological Work of Gender in Mid-Victorian England* (Chicago: U of Chicago P, 1988) 10.

50. Terry Lovell, *Consuming Fiction* (New York: Verso, 1987) 110.

51. Lovell 105.

52. McClintock 39.

53. Hardy 410.

54. McClintock says, "Through the rituals of domesticity ... animals, women and colonized peoples were wrested from their putatively 'natural' yet, ironically, 'unreasonable' state of 'savagery' "(35).

55. James Kendall Hosmer, ed., *Winthrop's Journal: History of New England, 1630–1649* (New York: Barnes, 1953). John Winthrop, founder of the Massachusetts Bay Colony (his "Citty upon a Hill"), sailed to the New World aboard the "Arabella" in 1630.

Maria Rye's Journey:
Metropolitan and Colonial Perceptions of Female Emigration

Marion Diamond

The process of emigration has always meant different things to different societies. In the idiosyncratic catalog of the Guildhall Library, London, which was designed long before either Dewey or the Library of Congress attained their hegemony, "Emigration" is listed as a subcategory of "Charities." As an Australian researcher, I took a long time to find this location, for the classification highlights a fundamental discrepancy between the way that Britain and her colonies viewed emigration in the nineteenth century. Whereas Britain regarded the support of emigration as a form of charity, the recipient colonies regarded it as no such thing.

This ambiguity of meaning is particularly acute in the case of single-female emigration. The colonies wanted single women immigrants, to alleviate a shortage of domestic servants. The mother country, on the other hand, saw female emigration as a mechanism to deal with a local problem, the so-called surplus woman problem that so preoccupied Victorian England. The 1851 and 1861 censuses drew attention to a surplus of women over men in the British population. The surplus existed across all classes, although the reading public was particularly preoccupied with the fate of middle-class women.[1]

One of the many reasons that contemporaries identified for this demographic imbalance was the tendency for men, more so than women, to emigrate to the colonies. Emigration was a phenomenon that affected virtually every class in British society in the nineteenth century, wherever population pressure, and the consequent squeeze on incomes, lured men into seeking a better future in the less populous settler societies of the new world. Migration was, however, a very gendered affair. Single men were the most likely, single women the least likely, to migrate. Women were seen as victims of this demographic imbalance, unable to find either work or husbands in overstocked labor and marriage markets. They might, however, improve their chances by migrating to the

colonies, where the demographic pattern was reversed and men out-numbered women.

At the same time, there was a growing interest in increasing the opportunities for women, including middle-class women, to enter the paid workforce, to earn their own livings in a society where, it seemed, there were too few men to maintain them in traditional dependency. Emigration and the quest for work were closely linked at all levels of society. Working-class women turned to migration during times of economic depression, such as the cotton slump in the factory districts of Lancashire during the American Civil War. Middle-class women also saw emigration as an option for impoverished women of their own class, who might find better-paid work abroad in the newly opening middle-class areas of teaching, nursing, and clerical work.

In the early 1860s, these two issues of emigration and employment came together in the work of Maria Rye (1829–1903), the daughter of a London solicitor. Rye was a shareholder in the feminist journal, the *English Woman's Journal*, associated with the Langham Place group.[2] In 1861, she became one of the founders of the Society for Promoting Women's Employment (SPWE) and established a law-copying and stationer's office in Portugal Street, Lincoln's Inn, to train and employ women in clerical work. With support from associates, both feminist and philanthropic, she founded the Female Middle Class Emigration Society (FMCES) in May 1862 to assist middle-class women to migrate to the British colonies in search of better opportunities for paid work. The FMCES provided interest-free loans to suitable applicants to help them pay their fares to the colonies. The women were to pay off these loans within two years and four months of their arrival in the colonies, from the allegedly high salaries they could earn there. Over a twenty-year period, the society helped about three hundred middle-class women migrate to Australia, New Zealand, Canada, and South Africa.[3]

In 1861 Maria Rye outlined her ideas on "The Emigration of Educated Women" to the Dublin meeting of the National Association for the Promotion of Social Science (NAPSS).[4] She repeated her argument in a paper on "Female Middle Class Emigration" to the NAPSS meeting in London in June 1862. Her argument was simple—and simplistic. There was a marked sex imbalance in the colonies and a dearth of educated women, either for employment as teachers, nurses, and governesses, or as wives for middle-class colonial men.

Although Rye is most closely associated with middle-class female emigration, she saw emigration as beneficial for all women, irrespective of

class, and her activities on behalf of female emigration went well beyond the FMCES. Rye saw emigration as a means of improving women's chances in the labor market, both abroad and at home, for if a portion of women were to move to the colonies, they would not only improve their own chances of finding work but would reduce the number of women competing for limited job opportunities at home. Most people believed that the colonies offered better employment prospects to women, as they certainly did to men, but women were usually too poor to pay the costs of emigration and were generally ignorant of the procedures involved. Moreover, the process of emigration was particularly hazardous for single women. The problem was to manage the transfer of women from England to the empire so as to guarantee both their physical security and comfort, and their reputations. Whether she was a working-class domestic servant or a middle-class governess, a "good character" was essential to any woman's future prospects of work and of marriage, but her character could easily be tarnished by hints of shipboard profligacy.

Rye set about investigating the mechanics of emigration. She read the reports of the government emigration commissioners, visited emigrant ships, and contacted ex-colonists living in England.[5] She wrote to key figures in the colonies, asking for information and help for her plans.[6] And in November 1862, she set out for New Zealand and Australia on a journey of investigation. She went to learn about the colonies, to investigate the conditions for receiving immigrants, and to persuade the colonial governments to accept more women as immigrants. She was away from England for three and a half years on a voyage of discovery that brought her face-to-face with the many differences between colonial and metropolitan perceptions of emigration.

Rye's journey took her first to Dunedin, in the southern New Zealand province of Otago, in February 1863. In May she moved north to Christchurch, in the neighboring province of Canterbury. She spent Christmas in the South Island before moving north to Wellington, then to Napier, the capital of the eastern province of Hawke Bay. She finally visited Auckland before crossing the Tasman Sea to Sydney early in 1865. She spent several months in and around Sydney and traveled north to Brisbane, the capital of Queensland, during the southern winter. The final leg of her journey took her to Melbourne and provincial Victoria in the last months of 1865. She left for Britain in early 1866 and was back in London by May.

Rye became a focus for public criticism throughout her journey. Wherever she went, colonial newspapers debated the aims of female

emigration. Almost without exception, the public implacably opposed the objectives of the FMCES and scoffed at the idea of an importation of middle-class women, all typified as "governesses." The press was more equivocal about the emigration of working-class women as domestic servants, acknowledging that a need existed but dubious about the quality of those on offer. And everywhere, there was a suspicion that single women who migrated alone to an area where men outnumbered women were nothing but shameless husband-hunters—or worse.

Rye came under sustained personal criticism, too, especially during the first few months of her journey in New Zealand. In August 1863, for instance, Bishop Harper of Christchurch commented, in a private letter to a friend:

> It would not be altogether a bad thing if some quarantine could be established through which, unmarried ladies of a certain age with very benevolent intentions and great zeal in endeavouring to carry them out, but with no knowledge of the wants and means of our colony, might be kept for a time at least, from landing among us.
>
> Miss Rye ... has been visiting us. She has endeavoured to effect her object chiefly through the Ladies of Christchurch—by tacitly expressing that she knows more than we do, of the kind of persons wanted in the Province and dictating certain measures as necessary to be adopted—I give her full credit for the very best intentions, but ... she knows but very little of the real condition of these Colonies, of their wants and difficulties, and the best means of supplying them, still less of the exertions that are being made among us for all religious and charitable purposes. And this ignorance is accompanied with a very high opinion of the importance of what she deems her mission, and of her own ability to direct us.[7]

The pattern was repeated throughout her journey. Rye must bear some of the blame for some of the antagonism she encountered. With minimal tact, she drew attention to colonial failings in a wide range of areas, publicizing her criticisms in letters to the English press and to her friends and patrons back home. She particularly offended colonists by writing to the *Times* (London), which had partially funded her trip, and published her letters. Rye's relationship with the colonists in New Zealand got off to a bad start. She arrived in Dunedin in February 1863 on the *John Duncan*, bringing with her about one hundred immigrant women, most of them factory hands from the depressed cotton districts of Lancashire. Their first experiences were not encouraging. The immigration barracks, where the

women were to stay until they found employment, was being used to house a troop of mounted police, complete with their horses, brought from Melbourne to keep control in the middle of a gold rush. There was nowhere to wash, nowhere to eat, inadequate food, and little privacy: "[A] more demoralizing school for undecided characters could not possibly be imagined, and a more discreditable place does not exist under the sun. Two or three illegitimate children and their mothers are at present residing there ... while the upper attics are occupied by a body of women who are known only to night and evil deeds." Rye's criticisms to the provincial authorities fell on deaf ears, so she published her complaints in a letter to the *Times*.[8] In due course, these comments reached New Zealand again when copies of the *Times* were imported.

The colonial response to Maria Rye focused on several issues. One was a provincial loyalty that manifested itself in resentment against criticism from an outsider, especially criticism that was perceived to be conducted in an underhand way. Colonists reacted defensively to her outbursts, pointing out her ignorance of local conditions and her lack of competence, both as a stranger and as a woman, to enter the public debate in areas well beyond her legitimate sphere.

Second, colonists were almost universally hostile toward female middle-class emigration. There was no perceived need for governesses in Australia or New Zealand, for except in rural districts, most children had access to publicly subsidized schooling. Even quite wealthy families preferred to send their daughters to school. Colonial debates about class played a part, too. On the one hand, there was a good deal of democratically inspired hostility toward the very idea of governesses. Even the governor of Victoria, Sir Henry Barkly, who might have been expected to reflect more conservative social attitudes, described "the system of resident governesses" as "a product of an artificial state of society, in a high state of civilization. I think it almost might be said that it cannot flourish except in the hot-bed of wealth and luxury, where the ordinary maternal duties are so interfered with by other avocations that it is not practicable for the mother to pay that attention in superintending her daughters' education, which she would do in a natural state of things."[9] On the other hand, the status of the emigrant gentlewoman was ambivalent. "We do not believe that either governesses or females of the middle class can be extensively utilised in Victoria," wrote the *Age* in 1863. "Among other reasons, the circumstances of their introduction to the colony deprive them of all claim to be regarded as of the middle class. They may possess the accomplishments and the virtues that will afterwards permit

them to rise to the sphere of life that adversity had cast them out of. But there is no getting rid of the fact of their pauper introduction."[10]

In 1864, Elizabeth Murray, the wife of a former Victorian goldfield commissioner, published *Ella Norman; or, A Woman's Perils*[11] to highlight the misfortunes confronting middle-class women in the Australian colonies. Murray had not liked Australia, and behind her tale of missing heirs and romantic stockmen in disguise, her book was an attack on the propositions of the Female Middle Class Emigration Society. "Look again at these emigration societies," says one character in the novel, "Who can doubt the amiable intentions of the good people who inundated the country with those hapless girls, who came out only to meet their ruin? They were made to believe they were coming to happy homes. It drives me mad sometimes to think of the benevolent feelings and the money expended by injudicious great people in working out unmitigated evil for their fellow-creatures, when possessed by some ridiculous crotchet or whim; as it often happens they are worked upon by some scheming adventurer."[12]

Just such an instance of ill-conceived benevolence occurred in December 1862, when the emigrant ship *Conway* arrived in Rockhampton, in provincial Queensland, with female emigrants recruited by the FMCES. The health officer reported that the passengers included "141 single women selected by Miss Rye, the promoter of what is called a 'middle class emigration.' Of this number 96 are governesses, the remainder, domestic servants of a superior description."[13] There was no way that Rockhampton could absorb nearly a hundred governesses, or even domestic servants "of a superior description." Most of the women had to be brought to Brisbane, six hundred kilometers away, where they stayed in the immigration barracks until they could find work in Queensland's relatively underdeveloped economy. Until then, they remained a burden on local charities. The *Brisbane Courier* responded by republishing an article from the London *Saturday Review*, "a most insulting article ... containing some cruel and unjust reflections on Miss Rye and the young women she assists to emigrate, insinuating that they were a class of females whom England would be more glad to get rid of than Australia to welcome." As a result, "suspicion and prejudice" were raised against the new arrivals.[14]

"The Export Wife-Trade"[15] was one of a number of articles to treat the subject of assisted female emigration with mingled hilarity and hostility. One of the *Saturday Review*'s milder allegations was that the colonies had turned against the emigration of educated women because

the process of selection insured that those who went were of no use in the colonies.

> It matters little what class it is desired to send abroad—governesses, paupers, penitents, or convicts; the principle of selection is the same. From our point of view it is natural enough ... we naturally turn out the non-effectives first. Accordingly, however pure may be the philanthropy of those who inaugurate schemes of emigration for the relief of overstocked labour markets, it is always the least estimable portion of the superfluity who are selected for the opera- tion. It is the most incorrigible convict, the most incapable pauper, the most unmarketable governess, the most ineligible maiden, who is selected for the benefit of the employer or the husband of the new country.

There was some truth in these allegations. The women who migrated through the FMCES were required to pay back their loans, and many sent letters back to the society with their repayments. Although these let- ters represent the experiences of more successful women, who were able to repay the society, most of them nonetheless reported that the market for governesses was as overstocked, and as discriminating, as in England. Of the nine governesses sent to Australia during 1863, for instance, the society's own records report that only three found paid work. One was unemployed but living with a relative, and two had married, including one who "[w]ent out to a situation, lost it, and married beneath her." The other three were "not highly qualified," including a "middle-aged woman with broken constitution" and one who, with "no qualifications as governess, failed entirely in obtaining employment in England, and met with many difficulties in Australia."[16]

For a variety of reasons, the colonial job market for governesses was much less welcoming than the FMCES optimistically expected. Most children, except in the most isolated areas, went to school. Governesses were seldom welcome in households where the mistress was clearly "inferior." One of the governess's main assets was her class: a good accent, ladylike manners, and sensibilities were precisely the characteris- tics British employers hoped she would transfer to her charges. But such sensibilities were less desirable in a household of uneasy gentility. Sev- eral FMCES governesses refer in their letters to their employers' lack of class. Lucy Phillips, for instance, wrote from Melbourne that her employer was "a very peculiar woman, *not a lady* by *any* means and she is never satisfied with her Governesses.... She wants more *superficial*

teaching than I can *conscientiously* give.... I am told, however, not to be disheartened by this freak of hers, it appears it is the usual way with many of the colonial families, there being a sort of jealousy between them and *English* people."[17] Such complaints, unless they could be hidden, cannot have made her an easy person to employ, especially within the constricted space of a colonial household.

One prosaic problem was the architecture of colonial houses, most of which were built without servants' quarters. Houses were often crowded, with fewer deliberate architectural separations than in Britain. This meant that domestic servants often had to make do with inadequate accommodation, compared with Britain, while live-in governesses were relatively rare, except in rural districts, because the houses were not large enough to accommodate a lady in adequate comfort and privacy. Accommodation in the colonial towns was expensive, taking a large proportion of the governess's salary. Ironically, teachers were better accommodated, since they were often provided with a schoolhouse.

A third issue in the debate over Maria Rye's visit related to the nature of women's work. It was commonly believed that women's work was based on innate, not acquired, skills. Women could do a job because of what they *were*, not what they had learned. This was as true of some newer careers, such as nursing, as of the old ones, such as domestic service and governessing. Rye's position on this issue was ambivalent. On the one hand, in her work with the Society for Promoting Women's Employment, she had emphasized the need for proper training for working women. In her correspondence with colonial governments, she argued that male immigration agents were incompetent at selecting domestic servants because they viewed looking after a household as an innate ability of every woman. Yet she concurred in this point of view when she persuaded Henry Jordan, the Queensland Immigration Agent, to allow assisted passages to middle-class women whose only experience of domestic service was as "servants" to their parents. The FMCES also insisted that the women they assisted sign a declaration agreeing to accept work as domestic servants if no other work was available.

Colonists had a legitimate grievance. In their efforts to recruit domestic servants, colonial governments gave assisted passages to single women *if* they were domestic servants. Yet for many working-class women, domestic service was a means to an end, a means of achieving the transition to the colonies relatively cheaply and securely. It did not mean they had trained for the work or had any intention of continuing it longer than was strictly necessary. Because a domestic servant lived in her

employer's household, she had a roof over her head and relative security, at least from outside dangers. She had little freedom but also little on which to spend her meager earnings, so domestic service offered an opportunity to save a little.

By midcentury in Britain, going into service was the least-attractive option for working women, so there were always positions available as local women moved out in pursuit of other careers—such as in shops or telegraphic agencies—or to marry. The concern of the colonies to recruit domestic servants was genuine, not just an alibi for the recruitment of marriageable women, but the imbalance in the sexes meant that servants tended not to stay in employment for long before they married. Indeed, a shortage of servants added an incentive for men to marry as the cheapest and most permanent means of acquiring a housekeeper! This process had been in existence for at least a generation in New Zealand, longer in Australia, and it brought with it certain difficulties for arriving women.

Many of those recruited as "maids of all work" in small, lower-middle-class households found themselves working for mistresses who had themselves been servants, perhaps not long ago. This did not make for an easy relationship. Indeed, it is possible that Jeanne Peterson's concept of "status incongruence," applied to middle-class governesses in middle-class households, was equally applicable to domestic servants within many colonial households. [18] Servants who had "married up" had no experience controlling servants or managing a household larger than the nuclear family. The topos of the incompetent servant—often Irish—is prevalent in colonial literature,[19] and probably valid, but another side to the issue was the incompetent mistress.

Incompetent servants were certainly common, for many women migrated under the general rubric of "domestic servant" to take advantage of the assisted passages this provided them, regardless of their actual skills. Daughters worked within their parents' household. Therefore, immigration agents argued, the skills they acquired must be sufficient for paid service. In many cases, they weren't. Girls who had worked in factories since childhood had no such skills. Irish girls, particularly from poor peasant households, had few skills to deal with larger and more sophisticated colonial homes. In this environment, a genuinely competent cook such as Agnes Stokes was able to use her talent as the basis for a very satisfactory, well-paid career.[20]

One of Rye's major preoccupations during her travels was to improve conditions for immigrant women on their arrival at a colonial port. Her experience of the immigration barracks at Dunedin focused her atten-

tion on these facilities in other centers. The immigration reception home was of critical importance for all immigrants but especially for single women. It served as a secure place for disembarking immigrants to stay, a place where they could recover from their journey, do three month's backlog of laundry, and meet prospective employers in a respectable environment. Rye's preoccupation with the need to establish reception homes in each entry port, under the supervision of a ladies' committee, stemmed from her recognition of this need.

However, working women in the colonies had a further need for accommodation. Immigrant women needed somewhere to live between jobs. In Britain, servants could usually stay with a relative, but immigrants usually lacked an extended family network. Commercial accommodation in colonial cities presented a problem: hotels were rare and expensive, particularly during times of high immigration such as to Melbourne in the 1850s or Dunedin in the 1860s, and they were perceived as dangerous for women as well—to their reputations, if not in reality. By 1856, a servants' home was established in gold rush Melbourne, and similar facilities gradually emerged in other centers. The need was locally recognized and was being addressed well before Rye's arrival, usually by the joint action of a charitable ladies' committee, subsidized by the local government.[21] The philanthropic concerns of the ladies' committees were naturally reinforced by their own requirements for domestic servants.

Both in Christchurch and in Melbourne, Rye tried, unsuccessfully, to impose her own priorities on these institutions. In Christchurch, an immigration and servants' home was being established when Rye arrived in mid-1863. She spoke at several meetings of women and helped to draw up proposals for the home,[22] but problems soon emerged. Rye planned the home on a lavish scale, but the estimated cost of three thousand pounds was far beyond the resources of the town. The cost was high because Rye expected the home to cater to different classes of women, with private rooms provided for "superior nurses and governesses." Her plan "blurred public understanding of the primary purpose of the Home."[23] The colonists were primarily interested in a servants' home to provide "a place of retreat for domestics in times of illness and unemployment," but these plans now became entangled with Rye's primary concern, middle-class emigration. Her interference provoked Bishop Harpur into the outburst quoted previously, possibly because his wife was a prominent member of the ladies' committee. By the time the Christchurch Home for Women of Respectable Character opened its

doors in January 1864, the Christchurch ladies had reasserted their control of the project, with a more modest institution designed for servants, not middle-class women.

Rye experienced similar problems in Melbourne, where she stayed with Bishop Charles Perry and his wife.[24] Fanny Perry and her friend Laura A'Beckett were both colonial correspondents for the FMCES, but like most colonials, their main concern was the local demand for domestic servants, and they were uneasy about Rye's preoccupation with middle-class emigration. A'Beckett, in fact, had already written to Rye in 1864, wishing it "to be distinctly understood that I disclaim all responsibility concerning" the FMCES's immigrants.[25]

Both women were among a group of Anglican ladies who had, since 1856, helped to run a "home" in Melbourne that provided cheap accommodation for working women and acted as a registry office. In November 1865, Rye met the committee of the home to ask if they would provide free accommodation to her prospective female immigrants. The committee was cautiously sympathetic but told her that the home was not a charitable institution.[26] She then wrote to them, outlining her requirements in most peremptory terms. The committee responded, as committees tend to do in such cases, by tabling the letter and setting up a subcommittee that was never heard from again![27]

In return for assistance from the committee, Rye promised that "[i]f I will undertake to send out a better class of female servant than is now arriving—will your Committee request the Melbourne Government to leave the selection of female servants in my hands—for five [Emigration] Commissioners ships after my arrival in England[,] the numbers not to exceed fifty Girls in each ship."[28] Wherever she went, Rye wrote to colonial governments, offering her services to recruit female servants. The response was mixed. It was most hostile in Queensland, in part because of the debacle of the *Conway*'s immigrants and in part because she was publicly, and simultaneously, critical of the government's immigration practices. She wrote to the Colonial Emigration Commissioners in London to criticize the condition of the Brisbane immigration barracks and the lack of security for women aboard the immigrant ships. The Queensland government responded to these claims by instituting an inquiry, by a former premier, that concluded:

> I should not do rightly if I omitted to mention that at the very time
> at which Miss Rye states these occurrences so disgraceful if true, to
> have taken place, she was a pertinacious applicant for employment

as a salaried emigration agent of the Government of Queensland. I was altogether unable to advise the Governor in Council to confer upon her any such appointment, being satisfied that she was in various ways unfitted for the office. . . . The conduct of this lady is so thoroughly appreciated in Australia, that the Council would not have thought it necessary to take any notice of her accusations, had not Her Majesty's Principal Secretary of State for the Colonies been pleased to raise the question of her truthfulness and candour by officially transmitting her letter to Queensland and calling for a report upon it.[29]

The provincial government in Dunedin was equally defensive of her criticism and hostile to her proposals. On the other hand, she established a foothold as an emigration agent when the governments of Victoria and of Hawke Bay, New Zealand, both accepted her offer to recruit domestic servants for their colonies.[30]

This varied response reflects the different stages of development of the different colonies. English commentators assumed that the demand for single women was greatest where the demographic imbalance between men and women was greatest. In fact, however, the reverse was true. Women were in most demand as servants in areas where families were established, housewives had higher expectations, and households were sufficiently permanent to require domestic assistance. The frontier colonies of Queensland and Otago, despite their serious shortage of adult women, did not need more; the older colonies, such as Victoria and New South Wales, and the provinces in the North Island of New Zealand, had enough women to need more.

This made nonsense of any simple equation between single-female emigration and a perceived demand for wives for the colonies. Yet the idea persisted, both in Britain and the colonies, that female emigration was predominantly about supplying wives for colonial bachelors. In September 1862, the *Saturday Review*, which regularly exhibited its resentment against demands for women's rights in general, and the Langham Place women in particular,[31] published an article entitled "The Export Wife Trade." The article was subsequently republished in Brisbane, in Christchurch, and in Melbourne. Assuming without question that the women sent out by Rye had marriage as their only objective, the *Review* pointed out the flaws in this plan: "The least romantic squatter, the most grovelling digger, will be revolted by seeing the ways of courtship made so straight and flat. The news that a cargo of hypothetical brides had arrived, and was waiting in the port-town to be looked at, would scare

away every possible bridegroom from coming anywhere near the coast." Besides, unless the "cargo of governesses ... could be trotted out upon the quay, in the presence of an admiring bevy of marriageable squatters," courtship would have to proceed more slowly. In the meantime, the women needed capital to live, and to eat and dress well, "for good looks are her stock in trade. She might as well go out fishing without bait, or shooting without powder, as attempt to fascinate a squatter with a starved face and ragged clothes."[32]

The suspicion that all Maria Rye's emigrants were husband-hunting old maids continued to surround the emigration scheme, causing distress to those women who were aware of the popular prejudice against them. Even sympathetic commentators often failed to comprehend that emigrant women might come in search of work, rather than marriage, and Rye was herself equivocal about the issue. In fact, marriage was often the outcome, if not the only objective, of the emigration of single women. Rosamund Smith reported that within a few weeks of the *Conway*'s arrival, a number of marriages had taken place, and regretted that "these hasty ... arrangements almost always result ... in conjugal misery or utter ruin.... [N]o one knows yet how many of the bridegrooms have left wives up the bush, or if not already married, how many of them are unprincipled, intemperate men, not calculated to make a decent woman happy."[33]

More frightening, however, was the possibility that impoverished women, irrespective of their class background, might turn to prostitution. Between "respectable" employment and prostitution, a large gray area of employment existed that was effectively off-limits, regardless of its actual immorality. Impeccable references and a "good character" were so important in obtaining employment that once these were compromised, there was no way back. What became of Miss Sampson, for instance, whose shipmate reported to the FMCES:

> Miss Sampson I suppose is still unoccupied, for in today's [Melbourne] *Argus* there is an advertisement—"A Lady recently arrived is anxious to obtain a situation in a respectable Hotel to Sing and play every Evening"—I am certain it is hers. I am afraid she won't do much good here—[s]he is not the person to get on in any hard work or honest employment. She has never been accustomed to employ herself and it is too late to begin and change her habits.[34]

Among the working-class immigrants, prostitution was undoubtedly one possible solution to poverty, although here, too, there was often a gray

area between perception and reality. One of the passengers from the *John Duncan*, for instance, reported that some of Maria Rye's immigrants had "gone on the town" in Dunedin. Her evidence, however, was merely that "nearly all the Servants wear white or color'd feathers in their hats & are flaunting about with men."[35] An alternative explanation may be that, cut off from the family ties that served to control their sexuality, women in the colonies were freer to make their own sexual choices. Promiscuity, after all, does not necessarily mean prostitution.

Maria Rye's experiences in Australia and New Zealand led her to conclude that such women were more vulnerable in the colonies than at home, where familial ties kept them virtuous, however poor. In May 1865, she wrote a long letter from Sydney to Barbara Bodichon, in which she tried to explain:

> I still think to the full as strongly as when I left home that women, educated or not, may come here with the very greatest advantage to themselves—but I see even clearer than ever that they must be women of a certain stamp.—[W]omen who dislike work, or who are not very steady in their principles—are a thousand fold better off at home—[T]here are scores of such women in England, they are not exactly idlers,—not at all immoral—but they work because they must—& are virtuous because they are surrounded by scores of good homes & by inducements of every king to go right—[A]ll this vanishes, or very nearly all vanishes here—& the colonies like the testing fire of the apostle try every man's work & every man's character to the very core—It's very marvellous how alone people are here,—women—men—families—it's all alike—they are here to day—gone tomorrow, & the natural result is that individuality is very prominent ... [Y]ou can easily see how that would tell ... on women who have no individuality to bring out, first they lean right—then they loll left—& then down they go.[36]

Rye left Australia in early 1866 and arrived back in England in May. She set up an office in the Adelphi, the immigration and shipping quarter of London, and during the next years, she recruited some hundreds of women and family groups to send to the Australasian colonies. Most of them, in deference to the colonies' requirements, were working-class women who could, with some justification, be classified as domestic servants. However, despite her greater awareness of colonial sentiments, Rye also continued her association with the FMCES, which sent out middle-class women to the colonies until the 1880s. In 1867, at the per-

suasion of her supporters, including Lord Shaftesbury, the British government awarded her a government pension of seventy pounds per annum, in recognition of her services to the cause of female emigration. Implicit in such a recognition was the enduring English belief that emigration was an appropriate subject of philanthropy. Rye's time in the colonies gave her new insights into colonial attitudes toward immigration, but she remained metropolitan in her concerns, more interested in alleviating England's "surplus woman problem," than in colonial requirements for its women immigrants.

Rye's journey was indeed a voyage of discovery, a metaphorical journey from ignorance to experience. Though colonists might scoff, in the eyes of her peers in England, her colonial experience established her credentials as an "expert" on colonial affairs. "I think it very hard for you who are at a distance from the colonies to understand them," Rye told Bodichon in 1865; "[T]hey are so intensely good, & so intensely bad, according to the use made of them that I can easily see how perfectly true pictures of life here are certain of condemnation at home & of apparent refutation by equally reliable information."[37] We are back where we began, therefore, with the elusive meanings of words and the shifting significance of ideas within the colonial or metropolitan context.

Notes

1. See William Rathbone Greg, "Why Are Women Redundant?" *Literary and Social Judgements*, 2nd ed. (London: Trubner, 1869) 280–316.
2. See Jane Rendall, " 'A Moral Engine'? Feminism, Liberalism and the *English Woman's Journal*," *Equal or Different: Women's Politics, 1800–1914*, ed. Jane Rendall (Oxford: Basil, 1987), 112–38; Candida Ann Lacey, ed., *Barbara Leigh Smith Bodichon and the Langham Place Group* (London: Kegan, 1987).
3. The records of the Female Middle Class Emigration Society, comprising reports and books of letters from emigrant women, are held at the Fawcett Library, London, and have been microfilmed by the Australian Joint Copying Project. A large collection of these letters has been edited in Patricia Clarke, *The Governesses: Letters from the Colonies, 1862–1882* (Sydney: Allen, 1985). A broader history of the emigration of middle-class women is told in A. J. Hammerton, *Emigrant Gentlewomen: Genteel Poverty and Female Emigration, 1830–1914* (London: Croom, 1979). There are also older studies of the topic by Una Monk, *New Horizons: A Hundred Years of Women's Migration* (London: HMSO, 1963); and G. F. Plant, *A Survey of Voluntary Effort in Women's Empire Migration* (London: Soc. for the Oversea Settlement of British Women, 1950). The special case of female emigration to New Zealand is covered in Charlotte Macdonald, *A Woman of Good Character: Single Women as Immigrant Settlers in Nineteenth-Century New Zealand* (Wellington: Allen/Historical Branch, 1990).

4. Maria S. Rye, *Emigration of Educated Women: A Paper Read at the Social Science Congress in Dublin, 1861* (London: Faithfull, Victoria Press, [1862]).
5. See, for instance, M[aria] S. R[ye], "Emigrant-ship Matrons," *English Woman's Journal* 5.25 (1 Mar. 1860): 24–36.
6. Rye, *Emigration of Educated Women* 10–11.
7. H. J. C. Christchurch [Bishop Harper], letter to Selfe, 12 Aug. 1863, pp. 287–88, Henry Selfe Letters, Christchurch Museum.
8. Maria Rye (Dunedin, 16 Mar.), letter to the editor, *Times* (London) 29 May 1863: 5.
9. Sir Henry Barkly, *Melbourne Argus*, 26 Feb. 1863.
10. *Age*, 15 Jan. 1863.
11. Elizabeth A. Murray, *Ella Norman; or, A Woman's Perils* (London: Hurst, 1864); reprinted with foreword and book reviews (Melbourne: Hill of Content, 1985). On further examples of governesses in colonial Australian literature, see Marion Amies, "The Victorian Governess and Colonial Ideals of Womanhood," *Victorian Studies* 31.4 (Summer 1988): 537–65.
12. Quoted in *Athenaeum*, 27 Feb. 1864, rev. of *Ella Norman*, reprinted in Hill of Content edition, 399.
13. Health Officer's Report on *Conway*, 2 Dec. 1862, COL/A35. 62/2798. Queensland State Archives.
14. R[osamund] S[mith], "Letters from Brisbane," *English Woman's Journal* 11.62 (1 Apr. 1863): 115–17.
15. "The Export Wife-Trade," *Saturday Review* 6 Sep. 1862: 276.
16. Quoted in Clarke, 76.
17. Quoted in Clarke, 125.
18. M. Jeanne Peterson, "The Victorian Governess: Status Incongruence in Family and Society," *Suffer and Be Still: Women in the Victorian Age*, ed. Martha Vicinus (Bloomington: Indiana UP, 1972) 3–19.
19. See, for example, Beverley Kingson, "The Servant Problem," chap. 3 in *My Wife, My Daughter, and Poor Mary Ann: Women and Work in Australia* (Melbourne: Nelson, 1975) 29–55.
20. Helen Vellacott, ed., *Stokes, Agnes, A Girl at Government House: An English Girl's Reminiscences "Below Stairs" in Colonial Australia* (South Yarra, Vic.: Currey, 1982).
21. In both Christchurch and Melbourne, for instance, the ladies' committees were sponsored by the Church of England, and the bishops' wives took a major part in their activities.
22. Rye spoke to the Anglicans on 10 June (*Press*, 12 June 1863) and the Wesleyans two days later (*Lyttelton Times*, 17 June 1863).
23. Macdonald 66–67.
24. 23 Nov. 1865, Alicia Jennings diaries, La Trobe Lib., State Lib. of Victoria.
25. Laura A'Beckett, 22 Dec. 1864, quoted in Clarke, 75.
26. Minutes of the Governesses' Home, MS11145, 13 Nov. 1865, in La Trobe Lib., State Lib. of Victoria.
27. Minutes of the Governesses' Home, MS11145, 11 Dec. 1865, in La Trobe Lib., State Lib. of Victoria.
28. Minutes, 11 Dec. 1865.

29. Executive Council minutes, EXE/D32, 7 Mar. 1866, 108–09. Used by permission of the Queensland government. The report was forwarded from Bowen to Cardwell 8 Mar. 1866 in the Governor's Despatches, no. 21, p. 476.
30. On Hawke Bay, see Charlotte Macdonald, *A Woman of Good Character*; on Victoria, Buckingham and Chandos to Sir J.H.T. Manners Sutton, 20 May 1867, Despatches of the Secretary of State to the Governor of Victoria 1084, vol. 5, no. 29, Public Record Office of Victoria.
31. See, in particular, "The Ladies' Club," 7 Jan. 1860, p. 12, on the Reading Room at Langham Place; "The English Governess," 19 Apr. 1862, p. 435; and "Women's Rights," 16 June 1866, p. 715. "Husbands and Wives" (5 Aug. 1865, p. 171) gives the full flavor of the journal's misogyny, containing an argument in favor of husbands controlling their "shrewish" wives, by beating if necessary.
32. "The Export Wife Trade" 276.
33. Smith, 115–17.
34. Isabella McGillivray, quoted in Clarke, 67.
35. Ann Parry, letter to Alice, Dunedin, 15 June 1863, MS 262 Parry Papers, folder 1, 1853–84, Alexander Turnbull Lib., Wellington.
36. Maria Rye, letter to Barbara Bodichon (written from Redfern, Sydney), 20 May 1865, Fawcett Autograph Letters, Guildhall Lib., London.
37. Rye, letter to Bodichon.

"Out of Their Natural Station": Empire and Empowerment in the Emigration of Lower-Middle-Class Women

A. James Hammerton

Most writing about women as emigrants has focused on the two poles of the class structure, the elite and the poor. This was as true of my own book, *Emigrant Gentlewomen*, in 1979 as it has been of much work since.[1] Without doubt these women formed the great majority of female emigrants. They also generated the bulk of the records, as governments fostered the migration of the poor, especially servants, and reformist and philanthropic institutions struggled to help a smaller group of elite casualties of the system, like distressed gentlewomen. But when I wrote about these latter women I was struck by increasing evidence in the later nineteenth century of the presence of a different group of emigrants, from the lower middle class, who sought eagerly to exploit opportunities intended for others and who were well equipped to cope with the rigors of emigration (Hammerton 174–75, 190). A few astute contemporary analysts, like Clara Collet, noticed the importance of these emigrants in British society generally (151–52), but for the most part they were neglected then as they have been in feminist and social history since. Their recovery is long overdue and, at this stage, still largely a matter of unfinished empirical business, but any such project will need to engage with theoretical and historiographical questions that barely touched the surface of historical writing two decades ago.

Although the influence of feminist and poststructural theory on writing about female emigration from Britain has been patchy, there has been a significant transfer of focus from Britain itself, the institutional center of emigrant motivation and recruitment, to the colonial destinations that influenced women's subsequent fortunes.[2] The shift in interest from emigrants to immigrants reflects a more general change of emphasis in the history of imperialism from the center to the periphery, as his-

torians turn to previously marginalized national identities. Only recently has that process been turned on its head, in Catherine Hall's analysis of English national identity in light of the cultural racism born of imperial relationships (*White* 205–09).[3] Such complex linkages have much to offer the study of women migrants, especially of those enthusiastic letter writers of all classes whose representations of their newly adopted homes must have contributed to the constant reimagining of colonies of settlement that was occurring in Britain during the imperial era.

In what follows I would like to canvass several lines of inquiry that I touched on in *Emigrant Gentlewomen* but that warrant further elaboration in consideration of lower-middle-class emigrants. After scrutiny of some class tensions in the relationship between feminism and the rhetoric of female emigration, I will consider some strategies for discovering the lower middle class in Britain. Finally, taking Colonial Australia as an example, I will examine the relevance of the thesis of "emigration as empowerment" for lower-middle-class women. These preliminary explorations might help to prepare the ground for a more ambitious project.

Social Class and the Rhetoric of Female Emigration

Emigrant Gentlewomen highlighted the dichotomy between two different generations of emigration promoters, one motivated by feminist goals, the other by more traditional philanthropic interests. On the surface this seemed plausible enough. From the 1850s to the 1880s the Female Middle Class Emigration Society, a direct outgrowth of the feminist Society for Promoting the Employment of Women, one of the central institutional expressions of the women's movement, single-mindedly pursued the advancement of careers for well-educated middle-class women in the settlement colonies. By contrast their successors, from the 1880s onward, drew their inspiration from philanthropic backgrounds, and although they continued to promote colonial opportunities for middle-class women, their work encompassed aid for a much wider social cross-section of women, including working-class domestic servants. Significantly, the issue of women's suffrage was symptomatic of deeper philosophical divisions in the approaches of these two groups. Ideological differences were also reflected in a more enthusiastic attitude among the philanthropic group toward domestic labor for genteel migrants and the issue of "inducements" for marriage in the colonies (124–78).

The deeper understanding of Victorian and Edwardian feminism gained in the last decade or more demands reassessment of this simple dichotomy (Bush 394).[4] Feminist impulses were evident in various socially conservative movements, like social purity, which rested on fundamental concepts of sexual difference (Walkowitz, *Prostitution* 253–55), so a similar orientation in the discourse of philanthropic emigration promoters is not surprising. In her analysis of female emigration rhetoric, Julia Bush stresses the intermingling of public and private categories and the resulting tensions; concepts of "imperious maternity" and eugenic duty, for example, were fused with women's ambitions in the public sphere. Crucially, she notes that the success of emigration promoters rested on conscious linking of feminist, domestic, and imperial priorities, as they yoked their own goals to the larger mission of Britain's imperial destiny. This strategic placement of women at the center of a male enterprise on a world scale was empowering both for promoters and emigrants, all pioneers in the larger mission of white settlement and racial hegemony (394–405).

Bush is right to stress the wide variation in ideology and background of the women at the helm of the emigration movement in late-Victorian and Edwardian years. It drew support from all sides of the suffrage issue and from women with varied political and social motives (400). At the same time, emphasis on this wide consensus can obscure the real tensions that persisted among the broad coalition of emigration propagandists, as it did among women promoting the wider feminist cause. A glance through the *Imperial Colonist*, the main organ of the emigration societies that published their annual reports and related publications, provides ample evidence of the tensions. Promotion of colonial motherhood for emigrants frequently accompanied an implied or direct criticism of suffrage agitation and wider feminist aims for equal employment and education. One enthusiast for the colonial "lady-help" insisted that women's "natural destiny" was marriage, "whatever may be said by the advanced suffragists," and Viscountess Strangford, noting that "I am told that women look *higher* now," insisted to the Women's Emigration Association in 1881 that there could be no mission so high as to be "the helpmeets of our Men and mothers of our Boys."

Idealization of the colonial mother often depended on derisive reference to the soul-destroying existence of women workers in English offices and schoolrooms, which drove them into the "great feminine unrest" but with no prospect of fulfilment (Dutton 131). Such comments from correspondents clashed with more forthright promotion of

women's employment by the societies' leaders, especially Ellen Joyce, president of the British Women's Emigration Association ("Home Helps"). But from the earliest days of the emigration societies, the suffrage issue had been a catalyst for division; for the emigration pioneer, Maria Rye, it was enough to justify her withdrawal from the Society for Promoting the Employment of Women, and it remained a sensitive issue until 1914, provoking official declarations of disassociation from organizers and some divisions among emigrants themselves (Hammerton 140, 146 n. 75).

For emigration promoters the issue at the center of these disputes concerned the essential goals of female emigration, which were linked closely to questions of class. Paradoxically, while skillful propagandists deployed the prospect of colonial motherhood to decisive advantage, using separate spheres as an instrument to link women to imperial destiny (Bush), sensitivity over charges of "husband hunting" continued to echo in feminist circles. Until the eve of the First World War, the rhetoric of the feminine civilizing mission coexisted with that of the pursuit of colonial careers for educated women with limited prospects in Britain, and the tension between the two goals was evident even outside the emigration societies. Louisa Hubbard, the founding editor of *Work and Leisure*, reflected on the strains in 1882 and concluded that although "match-making mothers and husband-hunting daughters" were "a disgrace to society in England," the greater numbers of men in the colonies meant that the stronger possibility of marriage "is an entirely misplaced argument against Emigration" and left women with greater choice than in England, where the alternative to marriage might be starvation ("Work" 194).[5]

In the late twentieth century, when we are accustomed to the language of difference and diversity in feminist theory and practice, it is easier to understand the tensions that confronted those women, from various political perspectives, who took on the onerous task of emigration promotion and recruitment.[6] Similarly, the seeming paradox of independent women in public advocating a domestic and subordinate female role, for which women like Eliza Lynn Linton and Ellice Hopkins provided ample precedent in the wider society, now seems less surprising (N. Anderson; Walkowitz, *Prostitution* 238). Such women coexisted in the emigration movement with feminists like Caroline Blanchard, whose career as an emigration agent for several colonial governments enabled her to pursue a higher ideal by advancing women's opportunities (Macdonald, "Howard" 204). But if the tensions were nuanced by the unifying

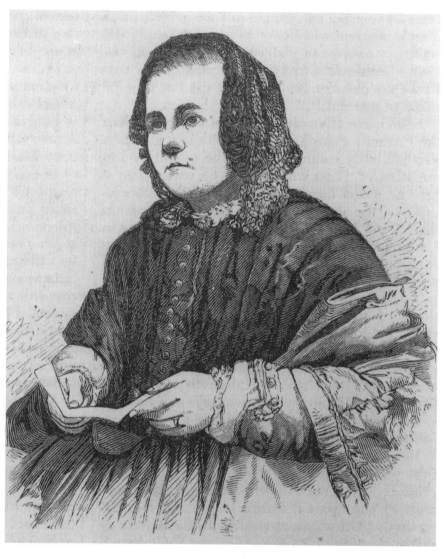

Caroline Chisholm, female emigration leader.
Courtesy of the Library of Congress, Photographs and Prints Division.

ethos of imperial mission, the material grounds for disagreement persisted throughout late-Victorian and Edwardian years; these can be identified most clearly in the wide variation in class backgrounds of the women assisted by the societies.

Throughout the nineteenth century, efforts to facilitate sponsored female emigration to the colonies had been mired in controversy over the most suitably qualified women. This is now a well-known theme in imperial history. Colonial demands for hard-working domestic and rural servants repeatedly clashed with British attempts to use emigration to solve internal social problems, ranging from crowded charitable institutions and workhouses to starving needlewomen and distressed gentlewomen. By late-Victorian years, when many colonies were financing assisted emigration schemes, their insistence on able domestic servants and their loud protests against useless "fine ladies" had been well understood by British societies, which explains the extraordinary lengths to which they went in setting up training institutions for genteel "lady helps" (Hammerton 158–62; 173–74). It also explains the societies' increasing willingness to facilitate the emigration of domestic servants alongside their preferred constituency of educated middle-class women. But working-class servants and impecunious gentlewomen made up only the two extremes of a broad spectrum of potential emigrants. Between them lay a highly mobile range of working-class and lower-middle-class women, who by the 1880s were reasonably well-educated and ambitious and adaptable enough to take advantage of colonial opportunities.

Lower-middle-class emigrants will be examined more fully in the following section, but it is pertinent here to note the complex ways in which emigration rhetoric was shaped by the promoters' awareness of class diversity among the societies' emigrants. Sponsoring "educated women" frequently worked as code for those of gentle birth in reduced circumstances. From the 1860s these remained the first priority of all the societies, but whereas the Female Middle Class Emigration Society of the 1860s and 1870s assisted well-qualified genteel women exclusively, its successors in the 1880s were forced to broaden their focus. Colonial demands for working-class servants, the repeated stress on hard work and adaptability, and the need for women to take up menial work and be prepared to "step down" socially in a rough colonial environment all contributed to the changing process. But lower-middle-class women's increasing willingness to emigrate was central to the societies' success.

Colonial insistence on emigrants' adaptability drove emigration promoters into reluctant admissions that many of their preferred genteel

candidates were simply unsuited to colonial life. "The average Kensington girl is the last person," Eve Grahame insisted, to take up working life in Western Canada (75–77).[7] In 1893, after two decades of promoting women's employment in England, Louisa Hubbard lamented the continued, intractable presence of distressed gentlewomen, or what she called "shiftless, untrained 'incapables,' " the tragic products of deficient education and failing tradition ("Tale" 310). While the societies developed elaborate training homes to enable such women to become domesticated "companion helps" in the colonies, they could not avoid the fact that women of less genteel origins could satisfy colonial demands more readily. Their warnings against the "untrained and incapable" (Perkins, "Openings" 87–88) and overrefined ladies standing on their dignity thus regularly accompanied insistence that the best emigrants were women from households without servants, where they had been used to regular domestic work and could turn their hand to anything a colonial mistress might require. These women might be the daughters of farmers, or even of the poorer clergy, but they came in increasing numbers from the struggling families of shopkeepers, clerks, and the upwardly mobile skilled working-class, who refused to send their daughters into domestic service in Britain. It was a delicate task to keep appeals to these women consistent with the lofty cultural priorities of the more genteel, which complicated the business of emigration rhetoric.

A barely concealed note of class resentment often pervaded discussion of lower-middle-class emigrants, largely because they were seen as indistinguishable from the working class but supplanting more genteel candidates in search of respectable alternatives. Viscountess Strangford, publicizing the Women's Emigration Society for the *Queen*, lamented the "over-education of the lower-classes," which had raised too many girls "out of their natural station, where their hands would find work" into an overflowing class seeking mental work. Some initiatives to provide training to gentlewomen in preparation for emigration were confessedly aimed at women "who do not care to mix with those who attend the classes at the Polytechnics or Technical Day Schools" ("Items" 20). But the business of emigrant recruitment could not afford to alienate potential clients. Lower-middle-class women, like more genteel ladies, needed to be persuaded that the domestic service they and their parents scorned in Britain could be turned to their advantage in the newer colonies without compromising their dignity.[8] Promotional literature stressed the sure success awaiting women where "class distinctions are not," enabling "superior women of all classes" to rise in the social scale through mar-

riage and in turn employ servants themselves (Malmesbury; "Woman's Life"; Clark; Joyce, "On Openings").

If the promotional literature for emigration was cautiously class conscious, the rhetoric of imperial mission scrupulously avoided any such distinction. Although the feminine civilizing mission was especially appropriate to women of gentle birth, who could "raise the tone" of colonial society, the lofty appeals to imperial duty tended to cut across class boundaries (Perkins, "Emigration" 125–28). The impulse to maintain the British empire, imperiled by "the want of British women to build up homes," demanded appeals to all classes of women to help correct the sex disproportion resulting from greater male emigration. But opposition in Britain to the recruitment of scarce, trained, working-class domestic servants drove the societies to appeal to women from a slightly higher class ("Memo"). Ellen Joyce, who was equally prominent as a leader of the BWEA and the Girls' Friendly Society (GFS), regularly stressed that the urgent "call to Empire" was appropriate for women of all classes "who want to be paid for work and can hardly keep body and soul together" ("Thirty Years" 141).

Joyce's close links with the GFS best exemplify the ways in which emigration rhetoric used a universally attractive language to appeal to a mixed social range of women. Her interest in emigration had developed from her early work with the GFS, which catered to working-class and lower-middle-class girls, and she continued to encourage links with its workers throughout her career as president of the BWEA. Joyce astutely adjusted her appeals to match her audience. Addressing the Central Bureau for the Employment of Women at a conference on the "Colonisation of Educated Women," for example, she stressed the "independence of the young woman," intellectual life, and the need for self-sufficiency; the colonial hinterlands were "little more secluded than the Yorkshire village from which Charlotte Brontë flooded the reading world of the fifties," and the empire cried out for cultured women of Brontë's calibre (Joyce, "On Openings" 102). Her regular talks to the GFS, by contrast, blended appeals to self-interest with social duty and self-sacrifice:

> I look upon Imperialism as a means of eradicating the selfishness of
> the individual which Socialism teaches, self for self. I take it that to
> inspire Emigration, to say, go where your comrades want you,
> where the Church wants you, where the Empire wants you, is to
> inspire an unselfish line of thought, whereas if you leave your girls
> to think that they may just as well go to Spanish lands, or Japanese,

or Chinese, because they may get good pay, it places the individual earnings above duty, above Empire, above friendship, above service to God.... Why should we lose power and population by letting our girls drift, when we have such proof of enormous success in Canada? Why should they go to the United States when so many from there are going over to Canada, believing prosperity there to be better secured, divorce much less practiced, and (as parents have told me) the social and loyal atmosphere for children "better to breathe?" ("Imperial" 124–25)

For the GFS Joyce needed to underline those anxieties about income, security, and moral stability that preoccupied both young emigrants and their parents; it would have been unproductive to waste her eloquence on cultural elitism before this audience. But the common denominator in all her propaganda was the appeal to empire, what she called the "science of empire building," in which all classes of women were indispensable ("Thirty Years" 138–39). The "imperial patriotism" of other speakers, too, knew no class boundaries; prospects for both employment and marriage might be conditioned by class background, but all British women held the key to the racial and cultural future of the empire by virtue of their "British citizenship" (Chitty 15–16).[9] The lofty appeal of this language, always eminently quotable, was all the more skillful for its shrewd evasion of the tensions confronting emigration promoters each time they appealed to different audiences.

Discovering the Lower Middle Class in Britain

In their practical day-to-day work, as opposed to their preoccupation with rhetoric, emigration promoters came to acknowledge the importance of lower-middle-class women, but this was masked both by historical preoccupations with the vulnerable gentility and culture of the wellborn and the common language of imperial mission, with its need to accommodate destinies of career and marriage. Historians have yet to probe beyond that camouflage to identify the place of lower-middle-class women in the larger patterns of female emigration, in part because these women have been so difficult to identify.

One of the first difficulties in defining these women is statistical. There is simply no reliable method of identifying lower-middle-class women from occupational data among emigrant records, nor, for that

matter, from more general population statistics. The majority of female emigrants were not listed by occupation; among those who were, the lower middle class might appear with equal frequency under the headings of "Teachers, clerks or professional women" or "Domestic servants" (Ferenczi 635; Hammerton 177). This is only one indication that the lower middle class was a liminal social category mostly defined by its rapid mobility. After midcentury children who entered white-collar occupations might originate from established clerical or shopkeeping families, on the one hand, or from skilled working-class families, on the other; for girls the desire to avoid the domestic service experienced by their mothers could be a powerful motive for entering offices or shops. For adolescents a humble clerical position, say in a warehouse, might be socially indistinguishable from manual occupations in the same workplace, but it could mark the beginning of an administrative career track with higher social status, identity, and marriage prospects.[10] For young emigrants the act of emigration itself could trigger social mobility, and this of course was a constant theme in emigration propaganda.

An additional obstacle to defining the lower-middle-class woman follows from the rhetoric of contemporary reformers. We have already seen the resentment of emigration promoters against upstart women who threatened the work opportunities of their preferred protégées, distressed gentlewomen. The same tendency dominated most Victorian feminist organizations pressing for greater employment opportunities for genteel women. In their analysis of the shortage of reliable domestic servants, for example, they attributed the causes to the modern preference of daughters of "respectable tradesmen, farmers, schoolmasters &c" for less servile occupations, such as nursing, clerkships, "*anything*, in short, rather than 'service'—while our domestics are recruited from the lowest strata" ("Domestic Service" 159–60). As well as being the source of the "servant problem" at home, then, these women were further defined as obstructions to the long and difficult campaign to bring a tone of respectability to old and new occupations, so that women from more elite backgrounds might adopt them. Occasional reminders from colonial correspondents that some governesses were not sufficiently "ladylike" to be treated as "one of the family" by genteel colonists were enough to maintain the discrimination (FMCES, Herbert to Lewin, 8 May 1879). Reformist discourse, sharply at odds with empirical experience, constructed a dichotomy between the deserving genteel and a socially undifferentiated mass of women below them.

Elementary-school teaching, which, through the pupil-teacher system, had long been staffed by working-class and lower-middle-class

women from the ranks, was a prominent and controversial example of where these class tensions flourished, as revealed in journals like Louisa Hubbard's *Work and Leisure*. The education reforms of the 1870s caused rapid expansion in places for elementary teachers, and reformers could not resist deploying arguments in favor of gentlewomen at the expense of existing teachers. Ladies who feared loss of caste by teaching the rough children of workers were reassured that their social position was calculated to "command the respect of their pupils and the confidence and esteem of their parents." Gentlewomen were better fitted to deal successfully with moral questions than women "familiarised with the habits and conversation of the lower orders from childhood." Moreover, the traditional pupil-teacher system defied educational and social principle, since "it is obvious, that the Teachers of each class should be drawn from that above it, rather than fictitiously and laboriously raised from the same" ("Work" 65–71). Teacher-training colleges, like the Bishop Otter Memorial College at Chichester, were set up "exclusively for women of gentle birth" but were only moderately successful in attracting their preferred clientele, and other students of lesser rank had to be accepted; "yet the greatest care is taken that no student shall be admitted with whom any lady could possibly object to associate." Class sensitivities, though, were ultimately assuaged by explicit Ruskinian appeals to the social mission of a "good woman of refinement and wide education … 'to assist in the ordering, the comforting and the beautiful adornment of the State' " ("Ladies" 179–83).

This rhetoric has obvious resemblances, on issues of class consciousness and social mission, to that of the emigration movement and underlines the wider discourse that framed feminist campaigns for employment and education. Whether in the form of imperial duty or social and moral tutelage, a higher destiny promised to shape the future of working women. But the language of noble destiny privileged the genteel over others, even though it was less-wellborn, socially marginal women who most emphatically represented new directions in female employment. A product of this was that lower-middle-class women, while everywhere acknowledged, were largely rendered invisible, defined mainly as upstart nuisances and barriers to the progress of the more deserving middle class. More generally, the late-Victorian and Edwardian New Woman was invariably characterized as a rebellious, young middle-class woman defying genteel conventions, whether through work, politics, or sexual behavior, but rarely as a socially marginal but upwardly mobile woman struggling to make a living (Marks; Cunningham). For these reasons we

are unlikely to hear the voices of lower-middle-class women spoken or represented in reformist discourse.

None of the late-Victorian and Edwardian stereotypes that depicted the lower middle class were flattering, but the most popular representations referred overwhelmingly to men. They were constructed predominantly through satire, most famously in the Grossmith brothers' Mr Pooter in *The Diary of a Nobody*. At work a dependent, deferential bank clerk, at home a pompous, pretentious but ineffectual suburban husband and father, Pooter was the butt of affectionate fun largely because of his feminized qualities, which is precisely what attracted the scorn of those socially above and below him. The female counterparts of Charles Pooter were less conspicuous, invariably married rather than single, and they drew more generally on satirical images of women rather than on sharply observed class-specific features. The figure of woman as archconsumer, the "shopping-doll" bent on spending beyond her husband's hard-earned but inadequate means, dominated both popular cartoon images and more critical commentary on suburban living.[11] These images complemented more traditional preoccupations with the nagging wife, whose assertive behavior violated the presumed harmony of separate spheres and underlined the diminished manhood of the lower-middle-class husband in his lack of mastery and independence (Crosland 48–57). But before the 1920s there was no stereotype of the lower-middle-class single workingwoman to match these cutting popular images. More serious commentators tended to stress the "soul-destroying" existence of the overworked office girl either to highlight the more general "degeneration" of modern life that diverted women from their biological destiny or, like emigration promoters, to reinforce the attractions of a more congenial goal like emigration (Dutton 131–32).

The sources used in most histories of female emigration have so far yielded little in the way of direct lower-middle-class testimony, probably because such testimony has not been high on the research agenda. Some encouraging work on assisted working-class immigrants to Australia, which highlights their resistance to official constructions of themselves as either shiftless, submissive victims or refractory schemers in need of control, points to strategies that might illuminate the agency and identities of lower-middle-class immigrants (Gothard).[12] Gothard found that even among assisted immigrants to Western Australia in the 1890s—all putatively servants—their level of wealth and literacy varied widely, and their heterogeneous class composition is reinforced by sources of direct testimony (112–15).[13]

British publications that catered primarily to a lower-middle-class readership convey a sense of the special place of emigration in their thinking, as readers expressed anxieties that they felt—rightly or wrongly—were unique to themselves. A revealing example is the extensive debate in the *Daily Telegraph* in 1868 dubbed "Marriage or Celibacy?" (Robson). The difficulty of achieving prudent, respectable marriage on a marginal income was the main focus of the debate for correspondents, male and female, until the dynamic of the discourse transformed it into a question of "Emigration or Starvation?" Much of the discussion, larded with ample citation of success stories, turned on the prospects for humble male clerks to prove their manhood in the colonies and thus marry comfortably (194–240). But the panacea of migration was offered with equal enthusiasm to women; in the words of the male correspondent, "Kangaroo":

> Emigrate. Don't waste your time in an over-crowded country like this. Good as it is, there are many better for you; therefore if you meet with an opportunity of going in company with a respectable family to South Australia or Victoria, go, and I will answer for it you will find plenty of employment and also plenty of competition for your fair selves among men who have not to count your cost before proposing, and who think a fair loving English girl a most precious and priceless blessing, as he does who subscribes himself *Kangaroo*. (194)

Such rhetoric was not so different from that of the female emigration societies and was equally depersonalizing of the subject, but its context was anchored in class-specific material realities of the lower middle class.[14]

One need not look far among the reputed "over-crowded" new occupations in Britain to find evidence of these lower-middle-class women that runs counter to dominant constructions. Evidence from the workplace is contradictory, tending to highlight low work expectations alongside drive and independence;[15] women also betrayed underlying anxieties about preserving their respectability, potentially undermined by cross-class association. In 1865, to assist him in preparing a manuscript for publication, the diarist Arthur Munby employed a woman who had worked for a higher wage as a law stationer's clerk:

> She was a young woman of 23 or so, respectable and decently drest; a Cockney girl however with something of the pertness and sham

gentility of the species.... Said she liked copying very much; had worked for Kerr the law stationer, who keeps 29 female hands, and earned 20/- a week; more than she gets now, but Kerr's girls were low and 'larky,' she did not like them.... [S]he lives with her married sister in Pentonville. I gave her a ticket for the Working Women's College meeting next Thursday: would like to go: means to learn *mapping*. Her quiet unconcern at being in my chambers was amusing. (Hudson 209)[16]

These were precisely the kinds of women who might decide to emigrate later in the century if employment conditions deteriorated or if family connections yielded knowledgeable promise of overseas opportunity.

A more fully rounded picture of both career and character can emerge from diaries, letters, and memoirs, even though they are not as plentiful for the lower middle class as for the more prosperous. The papers of Ruth Slate and Eva Slawson from 1897 to 1917 provide a rare example (T. Thompson). Both came from lower-middle-class Methodist backgrounds of earnest, hard-working respectability. Ruth's father was an insecure commercial clerk, and Eva was illegitimate and adopted by her grandparents, her grandfather being a master baker who fell deeply into debt. Their own careers illustrated the economic marginality that allowed them to move easily in manual or white-collar directions. Ruth moved from manual packing to clerical work; Eva, by dint of early training, from domestic service to typing. Most striking, though, is the intellectual and personal life that they pursued with single-minded resolution. Both inherited the long nineteenth-century working-class dynamic of social and cultural self-improvement, most directly traceable to devout nonconformist religious involvement; they shared and discussed their discoveries of contemporary and classic works of fiction and social commentary. And despite limited career success they were enthusiastic supporters of late-Victorian and Edwardian feminist campaigns, especially of the nonmilitant suffrage movement. Without the participation of such women, like the "lady clerks" who thronged London suffrage marches, the rank and file of the movement would have been less substantial (148–88). And in Ruth's case the influence of this greater independence and idealism in work and politics was enough to prompt her to demand a more equal partnership from prospective marriage partners (107–47).

The limited amount of work to date on lower-middle-class women in Britain at least establishes that by the late nineteenth century they were energetically consolidating their respectable status and striving for greater

degrees of independence in public and private life. Whether in elementary teaching, nursing, clerical and shop work, or the lower reaches of the civil service, they had less to lose than the more genteel in their drive for economic security (Widdowson). Moreover, evidence from breach of promise cases shows them to have been in the forefront of those women who demanded, and obtained, recompense from disloyal fiancés (Frost). Their standard of assertiveness and ambition was high, and their place in what has been called a "revolution without generals," for example in taking the initiative in birth control, was no doubt far more central than has been acknowledged (Allen, "Contextualising" 35).[17]

It is worth asking what difference these women made to the pattern and consequences of female emigration, since to date we have little more than general acknowledgement of their participation in a mass movement. For further enlightenment we need to turn to their experience in colonial destinations, where the evidence so far has been slow to appear. Simply identifying these women as a distinct social class is difficult in those colonial societies where class structures were often less visible and less important than in Britain (Ward 6–8, 174–75). Moreover the whole enterprise might be objected to on prima facie grounds that social stratification approaches are inappropriate for women who may not have shared the class identities of their fathers or husbands, although such objections take no account of cultural identities (Macdonald, A Woman 149). At the very least, it would be useful to establish whether the kind of upward social mobility and ambition that distinguished these women in Britain continued after emigration. It may be that the grand visions of upward mobility for women through marriage, which emigration propaganda promised and some elite commentators deplored (Twopeny 108), may have gone unrealized, as Charlotte Macdonald found for mid-Victorian New Zealand (A Woman 145–49). But this needs to be tested together with the more general New World boast of occupational, social, and economic mobility.

Empire and Empowerment
for the Lower Middle Class?

It would be useful, first, to test the relevance to lower-middle-class emigrants of aspects of the conventional wisdom in existing emigration literature. In recent work on women and the empire, a powerful theme has

developed of imperialism as a force of empowerment for women (Burton). Feminists embraced the concept of imperial mission as a part of their own burden and as a ground for legitimating their claims to equal citizenship (207–08). The capacity of the imperial relationship to enable women to transgress the confines of feminine constructions of dependence and innocence was certainly extensive. The cross-cultural relationship was central to this construction. As early as the Indian Mutiny, Palmerston and others praised those Anglo-Indian women who were reputed to have resisted, with "manly" courage, Sepoy mutineers bent on rape and murder (Dawson 92, 308 n. 50).[18] And the imperial identity of British feminists enabled them to adopt the mission of saving Indian women as a key sphere for the exercise of their own moral authority (Burton).

The relevance of this empowerment thesis to lower-middle-class emigrants is uncertain. The feminist imperial identity drew on the activity of elites, as did the bulk of the emigrationists' rhetoric explored previously in this essay. Imperial motherhood beckoned elite British women to civilize the empire generally and colonial men in particular (Bush).[19] But this begs several questions both about the experience of nonelite emigrant women in colonial life and about their relationships with indigenous populations, on which the literature of female emigration is mostly silent.

To a degree all British migrants were privileged by the imperial relationship that displaced indigenous populations and defined them as uncivilized and in need of rescue, Christianization, or control. For migrant populations this was mostly unaffected by the nineteenth-century evolution in racial attitudes, from early Evangelical constructions of Europeans' moral superiority to midcentury assertions of native populations' biological inferiority (Hall, "From Greenland," *White* 208–09; Lorimer 131–61). Only in South Africa, where there was routine household contact, have the relationships between female immigrants and native populations been scrutinized in detail. In that case women's civilizing mission proved to be a less potent influence than racial tensions between black and unskilled white workers, which accelerated white women's hostility to and retreat from manual work (Swaisland 162). An underclass of cheap black labor benefited white women emigrants of all classes, and their imperial civilizing mission was aimed instead at neutralizing the influence of the Boer population (42–43).

In other colonial destinations the relationship between women immigrants and indigenous populations was less clear-cut, as the Australian example suggests. Letters from single middle-class immigrants in Aus-

tralia, for example, are notable for their silence on contact with Aborigines. Among all the Australian immigrants corresponding with the Female Middle Class Emigration Society in the '60s and '70s, only one, Maria Barrow, chose to comment on the presence of the Aborigines, in typically negative terms. Noting that a "great party of Natives" had eaten dinner outside "within a stone's throw" of the house in the Melbourne rural suburb of South Yarra, she described them as "very ugly and old, the women particularly, and I was rather afraid of them, however, they appear to be quite harmless" (FMCES 17 Feb. 1862). Her sister immigrants who wrote from farm stations must have had more regular contact and observation yet chose never to mention it in their otherwise newsworthy letters. Without knowing the local conditions of race relations in these communities it is difficult to interrogate this overwhelming silence. In frontier districts the conditions were similar to those in South Africa; Aboriginal women often held responsible domestic positions, such as housekeepers, rendering domestic space a site of routine contestation.[20] But Aborigines were more likely to be irrelevant to the daily circumstances and livelihood of white governesses and women in the towns and suburbs. Unlike black South Africans, Australian Aborigines posed little direct competitive threat to urban women and seem to have occasioned little more than mild curiosity, fear, and a preoccupation with physical difference.

Earlier women settlers, especially when married, had recorded more regular contact. From the earliest days of white occupation in the region around Melbourne, which was only settled in the 1830s, women acknowledged close daily contact with local tribes. As wives of station owners, often left alone to manage a primitive house and station during husbands' prolonged absences, these women needed to develop close relations of reciprocity and negotiation with Aborigines. At the same time as the extensive slaughter and control that followed early settlement, some women developed relationships with Aborigines that embodied both the customary paternalism born of class and racial arrogance and a subtle respect stemming from the dictates of day-to-day coexistence.[21]

Katherine Kirkland's experience serves as an instructive example. In the late 1830s, she settled with her husband near Geelong, about fifty miles southwest of Melbourne, and had daily contact with local tribespeople. Her account includes her family's employment of Aborigines to mind livestock, sheep-stealing incidents, and close descriptions of native beliefs, rituals, and hospitality (Kirkland 177–214). Although some

encounters provoked fear of attack by the Aborigines, Kirkland carefully distanced herself from the more extreme fears of her servant (177–78). Her characteristically patronizing descriptions dwelt on native laziness and brutality, especially of men, whose treatment of women and children struck her as unmanly, although her disgust with their behavior was exceeded by that for the "dirty and uncomfortable" life adopted ostentatiously by the white male settlers (176, 179–80, 190–91, 197). The subtle mix of toleration and hostility embodied in her paternalism was best illustrated by her initial amusement at her four-year-old daughter's easy association with local Aborigines and her relief when they later moved to Melbourne, enabling her to "pay more attention to Agnes," who was "almost running wild" (179, 204).

Kirkland's ambivalence typifies the attitudes of many early women settlers whose prejudices were mediated by the experience of routine contact.[22] But with increasing urbanization and concentration of white immigrant populations in the cities and towns, women's opportunities for personal contact diminished sharply, leaving them with few resources to question prevailing racial attitudes, which hardened in Australia during the century as they did in England.[23] This applied especially to lower-middle-class women who, if they turned initially to domestic service out of necessity, rapidly moved into the widening opportunities for shop and white-collar work in the cities and for residence in the suburbs, insulated from the presence of what white Australia increasingly characterized as a "dying race" (Broome 120–23). Their silence about a relationship that was a precondition of their own prosperity is in this sense understandable.

Beyond cross-cultural contact it becomes difficult to assess relative degrees of empowerment for women migrants, and we still lack the empirical research to establish to what extent lower-middle-class women may have experienced the urban colonial workplace as empowering. Contemporary accounts that construct the workplace for these women tend to focus on domestic service, which was most visible and mattered most to the middle class as employers. In Australia, in particular, colonial egalitarianism for women was frequently interpreted simply as greater bargaining power, and refractory behavior of servants, a sign, perhaps, of increased scope for negotiation accruing to single women (Trollope 474–75; Twopeny 49–62; Kingston 30). This is consistent with emigration propaganda that held out the prospect of rapid graduation to higher status through work or marriage (Hammerton 148–78).[24] But application of these findings to women in other occupations remains to be

demonstrated.[25] Competition for the limited number of white-collar positions sought by the lower middle class in Australian cities tended to depress wages and conditions as it had in Britain, but comments on these trends by women observers were optimistic, concluding that Australian women enjoyed greater "freedom and independence" than their "English sisters" (Alexander 171–72). Celebration of the success and independence of the "business girl" was coupled with criticisms of her obsession with dress, reflecting upper-class anxieties about the moral consequences of independence (Ackermann 289–91).

It is easy to overstate this greater colonial freedom. Despite its regular trumpeting in emigration propaganda, colonial job prospects attractive to the lower middle class were limited in number, although they followed similar paths to those in British cities, as in postal and telegraph offices (McCuskey 51). Some feminist scholars have suggested that compared to Australia, Britain presented a greater range of work opportunities and also presented the stronger possibility of a "culture of spinsterhood," where there was a preponderance of women and lower marriage and fertility rates (Allen, *Sex* 4). But most recent research on the early development of female white-collar work in Britain has stressed the oppressiveness and limitations stemming from rigorous gender segregation (Jordan).[26] Similar restrictions in Australia may have meant that there was little difference between British and Australian working conditions (Deacon 152–203).[27] Those less tangible areas stressed by contemporaries, like greater "freedom and independence," may therefore tell us more about relative, general conditions than about the workplace *per se.* But if we are to take the propagandists at their word we should also revisit colonial marriage and motherhood, which they promoted as the ultimate source of fulfillment for all classes of women migrants.

Assumptions that women's emancipation through colonial life meant more fulfilling marriage and motherhood extended well beyond the world of emigration promoters and were directed as much at lower-middle-class women as at others. Shan Bullock's 1907 novel, *Robert Thorne: The Story of a London Clerk*, plays on the oppressive nature of white-collar work in London for both men and women and finally sends Robert and his wife, Nell, off to New Zealand, where they could become "real men and women" (278, 288–91). "Real women," in Bullock's popular reading, were those freed from the pressures of competitive life in England to pursue the laborious but simple career of colonial motherhood. Women's empowerment in this rural idyll was that of a preindustrial freedom to preside over a productive and nurturing

domestic center. But it bore little relationship to the material realities of colonial marriage.

By the time Bullock was writing, the colonial destiny for most immigrant women was the town or suburb, where family structures and relationships were not radically different from those in Britain. This was particularly the case in Australia (Davison 12–14, 138–40, 153); in the new suburbs the ideals of domesticity could flourish across a broad class spectrum.[28] Contemporaries stressed the firm hold of separate spheres and patriarchal authority, although comments on colonial difference ranged from the more thorough practice of companionate marriage and closer conjugal intimacy to wives' more determined "management" of their husbands (Ackermann 76–80; Twopeny 100–02). By the 1880s, the intense promotion of suburban lifestyles and home ownership attracted lower-middle-class families along with artisans and professionals, and while modest incomes limited the realization of the wilder promises, family budgets point to a generally higher standard of living than in British towns (Davison 137–55, 190–201). Much of the propaganda was targeted directly at those on marginal incomes with status anxieties and held out the promise of material prosperity undreamed of in Britain, so that, in the words of one marriage guide for women, "persons on moderate incomes could live life free from sordid surroundings without straining for false appearances" (Old Housekeeper 16). Social mobility, for women as well as men, was steady enough to give some credence to the propaganda of instant success (Fahey 98–100).

There is no consensus among Australian historians as to whether differences in colonial marriage practices worked to women's relative advantage or disadvantage, but there is little question that intense privatization of a predominantly suburban nuclear family, attractive to lower-middle-class immigrants, had developed by the last quarter of the nineteenth century (Grimshaw and Willett). Whether favorable social and economic conditions and the relatively high status given to women's domestic role created a receptive climate in Australia for liberal ideas conducive to women's political rights has still to be established (Grimshaw, "Women" 419–21). Strong family structures, kin networks, and family-centered ideologies did enhance the status of suburban housewives, even while they more firmly entrenched the gendered segregation of public and private spheres. In both Australia and New Zealand these features have been used to explain the earlier winning of the suffrage and strong feminist reform programs, like those in favor of temperance, property rights, and the "endowment of motherhood" (Grimshaw,

"Women" 418–21; Dalziel).[29] The meaning of both the "greater status" of marriage and motherhood and its political consequences have still to be fully interrogated, especially for those women on the margins of the middle class who embodied Victorian ideals of self-improvement. But the evidence that an upwardly mobile trajectory inspired women's commitment to feminist causes is persuasive.[30]

Lower-middle-class women were never central to the projects of either emigrationists or colonial governments. Reformers intent on helping other classes of women tended to ignore lower-middle-class women or dismiss them as irritants. Their invisibility as emigrants stemmed from this disregard as well as from their marginal class identity and flexible approach to employment. Yet the powerful rhetoric that persuaded women to emigrate was shaped in part by the ambitious presence of women from the lower middle class. They adapted well to the increasingly suburban and socially mobile lifestyles beginning to dominate urban colonial societies by late-Victorian years, and they may have played a larger role in feminist reform movements than we have allowed. Their underrepresentation in empirical research on emigration continues to obscure their identity, and their recovery in the dynamics of emigration and empire should have implications for both colonial and British identities if it can, in Hall's words, complicate "the relation between centre and margin" (*White* 206). Lower-middle-class emigrants undoubtedly carried a tangle of class consciousness, material ambition, and ideals of self-improvement in their cultural baggage. By the early twentieth century, in an international climate where suburban identities were becoming increasingly common across the class spectrum, perceptions of greater freedom and opportunity for women in colonies of settlement may have affected British self-awareness, just as, in Australia, the image of the "workingman's paradise" influenced British political discourse. Because suburban identities were so deeply gendered and tended to legitimate traditionally gendered notions of separate spheres, just at the moment when they were coming under scrutiny, the center-periphery interrelationship was probably more complex than we have allowed.

Notes

1. For representative examples see Bush; Jackel; Clarke; Hamilton; and Gothard.
2. See, for example, Swaisland; Jackel; Clarke; MacDonald, *A Woman*; and Curtin.
3. See also Burton.

4. Some of the defining texts are Levine; Kent; and Holton.
5. The issue was debated regularly in the *Imperial Colonist*, such as in "A Word to Our Country Workers."
6. On difference in feminism see Hirsch and Keller.
7. Johnson stressed the prejudice against the term "lady-help" in Natal, "the limp dreary creature, lacking energy and backbone, whose chief aim in life it is to convince her employer that she has seen better days" (42–44).
8. Society workers discussing parties of working-class emigrants often alluded to "girls who had thought themselves rather above the position of servants in England" but who accepted situations as nursemaids after emigration (Atkins 12–13).
9. Interestingly the value of female citizenship was here asserted as a natural possession of all women of British birth at the very time when political citizenship was being demanded by suffrage activists.
10. For a striking example see the career of Ruth Slate (T. Thompson 3–4).
11. On "shopping dolls," a term first coined by Karl Pearson, see Walkowitz, *City* 150; on woman as the "consuming subject" see Richards 205–06. Elaboration of the scorning discourse of lower-middle-class suburbia can be found in Crosland.
12. For similar strategies in the study of working-class emigrants to New Zealand, see Macdonald *A Woman*.
13. A list of emigrants' private possessions that was compiled following a fire on the S. S. Port Phillip, bound for Western Australia in 1896, indicated sharp disparities among women who were categorized uniformly as servants. The goods of one woman included the works of Tennyson and Goldsmith (Gothard 112–13).
14. The *Daily Telegraph* was a classic example of a national newspaper with a large lower-middle-class readership, although not exclusively so. Later examples that shared a working-class readership reflected a greater interest in leisure, such as *Pearson's Weekly* and *Tit-Bits*.
15. On low work expectations see Lewis 44.
16. For discussion of this episode and the general position of women clerks, see Zimmeck; and G. Anderson. Munby taught at the Working Women's College in Queen's Square, Bloomsbury. He described an earlier encounter in a Soho dancing room in 1863 with a "lady clerk" whose social background remained uncertain (Hudson 155–57). Munby's discussion of these encounters are a salutary reminder that not all of his observations were driven by obsessions with women immersed in dirt and drudgery, themes stressed by McClintock (75–180); the ticket he gave his copyist for the Working Women's College Meeting was in character with the paternalistic influence he attempted to exert over working-class women, but he was also collaborating in her drive for upward mobility. Flora Thompson's career move from a poor family in Oxfordshire to a town post office indicates similar possibilities of social mobility for rural women (F. Thompson). On gentility and women's office work see Lewis 42–43; and Jordan.
17. Patricia Branca's work two decades ago on the role of the middle-class wife in pioneering modern methods of household management, birth control, and child-rearing was based predominantly on evidence of lower-middle-class women, but there has been no substantive work since that attempts to investigate these married women in greater depth.
18. On rape and the Indian Mutiny more generally, see Paxton.

19. On the oppressive implications of the discourse of imperialism for women in Britain, see Davin.
20. See, for example, Bennett 162–63.
21. On dispossession and slaughter of Aborigines see Reynolds; Broome; Markus. For a general discussion of white women's oppression of Aboriginal women, see Huggins and Blake 53–58.
22. For similar examples see Bride 77, 161–62, 314; Moore 146; Priddle 32; L. Frost 151–55, 170; and Durack 43, 112–13.
23. The general indifference was reflected in contemporary texts (e.g., Alexander) on Australian women, which praised white "pioneers" but ignored Aboriginal women. On hardening of racial attitudes in Australia see Broome 87–94 and Markus 16–17.
24. The improvement in conditions has been challenged by several Australian historians, such as Kingston 137–40.
25. The "double burden" of "home and public work," which some women commentators considered uniquely heavy in Australia, was drawn largely from observation of the servant shortage among the upper and middle classes but had implications for the domestic labor of lower-middle-class women (Kingston 18–20).
26. See also Lewis; Dohrn; Zimmeck; and Cohn.
27. Deacon discusses a short-lived innovation in the New South Wales civil service of more egalitarian white-collar opportunities for women from the 1880s to the turn of the century; but the official recognition in Australia of a "family wage," earned by a male breadwinner, undercut women's opportunities more generally (196–98).
28. On the discursive contest in late-nineteenth-century Australia between a masculinist and feminized culture, see Lake, "Politics." The debate had important implications for the status of suburban domesticity and marital relationships.
29. On the movement for maternal or child endowment in Australia, see Lake, "Mission."
30. See, for example, Grimshaw, "Bessie." The Australian cases mirror those in Britain, such as Ruth Slate and Eva Slawson (T. Thompson).

Works Cited

Ackermann, Jessie. *Australia from a Woman's Point of View.* London: Cassell, 1913.
Alexander, Mrs. Hirst. "Women of Australasia." 1900. *Freedom Bound I: Documents on Women in Colonial Australia.* Ed. Marian Quartly, Susan Janson, and Patricia Grimshaw. St. Leonards, NSW: Allen, 1995. 169–73.
Allen, Judith. "Contextualising Late-Nineteenth Century Feminism: Problems and Comparisons." *Journal of the Canadian Historical Association* ns 1 (1990): 17–36.
Allen, Judith. *Sex and Secrets: Crimes Involving Australian Women since 1880.* Melbourne: Oxford UP, 1990.
Anderson, Gregory, ed. *The White-Blouse Revolution: Female Office Workers since 1870.* Manchester, Eng.: Manchester UP, 1988.
Anderson, Nancy Fix. *Woman against Women in Victorian England: A Life of Eliza Lynn Linton.* Bloomington: Indiana UP, 1987.
Atkins, "Miss." "Account of a Journey to Canada." *Annual Report.* London: British Women's Emigration Association, 1888. 12–13.

Bennett, Mary M. *Christison of Lammermoor*. London: Alston, 1927.

Branca, Patricia. *Silent Sisterhood: Middle-Class Women in the Victorian Home*. London: Croom, 1975.

Bride, Thomas Francis, ed. *Letters from Victorian Pioneers*. Melbourne: Heinemann, 1969.

Broome, Richard. *Aboriginal Australians: Black Responses to White Dominance, 1788–1994*. Sydney: Allen, 1994.

Bullock, Shan. *Robert Thorne: The Story of a London Clerk*. London: Werner, 1907.

Burton, Antoinette. *Burdens of History: British Feminists, Indian Women, and Imperial Culture, 1865–1915*. Chapel Hill: U of North Carolina P, 1994.

Bush, Julia. " 'The Right Sort of Woman': Female Emigrators and Emigration to the British Empire, 1890–1910." *Women's History Review* 3.3 (1994): 385–409.

Chitty, "Miss." "Imperial Patriotism." *Imperial Colonist* 3.26 (Feb. 1904): 15–16.

Clark, Georgina B. "Are Educated Women Wanted in Canada?" *Imperial Colonist* 8.98 (Feb. 1910): 22–24.

Clarke, Patricia. *The Governesses: Letters from the Colonies, 1862–1882*. Melbourne: Hutchison, 1985.

Cohn, Samuel. *The Process of Occupational Sex-Typing: The Feminization of Clerical Labor in Great Britain*. Philadelphia: Temple UP, 1985.

Crosland, Thomas William Hodgson. *The Suburbans*. London: Lang, 1905.

Cunningham, Gail. *The New Woman and the Victorian Novel*. London: Macmillan, 1978.

Curtin, Emma. " 'In Awe of Mrs Grundy': British Gentility and Emigrant Gentlewomen in Australia." Diss. La Trobe Univ., Melbourne, 1995.

Dalziel, Raewyn. "The Colonial Helpmeet: Women's Role and the Vote in Nineteenth Century New Zealand." *New Zealand Journal of History* 11.2 (Oct. 1977): 112–23.

Davin, Anna. "Imperialism and Motherhood." *History Workshop* 5 (1978): 9–65.

Davison, Graeme. *The Rise and Fall of Marvellous Melbourne*. Melbourne: Melbourne UP, 1978.

Dawson, Graham. *Soldier Heroes: British Adventure, Empire and the Imagining of Masculinities*. London: Routledge, 1994.

Deacon, Desley. *Managing Gender: The State, the New Middle-Class and Women Workers, 1830–1930*. Melbourne: Oxford UP, 1989.

Dohrn, Susanne. "Pioneers in a Dead-End Profession: The First Women Clerks in Banks and Insurance Companies." *The White-Blouse Revolution: Female Office Workers since 1870*. Ed. Gregory Anderson. Manchester, Eng.: Manchester UP, 1988. 48–66.

"Domestic Service." *Work and Leisure* 1886: 159–60.

Durack, Mary. *Kings in Grass Castles*. 2nd ed. Victoria: Hawthorn, 1974.

Dutton, Piers. "Rhodesia for Women: Town Life." *Imperial Colonist* 11.139 (Aug. 1913): 131–32.

Fahey, Charles, Patricia Grimshaw, and Melanie Raymond. "The Other Side of 'Marvellous Melbourne.' " *Colonial Frontiers and Family Fortunes*. Ed. Jane Beer, Charles Fahey, Patricia Grimshaw, and Melanie Raymond. Melbourne: U of Melbourne, 1989. 81–156.

Female Middle Class Emigration Society. Letter books. Fawcett Library, Guildhall U, London.

Ferenczi, I., and Wilcox, eds. *International Migration*, 2 vols. (New York: Gordon, 1969).

Frost, Ginger. *Promises Broken: Courtship, Class and Gender in Victorian England.* Charlottesville: UP of Virginia, 1995.

Frost, Lucy. *No Place for a Nervous Lady.* Fitzroy, Vic.: McPhee-Gribble/Penguin, 1984.

Gothard, Janice. " 'Pity the Poor Immigrant': Assisted Female Migration to Colonial Australia." *Poor Australian Immigrants in the Nineteenth Century.* Ed. Eric Richards. Canberra: Australian Natl. U, 1992. 97–116.

Grahame, Eve. "Women Who Can Do Things." *Imperial Colonist* 12.148 (May 1914): 75–77.

Grimshaw, Patricia. "Bessie Harrison Lee and the Fight for Voluntary Motherhood." *Double Time: Women in Victoria—150 Years.* Ed. Marilyn Lake and Farley Kelly. Ringwood, Victoria, Austral.: Penguin, 1985. 139–47.

———. "Women and the Family in Australian History—A Reply to *The Real Matilda.*" *Historical Studies* 18.72 (Apr. 1979): 412–21.

Grimshaw, Patricia, and Graham Willett. "Women's History and Family History: An Exploration of Colonial Family Structure." *Australian Women: Feminist Perspectives.* Eds. Norma Grieve and Patricia Grimshaw. Melbourne: Oxford UP, 1981. 134–55.

Grossmith, George, and Weedon Grossmith. *The Diary of a Nobody.* 1892. London: Penguin, 1965.

Hall, Catherine. " 'From Greenland's Icy Mountains ... to Africa's Golden Sand': Ethnicity, Race and Nation in Mid-Nineteenth Century England." *Gender and History* 5.2 (Summer 1993): 212–30.

———. *White, Male and Middle-Class: Explorations in Feminism and History.* Cambridge: Polity, 1992.

Hamilton, Paula. "The 'Servant Class': Poor Female Migration to Australia in the Nineteenth Century." *Poor Australian Immigrants in the Nineteenth Century.* Ed. Eric Richards. Canberra: Australian Natl. U, 1992. 117–31.

Hammerton, A. James. *Emigrant Gentlewomen: Genteel Poverty and Female Emigration, 1830–1914.* London: Croom, 1979.

Hirsch, Marianne, and Evelyn Fox Keller, eds. *Conflicts in Feminism.* New York: Routledge, 1990.

Holton, Sandra. *Feminism and Democracy: Women's Suffrage and Reform Politics in Britain, 1900–1918.* Cambridge: Cambridge UP, 1986.

Hubbard, Louisa M. "Tale." *Work and Leisure* Dec. 1893: 309–26.

———. "Work and Leisure Reporter." *Work and Leisure* 1882: 193–98.

Hudson, Derek, ed. *Munby, Man of Two Worlds: The Life and Diaries of Arthur J. Munby, 1828–1910.* London: Abacus, 1974.

Huggins, Jackie, and Thom Blake. "Protection or Persecution? Gender Relations in the Era of Racial Segregation." *Gender Relations in Australia: Domination and Negotiation.* Ed. Kay Saunders and Ray Evans. Sydney: HBJ, 1992. 42–58.

"Items of Interest." *Imperial Colonist* 3.26 (Feb. 1904): 20–23.

Jackel, Susan, ed. *A Flannel Shirt and Liberty: British Emigrant Gentlewomen to the Canadian West, 1880–1914.* Vancouver: U of British Columbia P, 1982.

Johnson, "Miss." "Domestic Helps in Natal." *Imperial Colonist* 2.4 (Apr. 1903): 42–44.

Jordan, Ellen. "The Lady Clerks at the Prudential: The Beginning of Vertical Segregation by Sex in Clerical Work in Nineteenth-Century Britain." *Gender and History* 8.1 (Apr. 1996): 65–81.

Joyce, Ellen. "Home Helps." *Imperial Colonist* 5.58 (Oct. 1906): 148–50.

————. "The Imperial Aspect of Girls' Friendly Society Emigration." *Imperial Colonist* 11.139 (Aug. 1913): 123–31.

————. "On Openings for Educated Women in Canada." *Imperial Colonist* 5.55 (July 1906): 100–04.

————. "Thirty Years of Girls' Friendly Society Imperial Work." *Imperial Colonist* 10.128 (Aug. 1912): 138–41.

Kent, Susan K. *Sex and Suffrage in Britain, 1860–1914*. Princeton: Princeton UP, 1987.

Kingston, Beverley. *My Wife, My Daughter, and Poor Mary Ann: Women and Work in Australia*. Melbourne: Nelson, 1975.

Kirkland, Katharine. "Life in the Bush." *The Flowers of the Field*. Ed. Hugh Anderson. Melbourne: Hill of Content, 1969. 173–214.

"Ladies as Elementary Schoolmistresses." *Work and Leisure* 1890: 179–83.

Lake, Marilyn. "Mission Impossible: How Men Gave Birth to the Australian Nation — Nationalism, Gender and Other Seminal Acts." *Gender and History* 4.3 (Autumn 1992): 305–22.

————. "The Politics of Respectability: Identifying the Masculinist Context." *Historical Studies* 22.86 (Apr. 1986): 116–31.

Levine, Philippa. *Feminist Lives in Victorian England: Private Roles and Public Commitment*. Oxford: Blackwell, 1990.

Lewis, Jane E. "Women Clerical Workers in the Late Nineteenth and Twentieth Centuries." *The White-Blouse Revolution: Female Office Workers Since 1870*. Ed. Gregory Anderson. Manchester, Eng.: Manchester UP, 1988. 27–47.

Lorimer, Douglas A. *Colour, Class and the Victorians: English Attitudes to the Negro in the Mid-Nineteenth Century*. Leicester, Eng.: Leicester UP, 1978.

Macdonald, Charlotte. "Howard, Caroline Cadette [later Blanchard]." *The Dictionary of New Zealand Biography*. Vol. 1. Wellington: Allen, 1990. 204–05.

————. *A Woman of Good Character: Single Women as Immigrant Settlers in Nineteenth-Century New Zealand*. Wellington: Allen, 1990.

Malmesbury, Susan, Countess of. "The Future of South Africa." *Imperial Colonist* 1.2 (Feb. 1902): 10–11.

Marks, Patricia. *Bicycles, Bangs and Bloomers: The New Woman in the Popular Press*. Lexington: U of Kentucky P, 1990.

Markus, Andrew. *Australian Race Relations, 1788–1993*. Sydney: Allen, 1994.

McClintock, Anne. *Imperial Leather: Race, Gender, and Sexuality in the Colonial Contest*. New York: Routledge, 1995.

McCuskey, Claire. "Women in the Victorian Post Office." *Worth Her Salt: Women at Work in Australia*. Ed. Margaret Bevege, Margaret James, and Carmel Shute. Sydney: Hale, 1982. 49–61.

"Memo." *Imperial Colonist* 9.116 (Aug. 1911): 346–48.

Moore, David R. *Islanders and Aborigines at Cape York*. Canberra: Australian Inst. of Aboriginal Studies, 1979.

An Old Housekeeper. *Men and How to Manage Them*. Melbourne: Massina, 1885.

Paxton, Nancy L. "Mobilizing Chivalry: Rape in British Novels about the Indian Uprising of 1857." *Victorian Studies* 36.1 (Fall 1992): 5–30.

Perkins, S. R. "Emigration." *Imperial Colonist* 3.35 (Nov. 1904): 125–28.

————. "Openings for Women in South Africa." *Imperial Colonist* 4.44 (Aug. 1905): 87–88.

Priddle, Vic. *Dung on His Boots.* Brisbane, Austral.: Brooks, 1972.

Reynolds, Henry. *Frontier: Aborigines, Settlers and Land.* Sydney: Allen, 1987.

Richards, Thomas. *The Commodity Culture of Victorian England: Advertising and Spectacle, 1851–1914.* Palo Alto, CA: Stanford UP, 1990.

Robson, John M. *Marriage or Celibacy? The Daily Telegraph on a Victorian Dilemma.* Toronto: U of Toronto P, 1995.

Strangford, Viscountess. "Emigration of Educated Women." *Queen* 4 Dec. 1886.

———. Speech. Women's Emigration Assn. June 1881. WEA brochure. Fawcett Library.

Swaisland, Cecillie. *Servants and Gentlewomen to the Golden Land: The Emigration of Single Women to Southern Africa, 1820–1939.* Providence, RI: Berg, 1993.

Thompson, Flora. *Lark Rise to Candleford.* Harmondsworth: Penguin, 1973.

Thompson, Tierl, ed. *Dear Girl: The Diaries and Letters of Two Working Women, 1897–1917.* London: Women's Press, 1987.

Trollope, Anthony. *Australia and New Zealand.* London: Chapman, 1873.

Twopeny, Richard. *Town Life in Australia.* London: Elliot, 1883.

Walkowitz, Judith. *City of Dreadful Delight: Narratives of Sexual Danger in Late-Victorian London.* Chicago: U of Chicago P, 1992.

———. *Prostitution and Victorian Society: Women, Class and the State.* Cambridge: Cambridge UP, 1980.

Ward, Peter. *Courtship, Love and Marriage in Nineteenth-Century English Canada.* Montreal: McGill-Queen's UP, 1990.

Widdowson, Frances. *Going Up into the Next Class: Women and Elementary Teacher Training, 1840–1914.* London: Women's Research and Resources Centre, 1980.

"Woman's Life in South Africa." *Imperial Colonist* 1.8 (Aug. 1902): 70–72.

"A Word to Our Country Workers." *Imperial Colonist* 6.65 (May 1907): 3–5.

"Work for Ladies in Elementary Schools." *Work and Leisure* 1881: 65–71.

Zimmeck, Meta. "Jobs for the Girls: The Expansion of Clerical Work for Women, 1850–1914." *Unequal Opportunities: Women's Employment in England, 1800–1918.* Ed. Angela V. John. Oxford: Blackwell, 1986. 153–77.

"The Visible Horizon Bounds Their Wishes": Seclusion and Society in Fanny Calderón de la Barca's Postcolonial Mexico

Eva-Lynn Alicia Jagoe

In *Life in Mexico during a Residence of Two Years in That Country*, Frances Calderón de la Barca describes the dress of the Poblana peasant woman with enough detail to physically reproduce it. This minute attention is accounted for in a later chapter, where Calderón announces her intention to copy this dress for a high-society costume ball. The Spaniards that visit her seem "anxious" to know whether she will wear it; two Poblana women come to offer their hairstyling services and tell her "that every one was much pleased at the idea of my going in a Poblana dress. I was rather surprised that *everyone* should trouble themselves about it" (76). Later in the day, however, she receives a visit from the secretary of state, the ministers of war and of the interior, and others. "And what do you think was the purport of their visit? To adjure me by all that was most alarming, to discard the idea of making my appearance in a Poblana dress! They assured us that Poblanas generally were *femmes de rien*, that they wore no stockings, and that the wife of the Spanish minister should by no means assume, even for one evening, such a costume" (76–77). Soon after, she receives messages from complete strangers advising her against it. Calderón, struggling under the dual etiquette of being a stranger in Mexico and the wife of the Spanish ambassador, has almost committed a faux pas that would have branded her entrance into society with shame and humiliation: "I was really thankful for my escape" (77).[1] Under the aegis of protection and tutelage, members of Mexican society have successfully policed her into conforming.

Frances Calderón, née Erskine, was born in Edinburgh in 1804 to a large and distinguished Scottish family. When her father went bankrupt and later died, Fanny, aged twenty-seven, moved to the United States with her mother and eight younger sisters, and they started a school in

Staten Island. Fanny met and married Angel Calderón de la Barca, a Spanish diplomat to the United States in 1838 and, in 1839, the first Spanish minister to Mexico, independent from Spain since 1821. Though they planned to live in Mexico indefinitely, the couple was forced to leave in 1842 because of revolutionary upheaval in Mexico City.

At the urging of William Prescott and others, Calderón revised and published her letters home. Her book shows traces of the epistolary form: as Prescott's preface confirms, "[I]t consists of letters written to the members of her own family, and, *really*, not intended originally—however incredible the assertion—for publication" (xvi). Though *Life in Mexico* is in print today and was quite popular when published, this book has not often been included in contemporary discussions of travel, imperialism, and gender studies, perhaps because the British relation to Mexico is not one of colonization. The nineteenth-century British women travelers most often studied are variously participants and commentators on Britain's imperial domain of Africa, Australia, or India. Yet Calderón's writing about nature, nationality, maternal sentiment, childhood, and communities of women offers another perspective on a Victorian woman's gaze and the translations that result when such a person interprets another country. Though Calderón's book was composed over a period of two years, it coheres in its thematic resonances. Culturally conditioned by her gender and economic position, and more specifically through the social relations of her marital position and her national affiliations, Calderón orders her experiences according to a template that she imposes on them.

The inscrutability of bodies, costumes, and display and the need to perform indeterminate roles are recurring fodder for anecdotes in *Life in Mexico,* evidenced by the Poblana dress incident. In her ethnographic renderings of the society she inhabits, Calderón is often confounded by what things mean and narrates her mistakes for the amusement of the British and American audience for whom she writes. But most of the book is filled not with her mistakes but with her comments and judgments, as she affectively interprets situations and settings according to her cultural habitus. Meaning becomes transparent if it can be cataloged or ordered according to recognizable categories. I locate her letters to her family in an interstitial space between longing and exile, personal nostalgia and Victorian cultural ideologies of filiation. Calderón draws on codified genres of the gothic and the sentimental to attest to the position of an active, acutely observant, and funny Scottish woman whose

role in Mexico is to be the wife of a Spanish diplomat, "the first representative of the Spanish monarchy who brings from the mother-country the formal acknowledgment of Mexican independence" (59).

The Threats of Nature

Calderón's forays to the country touch upon questions of freedom and nature, exposing the fragile balance of social convention and gender prescription along which a foreign woman must teeter. When political upheaval makes Mexico City unsafe for her party, they rent a house in the country. Her husband still goes into town every day, leaving the women behind with the injunction to not venture beyond their orchard because "it is not considered safe" (354). At this point in the book, her reader has enough of a sense of Calderón to know that this would be stifling to her, and is therefore not surprised when she violates this rule:

> We ventured to take a walk alone yesterday morning through the lanes ... for which piece of imprudence we were severely reprehended, and to-day it appears that two women had been robbed and ill-treated on the road near here; so we are too ready to subscribe to the renewal of our sentence of imprisonment in the house and orchard, when we have no gentlemen with us; but it must be confessed that it takes greatly from the charms of a country life, not to be able to walk out fearlessly. (370)

"The charms of country life" conjures up images of English or American country life, where long walks are among the chief benefits for women accustomed to the strictures of the city. Yet the Mexican country house is of a different order. The combined violence to women of male reprehension and physical ill-treatment makes for a powerful restraining force, one to which Calderón acquiesces with the reticence of sarcasm and confession.

In an earlier passage about the country, she has already alluded to a kind of primordial haunting; a hint of violence lurks in a vestigial colonialism:

> There is an indescribable feeling of solitude in all houses in the environs of Mexico, a vastness, a desolation, such as I never before experienced in the most lonely dwellings in other countries. It is not sad—the sky is too bright, and nature too smiling, and the air

we inhale too pure for that. It is a sensation of being entirely out of the world, and alone with a giant nature, surrounded by faint traditions of a bygone race; and the feeling is not diminished, when the silence is broken by the footstep of the passing Indian, the poor and debased descendant of that extraordinary and mysterious people who came, we know not whence, and whose posterity are now "hewers of wood and drawers of water," on the soil where they were once monarchs. (263)

The rhetoric is familiar, not unlike what has been passed down through the line of English male naturalists who come before and after her: Humboldt, Darwin, Bates, Wallace, Hudson, and others.[2] Latin America represents originary nature, the site where the mysteries of the life of the species can be uncovered and explained. The presence of the Indian is picturesque and sad, yet carries with it tinges of an "extraordinary and mysterious" past that is sublime. One feels alone not because one is a woman and left alone and restrained but because one is taken out of this world. Nature is still bigger than humans and renders them insignificant through its permanence. Paul de Man discusses this attitude in relation to the Romantics' view of nature and, in particular, comments on Wordsworth's phrase "the stationary blast of waterfalls": "[S]uch paradoxical assertions of eternity in motion can be applied to nature but not to a self caught up entirely within mutability. The temptation exists, then, for the self to borrow, so to speak, the temporal stability that it lacks from nature" (197). This temptation is what fuels the Romantic use of metaphor or symbol, which is grounded in the idea of a translucent original unity between sign and signifier.

That Calderón feels her insignificance and solitude in the face of nature follows a trope that, though common in the aesthetic ideology of the late eighteenth and nineteenth centuries, takes on a more complicated significance when gendered. For her, the desire to coincide with nature, to exist in a moment of unmediated union with it (which many Romantics and Victorians believed occurs in childhood, either personal or of the race), is always repudiated. She functions within what de Man would describe as irony, aware of the temporality of language whereby there is always reference to an anterior sign. Irony invokes the relationship within consciousness of a multiplicity of selves, yet this relationship is not one of intersubjectivity but of distance and difference. Human and nature are different. As a woman, Calderón is not free to have even the pretense of oneness with nature to which men trained in the Romantic tradition can appeal for solace. Imprisoned by her gender, she enacts a

series of performative gestures in which, as narrator, she is creating and destroying selves. She stands removed from the fiction in which she is involved, withdrawing so as to explain the rules of the game. Yet she has also gone beyond the distinction between fact and fiction into a "para-ontology" in which she can only establish any kind of knowledge of self by the proliferation of selves. For a woman, the emigratory and colonial experience is haunted by this violence and the recurrent mediations of self that it requires.

This self-irony is necessarily isolating. Yet another time when she is left alone: "C—n has gone to dine with the English minister, and I am left alone in this large room, with nothing but a humming-bird to keep me company; the last of my half-dozen. It looks like a large blue fly, and is perfectly tame, but will not live many days" (213). Without her husband, she is left with one of the more clichéd symbols of female dependence—the caged bird. That it is more of an insect than a bird touches on the representational function of the miniature and its difference from that which it replicates. The hummingbird's ambiguous species status echoes Calderón's indeterminate role in Mexico. As an emigrant instead of a traveler, Calderón collects live specimens rather than the stuffed ones that many Victorians took home with them from their travels. Domestication of animals can be seen as the emigrant's equivalent of the traveler's taxidermy; both acts of cultural collection. The denial of the moment of death that the taxidermist renders through "imposing the stasis of an eternal death" (Stewart 144) is also left pending through the epistolary form. Tameness will kill the bird more slowly, but the temporal structure of Calderón's description ensures that it "will not live many days." Why does she not do something to save it, let it free? The allegorical equivalence of bird and woman is predicated on this relation of death, imprisonment, and violence.

Mary Louise Pratt describes the indoor world of the female travelers as the "seat of the self": "[T]he indoor, private world does not mean family or domestic life, but in fact their absence: it is the site above all of solitude, the private place in which the lone subjectivity collects itself, creates itself in order to sally forth into the world" (159). For Calderón, this solitude seems to be akin to an imprisonment that the cultural order imposes on her because of her foreign status and her gender. The temporal structure of the epistolary form allows for the constant reconfigurations of selves, the space of solitude that is violently creative. Unlike many travel narratives, written from notes after the trip is over, most of *Life in Mexico* is written as letters from an emigrant whose discourse is

constantly in flux. What this form discloses is the writer's profound uneasiness about her identity in a newly postcolonial society. The ethnographic collides with a sense of personal. Forced to create a space for herself, Calderón cannot content herself with easy descriptions of the picturesque but must negotiate the violence of her position through a constant reinterpellation of self.

National Filiations

Nostalgia, movement, and nationality are complicated by Calderón's mediations. Her letters home interpellate a family and a past that becomes protean through the lens of nostalgia: "I thought of Christmas in 'Merrie England,' and our family gatherings in the olden time, and as if one had not travelled enough in the body, began travelling in the mind, away to far different, and distant, and long gone-by scenes, fell asleep at length with my thoughts in Scotland, and wakened in Mexico!" (51). The slippage between the personal and impersonal pronoun mirrors that between a historicized England and Scotland. The fictionalizing status of a "Merrie England," an image linked with Gothic revivalism and a melodramatic nostalgia, elides Scottish and English history, conflating the two countries and sentimentalizing the power relations between them.[3] The time travel "one" undergoes elides subsequent changes and attempts to fix a moment in time that has already passed. Her family is in fact scattered: her father dead in France, a brother dead in India, a sister in disgrace for having run off to Jamaica and left her husband and their five children, and her mother and many sisters in New York (xix). Her dream gathers her family in an interchangeable England/Scotland as opposed to the separation that individual will and the global economies of empire and nation has enacted.

While this image of a romanticized Scotland offers her solace, a Mexican rendition of Scottishness, perhaps just as fanciful as her dream, provokes a strong reaction from Calderón. At the costume ball—the very gathering at which she almost embarrassed herself by appearing as a Poblana—, she sees a costume whose various signifiers she can read adroitly: "There was a young gentleman pointed out to me as being in the costume of a Highlander! How I wished that Sir William Cumming, Macleod of Macleod, or some veritable Highland chieftain could suddenly have appeared to annihilate him, and show the people here what the dress really is!" (82). The violence of the image of annihilation

paired with the didactic—would the people care what the dress really is?—is fortified by the strength of the Scottish name, a hearkening to her heritage that reveals her isolation in Mexico. She knows a Scottish Highlander when she sees one, just as the Mexicans know a loose woman when they see one; however, her cultural powers of discernment are rendered null in Mexico and do nothing to save her from possible humiliation. The strictures of the costume ball do not allow representations of certain Mexican classes but sloppily embrace all manner of European mimicry, whether accurate or not.

Calderón's imagination seems to allow violences that her rational language does not. The mistaken Mexican annihilated by the Highlander is just one example of a recurring trope in this text where aggressions and frustrations toward the host country gain expression. In grappling with the contingencies of colonialism and temporality, she engages in yet another dreamlike sequence until she is "startled ... from the profane ideas in which she was indulging" (357). In an extended allegory of comparison, the colonial past is inscribed through a haunting legacy in the Mexican village. She compares it to the New England village, which "proclaims prosperity, equality, consistency; the past forgotten, the present all in all, and the future taking care of itself. No delicate attentions to posterity, who can never pay its debts" (356), while in the Mexican village, "here, everything reminds us of the past.... It is the present that seems like a dream, a pale reflection of the past. All is decaying and growing fainter, and men seem trusting to some unknown future which they may never see" (357). Issues of inheritance are imbricated with echoes of the parental. Able to forget the mother country and be in fact "new," the North American village does not need to worry about its progeny.

The Mexican nation should beware of its backward-looking tendency. Living in its colonial past endangers its future, encouraging dependence and colonization. The "newness" of the North Americans does not connote youth or childishness so much as vigor and acuity. The New Englander who sees only the present gazes with a possible imperial eye, unimpressed with the past, less preoccupied with monuments than with present comfort:

> Let them [the Mexicans] beware lest half a century later, they be awakened from their delusion, and find the cathedral turned into a meeting-house, and all painted white; ... the silver transformed into dollars; the floor washed (which would do it no harm), and round the whole, a nice new wooden paling, freshly done in

green—and all this performed by some of the artists from the *wide-awake* republic farther north (357).

The irony of this prophecy is that it is in fact self-fulfilling. In the campaign against Mexico in 1847, the North American army used Calderón's book as a guide because of its detailed descriptions of the geography and local customs (Robinson 233). The whole passage seems to be an allegory of writing epistolary fashion. Calderón contradicts her own opinions and observations because she writes in the present, little remembering what she has written, little imagining the violent consequences her writing will have.

The Mexican people's relation to past and future is etched in memory and in custom. Like Benjamin's rendition of Klee's angel, they move forward looking into the past. For Calderón, the nation and the family function along a continuum, both bearing the same relation to temporality: "I have seen no country where families are so knit together as in Mexico, where the affections are so concentrated, or where such devoted respect and obedience are shown by the married sons and daughters to their parents. In that respect they always remain as little children" (197). While in Victorian Britain marriage signifies a break from one's parents and the beginning of the new role of becoming a parent, in Calderón's Mexico the prior family takes precedence over the new. Is Calderón condescending in her infantalization of the Mexican adult, or is she jealous of such concentrated affections? Rather than simply another example of a smug metropolitan traveler's observations, this quotation hints at the loneliness and sense of exile that she encounters as a female emigrant. Is this part of a letter to her family, to her mother? How do her comments about Mexican families reflect her own filial ties? Though economically and racially privileged in Mexico, she must still negotiate Victorian and Mexican cultural ideologies and her sense of self. Calderón's descriptions, comments, and interpretations, however condescending, are steeped in a sensibility that reads familial relations as the organizing principle of emotion and action. Attraction to and distance from these Mexican familial structures coexist in her narrative, which carries traces of both an "objective" travel account and a discourse of self.

She is evidently surprised at one of the options available to young Mexican women: "It appears to me, that amongst the young girls here there is not that desire to enter upon the cares of matrimony, which is to be observed in many other countries. The opprobrious epithet of 'old maid' is unknown" (164). In the literature of the early Victorian period,

this option for women does not seem to obtain, directed as novels and popular advice texts are toward the closure of marriage. Calderón herself was thirty-four years old when she married and had been a schoolteacher till then, both indicators of that stereotype of "old maid" to which she refers. Her characterization of conjugal life through the term "cares of matrimony" indicates an admiration of Mexican society in its relative freedom from marital pressure for women.

Her respect for Mexican women is inseparable from her penchant for the picturesque. This aesthetic is firmly grounded in ideologies of the natural and healthy body: "Amongst [the common women] were many handsome faces, but in a still lower and more Indian class, with their gay-coloured petticoats, the faces sometimes beautiful, and the figures more upright and graceful; also they invariably walk well whilst many of the higher classes, from tight shoes and want of custom, seem to feel pain in putting their feet to the ground" (130). Inseparable from the accoutrements of class, these bodies are emblazoned with the marks of their culture. The pain of these bodies is a signifier of class to which Calderón will not submit—remember her determination to walk down country lanes—therefore differentiating her British body from these Mexican ones. Her admiration extends itself to the Indian, who, it is to be supposed, walks well because of her less restrictive apparel. The less confined, more natural gait is to be admired from Calderón's perspective, a predisposition that shows itself over and over again in her text. Bound by their conventions, the upper-class women of Mexico seem ridiculous and pitiable, having lost their freedom through their own willingness to conform to fashion and etiquette.

However, the difference of their customs also allows Calderón to favorably compare them to the English, demonstrating once again that, in the shifting allegiances that the epistolary form sanctions, signifiers can shift depending on what argument the writer wants to make, what mood she is in. More than once, Calderón is fed up with the English and their close-minded circles and subtly derides the English through her portrayals of Mexican society:

> [Mexican women] are true patriots, and the visible horizon bounds their wishes. In England especially, they are completely out of their element. A language nearly impossible for them to acquire, a religion which they consider heretical, outward coldness covering inward warmth, a perpetual war between sun and fog, etiquette carried to excess, and insupportable stiffness and order in the article of

the toilet; rebosos unknown, *cigaritos* considered barbarous. . . .
They feel like exiles from paradise, and live but in hope of a speedy
return. (225)

In this case, the signifiers of Mexican femininity are not bound feet but
cigaritos. Mexican women are tied to their culture because of the license
it gives them. However, this passage begs the question: [I]s a woman who
happily travels not patriotic? Calderón, no longer in Scotland or in New
York, often identifies herself with the English in Mexico, though as evi-
denced in the preceding quotation, her text is full of veiled criticisms.
Whose side is Calderón on? As amateur ethnographer, she is merely
commenting on differences, attributing well-worn stereotypes to both
the impetuous Mexican and the stiff English. Forgotten are the many
times she has complained of Mexican "etiquette carried to excess."[4]

What these contradictions indicate is a reader of culture whose per-
ception is inflected with Victorian ideologies of proper feminine roles
but who is capable of disagreeing with herself and proving herself wrong.
In her eagerness to write her impressions, she loses some integrity as an
objective observer of Mexican customs and discloses little moments of
pleasure and infatuation. In *Plotting Women*, Jean Franco signals places
in Calderón's text where "the tone of condescension and the distance of
the speaker from her material is characteristic of metropolitan travel lit-
erature of the period, which converted the enire peripheral world into
the amusing or disgraceful object of a superior gaze" (91). However, this
is too simplistic. Calderón is not a traveler so much as an emigrant, one
who cannot be content to gaze at the peripheral world but who must
make her way in it. As we saw earlier with the Poblana dress incident,
Calderón can make a fool of herself in Mexican society, and it will mat-
ter. Brought there as a representative of the metropolis, she is neverthe-
less expected to bow to the peripheries' culture, to adapt to it rather than
to change it.

And her willingness to do so differentiates her from other Anglo expa-
triots who live in Mexico:

Of [English] families, there are no more than half a dozen resident
here, the members of whom form a striking contrast in complexion
to the *Mexicanas*. With very few exceptions . . . they keep them-
selves entirely aloof from the Mexicans, live quietly in their own
houses, into which they have transplanted as much English com-
fort as possible, rarely travel, and naturally find Mexico the dullest
of cities. (213)

She herself is peripheral to this kind of exiled society because of her ties to Scotland, the United States, and Spain. As Sara Suleri says in her discussion of a female traveler to India: "Parks's narrative ... is too fraught with a secret knowledge that psychically speaking, Anglo-India gave her no inside to which she could belong" (91). Liminal, Calderón cannot be content to find Mexico "amusing or disgraceful" but must learn to adapt to it. Whereas when she first arrives, she sees "few striking beauties, little grace, and very little good dancing" (81), she later notices subtle changes in her perception: "Perhaps it is that I am getting accustomed to the Mexican style of face, but it appeared to me that there was a great deal of beauty assembled; and as for fine voices, they are as common in Mexico as they are rare in England ..." (291) This awareness that perception is constituted through comparison and difference, that aesthetic judgment is contingent on a temporal subjectivity, is one of the ways in which Calderón proves herself to be open to self-contradiction.

Little Things

Calderón is not just intrigued by those adults who "remain as little children" but also is constantly describing children and their family relations. The conflation of these images of childhood and a fetishicization of the child's small size is analogous to a fascination with the miniature. As Susan Stewart points out, "[T]he miniature is a cultural product, the product of an eye performing certain operations, manipulating, and attending in certain ways to, the physical world" (55). The production of both childhood and the miniature is subjective, performed differently by different eyes. In *Life in Mexico*, these productions gather around them a host of meanings according to Calderón's desires and the clashes of culture that she encounters through these appropriations. She is fascinated with filiation in both senses of the word: the relation of parent and child is a recurring topic of observation as is the descent or derivation of culture and cultural forms.

During Holy Week, Calderón mingles among the crowds who are dressed up for the occasion. In her view, the most egregious excess is the ornamentation of the Mexican children of a certain class:

> [A]las! how [the children] were dressed! ... Now and then the head
> of a little thing that could hardly waddle alone, might have
> belonged to an English dowager-duchess in her opera-box. Some

had extraordinary bonnets, also with flowers and feathers, and as
they toddled along, top heavy, one would have thought they were
little old women, till a glimpse was caught of their lovely little
brown faces and black eyes. (136)

In case her reader thought to be amused or delighted at the portrayal of
such a spectacle, Calderón begins her commentary with an exclamation
of dismay.[5] With heads disproportionate to their waddling, toddling bod-
ies, these children have been prematurely aged and gendered feminine.
In metaphorical inverse to the educating reformers' insistence that chil-
dren play more and have their heads less stuffed with knowledge—and
remember that Calderón is a teacher—these children's heads are
encumbered with the weight of adult accoutrements. In comparing the
Mexican child to the English dowager-duchess, Calderón aligns herself
as a Scottish, not English, woman with the simple child underneath the
bonnet, more natural, less ostentatious, less class-driven. Much as the
English culturally colonize the Scottish, the Mexican adults, in their
dressing of the child's head, crush him or her under the weight of their
social mores.

This link between colonization and the head is made explicit in
Calderón's weird extended metaphor describing her debut in Mexico
City. The first Sunday there she goes to the cathedral, built upon the
ruins of an Aztec temple where, she is told, "monstrous idols" were wor-
shiped and human sacrifices were made regularly. The Spanish pres-
ence is to be appreciated: "[L]et the memory of Cortes be sacred, who,
with the cross, stopped the shedding of innocent blood, founded the
cathedral on the ruins of the temple which had so often resounded with
human groans, and in the place of these blood-smeared idols enshrined
the mild form of the Virgin" (61). The Gothic edifice, however, is filthy
and populated by lepers and Indians; she is later told that few ladies go to
the cathedral. She "kneels with a feeling of horror," and "besides, many
of my Indian neighbours were engaged in an occupation which I must
leave to your imagination; in fact, relieving their heads from the pressure
of the colonial system, or rather, eradicating and slaughtering the
colonists, who swarm there like the emigrant Irish in the United States"
(61). This felicitous hodgepodge of a passage is introduced through the
titillating insistence that she cannot even write of the Indians' actions.
However, rather than leave it to her reader, she allows herself the free
flow of imaginative play in her obscure allusions. So, to spell out this pas-
sage, the Indians' heads are weighted down —"top heavy"—by the colo-

nial system as they sit among the ruins of their ancestors' sacred temple, ruined by intrusion, pillage, and hundreds of years of Spanish rule. Then Calderón's writing, led by the image of colonialism, shifts into a landscape in which the Indians are winning against the colonists, ridding their country of this pest. The first indication that all this may be about lice is in the verb "swarm," but then the discussion shifts quickly into the simile about the Irish, bringing up issues of English colonization (of both Ireland and the United States) and the subtle distinctions between colonization and emigration. Having emigrated first to the United States as a member of the kingdom that once colonized it, and then to Mexico as the wife of a former colonist of that country, Calderón's allusion to Ireland seems to be no throwaway image.

The continuum along which the merciful presence of the colonizer Cortéz leads to the filth of the Indian through colonization is riddled with gaps, as is that between adult care and children's nature. The child is subject to the adult's whims of excessiveness and ornamentation but provides a core of innocence and simple beauty that is untaintable. For Calderón, the child is the locus around which real affections can be garnered and the truth elicited. The literature of the day, such as Wordsworth's poems and Dickens's early sentimental novels,[6] helps establish an image of the child as knowing and yet innocent. The discourse of loss, eternal life, the temporal status of earthly life, and connections with nature ("earth's diurnal rounds") surround infant and child mortality in an increasingly sentimental vein. After *The Old Curiosity Shop*, which was published two years before *Life in Mexico*, can the portrayal of a child's death ever be the same given the fervent weeping and mourning that ensued on both sides of the Atlantic in response to little Nell's death? Calderón is told by a woman that, on the death of her grandchild, she bedecked him in rich lace and the borrowed diamonds of aristocrats:

> The street was hung with draperies, and a band of music played,
> whilst he was visited by all the titled relatives of the family in his
> dead splendour, poor little baby! Yet his mother mourned for him
> as for all her blighted hopes, and the last scion of a noble house.
> Grief shows itself in different ways; yet one might think that when it
> seeks consolation in display, it must be less profound than when it
> shuns it. (89)

Once again a child is overdressed, this time even more chillingly. Throughout her writing, Calderón attributes to the mother the position that she herself seems to take. Against the opulence of the funereal dis-

play, Calderón imagines the "poor little baby's" mother and her more real grief. In this particular instance, the mother's mourning seems to be connected more with questions of inheritance and patrimony than with affection, yet at the same time Calderón assumes that the mother shuns the display through which sorrow is ritualized. Not necessarily less felt, grief can have different cathartic expressions in different cultures, but Calderón sees ceremony as secondary in profundity to simplicity and mourning.

Death and maternity are linked repeatedly in *Life in Mexico*. The imagining of maternal ties seems to be a way for Calderón to prod herself into an understanding of death, to bring herself closer to the moment, less an ethnographer than an empathic observer. And it seems a way to mitigate or at least negotiate the violence of the colonial encounter. Even when tongue-in-cheek, the recollection of the living parent adds a certainty to the death. At the beginning of the book, Calderón is bored and isolated on the ship while the shore stands tantalizingly proximate and the sea maddeningly calm. She is thrown upon her limited resources: "[W]ith books one might take patience, but I read and re-read everything I possess or can find" (22). The men's more active release from boredom is also repetitive: they kill "a preposterous number" of sea animals. One day, the sailors haul in a shark and kill it: "He was said to be quite young, perhaps the child of doting parents. The juvenile monster had, however, already cut three rows of teeth" (19). The extremes of love and such violent natural traits are emblematic of the vulnerability of the natural. That which is most admirable for Calderón—natural parental love unmediated by society—often comes up against the violence of grief, separation, and patriarchal and colonizing oppression. Anticipatory and eager, she is relegated to solitude and repetition in ways that prefigure experiences she will have as a woman in Mexico. The sentimental mode and its interpretations of the natural, parodied in the shark incident, founder in realizations of her isolation.

The image of cutting teeth is one that appears again near the end of the volume. A highway robber has been killed and his head left on a post by the side of the road: "That grinning skull was once the head of a man, and an ugly one too, they say; but stranger still it is to think, that that man was once a baby, and sat on his mother's knee, and that his mother may have been pleased to see him cut his *first tooth*. If she could but see his teeth now!" (463) The imagining of a line of descent offers a host of speculations about uncertain futures and responsibility. Is the man indebted to his mother's love, responsible to her expectations? Calderón

pictures the mother so as to feel, if not grief, then the uncanny sense of how alive the dead person once was. She seems most intrigued by the unnatural specter of the child who leaves his or her mother bereft and full of natural grief. The memento mori of the skull does not fulfill this need for the thrill of the uncanny; she needs the image to be "stranger still."

The place where this fascination with maternal affections and the uncanny most come together is in the gothic space of the convent: "You will think I pass my time in convents, but I find no other places half so interesting, and you know I always had a fancy that way" (273). What way? Her public reader does not know whether she has considered the novitiate for herself (though being Scottish this seems unlikely) or whether her interest extends itself ethnographically, though "having a fancy" implies a more subjective stance. The Gothic genre reverberates throughout her descriptions of black veils, covered bodies, and torture implements, and the thrill of recoil and attraction seems derived from a discourse on sensationalism. Calderón is impressed by the nuns' virtue, humility, and cleanliness, and comments on their "caressing manners" (276). After leaving, "the thoughts of these poor women cost me a sad and sleepless night" (277). Like heroines of a Radcliffe novel or even of *The Monk*, the innocence and piety of the nuns attract and renders the terrors they suffer more acute, though their self-negation renders their pain psychologically complex and internalized in ways that the presence of the Gothic villain does not.[7] Interpellated by the vocation of the convent, they willingly do to themselves what in the Gothic novel is cruelly imposed from without.

Invited into a convent, Calderón is shocked by the bodily harm that the nuns inflict on themselves in the name of penances: sleeping on wooden boards, wearing crowns of nails, "on her breast a cross with nails, of which the points enter the flesh, of the truth of which I had melancholy ocular demonstration" (275). Did Calderón ask to be shown this evidence, or did the nun offer? However the gaze was solicited, proving the truth carries with it a certain frisson of titillation. Calderón is fascinated. The detailed categorization that she gathers of the various penances the nuns inflict on themselves makes these marked bodies collectable images.

As observer and interested guest, she is presented with wax dolls made by the nuns of themselves. She develops a collection of dolls from different convents, souvenirs of visits that were difficult to achieve and not to be repeated. Through making representations of themselves, the nuns

give her a way to remember them, to transport them in some way to the secular world. Calderón's collection enables her to pry into the details of their bodies, to undress them, discovering that they wear the coarsest material next to their skin. This license to inspect the nuns' tortured bodies through these detailed miniatures makes the very private world of the convent public to a foreign audience. Put on display as pitiable yet admirable objects of cultural interest, the nuns offer a fascinating instance of Mexican otherness for Calderón's audience. Yet the images that the Englishwoman collects are those proffered to her by subjects very much in charge of their self-representation and in the dissemination of that representation. They have chosen to allow her into their convent, prepared the food and entertainment that she will receive, and given her the souvenirs that they want her to take away. The fetishicization of the miniature is located within the interstices of the relation between the Anglo and the other, touching on a shared aesthetic of tininess.

The spectacle that most enthralls and repulses Calderón's fancy is the initiation ritual of the novice. Calderón sees the novitiates as "poor little entrapped things" (143) who are manipulated into taking the veil through lack of dowry, boredom, paternal persuasion, or insidious pressure from their confessors. During the ceremony, the church is ornately decorated and the other nuns, shrouded in black, surround the girl, dressed in her bright finery, and then cover her with black, enacting her worldly death. Often explicitly theatrical, the "stage" upon which the tableau takes place is brightly lit and the rest of the church is dim: "[T]he new-made nun was in a blaze of light, and distinct on the foreground, so that we could mark each varying expression of her face.... Suddenly, and without any preparation, down fell the black curtain like a pall, and the sobs and tears of the family broke forth. One beautiful little child was carried out almost in fits" (199). As if to insist to the reader of sensibility that this is a scene worthy of attention, Calderón includes a long poem written by an acquaintance of hers to whom she described one of these ceremonies. The poem includes references to "the maid miscalled the Heavenly Bride" and to "the child whom [the mother] hath reared in vain" (201). This is true Radcliffe style.

The familial horror and, explicitly, what Calderón interprets as the maternal suffering, is the axis around which Calderón's ambivalent attraction to the ceremony revolves. "I had almost made up my mind to see no more such scenes, which, unlike pulque and bull-fights, I dislike more and more upon trial" (195), but she is invited to see an acquaintance join the convent and goes supposedly unwillingly. In her descrip-

tion of the scene, Calderón soliloquizes on the relation between mother and child, an intimacy about to be torn asunder by the cloister.

> The most terrible thing to witness was the last, straining, anxious
> look which the mother gave her daughter through the grating. She
> had seen her child pressed to the arms of strangers, and welcomed
> to her new home. She was no longer hers. All the sweet ties of
> nature had been rudely severed, and she had been forced to con-
> sign her, in the very bloom of youth and beauty, at the very age in
> which she most required a mother's care, and when she had but
> just fulfilled the promise of her childhood, to a living tomb. (197)

Once again we are told of the horror of the child who dies, whether metaphorically or literally, before the parent. "The promise of child-hood" recalls the mother of the dead child, discussed in the preceding scene, whose hopes are blighted. Childhood here is represented as a transitional phase, a stage of maternal expectation in which the closure of adulthood is the ultimate goal. The daughter, "at the very age" where she is ready to enter the marriage market and reproduce, is at the culmination of her mother's dreams. "It reminded me of a marriage feast previous to the departure of the bride, who is about to be separated from her family for the first time. Yet how different in fact is this banquet, where the mother and daughter met together for the last time on earth!" (196). It seems that we are talking on a level of scale, not of binarism. Marriage, like entry into the convent, is an enforced separation of mother and child in which the child "is no longer hers." The unwritten difference, however, is one of reproduction. The "living tomb" of the convent is a sterile one where the "new home" is a group of veiled women: "She then went round alone to embrace all the dark phantoms as they stood motionless, and as each dark shadow clasped her in its arms, it seemed like the dead welcoming a new arrival to the shades" (194). The deathlike rupture of the "blooming" of womanhood is enacted by the embrace of a community of women. Taken out of the economy of marriage, she dies to the world.

Calderón's interpretations include complicating details that disclose her bias toward a negative view of the convent. Though she meets novitiates who laugh and look happy before taking the veil, she is sure it is in the most "unnatural and hysterical manner, as I thought" (192). And the nuns already in the convents "all seem as cheerful as possible, though it must be confessed that many of them look pale and unhealthy" (275). These qualifiers evince a will to read the outward signifiers in a certain

way, to impose pity when none may be needed. Sara Suleri discusses the Anglo-Indian Victorian woman's reaction to the zenana, or harem, an enclosed private space where women live separated from society as the wives of the male head of household. She writes of the traveler Fanny Parks's account of her visit to the zenana: "Parks's disappointment suggests a narcissistic failure to locate a cultural mirror-image for her oppression in the picturesque: the zenana as a figure of imprisonment must now be substituted by a more complex understanding of how such a space could signify the possibility of mobility within secrecy" (94). While looking to the convent as a symbol of the oppression of women by a patriarchal and religious society obsessed with past, Calderón is drawing out the dividing lines between these other women and her own life. That those "poor entrapped things" could be happy or empowered by their life choice undermines the tenous yet jealously guarded belief in her own freedom and superior comfort that bolsters Calderón's course of action and inures her to the solitude she confronts in Mexican, Anglo, and Spanish society. It is ironic to note that when her husband died, Calderón retired to a convent in France for a few years (Robinson 233).

Calderón's position as an emigrant in the Mexico of the mid-1800s is traversed with the various threads of gender, race, class, and nationality out of which her identity is woven. Identifying with and at the same time repudiating the critical "mean-well" Mexican, the retiring English, the imprisoned novitiate, or the memento mori of the hummingbird and the debased Indian descendant, she places herself precariously and ironically in close contact with the violence they represent. *Life in Mexico* is structured through her observations and interpretations of national, cultural, and familial lines of descent and filiation, lines that connect yet also demarcate her position outside of them. Surrounded by what she, in her exile, sees as a culture of strong familial affection, Calderón writes through an isolation that renders her a sentimentalizing yet acutely perceptive observer of cultural nuance.

Life in Mexico, though informative, is not pedagogical. It does not lead from ignorance to knowledge but rather skims across many surfaces, never working toward any type of closure. Aware to the end of the irreversible and irrevocable flow of her letters, Calderón is quick to contradict herself and to insist that what she has written is always open to revision: "How necessary for a traveller to compare his judgments at different periods, and to correct them!" (528). Not all are correctable. In observing customs and mores laden with meanings, Calderón never has

the complete "inside story." Almost two hundred pages after the Poblana dress incident, the costume pops up again, imbricated in a complicated pattern of signification that only confuses the class and racial lines that Calderón is desperately trying to read and act upon: "This evening the Señora A——came after it was dark, in a Poblana dress, which she had just bought to wear at a *Jamaica*, which they are going to have in the country—a sort of fair, where all the girls disguise themselves in peasants' dresses, and go about selling fruit, lemonade, vegetables, etc., to each other—a very ancient Mexican amusement" (211). Perhaps, in the months that have passed, Calderón has figured out why some society women are permitted the costume of the Poblana for certain functions, or perhaps she is wondering why the Señora A—— is dressed up as a wanton woman. The only allusion she makes to her former humiliation is a comment that shows her seeming expertise in Mexican matters: "[S]he looks beautiful in this dress, which will not be objected to in the country, though it might not suit a fancy ball in Mexico" (211). It might not? The grace with which the past is elided, the violent policing of her body unmentioned, does not erase the fact that she is excluded from the "each other" of Mexican society; as a Scottish woman she has not been allowed to don the disguise that would make her part of ancient customs. Excluded because of her gender, class, heritage, or nationality, Calderón hovers between the identities of ethnographer and participant, never fully part of the community that she depicts in so much detail.

Notes

1. Especially because of the Gothic elements of her book, which I will deal with later, I am tempted to identify Calderón with the heroine of Daphne du Maurier's *Rebecca*, who is tricked into appearing in the same costume as had the first wife and mistress of her house, the dreaded and adored Rebecca. Joan Fontaine's screen version renders the heroine's descent down the mansion steps, and the horror and confusion that dawn on her face as she encounters Lawrence Olivier's wrath, an unforgettable performance of shame.
2. Alexander von Humboldt, *Selections from the Works of the Baron de Humboldt, Relating to the Climate, Inhabitants, Productions and Mines of Mexico* (1824); Charles Darwin, *Journal of Researches into the Natural History and Geology: of the Various Countries Visited during the Voyage of H. M. S. Beagle round the World* (1839); Henry Walter Bates, *The Naturalist on the River Amazon* (1863); Alfred Russel Wallace, *Notes of a Botanist on the Amazon and Andes* (1908); W. H. Hudson, *Long Ago and Far Away: A History of My Early Life* (1918).
3. See Christina Crosby on the personalization and commodification of history, especially her chapter on Dickens *Little Dorrit* and melodrama for a reading of the ways

in which "history becomes nostalgia, and the social is identified with the familial" (9).

4. I.e., "This civility so lengthened out, as if parting were such 'sweet sorrow' ... seems rather misplaced" (83), and "[s]ome Mexican visits appear to me to surpass in duration all that one can imagine of a visit.... These should not be called visits, but visitations" (53).

5. Compare the bonnets: "[W]e went to visit the mines, and it was curious to see English children, clean and pretty, with their white hair and rosy cheeks, and neat straw bonnets, mingled with the little copper-coloured Indians" (172). These English children are dressed as befits their age and race.

6. Calderón is quick to assure her reader that she is reading contemporary English literature while in Mexico: "Fortunately, there is an English society here, a kind of book-club, who ... have united in a subscription to order from England all the new publications, and as C——n is a member of this society, we are not so *arrierés* in regard to the literature of the day as might be supposed" (213).

7. That Calderón is familiar with Radcliffe is made clear when she makes a social visit and is led into the drawing room, only to find it hung with black and to see a body lying on the table, covered with a black veil. When the lady of the house walks in, Calderón asks pointed questions about the health of the family, but her hostess carries on as usual. Not till the end of the visit does she mention that the body is a replica of Christ for a church festival. "I never felt so relieved in my life, and thought of the Mysteries of Udolpho" (117).

Works Cited

Calderón, Frances. *Life in Mexico during a Residence of Two Years in That Country.* London: Century, 1987.

Crosby, Christina. *The Ends of History: Victorians and "the Woman Question."* New York: Routledge, 1991.

de Man, Paul. "The Rhetoric of Temporality." *Blindness and Insight: Essays in the Rhetoric of Contemporary Criticism,* 2nd ed. London: Methuen, 1983.

Franco, Jean. *Plotting Women: Gender and Representation in Mexico.* New York: Columbia UP, 1989.

Holland, Norman S. "Fashioning Cuba." *Nationalism and Sexualities.* Ed. Andrew Parker, Mary Russo, Doris Sommer, and Patricia Yaeger. New York: Routledge, 1992. 147–56.

Pratt, Mary Louise. *Imperial Eyes: Travel Writing and Transculturation.* London: Routledge, 1992.

Robinson, Jane. *Wayward Women: A Guide to Women Travellers.* Oxford: Oxford UP, 1990.

Stallybrass, Peter, and Allon White. *The Politics and Poetics of Transgression.* Ithaca: Cornell UP, 1986.

Stewart, Susan. *On Longing: Narratives of the Miniature, the Gigantic, the Souvenir, the Collection.* Durham: Duke UP, 1993.

Suleri, Sara. *The Rhetoric of English India.* Chicago: Chicago UP, 1992.

"An Act of Severe Duty":
Emigration and Class Ideology
in Susanna Moodie's
Roughing It in the Bush

Sherrie A. Inness

"This colony is a rich mine yet unopen'd," states Colonel Rivers, hero of
The History of Emily Montague (1769), the first Canadian novel about
the riches awaiting settlers in Canada. "Nothing is wanting but encour-
agement and cultivation," he continues. "[T]he Canadians are at their
ease even without labor; nature is here a bounteous mother, who pours
forth her gifts almost unsolicited" (Brooke 1: 50). Rivers, a poor gentleman-
soldier who emigrates from England, claims he is going to become
"lord of a principality" in his new country that "will put [the] large-acred
men in England out of countenance" (1: 3). Although Rivers is a fic-
tional character, his grandiose views on Canada were echoed by many
men living in the late eighteenth and early nineteenth centuries. For
instance, William Catermole in his 1831 lectures in Colchester and
Ipswich, England, painted a vivid picture of the benefits to be derived
from emigration to Canada. "The emigrant who goes out with habits of
industry, and will only retain them, not suffering himself to be led away
with the ridiculous hope of finding a place where idleness may repose,
while the earth shall produce its fruits spontaneously," Catermole
observed, "cannot fail of success" (vii). He praised the "general air of
prosperity" (50) that pervaded the whole country, predicting that a hard
worker could make a profit even in his first year, and cited statistics on
increased immigration, land prices, and wages to support his claim that
Canada, blessed with rich soil and an abundance of game, fish, and fruit,
was a land of opportunity. Nor was Catermole alone in considering
Canada the foremost location for British emigration. In 1807, Isaac Weld
Jr. reported, "There can be no doubt but that a man of moderate prop-
erty could provide for his family with much more ease in Canada than in
the United States" (414).[1] Similarly, George Heriot in his well-known

early-nineteenth-century travel narrative, *Travels through the Canadas* (1807), was enthusiastic about the boundless opportunities the new frontier offered. "Every person in Canada may have within his power the means of acquiring a subsistence," Heriot wrote (253).[2] Catermole, Weld, and Heriot were only a few among hundreds of male orators and writers who promoted Canada as the promised land for any man willing to labor and who helped to encourage a vast wave of British emigration to Canada in the first half of the nineteenth century.[3] As Susanna Moodie writes, "A Canada mania pervaded the middle ranks of British society" (*Roughing* xix).

What these public speakers and writers frequently overlooked, however, was how British women perceived emigration, and what it entailed for them. Emigration did not hold the same promise for women as it did for men. Like Moodie's fictional Flora Lyndsay, who declares, "I would rather live in a cottage in England, upon brown bread and milk, than occupy a palace on the other side of the Atlantic" (*Flora* 4), many women did not want to leave their country and part from their loved ones, in all likelihood never to see them again.[4] Although men believed farm work would be easier in Canada and looked forward to many a full day's hunting—like Moodie's Brian the Still Hunter who hunts from dawn to dusk—women did not have the same optimistic expectations about their work in the new country, which would only be more exhausting in the Canadian backwoods where both domestic help and manufactured goods were scarce. Many of the women would have experiences similar to those of Anne Langton, a British emigrant who, in addition to baking bread, preserving fruits, canning vegetables, sewing her own clothes, and performing a host of everyday chores, also made soap, dipped candles, boiled off maple syrup, glazed windows, and slaughtered pigs. "All around one sees such a multiplicity of things that should be done," Langton sighed, "and the ways and means to accomplish them so few and small" (32). On a "grumbling day" she remarked, "[W]oman is a bit of a slave in this country" (95). The work done by Anne and other middle-class women, as well as by their servants, is often elided in heroic, male-authored travel texts and in immigration narratives.

It is hardly surprising that Anne's complaints were not addressed by male writers extolling the virtues of Canada; they wanted no dissenting voice to undermine their myth of a bountiful and blissful land. Confronted with this dominant discourse that depicted emigration as the ultimate heroic adventure for men, Canadian-British women writers sought to construct a different representation of emigration and their adventures

in the new land.[5] Catharine Parr Traill, Anne Langton, Anna Jameson, Elizabeth Simcoe, and Susanna Moodie are a few of the best-known authors who described their experiences in Canada, helping to create a body of Canadian literature with what Margaret Atwood refers to as a "preponderance of women writers" (Introduction xiv). The most famous of these was Susanna Moodie,[6] one of the "scribbling Strickland sisters"—Eliza, Agnes, Jane Margaret, Catherine, and Susanna—all of whom wrote a vast variety of poems, autobiographies, novels, and essays (Peterman 116).[7] Susanna, who emigrated to Canada in 1832, describes her experiences in the Canadian backwoods in her most famous work, *Roughing It in the Bush*, one volume in a trilogy of emigration and settlement tales that includes *Flora Lyndsay* (1854) and *Life in the Clearings* (1853).[8] Neither of the other two texts achieved the success of the first, which went through three English and several American editions in the 1850s, as well as several Canadian editions.[9] *Roughing It* is an autobiographical account composed of a collection of vignettes about life in Canada and the odd assortment of people (such as John Monaghan, Brian the Still Hunter, and "the little stumpy man") Moodie encounters.

The often uneven text combines what Carol Shields refers to as "diluted Wordsworthian passion" (6)—frequently expressed in poetry—with grim, factual commentary on the problems facing the settler. This uneven tone has caused problems for critics, who are divided over whether it is a flaw in the work or an indication of Moodie's schizophrenic personality. The latter view was made famous in Margaret Atwood's series of poems, *The Journals of Susanna Moodie* (1970), in which Atwood depicts Susanna as a paranoid schizophrenic who vacillates between praising and condemning Canada. For Atwood, Moodie is "a word in a foreign language" (11), constantly struggling to make sense of a world that, as a middle-class immigrant, she cannot fathom. Although Atwood's poetic creation of Moodie is different from Moodie herself, Atwood's poems have inevitably colored how Moodie's works are read and interpreted by critics, encouraging the perception of Moodie as a woman on the edge of insanity, unable to handle the trials of emigration. Such a view of Moodie, however, gives a distorted picture of her agency and rationality. As Fiona Sparrow points out, "There is more of the rationalist in Susanna Moodie than is generally allowed" (25). "[Moodie] can sound prejudiced and melodramatic," Sparrow observes, "but for the most part she speaks with a voice both controlled and sane" (27).[10] Concurring with Sparrow, I shall show in this essay that *Roughing It* is a rational attempt to develop a woman-centered literary style that

can articulate the diverse experiences of emigration more fully than can traditional male-authored narratives.[11] At the same time, however, we must recognize that Moodie is a "watchful visitor—a tourist and sightseer" whose "observations are directed toward a European audience" (Giltrow 133). Although Moodie restructures the traditional male-authored immigration narrative, she does not question the division between British "civilization" and Canadian "barbarity," displaying her alienation from her new land.

This essay also argues that what David Jackel identifies as the text's "unstructured" nature (3), far from being a flaw or, as Marian Fowler claims, an attempt to reproduce "the usual meanderings of the sentimental novel" (105), marks the author's attempts to describe an experience that refuses to fit into an organized, coherent, progressive narrative.[12] Thus, Jackel's criticism that Moodie "is unable even to take advantage of chronological ordering, the simplest means of giving structure to a narrative of personal experience" and that she writes at times "as if she had no knowledge of what would happen next" (10) expresses a narrow, formalist, and male-constructed ideology about how the immigration narrative should be written, a perspective that does not consider what Moodie is attempting to accomplish: the presentation of an alternative view of immigration.

Caren Kaplan's discussion of the importance of deterritorialization in postmodern writing promotes understanding of Moodie's fragmented prose. Kaplan writes that *deterritorialization* is a term "for the displacement of identities, persons, and meanings that is endemic to the postmodern world system" (188). "Gilles Deleuze and Felix Guattari use the term 'deterritorialization' to locate this moment of alienation and exile in language and literature," Kaplan continues. "In one sense it describes the effects of radical distanciation between signifier and signified. Meaning and utterances become estranged." Although Kaplan's analysis helps to explain the fragmentation of national and personal identities that is so prevalent in the postmodern age, deterritorialization is hardly unique to postmodernism. Moodie herself is an important example of the nineteenth-century, deterritorialized author, who writes in an attempt to understand the displacement that she has undergone; her disjointed, unstructured prose is analogous to the fragmented subjectivity she experiences as an emigrant. Thus, by analyzing how several elements of the emigration story are rescripted or contested by Moodie rather than examining how the episodes that compose much of this text either cohere or fail to cohere, we gain a better understanding of how this work estab-

lishes a discourse in contradistinction to the more prevalent male-authored narratives of emigration. We also discover, however, that because of her failure to question class divisions and because of her adherence to ethnic stereotypes (such as that the Irish are "barbarians"), Moodie was ultimately unable to write a text that addressed the problems of more than a small group of middle-class and upper-middle-class women.

"A Matter of Necessity, Not of Choice"

As I have suggested, bourgeois women often did not share their husbands' enthusiasm for emigration. For example, Moodie begins *Roughing It* with a very different account of emigration than Catermole's: "In most instances," she writes, "emigration is a matter of necessity, not of choice; and this is more especially true of the emigration of persons of respectable connections, or of any station or position in the world." Moodie continues, "Emigration may ... generally be regarded as an act of severe duty, performed at the expense of personal enjoyment" (xv). Here, Moodie reiterates one of the key tenets of British imperialism: It is one's duty to move to the colonies and further the state's growth. Moodie does not question the necessity for emigration but resigns herself to her fate, pointing out to her readers that emigration is "the only safe remedy for the evils arising out of an over-dense population" (209). According to this Malthusian logic, it is the woman's responsibility to emigrate or suffer the consequences of not doing so.

Although Catermole, Weld, and Heriot displayed little concern about the class mixing that was bound to occur in Canada, a less hierarchical and status-conscious society than England, Moodie perceives potential class mingling as a great threat and vainly seeks to recreate the class distinctions to which she was accustomed. She expresses nothing but derision for the "absurd anticipations" of the working-class men and women on board her ship. "I was not a little amused at the extravagant expectations entertained by some of our steerage passengers," she writes, adding: "The sight of the Canadian shores had changed them into persons of great consequence. The poorest and the worst-dressed, the least-deserving and the most repulsive in mind and morals, exhibited most disgusting traits of self-importance. Vanity and presumption seemed to possess them altogether" (22). Again, Moodie is appalled when a working-class Irishman clad in a "tattered great-coat covering bare, red legs" jumps for the

first time on the Canadian shore, shouting, "Whurrah! my boys! ... Shure we'll all be jontlemen!" (14). Moodie's rhetoric makes it clear that she does not embrace class mobility with the same enthusiasm as the steerage passengers.

Moodie's class bias is again evident when she goes onshore for the first time at Grosse Isle, the disinfection point for emigrants. She is confronted by a "motley crew" of Irish washing their clothes in the shallow water and "screaming and scolding in no measured terms." "We were all literally stunned by the strife of tongues," Moodie writes. "I shrank, with feelings almost akin to fear, from the hard-featured, sun-burnt harpies, as they elbowed rudely past me." She calls the people "vicious, uneducated barbarians" who are "perfectly destitute of shame, or even of a common decency." Moodie and her husband "[turn] in disgust from the revolting scene" and try to find some calm and peace in the tranquil scenery (11). Mrs. Moodie, however, complains that even the natural beauty is "spoiled by the discordant yells of the filthy beings who were sullying the purity of the air and water with contaminating sights and sounds!" (13). As T. D. MacLulich observes, "The immigrants-gone-wild at Quebec evoke [Moodie's] own panic on the edge of the new world, which may prove to be a place in which all the certainties of the English gentry are turned topsy-turvy" (120). In this upside-down world, counter to all she has known, it is not at all surprising that Moodie is unable or unwilling to endorse imperialism, which stresses that social progress and a high degree of civilization will inevitably result from the influx of British emigrants and colonial administrators. Instead, Moodie repeatedly suggests that in the colonies, all Anglo emigrants (whether Irish or British), regardless of class, have the potential to deteriorate into barbarism.

The disorder Moodie finds in Canada, which she is at a loss to understand and desperately wants to bring under control, is not limited only to the country's inhabitants. It is a disorder of the land itself, symbolized by the epidemics she finds upon her arrival. The text's emphasis on disease is evident from the first line of the first chapter: "The dreadful cholera was depopulating Quebec and Montreal, when our ship cast anchor off Grosse Isle" (1).[13] Shortly after the Moodies' arrival, their ship is visited by health officers "who [talk] much and ominously of the prevailing disorder, and the impossibility of strangers escaping from its fearful ravages" (23). Chapter 3 begins, "Of Montreal I can say but little. The cholera was at its height, and the fear of infection, which increased *the nearer we approached its shores*, cast a gloom over the scene, and prevented us from exploring its infected streets" (33; emphasis added). Moodie con-

tinues, "The dismal stories told us by the excise-officer ... of the frightful ravages of the cholera, by no means increased our desire to go *on shore*" (34; emphasis added). Note the repeated references to the Canadian shore; cholera seems to be a disease that emanates from the land itself rather than from the people, reflecting Moodie's fear of the new environment.

Montreal, instead of signifying the freedom and openness the settlers hope to find in the new land, is forbidding and menacing. Moodie paints a grim picture of the evils that lie in wait for the immigrant who dares venture into this city:

> The town itself was, at that period, dirty and ill-paved; and the opening of all the sewers, in order to purify the place and stop the ravages of the pestilence, rendered the public thoroughfares almost impassable, and loaded the air with intolerable effluvia, more likely to produce than stay the course of the plague, the violence of which had, in all probability, been increased by these long-neglected receptacles of uncleanliness. (34)

The insecurity found on land is juxtaposed with the safety Moodie locates on board the ship: "The sullen toll of the death-bell [and] the exposure of ready-made coffins in the undertakers' windows ... painfully reminded us ... that death was everywhere.... Compared with the infected city, our ship appeared an ark of safety" (40). Peter Stallybrass and Allon White's description of the nineteenth-century European city as a "locus of fear, disgust and fascination" for the middle class, particularly disturbing because the lower classes could easily mingle with higher classes (125), provides a basis for understanding Moodie's obsessive concern with the decay and putrefaction to be found in Montreal. By transposing an ideology with which she is familiar onto Montreal, Moodie makes her environment more intelligible. Intelligibility, however, does not necessarily lead to greater acceptance. Instead, for Moodie the Canadian city, like the European city, becomes a zone of chaos and class confusion, where cholera is only the most obvious sign of the prevalent social disorder.

Moodie is constantly engaged in mapping British class ideology onto both the Canadian city and the hinterland. Thus, her attention to the "intolerable effluvia" and "long-neglected receptacles of uncleanliness" may also represent her desire to associate herself with the upper class by intimating that she has an acute sense of smell. Smell, being pervasive and invisible, could "invade the privatized body of the bourgeoisie" dur-

ing the nineteenth century (Stallybrass and White 139). "At one level smell was re-formed as an agent of class differentiation," Stallybrass and White write. "Disgust was inseparable from refinement: whilst it designated the 'depraved' domain of the poor, it simultaneously established the purified domain of the bourgeoisie" (140). In other words, the more disgust Moodie expresses, the more evident her identification with the upper classes. Also, the greater her sensitivity to the odors that the Montreal inhabitants seem to tolerate, the more clearly she presents herself as both a foreigner and an individual with more refined sensibilities than the local inhabitants.

Moodie's dread of the cholera reveals her bourgeois fear of contact with the lower classes, particularly the Irish, but her reaction is also symbolic of the immigrant's ambivalent attitude toward assimilation in the new country. Either the immigrant may succumb to cholera (and homesickness) and may die, never benefiting at all from Canadian life, or she may be cured of both her illness and her homesickness. Given this reading, it is understandable why Moodie provides a detailed description of one cure for cholera that supposedly saved many. An itinerant physician is credited with saving thousands of people with a mysterious remedy "all drawn from the maple-tree": "First he rubs the patient all over with an ointment, made of hog's lard and maple-sugar and ashes, from the maple-tree; and he gives him a hot draught of maple-sugar and ley which throws him into a violent perspiration. In about an hour the cramps subside; he falls into a quiet sleep, and when he awakes he is perfectly restored to health" (36). It is not by chance that the doctor's medication is composed of ingredients from the maple tree, a symbolic reference to Canada itself. According to this analogy, the immigrant must become assimilated into the Canadian community, an experience that might induce "violent perspiration." Ultimately, however, the immigrant accepts the new homeland and is restored to health. Although Moodie regards acceptance of the new country as necessary, she herself finds assimilation into Canadian culture difficult because she continually struggles to reconcile her British values with Canadian ones.

Moodie's uncertainty as to whether British middle-class beliefs could survive in Canada undermines the belief, prevalent in the nineteenth century, that British colonialists, whether in Canada, Australia, South Africa, or India, could always succeed in imposing their own ideology onto a foreign country. Although male writers invariably emphasized that land ownership would result in a more moral populace, Moodie stressed the lack of connection between owning land and moral good-

ness, depicting the rural environment as, instead, a breeding ground for vice. For instance, the English gentry, who can afford to move to the backwoods to hunt and fish, abandon their ethical principles almost as quickly as the Irish laborers. Moodie remarks that British men soon add to their "profitless accomplishments" of hunting and fishing the "bush vices of smoking and drinking, and quickly throw off those moral restraints upon which their respectability and future welfare mainly depend" (xxxi). For Moodie, no amount of moral rectitude is sufficient to save a man or woman from inevitable corruption in the hinterland. An itinerant preacher shares her views: "[T]he bush is a bad place for young men," he warns. "The farther in the bush ... the farther from God, and the nearer to hell" (310). Moodie regards the wilderness as both a physical and spiritual wasteland. The wilderness is not the earthly paradise envisioned by many male writers of the nineteenth century in their travel and emigration accounts.

In *Roughing It,* Moodie refutes the common Romantic assumption that living in a wilderness area, far from the corruption of cities, makes a person both spiritually and morally stronger. Although upon her arrival she delights in Canada's natural beauty, her enthusiasm later wanes as she becomes increasingly disillusioned with nature as a source of moral and spiritual rejuvenation. She depicts nature, instead, as "red in tooth and claw," offering little security to the middle-class female immigrant like herself, who is constantly fearful of the known and unknown dangers of the woods. Moodie refers to the bush as a "green prison," a description that surely expressed the thoughts of many other women immigrants (*Clearings* xxxii). Living closer to nature fails to offer the immigrant a heightened experience of the sublime, as described by such Romantic poets as Wordsworth, Keats, and Shelley; instead, the middle-class woman is confronted with the sordid actuality of daily life in the backwoods, a reality that seems impossible to change. Longtime Canadian settlers tell Tom Wilson, the Moodies' friend and fellow immigrant, that it is "impossible to be nice about food and dress in the *bush;* that people must learn to eat what they could get, and be content to be shabby and dirty, like their neighbors in the *bush*" (*Roughing* 72). Thus, the bush, associated with disorder and filth, also becomes identified with the lower classes and uncouth behavior. Mrs. Moodie is informed by a Canadian that "ladies and gentlemen have no business in the woods. Eddication spils [*sic*] man or woman for that location" (246). Attributes (such as education) that are valued in England are worthless in this new country. At one point, Mr. Malcolm, a visitor at the Moodies' house, tries to justify

his swearing to Mrs. Moodie, saying, "Surely, in the woods we may dispense with the hypocritical, conventional forms of society, and speak and act as we please" (366). Malcolm fails to recognize that it is exactly those "hypocritical, conventional [British] forms of society" that Moodie is trying to perpetuate in the wilderness.

Since Moodie is intent upon recreating British society in the Canadian backwoods, she is upset by the indiscriminate intermingling of classes, as well as by the reversal of traditional gender roles. As Carol Shields notes, Moodie's women tend to grow more "self-sufficient and masculine in the woods, while men tend to become less self-sufficient and more feminine" (7).[14] Mr. Moodie, Brian the Still Hunter, Tom, and Malcolm are only a few of the men in *Roughing It* who are either idle or incompetent and force women to take over masculine responsibilities. When her husband proves to be inept in financial matters, Mrs. Moodie must raise money through her painting and writing. For her, this gender role inversion refutes the popular assumption that men, once they emigrated to the frontier, would prosper through their own agency. Moodie contradicts the then-prevalent belief that frontier men were "natural" leaders, as well as the personification of manliness. Instead, she implies that the frontier actually sapped male agency.

Nowhere is Moodie's struggle to reconcile her British Romantic views with the actuality of Canada more apparent than when a group of Indians visits her. She describes the Indians as "a people whose beauty, talents, and good qualities have been somewhat overrated, and invested with a poetical interest which they scarcely deserve" (264).[15] Although she suggests that the Romantic depiction of the Indian as a "noble savage" is inappropriate, she seems unable to avoid using Romantic rhetoric. She remarks that an "Indian is Nature's gentleman—never familiar, coarse, or vulgar" (284), showing her allegiance to the same Romantic values that she questions.[16] Again, Moodie succumbs to Romantic ideology when she ponders the Indians' fate: "Often I grieved that people with such generous impulses should be degraded and corrupted by civilized men; that a mysterious destiny involves and hangs over them, pressing them back into the wilderness, and slowly and surely sweeping them from the earth" (289). In this passage we see that Moodie, despite attempting to redefine the emigrant experience for middle-class women as different from men's, is no more able to escape complicity in the imperialist project than the nineteenth-century British male. By alluding to a "mysterious destiny," Moodie refuses to acknowledge any human—never mind British—agency in the destruction of the

Indians; she affirms the basic premise of imperialist colonialization: Native peoples have less right to their lands than do the British.

In *Winter Studies and Summer Rambles in Canada* (1839), Anna Jameson expresses thoughts about the Indians similar to Moodie's. Jameson, however, is more enthusiastic than Moodie about the picturesque possibilities of the Indians; she comments after she meets a group of Indians that there was not "a figure among them that was not a study for a painter" and wished that her "hand had been readier with the pencil to snatch some of those picturesque heads and attitudes!" (2: 134). Here, to borrow Abdul JanMohamed's words, "[C]olonialist discourse 'commodifies' the native subject into a stereotyped object and uses him as a 'resource' for colonialist fiction [or, I would add, any form of colonialist aesthetic production]" (64). In other words, Jameson ignores the agency and subjectivity of Indians, regarding them only as useful commodities. At the same time, she criticizes the Indians for their "dirty," "barbaric," and "ignorant" habits and alludes to them as her "dingy, dusky, greasy, painted, blanketed, smiling friends" (2: 192). Obviously, such "barbaric" individuals do not deserve to be treated with the same respect as white people. For Jameson, the Indians are only subjects for paintings, and like Moodie, she believes that they are doomed to extinction: "The attempts of a noble and a fated race, to oppose, or even to delay for a time, the rolling westward of the great tide of civilization, are like efforts to dam up the rapids of Niagara. The moral world has its laws, fixed as those of physical nature" (2: 38). Jameson's words, like Moodie's, are chilling. She does not attribute any responsibility to the individuals who compose the "great tide of civilization," thus relieving them of any culpability in the extermination of the Indians. Furthermore, her teleological language makes the Indians' destruction seem more like a natural disaster than the result of human agency.

Moodie's and Jameson's insistence on the nobility of the native Canadians must be examined in more detail, since it seems to refute JanMohamed's argument that colonial texts display a "vociferous insistence ... upon the savagery and the evilness of the native" in order to "justify imperial occupation and exploitation." "If such literature can demonstrate that the barbarism of the native is irrevocable, or at least very deeply ingrained," JanMohamed continues, "then the Europeans attempt to civilize him can continue indefinitely ... and the European can persist in enjoying a position of moral superiority" (62). Although JanMohamed's argument helps to explain the operation of some colonial texts, it does not fully explain Moodie's and Jameson's insistence that the

Indians are both barbarous *and* noble. What we find is that, paradoxically, nobility can be used as effectively as barbarism to explain the dominance of European culture in its colonial lands, since both the noble native and the barbarous native are defined as incapable of assimilation into Anglo society.

Moodie's and Jameson's rhetorical emphasis on the nobility of the Indians also conceals the harsh living conditions forced upon them by European settlers, who encroached upon the Indians' land and contributed to the spread of disease. Although the northern Indians did not meet with mass eradication to the same extent as did tribes in the United States, their numbers were still greatly reduced. In the 1790s, Alexander MacKenzie could report in his travel log of his trip across Canada: "I explored those waters which had never before borne any other vessel than the canoe of the savage; and traveled through deserts where an European had never before presented himself to the eye of its swarthy natives" (vii); yet in the nineteenth century, because of the influx of Europeans and the diseases they brought with them, the original inhabitants were decimated. By 1845, Henry Warre reported that the Indians were reduced from "sickness and other causes, to less than one-third of their former number" (1). And the Canadian government, like that of the United States, did little to stop the decimation. As even Anna Jameson admits, "Every means hitherto provided by the Canadian government for the protection of the Indians against the whites has failed" (2: 45). This grim historical background must be taken into account by present-day critics so we recognize that Moodie's text is concealing as much as it is revealing about the actual lives of Indians. Moreover, her bourgeois European background necessarily colors how she perceives Canada's first inhabitants. (All travel fiction, including the immigration narrative, is inevitably biased because writers are discussing their subjective experiences in a foreign and often unfamiliar country.)

Moodie's subjectivity and her adherence to English rather than Canadian values are clearly evident in her many tirades about the poor quality of domestic servants available in her new country, a subject about which she is obsessed.[17] She repeatedly criticizes what she calls the "insolent airs of independence" (217) of Canadian servants who know, because of the high demand for servants, that they can insist on higher wages or leave one position and immediately find another. In her writings, Moodie is particularly critical of newly arrived servants, warning in *Flora Lyndsay*: "Persons emigrating to Canada cannot be guilty of a greater blunder than that of taking out servants with them.... [T]hey no sooner

set foot upon the North American shores, than they suddenly become possessed with an *ultra republican* spirit" (1: 114).[18] Once this happens, according to the narrator, the servant is rendered useless: "Ask such a domestic to blacken your shoes, clean a knife, or fetch a pail of water from the well at the door, and ten to one she will turn upon you as fierce as a lioness, and bid you do it yourself" (1: 115). Moodie fears a world turned upside down, where masters and mistresses are made to serve those who formerly served them. It is clear she does not think her former servants are intellectually or morally prepared to govern others. She scoffs at their accomplishments and criticizes Canadian servants who "think themselves as good as their employers" (xix).[19] Moodie is particularly critical of the lower classes' lack of manners toward the middle class. "The utter want of that common courtesy with which a well-brought-up European addresses the poorest of his brethren, is severely felt at first by settlers in Canada," she observes. "At the period of which I am now speaking, the titles of 'sir' or 'madam' were very rarely applied by inferiors." On the other hand, Moodie notes, "[M]y bare-legged, ragged Irish servants were always spoken to, as 'sir' and 'mem,' [sic] as if to make the distinction more pointed" (213). To a nineteenth-century English audience, the possibility that the Irish regarded themselves as superior to the English would have been shocking, suggesting to the readers that Canada was far outside the civilized pall.

The conduct of such disobedient, rude, lower-class individuals encourages Moodie to dwell on the reasons for their behavior:

> Why they treated our claims to their respect with marked insult and rudeness, I never could satisfactorily determine.... Then I discovered the secret.
>
> The unnatural restraint which society imposes upon [uneducated emigrants from Britain] at home forces them to treat their more fortunate brethren with a servile deference which is repugnant to their feelings.... Necessity compels their obedience; they fawn, and cringe, and flatter the wealth on which they depend for bread. But let them once emigrate, the clog which fettered them is suddenly removed; they are free; and the dearest privilege of this freedom is to wreak upon their superiors the long-locked-up hatred of their hearts. (213–14)

Although Moodie's analysis of the possible reasons for class antagonism in England is perceptive, she still does not question the organization of society, presuming that members of the upper and middle class are

"superiors." She perceives the rebellious conduct as unimportant, as merely an inconvenience and a major annoyance that the upper classes can avoid by remaining in England.

For Moodie, the lower classes present a much greater threat to her physical well-being than do the Indians, whom she quickly dismisses as picturesque but doomed. The lower classes, however, are not so easily dispensed with and prove to be extremely articulate about their "long-locked-up hatred." The most notable example of class conflict occurs when Moodie is washing clothes for the first time and is watched by a working-class Canadian woman, Mrs. Joe, who sneers: "I am glad to see you brought to work at last. I hope you may have to work as hard as I have. I don't see, not I, why you, who are no better than me, should sit still all day, like a lady!" (140). "I guess you don't look upon us as fellow-critters," Mrs. Joe continues, "you are so proud and grand. You don't choose to sit down at meat with your helps.... I hate you all; and I rejoice to see you at the wash-tub, and I wish that you may be brought down pon [sic] your knees to scrub the floors" (141).[20] Demonstrating her inability to fully understand class relationships in her new country, Moodie is "hurt and astonished" by Mrs. Joe's speech (141). Moodie adheres to English social codes, and she equates the breakdown of such codes in Canada with the essential barbarism of the nation.

Lower-class men and women refuse to be silenced, showing that emigration can sometimes offer a voice to the disenfranchised. Mrs. Joe is not the only working-class woman who will not accept her position. When the Moodies move into temporary living quarters, they are met by a young woman "with ... a forward, impudent carriage, and a pert, flippant voice" (86) who has come to borrow some whiskey and who Moodie mistakes for a servant. The visitor resents this assumption, remarking, "I hope you don't take me for a help. I'd have you know that I'm as good a lady as yourself" (87). Although Moodie clearly intends this as a comic speech, present-day readers might feel some empathy toward the visitor, who is determined not to be snubbed. When Moodie calls the visitor a "girl," she replies sharply, "Now, don't go to call me 'gal'—and pass off your English airs on us. We are *genuine* Yankees, and think ourselves as good—yes, a great deal better than you. I am a young lady" (88). It becomes evident in this verbal exchange that, as well as class conflicts, there are nationalist differences in Canada. Moodie satirizes Americans as greedy, unkempt, rude, and illiterate, ridiculing their pretensions to elegance and breeding just as she disparages the Irish.[21] Obviously, for Moodie one of Canada's drawbacks is the lack of demar-

cation between different groups of emigrants, resulting in what appears to her to be cultural and social anarchy.[22]

According to Moodie, the American girl's request to borrow a flask of whiskey is symptomatic of what is wrong in Canada.[23] Borrowing is frequent and continuous. Moodie complains that in Canada, even one's land is borrowed without permission: "[O]ur new home was surrounded by these odious squatters, whom we found as ignorant as savages, without their courtesy and kindness" (81). Moodie is as critical of those who would borrow a plot of land as she is of the women who try to borrow household supplies from her. What is borrowed is not significant; it is the act of borrowing that denotes Canada as an "uncivilized" country that has not yet become a capitalist economy. Borrowing blurs the distinction between private and public property, as goods tend to be traded indiscriminately among a large group. Also, goods are borrowed without compensation or promise of payment. Rather than having a capitalist economy, essential for the emigrant to prosper financially, Canada has an economy based on borrowing, which can only lead to economic disaster. Moodie suggests that financial and material gain — the most common reason for emigration — is difficult, if not impossible, to achieve. By arguing that emigration, far from leading to material gain, results in fiscal ruin, Moodie raises a distinct countervoice to the dominant ideology.

"The Secrets of the Prisonhouse"

Moodie's subversion of the male-authored emigration narrative is also apparent in the conclusion of *Roughing It*, when she suggests that middle-class British men and women should avoid emigration altogether. She writes, "If these sketches should prove the means of deterring one family from sinking their property, and shipwrecking all their hopes, by going to reside in the backwoods of Canada, I shall consider myself amply repaid for revealing the secrets of the prisonhouse, and feel that I have not toiled and suffered in the wilderness in vain" (515). As well as revealing Moodie's personal anxieties about emigration, her words show her desire to expose the "secrets" about British colonialism that were seldom brought up in contemporary discussions of emigration to Canada. She also points out that the reality of emigration for men might have little to do with the experiences of women: males might find personal agency and physical freedom in the woods, while females might find only a

"prisonhouse." As I have mentioned, however, Moodie's perception of the imprisonment that rural Canadian life foists on women is intimately connected with her class position; we must not assume that Moodie expressed the thoughts of all nineteenth-century female immigrants. Moodie herself would be the first to deny that she spoke for working-class Irish women or for women from other ethnic backgrounds.

Moodie's ambivalent attitude toward emigration demonstrates that deterritorialization is never an experience of absolute alienation and exile. Rather, as is evident in Moodie's fiction, the deterritorialized writer struggles with feelings of exile and attempts to make all that is alien more familiar by viewing it within the context of imported ideologies. Moodie, for instance, judges her Canadian domestics by middle-class British standards of correct behavior, showing her complicity with Anglo males in importing British values and beliefs into the colony. Despite her conformity with some aspects of colonialist ideology, it should not be inferred that Moodie's views were always congruent with those of male writers, who did not give the same consideration to gender that she did. Deterritorialization offered Moodie a location for subversion of imperialist ideology that she would not have found without the experience of physical and psychological displacement; however, deterritorialization also created a space for Moodie to reaffirm her bourgeois notions of class separation and racism. Deterritorialization, therefore, cannot offer the subject full escape from the hegemonic codes of her former nation. Such a perception of the complexities of emigration allows the reader to better understand how travel between countries can be both a socially conservative and subversive experience, invoking the questioning of certain beliefs while simultaneously affirming others.

Notes

1. Martin Doyle, like Weld, was convinced that Canada was a far superior destination for emigrants than the United States and, in his emigration guide, sought to steer his readers to Upper Canada so they would avoid "the blunder [they] might otherwise commit by settling in the States" (3). The English commonly assumed in the early nineteenth century that Canada, still a British colony, would offer a more hospitable region to settle in than the United States.
2. Not all men were equally enthusiastic about the benefits of Canadian emigration. Taylor, for instance, warned his readers to think carefully before they left the "comforts of their English homes, for the miserable huts and habits of a foreign country" (81–82). Even Taylor, however, forecasted prosperity for men willing to work hard, forego whiskey, and avoid land speculation.

3. Some women writers were as positive as Catermole about the benefits of Canadian life. Anna Jameson, for instance, described Upper Canada as a "paradise of hope" flowing with "milk and honey" (2: 35).

4. In her writing, Moodie repeatedly dwells upon this painful break that the emigrant must make. See "The Vanquished Lion" (1831); "The Sailor's Return; or, Reminiscences of Our Parish" (1841); "The Broken Mirror: A True Tale" (1843); "The Well in the Wilderness: A Tale of the Prairie — Founded upon Facts" (1847); and "Trifles from the Burthen [sic] of a Life" (1851). All of these stories are included in Thurston's collection of Moodie's short fiction.

5. Questioning the representation of emigration and western migration was not limited to Canadian fiction; U.S. women writers also provided a reading of westward expansionism that questioned dominant ideology. For example, Moodie's *Roughing It* has many similarities with Kirkland's account of life in rural Michigan, a work with which *Roughing It* was compared when it was first published (Ballstadt 110). Also see Kolodny's thoughtful study of Kirkland's work (131–58).

6. For an overview of critical essays on Moodie, see Noonan.

7. Probably the best-known of these sisters was Agnes, who wrote the multivolume *Lives of the Queens of England* (1840–48) with her sister Elizabeth. Susanna and her sister Catherine, who also emigrated to Canada, achieved a lesser degree of fame with their many accounts of Canadian life.

8. The interested reader should locate the unedited version of this text, not Carl Klinck's popular edited version, which has done much to alter the public perception of Moodie's work. As Peterman comments about Klinck's version, "[M]uch of the bush [has been] removed" (115). Other critics, such as Fiona Sparrow, concur with Peterman's assessment (27).

9. For an excellent account of the reception *Roughing It* received in the nineteenth century in Britain, Canada, and the United States, see Ballstadt (104–10).

10. Certainly many of Moodie's readers perceived her text as rational, sane, and a direct reflection of reality. For instance, the *New York Albion* review of 10 July 1852 praised the book's "obvious stamp of truth" (qtd. in Ballstadt 109).

11. Not all critics agree that rationality can be found in *Roughing It*. For instance, Gairdner discusses the "fundamental uncertainty" and "dark chaos" found in the text (40). He, however, overlooks Moodie's simultaneous attempts to order and understand the chaos, as well as her growing recognition that all countries do not adhere to the British model.

12. Fowler's claim that *Roughing It* must be understood as a dual text (a sentimental narrative and a Gothic novel influenced by the work of Ann Radcliffe, Charlotte Smith, and Clara Reeve) is not without validity. In this essay, however, I am more concerned with examining *Roughing It* as an immigration narrative that expresses a gendered viewpoint than with tracing its roots in the sentimental or Gothic traditions.

13. We must recognize the historical validity of Moodie's fears, as well as their symbolic nature. The living conditions at Grosse Isle, the quarantine station for new immigrants throughout the nineteenth and early twentieth centuries, would have shocked anyone. Quarantined patients were housed in barracks with the windows painted over, since light was considered harmful to invalids. Guards controlled patients' movements, preventing escapes to the mainland. During one of the vari-

ous plagues that swept through Montreal in the 1800s, from fifty to over a hundred people would die every day on Grosse Isle from cholera, typhus, smallpox, diphtheria, or malnutrition and ill health brought on by the long voyage from Europe. The worst plague year was 1847, when over 5,300 Irish immigrants died. In 1832, when Moodie visited Grosse Isle, the cholera epidemic was so fierce that victims were buried in shallow mass graves in mudflats that were exposed when the bay waters retreated. Given the grim reality of Grosse Isle, Moodie's fears seem less exaggerated. (I am indebted to Gary Thomson's article, "Island of the Sorrows," for much of the information contained within this paragraph.) For information on the devastation wrought by cholera in Quebec, see Raible.

14. Not all women shared Moodie's views about gender roles in Canada. For instance, Anne Langton writes in her journal about her experiences in Canada, "I have caught myself wishing an old long-forgotten wish that I had been born of the rougher sex. Women are very dependent here, and give a great deal of trouble" (60).

15. Mr. Moodie finds the native Canadians more interesting than his wife does and is intrigued by the poetic quality of their language, but when he attempts to collect some native songs, they refuse to give them out, saying they are "no good for white ears" (273). Mr. Moodie's failure is similar to that of Mr. Rivers in the novel *Emily Montague*. When he attempts to find an Indian to translate some native songs, he is informed that "the Indians were not us'd to make translations, and that if [he] chose to understand their songs [he] must learn their language" (Brooke 1: 21). Clearly, the Canadian natives resist becoming mere curiosities for the white man.

16. Moodie is less complimentary about half-castes: "The half-caste is generally a lying, vicious rogue, possessing the worst qualities of both parents in an eminent degree" (293). For her, the half-caste did not possess the poetic possibilities of the full-blooded Indian.

17. Many British observers shared Moodie's concern about servants. Even George Heriot, despite his enthusiasm for Canadian life, thought that Canadian servants were "bad" because "indolence and a spirit of independence make the yoke of subjection, however light, to appear to them burdensome and unpleasant" (256). Similarly, Anne Langton complained in her journals about the difficulties of obtaining good help: "Our new [domestic] is by no means promising, and [has] to be perpetually reminded.... Such as ours, I suppose, is the ordinary sort of Canadian servant" (91).

18. Kirkland expressed similar thoughts about the difficulty of locating good servants in rural Michigan: "I have ... seen the interior of many a wretched dwelling, with almost literally nothing in it but a bed, a chest, and a table.... [B]ut never yet saw I one where the daughter was willing to own herself obliged to live out at service" (61). Kirkland finds Michigan "appalling" and only gradually adapts to the habits of her neighbors. Also see Trollope's account of her problems with servants in Ohio (44–48). For British women writers, the poor domestic service found in Canada and the United States became a metaphor for the "uncivilized" nature of these countries.

19. Similarly, Catharine Parr Traill warns in her *Canadian Settler's Guide* (1855): "There is an error which female servants are very apt to fall into in this country, which as a true friend, I would guard them against committing. This is adopting a free and easy manner, often bordering upon impertinence, towards their employ-

ers" (6). Unlike Moodie, Traill warns employers that they should treat their servants with consideration.

20. This is not the only example of the Joe family's class hostility toward the Moodies. When they move out of the house the Moodies are to occupy, the Joe family members girdle the apple trees, flood the house with water, and leave a trapped skunk in the house.

21. Anti-American feelings were prevalent in nineteenth-century Canada among members of all classes, who feared that the expansionist United States would inevitably wish to expand into Canada's western territories. Thus, by condemning Americans, Moodie made *Roughing It* more, not less, salable in both England and Canada.

22. Moodie's feelings about class separation become less pronounced by the time she writes *Clearings*. She writes in this later work, "To those persons who have been brought up in the old country, and accustomed from infancy to adhere to the conventional rules of society, the mixed [Canadian] society must, for a long time, prove very distasteful. Yet this very freedom ... is by no means so unpleasant as strangers would be led to imagine." Still, Moodie adds, "The lady and gentleman in Canada are as distinctly marked as elsewhere. There is no mistaking the superiority that mental cultivation bestows; and their mingling in public with their less gifted neighbours rather adds than takes from their claims to hold the first place" (38). Moodie might have agreed with Caroline Kirkland, who commented that "a greasy cookmaid, or a redolent stable-boy, can never be, to my thinking, an agreeable table companion" (82–83). Both Moodie's and Kirkland's rhetoric indicate that women's emigrant narratives often tried to assure middle-class readers that the bush was not devoid of social codes.

23. Concerns about borrowing were frequently expressed in women's emigration narratives. See Kirkland (105–12) and Traill (25–27).

Works Cited

Atwood, Margaret. Introduction. *Roughing It in the Bush*. By Susanna Moodie. Boston: Beacon, 1986. vii–xiv.

———. *The Journals of Susanna Moodie*. Toronto: Oxford UP, 1970.

Ballstadt, Carl, Elizabeth Hopkins, and Michael Peterman, eds. *Susanna Moodie: Letters of a Lifetime*. Toronto: U of Toronto P, 1985.

Brooke, Frances. *The History of Emily Montague*. 1769. 4 vols. New York: Garland, 1974.

Catermole, William. *Emigration: The Advantages of Emigration to Canada*. 1831. Toronto: Coles, 1970.

Cowan, Helen. *British Migration to British North America*. Toronto: U of Toronto P, 1961.

Doyle, Martin. *Hints of Emigration to Upper Canada: Especially Addressed to the Middle and Lower Classes in Great Britain and Ireland*. Dublin: Curry, 1834.

Fowler, Marian. *The Embroidered Tent: Five Gentlewomen in Early Canada*. Toronto: Anansi, 1982.

Gairdner, William. "Traill and Moodie: Two Realities." *Journal of Canadian Fiction* 1 (1972): 35–42.

Giltrow, Janet. " 'Painful Experience in a Distant Land': Mrs. Moodie in Canada and Mrs. Trollope in America." *Mosaic* 14 (1981): 131–44.

Heriot, George. *Travels through the Canadas*. London, 1807.

Jackel, David. "Mrs. Moodie and Mrs. Traill and the Fabrication of a Canadian Tradition." *Compass* 6 (1979): 1–22.

Jameson, Anna. *Winter Studies and Summer Rambles in Canada*. 2 vols. New York: Wiley, 1839.

JanMohamed, Abdul R. "The Economy of Manichean Allegory: The Function of Racial Difference in Colonialist Literature." *Critical Inquiry* 12 (1985): 59–87.

Kaplan, Caren. "Deterritorializations: The Rewriting of Home and Exile in Western Feminist Discourse." *Cultural Critique* 6 (1987): 187–98.

Kirkland, Caroline. *A New Home—Who'll Follow? or, Glimpses of Western Life*. New York: Francis, 1839.

Kolodny, Annette. *The Land before Her: Fantasy and Experience of the American Frontiers, 1630–1860*. Chapel Hill: U of North Carolina P, 1984.

Langton, Anne. *A Gentlewoman in Upper Canada: The Journals of Anne Langton*. Toronto: Clarke, 1950.

MacKenzie, Alexander. *Voyages from Montreal on the River St. Lawrence through the Continent of North America to the Frozen and Pacific Oceans: In the Years 1789 and 1793*. London, 1801.

MacLulich, T. D. "Crusoe in the Backwoods: A Canadian Fable?" *Mosaic* 9 (1976): 115–26.

Moodie, Susanna. *Flora Lyndsay; or, Passages in an Eventful Life*. 2 vols.. London: Bentley, 1854.

———. *Life in the Clearings*. 1853. Toronto: Macmillan, 1959.

———. *Roughing It in the Bush*. 1852. Boston: Beacon, 1986.

Noonan, Gerald. "Susanna and Her Critics." *Studies in Canadian Literature* 5 (1980): 280–89.

Peterman, Michael. "In Search of Agnes Strickland's Sisters." *Canadian Literature* 121 (1989): 115–24.

Raible, Chris. " 'In Sable Garments of Mourning …': Cholera Devastates Upper Canada, 1832." *Beaver* 72 (Apr./May 1992): 43–50.

Shields, Carol. *Susanna Moodie: Voice and Vision*. Ottawa: Borealis, 1977.

Sparrow, Fiona. " 'This Place Is Some Kind of Garden': Clearings in the Bush in the Works of Susanna Moodie, Catherine Parr Traill, Margaret Atwood and Margaret Laurence." *Journal of Commonwealth Literature* 25 (1990): 24–41.

Stallybrass, Peter, and Allon White. *The Politics and Poetics of Transgression*. Ithaca: Cornell UP, 1986.

Stouck, David. "Secrets of the Prison House: Mrs. Moodie and the Canadian Imagination." *Dalhousie Review* 54 (1974): 463–72.

Taylor, James. *Narrative of a Voyage to, and Travels in Upper Canada, with Accounts of the Customs, Character, and Dialect of the Country, also Remarks on Emigration, & c.* Hull: Nicholson, 1846.

Thomson, Gary. "Island of the Sorrows." *Beaver* 71 (Feb./Mar. 1991): 35–38.

Thurston, John, ed. *Voyages: Short Narratives of Susanna Moodie*. Ottawa: U of Ottawa P, 1991.

Traill, Catharine Parr. *The Canadian Settler's Guide*. 1855. Toronto: McClelland, 1969.

Trollope, Frances. *Domestic Manners of the Americans*. 1832. London: Century, 1984.

Warre, Henry James. *Sketches in North America and the Oregon Territory*. London: Dickinson, 1848.

Weld, Isaac, Jr. *Travels through the States of North America and the Provinces of Upper and Lower Canada during the Years 1795, 1796, and 1797*. London, 1807.

A Theosophist in India

Mark Bevir

Different types of Victorian subjects who emigrated had very different experiences of doing so. Their different experiences typically reflected both the identity they took abroad and the way their new national context transformed the nature and significance of this identity. The way any given woman experienced emigration is complicated further by her individuality; she cannot be entirely reduced to any particular type of subject. Consider, for instance, the case of Annie Besant.[1] When Besant first arrived in India in 1893, and again when she emigrated there permanently in 1898, she did so with a very clear public identity: she was the most famous member of the Theosophical Society. Moreover, her identity as a theosophist made her a public champion of a modern form of occultism that identified ancient wisdom in the religious traditions of the Indian subcontinent. In Britain, the theosophists constituted a moderately fashionable group on the fringe of an occult revival that also included spiritualism, new mystical forms of Christianity, and other liberal, even New Age, religious movements that arose in the wake of the Victorian crisis of faith. Theosophy instanced the popular and respectable concern with exotic cultures captured by John Galsworthy's *White Monkey*, the account of Victorian fascination with China.[2] In India, in contrast, theosophy represented a cultural challenge to the legitimacy of the Raj. By championing Indian religions, theosophists questioned the ideological basis of British rule in a way that at least potentially made them a political threat. Therefore, the experience of those theosophists who emigrated to India was often an unauthorized one. While most theosophists who traveled to India had an encounter with the subcontinent contrary to that authorized by the Raj, Besant's experience was especially confrontational not only because of her prominence in the Theosophical Society but also because of her particular inheritance from the radical movement in Britain. In exploring Besant's life in India, therefore, we are untangling a complex web of religious and political identities that were formed in Britain but later given a very different significance by being transplanted to Indian soil.

To appreciate the significance of Besant's change in national iden-
tity, we have first to understand the public identity she had
acquired through her participation in the secular, radical, socialist,
and theosophical movements in Britain. The Theosophical Society
was formed in 1875 with Henry Olcott as its president and Madame
H. B. Blavatsky as its prophet.[3] It had three explicit aims: to explore
the psychic powers latent in Man, to promote the study of compara-
tive religion, and to advance human brotherhood. More generally,
the society emerged out of the spiritualist movement: Blavatsky and
Olcott met while exploring spiritualist phenomena in Vermont; the
leader of the British section of the society, Charles Massey, its later
president, Dr. George Wyld, and other members joined having
already been active members of the British National Association of
Spiritualists; and Besant herself turned to theosophy after her explo-
rations into spiritualism convinced her pantheism might solve
"some problems, especially of psychology, which Atheism leaves
untouched."[4]

The location of the Theosophical Society within the spiritualist move-
ment lent it a fashionable, almost respectable, air, at least among the
more bohemian elements of London society. The Victorian crisis of faith
created a climate in which many people looked to spiritualism to provide
evidence of an afterlife and so a basis for religious faith. Far from being
the home of a few cranks, the spiritualist movement attracted eminent
political families, including the Balfours and Gladstones, as well as writ-
ers and philosophers, such as Sir Arthur Conan Doyle and Henry Sidg-
wick. By drawing on the genteel atmosphere of Victorian spiritualism,
Blavatsky managed to attract to theosophy a small group of aristocrats,
most of whom were women, including the Countess Wachtmeister. As a
leading theosophist, therefore, Besant represented a small group of
occultists who were rather fashionable with the more languid section of
British society. Aldous Huxley assigned just this identity to Besant in
Crome Yellow.[5]

Yet Besant's identity in the genteel world of the theosophists sat rather
uneasily alongside her earlier public persona as a radical secularist and
socialist. After a firmly evangelical upbringing and an unhappy marriage
to an evangelical clergyman, Frank Besant, she had a personal crisis of
faith that ended with her joining the National Secular Society (NSS).[6]
Thereafter her infamy spread as she became increasingly prominent in
the secularist cause, becoming vice president of the NSS and standing
second in the movement only to Charles Bradlaugh himself. During

much of the 1870s and 1880s, she gave public talks to workingmen's clubs in what was regarded a most unladylike manner. And, together with Bradlaugh, she fought a well-publicized trial in defense of the right to publish information about birth control.[7] It was against this background that her husband won custody of their two children by representing her as ungodly, immoral, and unfit to be a mother. Before long she had become an outcast, of whom the Master of the Rolls said, "[O]ne cannot expect modest women to associate with her."[8] Besant's public identity as a radical troublemaker was reinforced during the 1880s when she joined the nascent socialist movement. Not only did she continue to promote radical ideas and speak at radical gatherings, she also began to involve herself with the trade unions: she played the key role in organizing a strike among the matchmaker girls at Bryant and Mays and then forming a union to represent them.

When Besant emigrated to India, therefore, she did so as a theosophist who stirred a fashionable interest, if also a kind of mockery, in British society. Indeed, like most theosophists who went to India, she did so specifically because she saw India as the motherland from which the ancient wisdom had derived and in which it remained most strong and accessible. She went to India because her identity as a theosophist was tied up with her vision of India as the place in which she should pursue her spiritual quest for wisdom. Behind this identity, however, lurked her radical past, and the change in her national context now brought that radicalism back to the fore. Her emigration altered her public identity in this way because theosophy had a different presence in India than it had in Britain. More specifically, the Raj institutionalized public identities based on a Christian discourse. Because British rule in India relied on a form of Christianity for its legitimacy, to renounce Christianity and to champion Indian religions in the way theosophists did was to challenge the legitimacy of British rule. Thus, when Besant emigrated to India, the new national context transformed the public identity of her theosophy from a genteel curiosity to a potentially radical political stance. Emigration once again placed her in direct confrontation with the state. Her response was to return to the techniques of agitation she had acquired as a radical secularist in Britain and use them to promote Indian nationalism.

To understand the impact of emigration on Besant's life, we have to follow three main steps. First, we have to appreciate how the Raj authorized certain discourses and ways of life. Second, we have to understand how the Raj thus defined theosophy and the life it encouraged as autho-

rized. Third, we have to trace the way Besant drew on her radical heritage to forward the political struggle to overturn the structure of authority thus set up by the Raj.

The British in India relied on an evangelical Christianity to legitimize their rule. To say this is not to deny that the Raj arose out of the trading, administrative, and even political activities of the East India Company. Nor is it to deny that Christianity obviously played different roles in the lives of the individuals who made up the British community in India: for some of them, it was little more than an organizing principle of public ceremonies; for most, it was an unexamined ethos that defined standards of public and private behavior; and for some, it was a bright and guiding faith that gave meaning to their individual lives, their public roles, and the British Empire.

Whatever place Christianity occupied in the lives of individuals, however, it certainly occupied a prominent place in the public discourse and presence of the Raj. The Raj endorsed the idea that only in a Christian society can an individual develop as a properly rational being in accord with the will of God.[9] The Raj, in other words, was creating the conditions under which Indians could realize their God-given capacities. This key idea inspired a ubiquitous critique of Hinduism for embodying a fatalistic pantheism that didn't value the individual and for portraying the world as an illusion, thus promoting asceticism at the expense of proper concern with facts.[10] Hinduism reduces individuals to parts of a greater whole into which they eventually will be reabsorbed. The situation of the individual in this world, moreover, is determined by his or her actions in past lives and so beyond his or her control. Hinduism thus undermines the dignity of the individual by encouraging people to see themselves as slaves of destiny. In addition, Hinduism represents the world as *maya,* an evil illusion to be overcome by ascetic withdrawal. Believers should detach themselves from the world and even seek spiritual merit by performing self-imposed penances. Hinduism undermines a rational concern with the facts by encouraging people to see reality as insignificant and superficial. The Raj was needed, therefore, to provide Indians with the cultural prerequisites for liberal self-rule. The British, with Christianity, were teaching Indians how to respect the individual and how to govern themselves in accord with a disinterested rationality.

Theosophists such as Besant rejected the Christianity that thus legitimized the Raj. For them, the Hindu faith in caste and rebirth represented not a sterile fatalism but an antidote to Victorian individualism, and Hindu pantheism represented not an otherworldly rejection of ratio-

nal facts but an antidote to the soulless materialism then being encouraged by Victorian science. Whereas the authorized discourse of the Raj complained that Hinduism reduced the individual to a mere part of a greater whole, Besant rejected Christianity for fostering an unhealthy individualism. She argued that Christianity emphasizes the salvation of the individual in a way that prevents people from seeing themselves aright as brothers. Theosophy, in contrast, proclaims the truth long recognized by Hindus that "the immanence of God" implies a "Solidarity" based on "universal Brotherhood."[11] All beings are manifestations of one divine form and therefore interlinked with one another. Hinduism puts the individual in a proper relationship to the social whole: it recognizes that the good of the individual is bound inextricably to that of society. Indeed, it teaches us that "the primary truth of Morality, as of Religion and of Science, is the Unity of Life."[12] Hinduism, therefore, provides the basis of an admirable social morality. Indeed, its cosmology shows how sacrifice to the greater whole constitutes the foundation of the universe.

Here Besant divided the evolutionary process into various stages, each beginning with an act of sacrifice in which the previous form perishes so "the life" in it may pour "itself out to take birth in a higher form."[13] For the Hindu, sacrifice and service are built into the nature of all being. Hinduism teaches us that "we live not to assert our rights but to do our duties, and so to make one mighty unit where each shall discharge his functions for the common good of all."[14] According to Besant, the European theory of rights provides a poor basis for society since it is not true: people are born neither free nor equal but rather absolutely dependent on others and with widely differing capacities. The idea of the independent individual with private ends is an illusion: individuals are not free to choose their own good because the good for man is determined by the spiritual nature of the evolutionary process. Besant concluded, therefore, that we should found society on a theory of duties, not rights. But, she continued, what do we mean when we talk of performing one's duty? We mean, she answered, the discharge of one's *dharma* (duty) as taught by Hinduism. India, therefore, possesses the key to the ideal society. The British need to learn from India "the ideals of self-discipline, self-control, and the subordination of the individual to the larger self."[15]

Whereas the ruling discourse of the Raj rejected Hinduism for encouraging an ascetic withdrawal from the world conceived as an evil illusion, Besant complained Western science pays insufficient attention to the inner or spiritual self and the way we should conduct our lives. Western science has undermined the Christian belief in revelation with-

out providing an alternative to the Bible as a source of morality—it has undermined supernaturalism without giving a natural account of ethics. Hinduism, in contrast, embraces a spiritual cosmology that not only incorporates Western science but also goes beyond it to provide us with a naturalistic account of ethics as the ruling force of human life.

According to Besant, the cosmology that theosophy took from the Vedas leads inexorably to both the doctrine of reincarnation and the law of karma. Her evolutionary theory implied the indestructible ego has to reappear on the physical plane simply because each individual needs a number of lives to evolve in the requisite manner. Thus, Besant explained, "the truth of reincarnation" follows from the "necessity for many lives" if the ego is to progress through all "the ascending stages of consciousness."[16] Reincarnation merely extends evolutionary theory from the physical world to the spiritual one. The law of karma then follows from belief in reincarnation. When an individual passes through physical death, the ego sheds its physical, astral, and mental bodies, leaving only the inner person, which then takes on a new outer body to reappear on the physical plane. Because reincarnation is a natural process, there is a law of cause and effect that controls reincarnation: the law of karma The law of karma grounds ethics in a natural law of cause and effect: current evils are the necessary results of past actions.

Because Hinduism recognizes the spiritual nature of the universe and gives a natural basis to ethics, it encourages people to live active and rational lives. In Besant's theosophical writings, the concept of karma acts as a call to action; it requires us to strive to make a better life for others and ourselves. To act to improve the present is not to deny the karma produced by the past but only to modify this karma in an attempt to influence the future. Although Hinduism teaches us that we can escape from the cycle of rebirths only if we first rid ourselves of desire, this teaching renounces only selfish desires, not the desire to do good unto others. Hinduism, with its concept of karma, thus provides an impetus to moral action in a way Christianity and materialism do not. Here Besant identified two ideals between which we must choose: there is "material wealth" to gratify spurious wants, or there is "knowledge of the intellect," "wealth of wisdom," and "the realising of man's higher nature."[17] Thus, Hindu asceticism represents a moral choice in favor of the true, spiritual life rather than a superficial, material one.

Besant's challenge to the authorized discourse of the Raj led her, like most theosophists who moved to India, to adopt a very different way of life from that most often associated with the British in India. The ruling

discourse of the Raj denounced the Indian way of life as degrading for the individual and unnecessarily ascetic. It implied that the British Empire was bringing Christianity to heathen peoples to enable them eventually to rule themselves in a rational, liberal manner. India was viewed as an unchanging land in which all individual liberties lay crushed beneath religious superstition and traditional custom. The British were teaching the Indians to dispense with their traditional way of life in favor of one based on true Christian virtues, such as respect for the individual. Debates among the colonial authorities typically arose not because any of them rejected this basic assumption but because people disagreed about the extent to which the Indians had already come to accept the relevant virtues or the speed at which they might be expected to do so.[18] Certainly there was near universal agreement that the point of the Raj was to bring the British way of life to the Indians, not the other way around.

The experience of most British women who lived in India was shaped by this ruling discourse. Women were held up almost as icons of the civilizing mission of the British Empire. Indeed, the domestic role of the English lady, representing self-sacrifice and devotion to duty, became a kind of metaphor for the imperial mission.[19] The English lady stood for civilization and order against the fatalistic self-renunciation of Hindu widows and the irrational passion of Kali, the Hindu goddess. The ideal of the English lady as an icon of imperial values required British women to remain aloof from both the native people and their customs. It is no accident, therefore, that the most common image of the memsahib is of a snobbish and selfish woman whose life consists of a frivolous round of social pursuits. Rudyard Kipling depicted many of the worst qualities of these women of the high Raj in his portrait of Mrs. Hauksbee as a bitchy woman whose world is restricted to the personal loves and animosities of the imperial elite.[20] Although some of the memsahibs, such as Maud Diver, complained Kipling had been unfair to them, they had to admit that sometimes, particularly in Simla, the women of the Raj did appear to regard frivolous, social pleasures as the sole aim of their existence. And Diver's attempt to explain this state of affairs by reference to a fatalism lurking in the very air of the subcontinent only confirmed the cultural snobbery of these women.[21] Of course not every memsahib belonged to the high Raj; others came to India with the military, with missionaries, or as the wives of junior civil servants stationed up-country. Yet these women typically tried to emulate, as best they could, the way of life held up to them by the high Raj. Thus, even a sympathetic historian,

anxious to dispel the image of Mrs. Hauksbee, concludes that "to be a memsahib" was "to bring up a brood of pale-faced, reputedly rather spoiled and listless children; to deal with ayahs and wet-nurses, cooks and gardeners; to pay duty calls, give supper parties, organize stalls for Fancy fairs; to suffer under the remorseless sun of the plains, to escape joyously to the cool air of the hills."[22] To be a memsahib was to struggle to preserve the marks of civilization in a foreign climate.

Because theosophists championed Indian religions and cultures against the supposed virtues of Western civilization, those of them who came to India were rarely willing to accept the authorized role of the memsahib. Instead they tried to find a way of living in accord with their commitment to the value of many Indian customs. Besant argued that the Indian way of life was designed to advance spiritual evolution by subordinating our lower natures to our higher ones. Even the hierarchy of castes showed how the Indians prized the spiritual life over mere material luxury: "[T]he highest caste in the older days, the Brahmans, were a poor class, and the wealth of the Brahman lay in his wisdom, not in his money-bags"; indeed he "might possess only two cloths, one in wear to-day, one drying for to-morrow, but social consideration was paid to him, kings would descend from their thrones and touch his feet, if he was a known Brahmana, a teacher of truth."[23] The Indians lived simple and pure lives dedicated to the conquest of their lower selves as a means to contact the divine. When theosophists like Besant came to India, therefore, they generally hoped not only to meet Indians and learn wisdom from them but also to adopt Indian customs as an outward sign of an inner grace.

Certainly Besant's theosophy encouraged her to interact with India very differently than the women of the high Raj upon whom Mrs. Hauksbee was based. Besant used Hindu teachings to structure her daily life. She began to perform *puja* (daily worship) as would an orthodox Brahman; she adhered meticulously to the various Hindu rituals that surround eating and ablutions; she wore traditional Indian clothes—showing a clear preference for a dramatic all-white sari; and she took to writing her letters while sitting cross-legged on a cushion. She adopted these and other Indian habits in an attempt to simplify her life and thereby come closer to the divine. In her opinion, she had become "Hindu in all save the outer ceremonies for which my white skin disqualifies me."[24] There could be no greater contrast with the official British stance toward Hinduism. Moreover, Besant immersed herself in high Indian culture. Indeed, she successfully taught herself Sanskrit by read-

ing the *Bhagavad Gita* and the *Upanishads* in the original and even went on to publish her own translation of the former.

Yet Besant had come to India not only to learn but also to preach. She said that she hoped to give the Indian people pride in their own culture. More particularly, she set out to revive a traditional Indian form of education and thereby make Indian ideals the basis of Indian society. Whereas the British hoped to educate administrators who would then be inculcated with British values, Besant wanted to educate Indians in the spiritual values of their indigenous culture; she complained that government colleges shunned all religious education and the missionary schools taught Christianity alone, when really Indian children should learn about their own Gods.[25] In 1896 and 1897 she toured India appealing for the financial assistance that then enabled her to open the Central Hindu College in Benares on 7 July 1898. A day in the college began with a Hindu prayer followed by chantings from the *Bhagavad Gita* and readings from the Hindu epics. Much emphasis was placed on Sanskrit as the linguistic basis of Indian nationality. Later, in 1904, Besant set up a parallel institution for Hindu girls. By 1905 the college had a hundred pupils, and Besant launched a campaign to use it as the nucleus of a national Hindu university. This campaign led to the laying of the foundation stone of Benares University in 1916. Madan Malaviya became principle of the university, with Besant reluctantly agreeing to restrict her involvement to that of an honorary member of the board of governors.

Besant also used the Central Hindu College to promote certain social reforms within the Hindu community. Married boys, for instance, were not allowed to enroll at the college since she opposed child marriages. Nonetheless, Besant only really began to try to reform Hindu social life in October 1913 when she gave a series of lectures in Madras under the title "Wake Up India." The lectures dealt with topics such as child marriage, foreign travel, the perversion of the caste system, the uplift of the depressed classes, and the promotion of Indian industries.[26] Besant denounced the *jatis* (local caste groups) that had grown out of the four original *varnas* (pure castes), claiming they encouraged exclusiveness; she argued foreign travel did not pollute but rather bred tolerance; and she was particularly critical of untouchability, arguing India could not be a free country while her people continued to treat a group of their fellows as second-class citizens. At the end of the year, Besant formed the Brothers of Service, whose members pledged to work for the education of the masses, to educate women in their family, not to keep women in seclusion, not to marry off their children until they were mature, to

accept publicly widows who remarried, to ignore distinctions of caste, and more. The final pledge required members "to promote union among the workers in the fields of spiritual, educational, social and political progress, under the headship and direction of the Indian National Congress."[27]

Whereas in Britain theosophy represented a genteel curiosity, in India it challenged the cultural basis of the Raj. Thus, theosophists who came to India found their beliefs pushed them toward an unauthorized colonial experience very different from that of the memsahibs. Theosophists often eschewed the snobbish, social trail from the plains to Simla in favor of absorption in native customs and activities designed to revive Indian culture. Many lived more or less exclusively among other theosophists and Indian social reformers, having very little contact with the high Raj or its provincial offshoots. Besant's theosophy certainly led her to align herself with the Indian people and their culture against their imperial rulers. Indeed, so staunch was her defense of Hinduism that one contemporary argued that "no Hindu has done so much to organise and consolidate the movement [the Hindu revival] as Mrs Annie Besant."[28] Besant repudiated the discourse and way of life that legitimized the Raj and by 1913 had identified herself with the nationalist movement.

Because Besant saw Hinduism as truly spiritual, the Indian way of life as pure, and Indian society as inherently organic, she could not accept the authorized historiography that legitimized British rule. She could not view India as a land of unchanging superstitions that was being liberated by the British. Instead, she saw ancient Indian society as an ideal, based on the true faith of the Vedas, which had since been corrupted by foreign rule. The British, she argued, had invaded India not to spread Christianity, to free a subject people, or to find adventure but to trade and find markets for the products they had begun to make in vast quantities after the industrial revolution. Once the British had conquered India, they discredited Hinduism by teaching the Indians the skills they needed to become clerks instead of immersing them in their own literature and religion. Worse still, the British had instilled in the Indians a European concern with rights so that the Indians now regarded caste as a mark of privilege and status that indicated how much respect an individual should be shown. Caste stood for social distinction, not social duty, so the caste system divided Indians into different groups instead of uniting them into a greater whole. The resulting conflicts ruined Indian society, for "out of the base marriage of Caste to Separateness, instead of the true wedlock of

Caste with Service, there sprang a huge and monstrous progeny of social evils, which preyed, and are still preying, on the life of India."[29]

As well as corrupting the great, religious culture of India, British rule had destroyed her economy and denied her people the right of self-government. Besant complained, as did many Indian nationalists, of the drain on Indian wealth needed to pay for the India Office, pensions to retired civil servants, and an army allegedly needed to defend India's frontiers. British rule had led to increased taxation of the Indian peasant, resulting in recurring famines, and to a neglect of the public works, such as irrigation, needed to promote economic development. In addition, the British destroyed the self-governing village of the ancient Aryans both by introducing peasant proprietors instead of common ownership of the land and by replacing elected officers who were responsible to the village with appointed officials who were responsible to the higher echelons of government. The British ruled India through an administrative bureaucracy that paid no attention to the voices of Indians but relied instead on executive fiat reinforced with large doses of repressive legislation. How, Besant asked pertinently, can India believe "in England's love of liberty in face of the Arms Act, the house searching's, the espionage, the autocracy, the frustration of her dearest hopes"?[30]

According to Besant, therefore, the British were not creating the basis for a liberal and rational form of government in India. On the contrary, they had brought to India a corrupt individualism and decadent materialism that had done much to destroy its former glories. The key political question, therefore, was how to return India to its true self. Here Besant's pantheism led her to argue that genuine change always had to come from within: the revitalization of India had to begin with a religious renaissance and then flow out through moral and social renewal to its political end. "The unifying of India," she explained, has to be both "founded on and permeated by a spiritual life recognised as the supreme good."[31] Yet once the educational and social uplift of India had begun, the next step was to push for home rule, that is, self-government within the framework of the British Empire. To accomplish these goals, Besant turned to the Indian National Congress in 1913.[32] From 1913 to 1916, she tried to persuade the leaders of Congress to take on board her four-fold campaign for religious, educational, social, and political reform. When the moderates in Congress insisted that it should remain a purely political organization, she formed the All-India Home Rule League.[33]

Through the All-India Home Rule League, Besant drew on her radical heritage to transform the way nationalists did battle with the Raj.[34]

To appreciate the impact she had, we need to contrast her radical, agitational style of politics with that of those moderates who had reinforced their control of Congress by expelling the extremists back in 1907. The moderates welcomed British rule as necessary to establish the preconditions for secular and liberal parliamentary government in India. The British had established public order, education, and even limited opportunities for representative government. Now the moderates wanted to work alongside the British to gradually introduce full self-government into Indian society. Their only real complaint concerned the comparative slowness with which the British were allowing Indians to participate in the political system. Their attempts to speed up the process centered on responsible debates and representations to government. Congress, they believed, should be a secular and liberal organization composed of those whose Western education and command of the English language enabled them to appreciate the liberal values of the British. Nationalism should rest on sober politics, the very moderation of which would indicate to the British the readiness of the Indian elite for increased political responsibility. Besant, in contrast, wanted to initiate a popular movement of radical agitation. She hoped such agitation would stir the Indian nation as a whole, giving them pride in their own heritage, thus encouraging them to win the self-government that was theirs by right. Instead of relying on responsible behavior to impress the British so that they would introduce reforms, she wanted to initiate a popular agitation that would compel the British to introduce reforms. "British politicians," she explained, "judge the value of the claims by the energy of those who put them forward."[35]

Besant's Home Rule League rejected the political activities of the moderates in favor of the radical agitation with which she had become familiar as a secularist and a socialist. The league set out to make its members into "Home Rule missionaries," who then would take the word to the people in their own languages and thus stir up an unstoppable popular movement.[36] To train home rule missionaries, Besant drew on the techniques of self-transformation that had served the secularists and socialists so well, techniques that owed much to Protestant notions of self-help and acting out one's faith in daily life. Indeed, Besant and her lieutenants used the Protestant language of duty, sacrifice, and service to describe how home rulers should place the cause at the center of their lives. *New India*, the main newspaper of the league, urged its readers to become more effective workers for the cause by obeying a few simple rules: "1. Be punctual; 2. Let food be nourishing rather than palatable; 3.

Hold your body erect when walking or sitting; 4. Go to bed at the same time every evening and arise at the same time every morning."[37] Punctuality—that crucial Protestant virtue—was seen as so important home rulers were urged to write "be punctual" boldly on a card and hang it in a prominent place where it would act as a constant reminder to them.

Having become effective workers, home rulers were then asked to promote the cause through a series of practical daily measures. They should educate their relatives, distribute home rule literature, find subscribers to *New India*, "talk about Home Rule whenever an opportunity occurs and make opportunities when they do not occur," and so on.[38] In addition, they should exhibit their devotion to the cause by both social and public work, since as Besant's leading lieutenant, the young theosophist George Arundale, explained, "A true Home Ruler is known by the active interest he takes in local affairs, in provincial affairs, and by the good ordering of his household."[39]

The league turned to cultural activities common among British radicals to provide emotional support for its members as they tried to transform their lives in the recommended way. Thus, a recruit to the movement joined a social club complete with its own insignia, a silver pendant with a ribbon of red and green; its own special day, 14 September, which was the day when Besant first spoke of home rule; and even its own song, "God Save Our Ind," sang to the tune of "God Save the King." Most of the league's branches took up Arundale's suggestion that they arrange social entertainment: the Calicut branch held several home rule tea parties, the Madras branch organized boat trips down the Buckingham Canal to Mahabalipuram, the Swimmal branch founded a badminton club, and numerous branches met regularly for "gossip over some music and light refreshments."[40]

The home rule missionaries created and sustained by these activities were intended to lead a radical agitation among the masses. Again, Besant drew on propaganda and politics with which she was familiar from her involvement with the secularists and socialists. She initiated a barrage of propaganda based on newspapers and pamphlets. When she took over *New India* in July 1914, its circulation was about a thousand; within a month this had increased to five thousand, and within a year it had become the biggest selling English-language paper on the subcontinent. Even before the formation of the league, her Self-Government Propaganda Fund produced numerous pamphlets, including sixteen in the Home Rule Series with runs of ten thousand each and a further ten under the auspices of *New India* with runs of five thousand each. Soon

each branch was undertaking more local initiatives. The Bombay City branch, like many others, began to arrange public meetings, publish tracts in both English and vernacular languages, hold public lectures, and organize classes to study public questions.[41] Numerous branches, including many in Madras Presidency as well as Bombay, sent lecturers on tours through the surrounding countryside. The branches also designed postcards and posters, adapted traditional religious songs to convey political messages, and sponsored political drama groups. All of these varied activities gave content to Besant's idea of an educative propaganda.

The league, through this propaganda, transformed the nationalist movement. Home rulers reached out to the masses through pamphlets and lectures in vernacular languages in a way the moderates had shunned. Thus, although the league itself was still dominated by Brahmans, its style emphasized the idea of a mass movement. Moreover, the league created, for the first time, a network of local groups, albeit only loosely linked to the league's national headquarters, that covered much of British India. Thus, although significant regional differences in levels of nationalist activity remained, the home rule movement created a more extensive pattern of organization than had existed before. Finally, and also most significantly, the League promoted an agitational style of politics that sought to wrest reforms from the British by its own strength rather than to persuade the British to grant reforms by its moderation. This agitational style of politics proved remarkably popular with the young generation of Indian nationalists, and it was they who swept Besant to power in Congress when they elected her its president in 1917. Yet while Besant's radical heritage transformed the nationalist movement and briefly gave her leadership over it, her agitational style of politics brought her into direct confrontation with the Raj.[42] As early as May 1916, the government of Bombay presidency barred her from entering its territory, and the government of Madras presidency demanded, under the Press Act, that she deposit two thousand rupees as security against unacceptable articles appearing in *New India*. In April and May 1917, the governments of Bombay, Madras, and the Punjab all publicly denounced the home rule agitation, while those of Bombay, the Central Provinces, and Madras banned students from attending demonstrations. After Besant spoke of using passive resistance to counter such repression, the government of Madras interned her and two of her associates. From June until September 1917, she was effectively kept under house arrest in the relatively inaccessible hill-town of Ootacamund.

Besant's political role in India arose from the way she used her radical inheritance to develop a nationalist struggle to which she became committed because of the new significance given to her theosophy by the change in her national context, that is, by her emigration to India. On the one hand, her agitational style transformed the nationalist movement in a way that made it possible for Gandhi to come to the fore as her own influence waned. She became immersed in the nationalist movement, initiating a range of activities earlier rarely associated with that movement. Moreover, in doing so, she set an important precedent for other Western theosophists who moved to India: as the president of the Theosophical Society, she gave legitimacy to an active political role that earlier theosophists had shunned but that was now adopted willingly by people such as Arundale. On the other hand, her use of an agitational style pitched her, as had her secularism, into a public battle with the state. No longer just a strange European who chose to mix with natives and mimic their ways, she became a public nuisance whose actions required colonial authorities to imprison her.

After Besant lost her dominant influence in the nationalist movement, as early as 1919, she remained politically active, but she no longer posed such a threat to the imperial authorities, and her main activities again became religious and social ones tied to the Theosophical Society. Here too, however, her emigration had significantly altered her public identity, as it did for most theosophists who moved to India. When she emigrated, she ceased to be the figurehead of a group on the fringe of a fairly fashionable occult revival, becoming instead the leader of a society that challenged the cultural basis of the Raj by defending and living in accord with indigenous values and customs. The latter identity underlay her unauthorized colonial experience, not only as a political nationalist but also as a religious leader and private person. She rejected the superiority of Christianity and British civilization in a way that excluded her from the public ceremonies and social activities of the British in India. Instead, she made a life for herself among fellow theosophists. She devoted herself to the practice and revival of Hinduism.

Notes

I thank the Leverhulme Trust for awarding me a Travel Abroad Studentship with which to pursue my research.

1. Besant published two versions of her autobiography, one before and one after she became a theosophist. See respectively A. Besant, *Autobiographical Sketches* (London: Freethought, 1885); and A. Besant, *An Autobiography* (Adyar, Madras: Theosophical Publishing, 1983). The most detailed biography is A. Nethercot, *The First Five Lives of Annie Besant* (London: Hart-Davis, 1961); and A. Nethercot, *The Last Four Lives of Annie Besant* (London: Hart-Davis, 1963). A more reliable study is A. Taylor, *Annie Besant* (Oxford: Oxford UP, 1992). For a shorter study, see R. Dinnage, *Annie Besant* (Harmondsworth: Penguin, 1986).

2. J. Galsworthy, *The White Monkey* (Harmondsworth: Penguin, 1967).

3. See M. Bevir, "The West Turns Eastward: Madame Blavatsky and the Transformation of the Occult Tradition," *Journal of the American Academy of Religion* 62 (1994): 747–67; and B. Campbell, *Ancient Wisdom Revived: A History of the Theosophical Movement* (Berkeley: U of California P, 1980).

4. *National Reformer* 30 June 1889. On the spiritualist movement and theosophy's relationship to it, see J. Oppenheim, *The Other World: Spiritualism and Psychological Research in England, 1850–1914* (Cambridge: Cambridge UP, 1985) 159–97. On the British Section of the Theosophical Society, see A. Sinnett, *The Early Days of Theosophy in Europe* (London: Theosophical Publishing, 1922).

5. A. Huxley, *Crome Yellow* (Harmondsworth: Penguin, 1936).

6. On the secularist movement, see S. Budd, *Varieties of Unbelief* (London: Heinemann, 1977); E. Royle, *Victorian Infidels* (Manchester: Manchester UP, 1974); and E. Royle, *Radicals, Secularists, and Republicans* (Manchester: Manchester UP, 1980).

7. See S. Chandrasekhar, ed., *A Dirty, Filthy Book: The Writings of Charles Knowlton and Annie Besant on Reproductive Physiology and Birth Control, and an Account of the Bradlaugh-Besant Trial* (Berkeley: U of California P, 1981).

8. *National Reformer* 2 June 1878.

9. Compare G. Studdart-Kennedy, *British Christians, Indian Nationalists, and the Raj* (Delhi: Oxford UP, 1991).

10. This critique of Hinduism clearly overlaps with the ruling assumptions of Western Indology, on which see R. Inden, *Imagining India* (Oxford: Blackwell, 1990).

11. A. Besant, *What Is Theosophy?* (Adyar, Madras: Theosophist Office, 1912) 9.

12. A. Besant, *The Basis of Morality* (Adyar, Madras: Theosophical Publishing, 1915) 26.

13. A. Besant, *The Ancient Wisdom* (Adyar, Madras: Theosophical Publishing, 1939) 308.

14. A. Besant, "The Place of Politics in the Life of a Nation," *India: Essays and Addresses* (London: Theosophical Publishing, 1913) 131.

15. A. Besant, *The East and the West* (Adyar, Madras: Theosophical Office, 1908) 9.

16. Besant, *Ancient Wisdom* 229.

17. Besant, "Place of Politics" 152.

18. Compare Studdart-Kennedy, *British Christians*. On how Besant's Indian activities transformed such debates, see P. Robb, "The Government of India and Annie Besant," *Modern Asian Studies* 10 (1976): 107–30.

19. Compare J. Sharpe, *Allegories of Empire: The Figure of Woman in the Colonial Text* (Minneapolis: U of Minnesota P, 1993).

20. R. Kipling, *Plain Tales from the Hills* (Ware, Hertfordshire, Eng.: Wordsworth, 1993).

21. M. Diver, *The Englishwoman in India* (London: Blackwood, 1909).
22. P. Barr, *The Memsahibs: The Women of Victorian India* (London: Secker, 1976) 201. Also see D. Kincaid, *British Social Life in India* (London: Routledge, 1973).
23. A. Besant, *The East and The West* 22–23.
24. A. Besant, *India: A Nation* (London: Home Rule for India League, 1917) xvi.
25. For her views on education in India and reports on her activities, see the essays collected in A. Besant, *The Birth of New India* (Adyar, Madras: Theosophical Publishing, 1917).
26. A. Besant, *Wake Up India* (Adyar, Madras: Theosophical Publishing, 1913).
27. A. Besant, *The Theosophist* Dec. 1913.
28. I. Chirol, *Indian Unrest* (London: Macmillan, 1910) 28. For a general study of the Hindu revival, see K. Jones, *Socio-Religious Reform Movements in British India* (Cambridge: Cambridge UP, 1989).
29. A. Besant, "East and West," in *India: Essays* 78.
30. A. Besant, *India and the Empire* (London: Theosophical Publishing, 1914) 16.
31. A. Besant, "The Means of India's Regeneration," in *India: Essays* 119.
32. Besant gave a normal account of her entry into nationalist politics in A. Besant, *The Future of Indian Politics* (Adyar: Theosophical Publishing, 1922). Later she added the occult explanation that she had acted under the orders of the Rishi Agartya, the Mahatma responsible for guiding the Indian nation—see *Theosophist* Nov. 1929.
33. M. Bevir, "The Formation of the All-India Home Rule League," *Indian Journal of Political Science* 52 (1991): 1–16.
34. Compare H. Owen, "Towards Nation-Wide Agitation and Organisation: The Home Rule Leagues, 1915–18," *Soundings in Modern South Asian History*, ed. D. Low (London: Weidenfeld, 1968) 159–95. On Indian nationalism more generally, see B. Chandra et. al., *India's Struggle for Independence* (Harmondsworth: Penguin, 1989); and P. Heehs, *India's Freedom Struggle, 1857–1947* (Delhi: Oxford UP, 1988).
35. *New India* 19 July 1915.
36. *New India* 4 Sep. 1916.
37. *New India* 5 Sep. 1916.
38. *New India* 2 Sep. 1916.
39. G. Arundale, *Home Rule Work*, Home Rule Ser. 15 (Madras: Vasanta, n.d.) 3.
40. *New India* 30 Sep. 1916, 25 Nov. 1916, 6 Nov. 1917, and 25 Sep. 1916.
41. "Rules and Regulations of Home Rule for India League (Bombay)," Political Papers of Annie Besant, Theosophical Soc., Adyar, Madras, India, part 2, file 14.
42. Compare Robb, "Government of India."

Angel in the Bush:
Exporting Domesticity through
Female Emigration

Diana C. Archibald

> Mid pleasures and palaces though we may roam,
> Be it ever so humble, there's no place like home.
> —John Howard Payne, "Home, Sweet Home"

The image of women in Coventry Patmore's "Angel in the House" has become emblematic of the position of middle- and upper-class women in Victorian England. Patmore praises domestic sainthood, glorifying woman's role in the home as that of priestess who preserves the sanctity of the domestic space from the impurities of the outside world. The rituals of home life, the familiar cultural practices, preserve the holiness of home both by establishing a haven for men from the cruel, corrupt world and by protecting gentlewomen from being contaminated by that world. The Victorian lady's rightful domain, then, is the home. Not only does she create the domestic space, but that space also defines her. If a woman's fulfillment lay at the hearthside, would any hearth do? Or is the Victorian definition of "home" more specific? On the one hand, "[H]ome is where the heart is" in that women, who are all heart, provide the essence of home, infusing it with their good influence. The London man of business, who during the day must work entirely in the realm of the mind, each day returns home to his "heart," to his "better half." Thus, as long as an angel-wife dwells in a man's house, that house is a "home." On the other hand, this understanding of "home" takes for granted that the "angel" will have access to all she needs to maintain such a domestic haven, that, in short, she lives in England. However, during the Victorian period hundreds of thousands of British citizens left England for the colonies and dominions and for the new republic of America. For these emigrants the old adage "home is where the heart is" took on a new dimension.

Time and again emigrants—both actual and fictional—refer to England, rather than their new country, as "home." Anthony Trollope remarks in his encyclopedic travel narrative *Australia and New Zealand* (1873) that the Australian colonist "always speaks of England as home. He remembers the Queen's birthday, and knows the names of the Queen's grandchildren.... All this is true loyalty."[1] For many emigrants whose families remained in England, "home" would always be Britain; family ties assured such an attitude. But often even the children and grandchildren of emigrants, colonists who had no firsthand recollection of the Old Country, still seemed to think of England as "home." Those of British blood, it is assumed, are British "at heart" even if born half a world away. For instance, in Thackeray's historical novel, *The Virginians* (1859), the first chapter is entitled "In Which One of the Virginians Visits Home." In this case, the Virginian in question is a second-generation American colonist; yet his "home" is nevertheless located in England. In *The Virginians*, as in other Victorian novels such as Charles Dickens's *Great Expectations* (1860–01) and Charles Reade's *Bloomer* (1857), a colonist makes the long-dreamed-of journey "home." At times, such a journey takes on almost mythic proportions. Many colonists spoke their whole lives of returning "home" to England. Of course, though some emigrants *did* eventually return, most did not, especially those who emigrated to Australia and New Zealand. The journey back from Oceania was far too arduous and expensive to allow any but a few to return to Great Britain. Despite the fact that emigrants to the Antipodes had established a new home, such a home still seemed just a temporary creation.

Such an attitude poses an interesting problem for the Victorian lady emigrant. For, if woman's place is in the home and home is in England, isn't woman's place in England? Likewise, if woman's function is to construct a home and if a true home can only be established in England, how can a female emigrant hope to fulfill her duty as a woman? The reaction of most women to this dilemma was not to emigrate in the first place. Indeed, convincing single middle-class or upper-class ladies to emigrate was especially difficult. However, the number of Englishwomen *of any class* emigrating to Australia, New Zealand, Canada, and even America consistently lagged behind the number of male emigrants in the nineteenth century. From 1820 to 1910 the proportion of female emigrants seldom reached more than one-third of the total number of emigrants, and most of these were married women traveling with their families.[2]

An 1866 article in London's *Daily Telegraph* claimed that "an inflow [of women] to the colonies would be like the transfusion of blood from

one dying of congestion, to one languishing for the vital fluid."[3] Indeed, at times the ratio of men to women reached a staggering five to one. Single women had to be "imported" to make up for this disparity; the future of the colony depended on restoring a balance of the sexes. It is thus no surprise that colonial officials and private agencies often resorted to special maneuvers to perform such "transfusions," that is, to attract more single female emigrants. However, numerous private charitable plans, government-sponsored assisted passages, and even specially arranged and supervised voyages failed to persuade large numbers of single Victorian women to emigrate to Australia and New Zealand.[4]

Why didn't more women, especially single women, take advantage of the opportunities the Antipodes, in particular, offered them? Perhaps most obviously, Australia and New Zealand were "understood ... to be symmetrically on the opposite spot of the globe," as the narrator of *Great Expectations* describes them. Such a great distance would surely disallow a hasty retreat if one had made a mistake. Furthermore, the arduous journey itself was not deemed safe for unaccompanied ladies, despite the efforts of such emigration reformers as Caroline Chisolm and Maria Susan Rye. Women on shipboard were often molested—or worse—by rude shipmates. No self-respecting woman of any class would expose her honor to such risks. Of course, one of the reasons women were so ill-treated on these voyages was the assumption that any woman emigrating to a land filled with transported criminals must have a flimsy character. Throughout the century Australia was viewed as a haven for moral reprobates, if not outright criminals. From 1787 to 1869 Britain transported almost 162,000 convicted felons to the Australian colonies.[5] Even by 1841 in New South Wales, for example, about one-fifth of the population were convicts.[6] Only a "loose" woman, it was thought, would choose to emigrate to a land of thieves and whores. The reluctance of ladies to associate themselves with such a crowd certainly kept many from even considering such a move. The fear of losing caste, a related concern, also deterred many gentlewomen from emigrating to Oceania.[7] The new land needed domestic servants, not domestic icons. Prospects for fulfilling their role as "Angel in the House" must have seemed bleak for English gentlewomen. Despite the rhetoric calling for women to emigrate and act as a civilizing force in an untamed land, realistic opportunities to do so remained dubious. Suitable Australian husbands for English lady emigrants would be especially difficult to find in a land of convicts and kangaroos, and without a husband, a woman could not establish a home of her own.

Works of literature, too, no doubt contributed to women's misgivings about emigrating to Australia. For instance, Charles Dickens's widely read *David Copperfield* (1849–50) appears to encourage emigration to Australia as a means of improving one's standard of living and social status. Bankrupts and fallen women have a new chance in a new country: Micawber becomes wealthy and respected, and Martha redeems her character and is rewarded with a husband and home. A similar message was prominent in emigration pamphlets and other forms of overt government propaganda that advertised Australia as a land of opportunity, specifically a land in which one could begin again. But the very nature of Dickens's successful emigrant characters almost certainly proved a stumbling block for some potential emigrants. In a sense, the failure of these characters to "make it" in England only further stigmatizes Australia as an island of moral reprobates and thus an unsuitable destination for honest folk. Oceania is a last resort of those whose failure is complete—the failed businessman threatened with prison, the fallen woman contemplating suicide.[8] Thus, though the novel might entice some emigrants to Australia with the success of its characters in a new land, the novel might just as easily discourage all but the most desperate from following in the footsteps of such moral failures. Perhaps men would not have minded being compared to Micawber, but what lady would wish to be likened to Martha or Little Em'ly? Of course, the practical impact of this novel on the practice of emigration would be difficult if not impossible to prove; however, an analysis of such works of literature does reveal much about Victorian attitudes toward emigration and the difficulties and disappointments of leaving home.

Notwithstanding the numerous impediments to female emigration cited previously, some Victorian women actually did emigrate to Australia, though never in the numbers that colonial officials sought. Women from all classes came to the colonies and did, in fact, build homes for themselves and their families. But to what extent did these emigrant women find their role in this new land problematic? Those women who did emigrate have left scattered records of the lives they led once they arrived in the colonies, but their attitude toward their role is difficult to determine from these letters and diaries alone. We also need a clear understanding of both what emigrants expected abroad and what was expected of them. Fictional representations of colonial women thus provide another essential source for understanding the lives of actual Victorian women, not because literature mirrors reality—though as cultural artifacts, works of literature, especially Victorian novels, often

reflect living conditions accurately—but because literature participates in creating "reality." By examining the "reality" of Australian life that literary texts construct, we not only gain insight into the expectations emigrants may have held regarding their new land, but we also understand more clearly nineteenth-century British culture, especially the Victorian ideals of womanhood, family, and home.

Anthony Trollope's 1873 Christmas story, *Harry Heathcote of Gangoil: A Tale of Australian Bushlife,* is one such illuminating representation of colonial life. Trollope's only work to be set entirely in the New World, *Heathcote* provides one of the few examples (by a mainstream British author) of English domesticity established in Australia. The family at the Queensland sheep run, Gangoil, is comprised of the story's hero, the handsome young squatter Harry Heathcote—modeled on Trollope's own son, Frederic, who emigrated to Australia in 1863—Harry's wife, Mary; their two children; and Mary's sister, Kate Daly. The plot mirrors that typically found in Victorian Christmas stories. As Anthony Trollope's biographer, P. D. Edwards, notes, "The essential requirement" of the genre, "as established by Dickens in the 1840s, was a spectacular resolution of class-conflicts and a patching up of personal differences, preferably consummated over Christmas dinner at the end of the tale."[9] The class conflict of this book is twofold. First, Harry is beset by his disgruntled former employees and ruffian neighbors who attempt to ruin him by setting fire to his parched but precious grass. Second, Harry perceives an enemy on a different front—the free-selector Giles Medlicot, who has bought some of the riverfront land that Harry formerly rented from the British Crown.[10] This particular Christmas season in 1871, Harry spends a great deal of time riding around in the dead of night looking for fires to extinguish, and it is not until Medlicot comes to Harry's aid during the long-awaited disaster that the class conflict is resolved. Medlicot not only helps Harry put out the fire set by his enemies, but he also provides evidence to prosecute one of the offenders. If they stick together, Harry and Medlicot can continue to maintain the social order.[11] The end of the story finds the Heathcotes and Mr. Medlicot and his mother all safe and happy at Christmas dinner together. Cementing this new friendship, Harry's sister-in-law and Medlicot become engaged.

Current critics have largely ignored this little Christmas story, though the tale was widely read in Trollope's own day. Coral Lansbury, one of the few modern critics to mention *Heathcote* at all, asserts: "It was a slight story, carried by little more than the pace of its narrative. The characters were pasteboard, the incidents stereotypes of Australian fiction.

But as a Christmas ornament it serves well enough."[12] Certainly the story draws upon stereotype and includes plot devices borrowed from colonial literature and Christmas stories. Yet despite the sentimental conventions of a genre that boasts such memorable moments as Tiny Tim crying, "God bless us every one!" *Heathcote* manages to present some sophisticated ideas.[13] Close attention to the text, focusing on women's attempt (and ultimately their inability) to create a true "home" in a hostile land, reveals the inherent contradiction between Victorian ideals of womanhood and the realities of life in Australia. Such an analysis shows how difficult, if not impossible, it was for these women to fulfill their duty as "angels" in the bush.

Fictional representations of colonial women, like Mary Heathcote and her sister Kate, often show them trying to establish a "home" in the Australian countryside by modeling that home on the British domestic ideal. By faithfully reproducing the cherished cultural practices of England—no matter how nonsensical such practices appeared under the Southern Cross—women, in a sense, "exported" England to their new country to assist them in constructing a "real" home. Such, basically, was the argument of these women of Australia: since home is England, and the essence of England is its culture, then one *can* have a home outside England if only one can properly maintain British cultural practices. As an added benefit, if women kept such cultural ties to the mother country intact, they would also facilitate a smoother reentry into British society when "someday" they returned "home." For example, when Harry holds his son in his arms and comments that he "wouldn't have the young'un a squatter" (8) because it's heartbreaking work, Mary replies that by the time the child grows up Harry will be "rich, and we shall all be in England" (9). Clearly, Mary assumes that the family will return "home"; thus she should not loosen their ties to the mother country too much. Until that return journey, the cultural practices that Mary and Kate maintain at Gangoil will hopefully create a proper home for the family.

Of course, Gangoil is a long way from London. No matter what the women do, they cannot entirely duplicate an English home. For one thing, even a middle-class English household often kept numerous servants, each with very specific duties to perform, but the Heathcotes are fortunate to have even one long-standing English servant woman (Mrs. Growler) and a Chinese cook (Sing-Sing). In actuality, most bush families, and even wealthy families in the growing Australian cities, found it difficult to keep servants more than a few months, especially female ser-

vants. Wages for domestics as well as the demand for working-class wives were quite high throughout most of the century in the colonies. Thus the unmarried working-class woman who did emigrate often worked for wages only a short time before marrying a colonist. For instance, when Anthony Trollope and his wife traveled to Australia in 1871, they brought an English cook with them "who was invaluable,—or would have been had she not found a husband for herself when she had been about a month in the bush."[14] Trollope's fictional family keeps a faithful old servant woman who had "lived with old Mr. Daly when he was prosperous" (82). Clearly, Mrs. Growler is the conventional "crusty but trusty servant" figure. The presence of a Chinese cook, on the other hand, proves in some ways more realistic, since Asian immigrants were often employed as cooks and houseboys. However, once more the character himself is stereotypical. When Gangoil nears doom, the cowardly Sing-Sing absconds, leaving the women to fend for themselves. Thus Christmas dinner at the end of the story must be cooked and served by Mary, Kate, and Mrs. Growler—not exactly an ideal arrangement. Though English literature is filled with instances of domestic disasters, such as the cook running off with the cartman, London families in reality had a wide pool of replacements to choose from, whereas Australian families might go months without household help.[15] The class-conscious Victorian reader would surely notice the paucity of servants at Gangoil and recognize the near impossibility of maintaining a proper "home" under these conditions.

The house at Gangoil itself poses certain impediments to the establishment of British-style domesticity. The station house is no town house. It is a typical bush house of this time, a single-story dwelling with three enclosed rooms (a bedroom on either side of a parlor) and a broad veranda that runs along three sides of the house. The veranda is the space "in which the family really passed their time.... Here were clustered the rocking-chairs and sofas and work-tables, and very often the cradle of the family. Here stood Mrs. Heathcote's sewing-machine; and here the master would sprawl at his length, while his wife, or his wife's sister, read to him. It was here, in fact that they lived"(11). The compartmentalization of activities into separate rooms in the London home is impossible in the bush.[16] The veranda, instead, serves as sitting room, receiving room, library, and smoking room. The ladies and gentlemen do not separate after dinner; all go out together to the veranda, where it is not quite as hot and stuffy as the indoor parlor where they eat meals. Climate, then, plays a large role in the alteration of the domestic space and

thus the domestic routine. The enclosed spaces of the house proper are stifling in the heat of an Australian summer. A new space must be designed. Yet this new space necessarily leads to new cultural practices. For instance, on the veranda, Harry smokes in front of the ladies, a sign of very bad manners back "home" but a matter of course in the common room in which they spend their evenings. On the veranda also, women's work and men's work mingle: Mary's sewing machine shares the same space as Harry's business papers. Furthermore, there is no nursery at Gangoil. Children and adults live together. Under these conditions it would be very difficult, if not impossible, to maintain the elaborate customs of urban England.

The inhabitants of Gangoil, though, understand that complete reproduction of the British domestic site is not possible. The women of the house know that they must make do with what *is* available; thus the cultural practices that they choose to maintain hold even greater significance than they would at "home." Though in all likelihood Mary and Kate were born in Australia, both women seem very well-versed in the cultural practices of a country a world away.[17] The book begins with the "young autocratic patriarch" (12) Harry Heathcote "returning home to his dinner" (3). Within a few pages we are not only told but also shown that the inhabitants of Gangoil are not of the common working class; they are, in fact, a gentleman and ladies. On this sweltering Australian summer night, the ladies have given us a telltale sign; they have "dressed for dinner, and were as bright and pretty as they would have been in a country-house at home" (7). Harry, on the other hand, sits down at the table wearing his work clothes. He is excused from changing his clothes because he is to return to the saddle directly after dinner.[18] Despite Harry's exemption and the heat, dirt, and isolation of the station house, the women uphold the practice of elaborate dressing for the evening meal. Birgitta Maria Ingemanson, in "Under Cover: The Paradox of Victorian Women's Travel Costume," notes that

> the great women travelers coolly persisted in donning their corsets and hats, dining in open nature on white linen cloths, and taking their stoves and often-intricate household utensils—in effect their homes—with them.
>
> Victorian dress and domesticity were certainly cumbersome and restrictive, but their function on the road can also be considered supportive, even permissive. In strange surroundings, familiar clothing along with well-known domestic props provided not only a reassuring sense of stability but also a façade of propriety behind which

the women were free to pursue the ulterior purpose of their travels: active participation in life.[19]

In the case of female colonists, as opposed to female travelers, elaborate clothing and "domestic props" served not as a covert escape from the confines of a too restrictive "home" but rather as reassurance of the immediacy of that "home." Mary is not a traveler evading domesticity but a dutiful wife seeking to establish it. Mary and Kate's insistence on the ritual of dressing for dinner thus signals their attempt to reproduce British domesticity in the Australian bush.

Another cultural practice that seems clearly out of place in the bush, but which is assiduously maintained in the novel, is the holding of a family religious "service" every Sunday. Trollope notes in *Australia* that "Sabbath-day observances are laxly kept in the bush." He also claims that "religious teaching, and the exercise of religious worship, are held as being essential to civilisation and general well-being by the people of Australia."[20] With "civilisation" at stake, Mary's insistence on a family service every Sunday for the residents of Gangoil is no surprise.

> At about noon, prayers were read out on the verandah, the congregation consisting of Mrs. Heathcote and her sister, Mrs. Growler, and Jacko [a rascally young hired hand]. Harry himself was rather averse to this performance, intimating that Mrs. Growler, if she were so minded, could read the prayers for herself in the kitchen, and that, as regarded Jacko, they would be altogether thrown away. But his wife had made a point of maintaining the practice, and he had of course yielded. (67)

Clearly, Mary does not see religion as one of those dispensable English customs that could be omitted in the bush without dire consequences. Even if the prayers are "thrown away" on some, the maintenance of the "practice" is what counts. A proper home must have proper religious observance, and in lieu of going to church (since there does not appear to be a church anywhere near at hand), the family holds its own service on the all-purpose veranda. In addition to this obvious religious practice, Mary coaches Harry throughout the story on Christian ideals such as forgiveness and charity. "It isn't Christian," Mary tells her husband, "for people living out in the bush, as we are, to quarrel with their neighbors just because they are neighbors" (26). One could easily replace the term "Christian" here with the words "seemly" or even "proper" and not significantly change the meaning. To be British is to be Christian is to be

civil to one's neighbors. Such comments suggest that appearances are important even in the bush.

The women at Gangoil, then, maintain the appearance of the domestic ideal, not only in the literal appearance of their persons but in the weekly routine of the house. The influence of the women in making the house a home can be found in other instances as well. When Medlicot asks Kate if Harry would be better off without the trouble of protecting a wife, Kate replies, "Well, no. I suppose it would be very rough without Mary; and he'd be so lonely when he came in.... I know it was very rough before we came here ... no regular meals, but just food in a cupboard when he chose to get it" (73). Living without the comfort of such basic domestic rituals as regular meals would leave a man's life "rough" and "lonely." These mundane domestic practices are more significant than one might at first think: regular meals, after all, do much to provide a sense of order and community. The women provide Harry with food for the mind as well as food for the body, for they read to him in the evenings. According to Trollope, the most popular works found in actual Australian homes were by Shakespeare, Dickens, and Macaulay.[21] Assuming the women of Gangoil read such authors, one can see how such entertainment would maintain a sense of both the high culture of the British past and the popular culture of the British present. In little ways, too, the presence of the women is felt, as in the pretty striped curtains and "flowering creepers" (13) of the veranda. Such details might seem insignificant until compared to those at the "home" of the Heathcotes' neighbors, the Brownbies of Boolabong.

The Brownbie residence is a despicable hovel, barely fit to be called a "house" let alone a "home": "The house itself was a wretched place, out of order, with doors and windows and floors shattered, broken, and decayed" (57). The house quite obviously reflects the character of its inhabitants. Old Brownbie had originally come to Australia as a transported criminal, and though all but one of his sons had heretofore escaped penal servitude, every one of them had surely deserved it. Boolabong, their cattle run (filled mostly with stolen stock), serves the country thereabouts as a refuge for every passing rapscallion. The same Sunday that we see the folks at Gangoil holding family prayers, for instance, we find Harry's two dismissed employees at Boolabong plotting their revenge. Predictably, "[T]here were none of womankind belonging to the family, and in such a house a decent woman-servant would have been out of her place" (57). The state of Boolabong causes woman's absence from there just as much as the absence of any woman causes the

state of Boolabong. There are no communal meals there; each man serves himself from a cupboard and eats in his own corner. There is no communal reading, only the communal spirits bottle. There is no Sunday service, there is no dressing for dinner, and there are certainly no pretty little flowers on the veranda. Instead, there are constant quarrels, violent outbursts, and illegal exploits. The absence of women clearly signals not only a lack of order and propriety but a lack of civilization.

In many societies women are the acknowledged culture bearers, the keepers of community. Though English literature does not always promote this idea, such a role for women is quite recognizable in certain texts. *Harry Heathcote of Gangoil* is one such text. Mary and Kate, and even Mrs. Growler and Mr. Medlicot's mother to some extent, not only preserve the cultural practices of English domesticity in and of themselves but also use these practices to form and maintain a vitally important community. The main problem Harry faces in the text, both literally and figuratively, is his isolation. Consequently, the women's most important actions work toward forming the one alliance that is necessary for the future safety and happiness of all.

Harry complains throughout the story of his lack of a trustworthy friend of appropriate rank, ethnicity, and gender. In the first scene of the novel we hear Harry lament that he has no one to talk to about his troubles except the women. He knows that by all rights "a man's back should be broad enough to bear all that for himself" (9), but then again most men have a male friend to talk to, and Harry has none. Later on, "[H]e thought that if he could only find some one person who would sympathize with him, and support him, he would not mind; but the mental loneliness of his position almost broke his heart" (52). The cause of Harry's isolation, however, is not solely the wide open spaces of the Australian bush. Harry, though certainly "industrious," "determined," and hardworking, is also described throughout the book as "imperious" and "obstinate." One night as Harry roams his property searching for fires, he asks one of his boundary riders why anyone would want to "ruin" him. The German immigrant replies, "You like too much to be governor over all" (21). Harry clearly does relish the role of master. In contemplating his potential ruin and removal from Gangoil, Harry's greatest fear is that "such a blow ... [would] force him to be servant instead of the master of men. Not to be master of all around him seemed to him misery" (36). But Harry's problems stem not from the aristocratic assumption that he was born to rule but from his *way* of ruling. "Somebody must be governor," says Harry, but as the German remarks, "Dat's true; only fellows don't like be made feel

it" (21). In Harry's attempt to "make the men around him respect him," he sometimes does not see "what justice demanded for others as well as for himself" (22). So the men of the neighborhood grow to hate Harry instead of respect him, and his foes lie in wait for the dry season, which makes Harry's ruin as simple as a well-placed match.

Harry is beset by enemies, to some extent through his own fault. But his subordinates, even those with whom he remains on good terms, would not in any case be suitable confidants. Only one man is Harry's "equal in education, intelligence, and fortune, if not in birth," and that man is Giles Medlicot. But Harry's prejudices and bad manners blind him to the suitability of such a friendship. When Medlicot first came to the bush, "being alone, [he] had desired friendship," assuming that he and Harry would be friends. "But his overtures had been coldly received" (27), so the friendship is never formed. Worse yet, Harry's rudeness has "unconsciously" led Medlicot to "commence hostilities" and to hire Harry's dismissed employee Nokes, thus triggering a chain of events that proves nearly disastrous for Harry (27–28).

Harry is given numerous chances throughout the book to improve relations with his free-selecting neighbor, but time and again these meetings prove futile. When Harry finally decides to have a man-to-man chat with Medlicot about Nokes, for example, he schools himself during the ride over on keeping his temper, which he actually succeeds in doing. The real problem, however, is not his temper but his lack of manners. He begins the interview with various references to Medlicot's status as a newcomer and ignorance of the ground rules of bush life. The narrator notes, "[O]n this matter he said much which, had he been a better tactician, he might probably have left unspoken" (40). Harry lacks "tact." He does not see how offensive he is being and furthermore does not have the manners to cover up his offensive ideas. Medlicot, on the other hand, fresh from the old country, behaves at all times quite appropriately. In fact, despite Harry's having "expressed himself badly" (43–44), Medlicot begins to wonder if there might be truth to Harry's fears. "Being more rational, more logical, and less impulsive than the other," Medlicot is better equipped to treat Harry with justice (44). Harry, however, knows nothing of Medlicot's change of heart. He leaves lamenting that "he had no one with whom he could converse freely.... He now found that when trouble came the privilege of dictatorship brought with it an almost insupportable burden" (46).

Luckily for Harry, the women at home know what he needs, and they have the expertise to fulfill that need. Through skillful manipulation of

British cultural practices, these "angels" of the bush unite the sheep run and the sugar mill in friendly community. From the moment he appears, the women of Gangoil recognize Harry's natural ally: "When she first saw Mr. Medlicot," Mary "felt it a God-send that such a man, with the look of a gentleman, and unmarried, should come into the neighborhood" (107). Mary anticipates the benefits of an alliance between her sister and such a man. Mrs. Growler, too, notes the free-selector's class and realizes the potential rewards for the folk at Gangoil: "A very nice gentleman is Mr. Medlicot.... And a deal of good they're going to do" (7). Despite their repeated assurances to Harry that Medlicot "had the manners of a gentleman," however, Harry refuses to give the man his due. "Women were always soft enough to be taken by soft hands, a good-looking face, and a decent coat," thinks Harry (20). He is not fooled by appearances. Yet Trollope clearly *is* signaling the reader that Medlicot is a gentleman, defined in *Australia* as a "combination of soft words, soft manners, and soft hands with manly bearing, and high courage, and intellectual pursuits"—such is "true gentility."[22] The women are more finely attuned to the trappings of culture and are thus better than Harry at reading such signs of gentility. As Elizabeth Langland argues in *Nobody's Angels: Middle-Class Women and Domestic Ideology in Victorian Culture*, middle-class Victorian women were "key players" in "consolidating power" for their class. Thus, they employed a range of "signifying practices ... from increasingly complex rules of etiquette and dress, to the growing formalization of Society" to sustain their family's position and the social hierarchy. Being the formulators of these "signifying practices," women were necessarily quite adept at reading the "practices" of other people.[23] Mary and Kate know one of their own when they see one.

Once Medlicot's social position is identified, the issue seems simple: "It was almost necessary that they should either be friends or absolute enemies. Mrs. Heathcote had been aware of this, and had declared that enmity was horrible" (28). The extremes of such a hostile environment as Australia intensify relationships, pushing all acquaintance into two camps: friend or foe. And as Mary says, "Quarreling is so uncomfortable" (26). Therefore, "in spite of Harry's aversion," his wife "had formed her little project" (108). Using the custom of "visiting," she triggers a chain of events to counteract Harry's mistakes. Women in England were accustomed to visiting one another, employing an elaborate system of "calling" behavior. Whether such visits entailed merely leaving one's card, engaging in polite conversation for fifteen minutes, or, with more intimate friends, "gossiping" the whole morning away, a return visit of some

kind was always required. To omit this formality would be seen as extremely rude, a clear "cut" to the neglected woman. Knowing that any visit made to Mrs. Medlicot (Giles's mother newly arrived from the Old Country) must be returned, Mary sees her first step, for, of course, that elderly gentlewoman could not make the journey to Gangoil unattended. In making a visit to their new neighbor, then, Mary and Kate were almost guaranteed a return visit by mother *and* son. Such visits would provide opportunity both for Harry and Medlicot to become friends and for Medlicot and Kate to fall in love, another surefire way to bring about friendship between the two men. As it happens Medlicot does take this occasion to attempt a reconciliation by agreeing to keep an eye on Nokes. And as is certainly expected in such a situation, the return visit brings with it an invitation to participate in another cultural practice—the dinner party.

Much rests upon Harry's response to the Medlicots' invitation to Christmas dinner. Mary knows, "If he would consent to this an intimacy would follow, and probably a real friendship be made" (75). Such is the normal course of things among civilized people. Apparently, once set in motion this "course" is more difficult to alter than Mary foresaw. Even Harry is caught up in the dictates of politeness. The threat of fire makes traveling to the Medlicots' impossible, but rather than giving a flat refusal, Harry proposes, "much to [his] own astonishment" (75), that the pair come to Gangoil instead. From this moment on, the salvation of Harry's sheep run and the marriage of Kate Daly are assured. The rest of the story leads to the happy celebration of these alliances at Christmas dinner, a grand replication of the cold-weather holiday of the British Isles, complete with flaming plum pudding. "That Christmas dinner at Gangoil was eaten with great satisfaction. Harry... was no longer oppressed by that sense of desolation which had almost overpowered him" (122). The community has made its covenant at the common table. Harry's toast to "Our friends at home!" (122) acknowledges the land whose cultural practices are the glue holding this new community together.

The "angels" in the bush, then, can somewhat successfully create a "home" in the wilderness. They bring order, propriety, and beauty to an untamed land and can in fact alter the course of events by creating communal ties. Ultimately, however, their "home" in the bush is never safe or permanent. With Medlicot's help, Harry fights off his enemies, but none of them is punished by the law. Nokes—the prime culprit and the man Medlicot identifies to the colonial police as an arsonist—escapes

from the area. Though the narrator assures the reader that Nokes "never since appeared in the neighborhood of Gangoil" (116), Harry's other disgruntled former employee, Boscobel, remains at Boolabong with the Brownbies, none of whom are even reprimanded by the authorities, let alone prosecuted. The British class system is breaking down in Australia. Laborers are too scarce and thus too well-paid to be kept appropriately humble and obedient. Servants speak their mind.[24] Wrongdoers have a whole continent in which to roam. Nostalgic for the days of Abraham when a great leader might exercise "absolute dominion and power," Harry yearns for a time when "the people were submissive and the world was happy" (92). This time, if it ever existed, is gone forever now, and Harry does not seem to be adjusting too well. Even the narrator of the story's happy ending can only claim that Harry has been "triumphant" — "so far" (122). In a sense, then, this "home" that the women of Gangoil have striven to establish is a temporary one whether Harry succeeds or fails. For if his neighbors never have the courage to attempt again to ruin him, Harry's livelihood is still open to the legal threat of free-selectors and the harsh natural environment. He may lose Gangoil, and thus his independence, at any time. On the other hand, if he succeeds, he will return to England. Medlicot's mother reminds us of this possibility at Christmas dinner: "You're young," she says, "and will win your way hame" (122). Australia, for these characters, is merely a stopping place, a place to "make your fortune" or "lose your shirt" but not to settle permanently.

Though some fictional characters, as well as real emigrants, assumed that they would eventually return to England, in fact, few colonists did so. Those who achieved great success in the colonies were rare. As Jack Brien, a miner in Trollope's *John Caldigate*, puts it, "There's gold pretty much everywhere, and you may find it, or you mayn't. That's where it is; — and the mayn'ts are a deal oftener turning up than the mays."[25] Trollope was far too well versed in the real hardships of colonial life to paint too rosy a picture of Australia in any of his works, regardless of the conventions of genre. In fact, Trollope's son, Fred, upon whom Harry is modeled, never did grow rich and return "home." In 1875, Fred Trollope sold his sheep run at a loss of over £4,600 and went into government work. And Fred was not the only son of a famous father to struggle for a living in the Antipodes; two of Charles Dickens's sons also emigrated to Australia, and they, too, found life in the colony full of hardships.[26] Though the working class often seemed to have better luck than gentlemen in improving their fortunes in the colonies, even workers too often

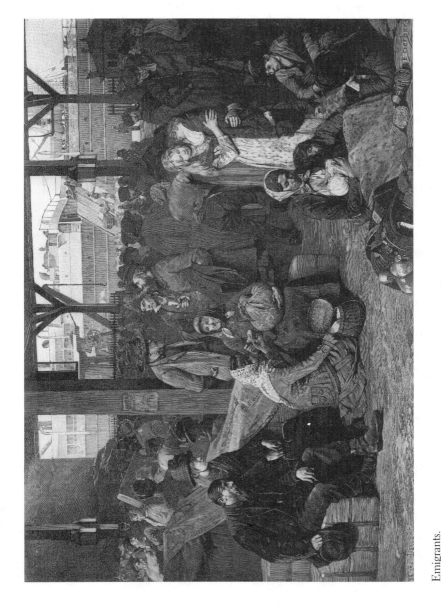

Emigrants.
Courtesy of the Library of Congress, Photographs and Prints Division.

fell on hard times.[27] The colonial economy was subject to violent crashes due to its overreliance on a single export item, wool, and to the effects of the gold rush. Female emigrants were even more vulnerable during these turbulent periods. Caroline Chisholm, upon arriving in Australia in 1838, was appalled to find immigrant girls living in horrible conditions in the cities, unable to find work or adequate housing.[28]

Emigrants to Australia were certainly not guaranteed prosperity. Some, no doubt, were unwilling to return to England empty-handed. Some had not even the means to pay for their passage. Some could have afforded the trip home but chose to stay in Australia anyway. As one letter to the London *Daily Telegraph* put it, "The idea of repatriation is almost always an idle dream" since soon "the tastes and sympathies of the majority of new comers are assimilated with those of their neighbors, and as their children grow up, the last ties with the old country drop away."[29] The land itself and the customs that spring from such a land influence the colonists of that land, regardless of efforts to maintain British cultural practices and thus preserve ties to home. Finally, some colonists remained in the colonies against their inclinations, merely out of duty to family. Drought, flood, and fire; convicts, coolies, and aborigines; dirt, heat, and wide open spaces—the life of an "angel" in the bush is filled with loneliness, physical discomfort, and uncertainty. Duty may tell her to stay, but her heart often still yearns for home.

Although some of Trollope's contemporary Australian readers criticized the inaccuracies and prejudices of his text, much of what he wrote accurately reflects colonial life. Trollope, unlike other authors who wrote about Australia, actually extensively explored both Australia and New Zealand and knew even more about them than some inhabitants.[30] It is no surprise, then, that one reviewer "boldly proclaimed that [the novel] threw more light on colonial life than any number of blue books."[31] In fact, *Harry Heathcote of Gangoil* provides a complex view of that "colonial life," a view much more subtle and insightful than previously recognized. On the one hand, the novel certainly depicts a great opportunity for women to fill the important role of civilizing force in an untamed land. On the other hand, the novel gives considerable insight into the problems inherent in this role. Not only was it nearly impossible for women truly to preserve the home as a sanctuary for a husband from the corruption of the outside world, but women themselves could also rarely remain "uncontaminated" by that rough and frightening world.

Victorian readers, especially women, could not help but note the difficult position in which the Gangoil women find themselves. The night of

the big fire and bush fight in *Heathcote*, Mary and Kate wait at the kitchen door for news of Harry. In the midst of these troubles, "[T]hey had no consolation to offer each other. The silence of the bush, and the feeling of great distances, and the dread of calamity, almost crushed them" (83). Sisterhood offers no comfort. The land itself seems to work against them. Society is in a state of war. All their attempts to transplant "home" half a world away could be undone in a moment, and they keenly feel the burden of such knowledge. Is it no wonder, then, that their guiding dream is to return one day to England? Few women reading such a tale would yearn to be in Mary's place, for the "angel" in the bush will never have a home while she lives out of sight of English shores. "Mid pleasures and palaces" or in the desolate bush, wherever she may roam, there surely is no place like home.

Notes

1. Anthony Trollope, *Australia and New Zealand*, vol. 1 (London: Dawsons, 1968) 10.
2. Charlotte Erickson, *Leaving England: Essays on British Emigration in the Nineteenth Century* (Ithaca: Cornell UP, 1994) 241. Erickson also demonstrates that even in 1841, when the number of women actually exceeded the number of men emigrating through government assistance to New South Wales, the number of men emigrating without aid proved high enough to keep women in the minority (191).
3. *Daily Telegraph* 6 Dec. 1866; cited in Charlotte Macdonald's *A Woman of Good Character: Single Women as Immigrant Settlers in Nineteenth-Century New Zealand* (Sydney: Allen, 1990) 7–8.
4. Erickson 243.
5. George Rudé, *Protest and Punishment* (Oxford: Clarendon, 1978) 1.
6. L. L. Robson, *The Convict Settlers of Australia* (London: Cambridge UP, 1965) 3.
7. See A. James Hammerton, *Emigrant Gentlewomen: Genteel Poverty and Female Emigration, 1830–1914* (London: Croom, 1979).
8. As Coral Lansbury notes in *Arcady in Australia: The Evocation of Australia in Nineteenth-Century English Literature* (Melbourne: Melbourne UP, 1970), "Implicit was the belief that emigration was a confession of failure at the least, and of social disgrace at the most" (28).
9. P. D. Edwards, introduction, *Harry Heathcote of Gangoil: A Tale of Australian Bushlife*, by Anthony Trollope (Oxford: Oxford UP, 1992) ix. All quotations from *Heathcote* will be taken from this edition and page numbers will be cited parenthetically within the text.
10. Trollope portrays free-selectors and squatters as natural enemies in the bush. Squatters were the aristocrats of Australia, renting vast tracts of land upon which to run their sheep and/or cattle, while free-selectors tended to be small farmers or ranchers who bought usually much smaller portions of land upon which they lived and worked. Medlicot has "free-selected" some of Harry's waterfront property to grow

sugarcane. For a thorough explanation of the difference between the two classes, see Trollope's *Australia and New Zealand*, vol. 1, ch. 6.

11. Early in the story after Harry's first argument with his neighbor Medlicot, he contemplates the proper order of things: "How were the 'hands' to be kept in their place if one employer of labor did not back up another?" (20) Harry is angry that Medlicot has hired a worker that he dismissed, but by the end of the book Medlicot has seen his error and offers information on that man for setting fire to Harry's grass. He has learned to "back up" his own class.

12. Lansbury 131–32.

13. From Dickens's famous Christmas story *A Christmas Carol* (1843).

14. Trollope, *Australia* 308.

15. Trollope notes in *Australia*, "The high rate of wages and the difficulty of getting persons to accept these high rates for any considerable number of months together, cause even the wealthy to dispense with much of that attendance which is often considered indispensable at home even among families that are not wealthy" (468).

16. Indeed, the compartmentalization of the British house itself into several rooms, their closed doors lining the hallway, contrasts remarkably with the open space of a colonial veranda. Visitors entering a London town house and an Australian station house would find themselves in vastly different environments.

17. The text merely states that Mary and Kate were the "orphan daughter[s] of a bankrupt squatter whom [Harry] had met in Sydney" (6), telling us little more than that their class standing is high even though their father lost his business. However, in a conversation late in the book between Kate and Medlicot, we learn in a more roundabout way that Kate was probably born in Australia. She tells Medlicot, "I can't even picture to myself what sort of life people live at home" (74).

18. Trollope lists the benefits of the life of the squatter in *Australia and New Zealand*, ending with the best of all: "But the joy that mostly endears his life to him is the joy that he need not dress for dinner" (99).

19. Birgitta Maria Ingemanson, "Under Cover: The Paradox of Victorian Women's Travel Costume," *Women and the Journey: The Female Travel Experience*, ed. Bonnie Frederick and Susan H. McLeod (Pullman, WA: Washington State UP, 1993) 5–6.

20. Trollope, *Australia* 313, 224.

21. Trollope, *Australia* 310.

22. Trollope, *Australia* 86.

23. Elizabeth Langland, *Nobody's Angels: Middle-Class Women and Domestic Ideology in Victorian Culture* (Ithaca: Cornell UP, 1995) 9. See also Nancy Armstrong, *Desire and Domestic Fiction: A Political History of the Novel* (New York: Oxford UP, 1987).

24. Trollope remarks in *Australia*: "The maidservant in Victoria has the pertness, the independence, the mode of asserting by her manner that though she brings you up your hot water, she is as good as you.... [She] does not shake in her shoes before you because you have £10,000 a year" (475–76).

25. Anthony Trollope, *John Caldigate* (1878–79; London: Oxford UP, 1946) 83.

26. For more information on Alfred and Edward Dickens, see Mary Lazarus, *A Tale of Two Brothers: Charles Dickens's Sons in Australia* (Sydney: Angus, 1973).

27. See Eric Richards, ed., *Poor Australian Immigrants in the Nineteenth Century*, vol. 2, *Visible Immigrants* (Canberra: Australian Natl. U, 1991).
28. In subsequent years Chisholm dedicated her life to improving the lives of emigrants through her emigration society, which sought to reunite families separated by emigration, and through establishing regulations for a safer passage for women and a more efficient system for distributing labor.
29. Qtd. in John M. Robson, *Marriage or Celibacy? The Daily Telegraph on a Victorian Dilemma* (Toronto: U of Toronto P, 1995) 223.
30. For instance, Edward Gibbon Wakefield wrote *A View of the Art of Colonization* (1849), which greatly influenced governmental policy, although he had never visited Australia.
31. Edwards xii.

A One-Way Ticket?
Emigration and the Colonies in the
Works of Charlotte M. Yonge

Catharine J. Vaughan-Pow

In her 1992 biography and analysis of the popular nineteenth-century writer Charlotte M.Yonge,[1] Barbara Dennis states that "[Yonge's] repeated theme is [her characters'] quest for virtue, worked out in the terms of domestic realism" (Dennis 91). This identification of Yonge as concerned primarily with religion and the family has characterized all comments upon her writing, both during her lifetime and since her death in 1901. Certainly, it is true that novel after novel analyzes the function of religion, the structure of the family, and in particular, the place of women. These themes were further explored in the *Monthly Packet*,[2] a magazine that Yonge edited for almost forty years and that offered a variety of reading to a domestic audience, visualized by Yonge as composed of young girls and women; and in *Womankind* (published in book form in 1887 but initially serialized 1874–76), a collection of essays in which Yonge gave her own opinions on desirable female conduct. Thus, Yonge consciously offers a stereotype of female domesticity, the acceptance of which she upheld as a religious and moral requirement, necessary to the appropriate functioning of her idea of a healthy British society.

However, there is a discernible tension in Yonge's writing, as she reveals not only her support for the stereotype but also an awareness of the limitations it imposed upon women and the compromises required of women to maintain their social position. For Yonge, as for many other female novelists at the time, gender behavior and social status were inextricably linked; failure to conform adequately to the norms of the one meant a corresponding slippage in the other. Leonore Davidoff's study *The Best Circles: Women and Society in Victorian England* centers this fundamental unease primarily on the criteria for membership of the middle and upper classes, an issue that Yonge debates. Constant scrutiny of these criteria was required as "[u]nder the impact of industrialisation,

... a flood of applicants ... threatened to overwhelm the lifestyle itself" (Davidoff 15), and it was women who undertook this task of assessing both criteria and applicants. Thus the needs of the individual were constantly juxtaposed with the demands of the group, for as Judith Rowbotham points out, "The most important element in [the] equation for social stability and individual success was the Family—the most universally admired and respected social unit of the century" (18). Although Yonge consciously upheld this conservative and patriarchal stance, she recognized that the tensions caused by this position were difficult to resolve and that the innate dilemmas that focused upon the woman in her designated roles as daughter, sister, wife, and mother could only be mediated through debate. Consequently, Yonge acknowledges the gap between the ideal and the actual, particularly in terms of the single woman and her resources, but fails to provide any solution other than those already proposed by the patriarchy.

In addition to domesticity and religion, travel and emigration form another aspect of Yonge's writing, an aspect that has not, as yet, received much consideration. Yonge was clearly aware of the impact that Britain's development as a colonial power in the second half of the nineteenth century had upon society, particularly the possibilities that it offered to the middle classes, although she saw this development in religious terms and regarded it as an opportunity to spread Christianity (given the missionary work that characterized the Oxford movement, of which Yonge was an advocate, this was inevitable). Thus, the proceeds from the sale of *The Heir of Redclyffe*, published in 1853, were devoted to the outfitting of the "Southern Cross," a ship destined to take missionaries to Melanesia, and twenty years later, Yonge produced a detailed biography of her cousin, Bishop John Coleridge Patteson of Melanesia, who had been killed in Nukapu in 1871.

While her fiction specifically supported the doctrines and activities of the Church of England, in considering countries other than England, Yonge focused upon the religion (both Christian and non-Christian) practiced in those places. Clearly, Yonge was predominantly concerned with the interaction of the spiritual and the social, and this concern characterizes her presentation of non-English societies. Furthermore, the interest in domestic and social practices underlying her depiction of English life was reflected in references to colonial or foreign lifestyles appearing in her fiction; these are generally described in relation to the conditions that English visitors or settlers encounter, resulting in an inherent comparison between English culture and alien ideas. Yonge is not alone in

employing this covert comparison: Edward Said comments in *Orientalism* that "an Englishman in India or Egypt in the later nineteenth century took an interest in those countries that was never far from their status in his mind as British colonies" (11). This comment is applicable also to an Englishwoman writing of countries that she had never visited but whose status as colonial acquisitions underpinned late-nineteenth-century thought. Yonge's acceptance or rejection of other cultures was similarly predicated upon the extent to which they conformed to the standards set up by English society; as she was primarily concerned with the depiction of characters who represented the positive aspects of this society, the impact of the alien or colonial society was necessarily played down.

Although the essays in *Womankind* may indicate Yonge's views on the place of women in English society, there are no explicit comments on their place in colonial or foreign communities; she saw her pronouncements on social issues as universally applicable to English women and therefore requiring no specific application. Consequently, readers must refer to the factual material in the *Monthly Packet* to examine the attitudes concerning foreign or colonial society that she incorporated into her fiction. In doing so, readers must remember that Yonge herself maintained no overt editorial "voice," as became common in nineteenth-century periodicals, and that while the material printed in the *Monthly Packet* was selected solely by Yonge and may be representative of the information and attitudes that she considered appropriate for her readers, the *Monthly Packet* contained no direct editorial statements or directions other than can be inferred from the articles published. The broad subject matter that the magazine covered includes articles on literature, history, geography, theology, and church affairs, in addition to fiction and poetry, and the didactic nature of the publication indicates that Yonge regarded it as a means of both entertainment and instruction. Examination of two randomly selected volumes reveals the breadth of material provided in a typical six-month period. Thus, volume 14 of the first series, which covers July to December 1857, has articles on the following topics: English history, church architecture, the catechism, Italian history, Hindu mythology, French literature, entomology, and physical geography. There are also several short poems and five long serialized stories, one by Yonge herself. Published in 1887, volume 14 of the third series has writings on English history, church history, the prayerbook, German mythology, French history, English literature, and the colonial church, in addition to fiction and poetry. It appears that the range of top-

ics covered changed little in the thirty years intervening between the two volumes.

The amount of space allotted to each type of article also appears unaltered. Thus the appeal for "Church Bells in New Zealand," which appears in 1857, occupies four pages out of over five hundred pages and, together with "The Little Duke in New Zealand," constitutes the only reference to colonial affairs in a volume that covers a six-month period. Similarly, the single article on the colonies that appeared thirty years later in 1887 entitled "The Centenary of the Colonial Church" is only six pages in length. This article is characteristic of the writing on the colonies that appeared in the *Monthly Packet*. The writer, D. J. Mackey, briefly traces the establishment of the Anglican Church in New Zealand, Australia, Canada, South Africa, and India, and while doing so reminds readers that the colonial church needs not only prayers but also money and volunteers with which to carry out its work. He dwells on the familiar aspects of the organization and worship of the institution but at the same time emphasizes the alien nature of the countries where it has been introduced. The writer is eager to reassure the reader that religious life has presented these colonial societies with structures that are recognizable and worthy, but the underlying suggestion is that the alien society is constantly threatening to overwhelm these institutions and that only constant surveillance in the form of prayer and service will protect them.

This suggestion is supported by Homi Bhabha's analysis of the workings of colonialism in "Of Mimicry and Man," where in assessing the inarticulate fears of the colonizing power, he writes that "the ambivalence of colonial discourse also disrupts its authority" (88); the mimicry demanded of the colonial subjects in relation to the new authority contains its greatest threat to that authority by the very fact of the forced resemblance between them. The gap between the two is seen to be no gap at all, and this resemblance raises terrifying possibilities that need to be quelled by constant assessment of the differences between authority and subject. Although Bhabha apparently addresses a nonlocalized colonial situation, the contextual references seem to represent India, a country and colony that Yonge largely ignores in her novels but does feature in articles in the *Monthly Packet*. In India, the colonizing power is localized in an administrative role rather than by a physical domination of the land by farmers and settlers who have displaced the previous inhabitants. Thus, references to India in the *Monthly Packet* (and also in novels such as *The Young Stepmother* [1861]) emphasize well-established cities and the presence of an administrative and martial

organization (see, for example, "Bengal Cantonments"). However, Yonge's primary concern is with the missionary aspect of colonization rather than the civilizing process of British bureaucracy; therefore, she finds the Indian experience and context a less fruitful source of information. Given this concern, Yonge's attitude toward colonies other than India, particularly the Antipodes, which feature in both her novels and the *Monthly Packet*, becomes more interpretable.

The concepts of the familiar and the alien are clearly present within articles on the colonies in the *Monthly Packet*, and a clear tension exists between the two; thus, "A Trip to Norfolk Island," published in 1881, which describes the consecration of a chapel on Norfolk Island, continually stresses the unfamiliarity of the landscape to the observer and the alien appearance of the native peoples—then immediately reassures the audience that a British lifestyle is being established and maintained. Moreover, this lifestyle has been accepted by the natives; the possibility of nonacceptance is not raised here, and the reader is encouraged to accept uncritically a perspective that both the (usually) anonymous writer and Yonge, in her editorial capacity, supported. This basic tension between the familiar and the alien, together with an unarticulated unease concerning the mere presence of natives, who act as a constant indicator of credibly non-British societies, is clearly apparent in articles concerning colonial life and society in the *Monthly Packet* and exemplifies the ambivalence that Bhabha identifies.

As previously suggested, the articles on the colonies that appear in the *Monthly Packet* deal either with the Christian missionary work that is being undertaken or with descriptions of the land and native life. In addition to those already referred to, examples of such articles include "Notes of a Voyage amongst the Pacific Islands" and "St Andrew's College Wellington." These were followed over the next fifteen years by short articles on "A Trip to Norfolk Island," "A Maori Haka," and "The Rabbit Plague in Australasia." General descriptions of the Antipodes, South Africa, and India featured in a geographical series entitled "The Earth As It Is." Descriptions of physical geography appear unbiased; however, when the writings describe the native inhabitants, a change occurs that can best be comprehended by referring to the 1881 article on Norfolk Island mentioned earlier, as it is typical of the few articles dealing with native peoples. The natives are consistently described as children: They are "native boys and girls" who are "on the most filial terms with the Mission folk." Their inferior status is emphasized by the repeated use of terms such as "little" and "young," as in "one very young baby was kept so

nice by its mother—quite a young girl," while their alien qualities are suggested by descriptions such as "[t]he little girls are dear little things, with such mops of soft wool we were always catching hold of it, the feel of it was so cosy" ("Trip to Norfolk" 491). These people are not regarded as adults, although some of them are married and parents, two conditions that in Yonge's presentation of British society imply automatic adulthood.[3] Instead, they are seen simultaneously as children, aliens, and pets, all of which require, by Yonge's definitions and beliefs, controlling, taming, and civilizing, a process achieved by the acceptance of British laws, customs, and society. The writer approves of natives who are apparently conforming to the British ideal as presented at the mission schools and colleges, and as sole editor of the magazine, Yonge endorses and encourages these attitudes.

The identification between editor and contributor is apparent in the article entitled "The Little Duke in New Zealand," which mimics the plot of *The Little Duke* (1854), an historical novel by Yonge, and in doing so identifies the Maori Wars of the 1850s with Norman France in the Middle Ages. A native child is thus seen as both historically European and geographically alien and is consequently displaced from both positions—a tiny example of the uncertainty that Bhabha describes in his 1985 essay "Sly Civility." Here Bhabha identifies a fundamental concern of the colonist for whom "passionate for unbounded, unpeopled possession, the problem of truth turns into the troubled political and psychic question of boundary and territory." The presence of the native within the territory claimed by the colonist must then provoke the question: "*Tell us why you, the native are there*" (78). Yonge resolved this question by relying upon her Christian beliefs: the native was "there" in order to be evangelized and, as a consequence, civilized. Hence, in the *Monthly Packet* she presents and extols those natives who do seem to accept the missionaries' beliefs and attitudes but ignores those who do not; the tensions caused by incorporating the latter into the text would be too great.

While analysis of the *Monthly Packet* offers some evidence for these inferred attitudes, Yonge's clearest statements on the colonies and emigration appear in her novels. For the purposes of this essay, I will consider only five representative novels from Yonge's output of over ninety: *The Daisy Chain* (1856), *Pillars of the House* (1873), *The Long Vacation* (1895), *Modern Broods* (1900), and *My Young Alcides* (1874). These novels present Yonge's perception of contemporary middle-class society at various times during her writing career; the first three titles constitute the

major part of a series dealing with three families whose stories are interlinked. The final title, *My Young Alcides,* is chosen because of the number of references to Australia and Australian lifestyle as understood by Yonge.

In her novels, Yonge does not give a complete depiction of colonial society, perhaps because she was preoccupied by English provincial society and regarded the colonies only as a useful resource for and addition to the opportunities already available to her characters. Thus, the colonies appear in her novels primarily as points of arrival and departure, places to which her characters are sent and from which they are occasionally recalled. The novels' perspectives remain firmly British, and although the audience is aware that events do occur in these unfamiliar places, they are revealed only in retrospect and by other characters. In *Pillars of the House* (1873), sixteen-year-old Fulbert Underwood leaves England for Australia and promptly disappears from the novel for sixteen years and seven hundred pages. His reception of the offer of emigration is expressed thus: "There was no sentiment about Fulbert. He jumped at the offer as instinctively as a young swallow would prepare to migrate, [and] seemed to brighten all over" (273). Yonge does not follow his progress in Australia; it is only when he returns to England that we learn that he has established a successful sheep station and is a wealthy man. Similarly, at the beginning of *The Daisy Chain* Yonge states that Flora Arnott, the beloved aunt of the May children, had emigrated to New Zealand with her husband twelve years before the novel's commencement; although she is referred to briefly throughout the book, few comments are made on her situation and circumstances until she visits her nieces and nephews in England, an event that takes place just before the end of the novel. Even then, little is revealed about her life in New Zealand, although this period would have included momentous events, such as the Treaty of Waitangi in 1847 and the early settlement of the country. The information that Yonge does give emphasizes the extent to which she and her husband have imposed their own English standards upon the Maoris whom they have encountered:

> They went when New Zealand was very new, and a very funny life they had! Once they had their house burnt in Heki's rebellion ... but [Mr Arnott] has a great farm, besides an office under government.... Aunt Flora has done a good deal that may be called missionary work ... teaching the Maori women and girls. They call her mother, and she has quite a doctor's shop for them, and tries to

teach them to take proper care of their poor little children ... and she cuts out clothes for the whole pah.... They meet in the pah for prayers every morning and evening.... [T]here comes a clergyman every fourth Sunday, and, on the others, Uncle Arnott reads part of the service to the English near, and the Maori teacher to his people. (251)

This passage constitutes the only significant description of Mr. and Mrs. Arnott's life in New Zealand and is not expanded in any way save in passing references to the particular difficulties that such a pioneering lifestyle presents for women. The domestic and religious emphases that are apparent here support the perspective that the natives are children requiring education and civilization, a view that Yonge was to endorse continually through the material published in the *Monthly Packet*.

This lack of detail about the colonies is remarkable only in that Yonge describes a wide variety of other countries and locations throughout her novels. Although her preferred setting is Britain (and by implication its colonies), she does not hesitate to move events to Europe; she provides detailed descriptions of northern Italy, Paris, the Rhineland, Malta, the Pyrenees, and the Swiss Alps and refers to Egypt and Peru. In addition, Yonge uses the United States as a background in one or two novels, and in her depiction of this country a possible clue emerges regarding her perception of the colonies, particularly those whose society depended upon British society for validation. Yonge presented the African and Antipodean colonies in primarily pioneering and rural terms, but in those novels where the action shifts to America, she noticeably ignored the developed urban civilization. Thus, Harry Alison, arriving in England from Australia in *My Young Alcides* (1874), is described as "born of a plebeian mother, bred up in a penal colony, and, no doubt, uneducated except in its coarsest vices" (5), and "the coming of the wild lad from the Bush was looked on as the end of all comfort" (8). Similarly in *Pillars of the House* (1873) the Australia to which Fulbert Underwood departs is a "rude colony," but significantly, the arrival of Edgar Underwood's son from America is awaited with deep disquiet by his relations because "[h]e must be welcomed and loved, but he was on the whole dreaded as much as hoped for.... Wilmet ... rejoiced that the river lay between to keep Kester and Edward out of the way of corruption" (541). Gerald's American upbringing is referred to as that available to "colonial children," and it seems that for Yonge there was little difference between American society and the relatively recent Antipodean colonization.

Consequently, the general impression that Yonge gives of America is of an uncivilized wilderness composed of desert, prairie, and swamp, and Americans, such as the Travis brothers of *Pillars of the House*, are seen as dangerous and potentially subversive individuals who can adversely affect those with whom they come into contact even though they may mean no actual harm. Thus, the "Americanized" Alfred Travis stringently rejects for his nephew the criteria that Yonge perceived as necessary for successful membership in British society: "[W]e are not going to have a rising young fellow like this, with a prospect of what would but out all your squires and baronets in the old country, beslobbered and befooled with a lot of Puseyite cant.... [I]t is time he should come and be a man again" (1: 155).

The only possible outcome of leaving England to venture to the " new republic" is misfortune; Edgar Underwood, who flees to America from Europe, is abandoned by his wife, endures poverty and ill-health, and is killed by Indians, while his young son receives a wound that will cause his own early death. For Yonge, America, with its ex-colonial status and alarmingly mobile society, represented a radicalism that repelled and disturbed her and that she rejected, especially where she perceived a direct challenge to British social norms. In this she was not alone: Anthony Trollope, for example, in at least three novels, depicted America and its citizens as a naive but substantial threat to English social structure.[4] This suspicion of America, emphasizing its lawlessness and danger to the unwary, is apparent in Yonge's novels—perhaps the result of the country's former existence as a British colony. Given this example, her apprehension over the nature of the Antipodean colonies and the type of person who settled there is scarcely surprising.

It would be unwise to assume that this biased presentation of colonial and ex-colonial society was due to Yonge's ignorance; she was evidently an educated woman whose writing and editing display a wide knowledge of many topics. As noted previously, she regarded the developing colonial society ambivalently; it is an extension of British society, and thus comfortingly familiar, and also a threat to that apparently stable existence that she valued. Consequently, her emphasis on the alien, uncivilized, and dangerous aspects of these colonies stresses the distance, both physical and emotional, between the locations occupied by colonizer and colonized, while minimizing any possible similarities between these entities. In addition, this emphasis on difference and distance endorses colonization as a civilizing and redeeming influence in those places

where it was practiced, which for Yonge, was the primary reason for undertaking colonial activity.

The caliber of the individuals who emigrate and the destinations to which they travel provide further evidence of Yonge's attitude to established foreign and colonial society. Those of Yonge's characters who do emigrate can be assigned to one of two categories, the first of which comprises those who are motivated by religion and are intent upon missionary work. This group is best represented by Norman and Meta May, who first appear in *The Daisy Chain*. He is an Oxford scholar with a potentially brilliant academic future, she a beautiful and gifted heiress. With little apparent trauma, they leave England for New Zealand, where Norman rapidly rises to the rank of archdeacon and successfully propagates the Gospel to receptive natives. Authorial approval is entire. Similarly, *Pillars of the House* features a young cleric, Charles Audley, who devotes most of his life to missionary work in Australia and returns to England only when threatened with blindness. In one sense, of course, emigration is irrelevant to this group, who perceive their spiritual welfare as predominant and are concerned primarily about their ultimate destination after death. Their physical location thus becomes almost meaningless except as it influences their spiritual effectiveness.

The second group comprises those characters who are the most troublesome and nonconformist; they cause problems within their families, work against the social mores that Yonge presents, and are often suspected of specific crimes such as theft, fraud, or embezzlement, which precipitates their departure. Fulbert Underwood of *Pillars of the House* is typical of this group: a restless adolescent, he continually resists the authority wielded by his eldest brother, Felix, and rejects the discipline that Felix attempts to impose upon him. Yonge is careful to point out that there is nothing criminal about Fulbert's activities, but he remains a cause of friction within the Underwood household; his departure to Australia is a relief to both himself and the family group. Another example is Edgar Underwood, who leaves England after attempting forgery and eventually reaches America, where he is able to make some sort of living for himself and his child. Yonge evidently found that the colonies could be very useful in providing a refuge for the unruly, or the fugitive, among her characters. These characters threatened the stability of the society that she upheld, and using the colonies as a refuge that could assimilate these antisocial aspects allowed her to remove the threat without closely examining the stance that it represented.

Given the prevailing contemporary attitudes toward travel, analysis of those characters who apparently choose to emigrate, rather than being forced to depart, reveals an interesting omission: there are no single women traveling to establish themselves matrimonially or economically in the receptive and mobile society of the colonies. The majority of emigrants are single men and an occasional married couple: there are none of the governesses or superior domestic servants to whom A. James Hammerton refers in his study *Emigrant Gentlewomen*. Hammerton shows that from the 1830s onward, there was a well-publicized tradition of female middle-class emigration from Britain to the colonies; indeed, beginning in the 1850s, various charitable societies existed solely to promote female middle-class emigration. Hammerton cites Edward Gibbon Wakefield, who in 1849 stressed the importance of women in the development of newly established colonies, writing that "[a] colony that is not attractive to women, is an unattractive colony" and that women's role in emigration was to provide "honour, virtue and refinement" to the new societies. As Hammerton points out, "[Women's] importance in the process of colonisation rested upon the familiar assumptions of the feminine civilising mission" (45) and as such was crucial in establishing a society that accepted British customs and attitudes. Hammerton also reveals how emigration to the colonies was a resource used to benefit unmarried middle-class women (whose marital status was a source of debate and concern); as a result, the notion of emigration became more respectable.

Despite the public debate on emigration and the opportunities that the colonies apparently offered to single women, Yonge focuses her attention on this aspect of emigration only in her final novel, *Modern Broods*, published in 1900. There, the emigration of single women is shown as a viable possibility as two young women go to New Zealand on a lecture tour. However, Yonge clarifies that as the father of one of them is already in that country, sufficient male sanction exists for the journey. This novel also contains another example of the emigration of a single woman in the character of Angela Underwood, who travels alone to Australia but, as she is a member of an Anglican sisterhood, who "was considered to have a peculiar faculty for dealing with those very unpromising natives, the Australian gins" (167). She potentially occupies much the same position as a wife, who is protected by her husband, and thus does not belong to the type of "distressed gentlewomen" (94) whom Hammerton analyzed in his study.

The inference here is that for Yonge, emigration by the female is, like the majority of activities performed by women in her novels, appropriate only if sanctioned or commanded by the male, whether a husband, father, or brother, or the male authorities of state and church. Thus, Meta Rivers of *The Daisy Chain* can only go to the mission field in the subordinate capacity of a wife and only if she is judged not to be a potential hindrance to her future husband. Wilmet Underwood (*Pillars of the House*) leaves England to care for her seriously wounded fiancé; she is prepared to travel alone, although she has never left England before, but her fiancé's father accompanies her and ultimately endorses her journey by performing her marriage ceremony before his departure to England. The sequel to this novel, *The Long Vacation,* published in 1895, gives a third example of this male sanction: Dolores Mohun receives a letter written by her fiancé before his death, exhorting her to travel to New Zealand and carry out the plans that they have previously made, a request with which she complies.

Analysis of the selected novels reveals that Yonge considered emigration to be largely an irrevocable step. She does present a number of individuals who manage to return to England despite the difficulties involved, but the majority of these characters are unable to resume permanently their former place in British society. The only major exceptions are those whose traveling has taken them to India, particularly those who have been associated with the British army. Thus, Captain John Harewood, formerly stationed in India, is able to establish himself as a member of the rural gentry in England, as his army rank validates him as a representative of British society while emphasizing the differences between his position and those under his command.

Other characters who travel to the colonies and then return are not so fortunate; they find that in leaving Britain, they have lost their original place in British society. Their options are limited: they either journey back to the colony, as in the case of Fulbert Underwood, or die, as do Harry Alison, the hero of *My Young Alcides,* and Angela Underwood (*Modern Broods*). Harry Alison has been brought up in Australia and returns to England as an adult; the action of the novel demonstrates the extent to which Harry can take the place in English life to which he is entitled by birth. While he is shown to be handsome, educated, and well principled, all this is negated by his colonial upbringing, which is held to have alienated him from British society. Australia as described by Yonge is a predominantly pioneer society that lacks both the urbanization and

rural cultivation that characterize England. The crudeness of the Australian bush is a key determinant in the shaping of Harry Alison's character, as are Australia's associations with crime and punishment, and Harry exemplifies Yonge's grapplings with the notions of similarity and difference in the colonial relationship between England and Australia. By the very nature of this relationship, Australian society must produce a mimicry of the authoritative British culture, but the differences that seem to characterize the two societies must be maintained to preserve the colonial hierarchy. The Australian Harry Alison cannot resume his place within British society; for him to do so would permit an identification and confusion that would threaten the security of British society.[5]

Angela Underwood is in a similarly unresolvable situation, further complicated by her gender; she has rejected marriage, a nursing career, and her role as a single daughter living at home. Although she has done (in Yonge's terms) excellent work in Australia with Aboriginal women, she is not a formal member of an Anglican sisterhood and now occupies an ill-defined and consequently threatening position in society. Yonge emphasizes that Angela has no possible future within late Victorian society and cannot resume the position that she once held; her only option now is to die and, in doing so, to achieve an unassailably respectable and appropriate status that is inaccessible to her during life. This ultimate success is confirmed by Yonge's reference to Angela's place in the "dear calendar of family saints" (*Modern Broods* 309) and its implication that death has simplified her complex status. While Angela has evidently been successful in the Australia that Yonge described, this very success renders her simultaneously more vulnerable and more threatening toward English culture.

Angela is an extreme example of those who are unable to return to the society that they left, but even those characters who would seem able to resume their place in England find that this is not possible. Thus Fulbert Underwood, despite having chosen to emigrate and having sent financial assistance to his family while in Australia, is uncomfortable in what he perceives as the too restrictive surroundings of his family's country mansion: " 'I can't think how any one can stand being cramped up by all these walks and enclosures!' and indeed his great swinging step seemed to spurn them" (*Pillars of the House* 2: 570). Fulbert returns thankfully to the society in which he has made a valid place for himself, but Yonge appears ambivalent about emigrants who make this choice. She acknowledges that the restrictions they perceive are valid: for example, despite having demonstrated his suitability for English society, Harry Alison will

continue to be regarded with suspicion in England until his early death removes his threatening potential, and although Fulbert Underwood returns thankfully to Australia, he is unable to persuade an English girl, to whom he is attracted, to marry him and accompany him back to the colony. The reluctance with which other characters accept such repeated departures suggests a loss of status associated with a character's inability to reconform to the demands of English society.

This inability to remain in Britain indicates an important paradox, of which Yonge may have been aware and which could account for the incomplete depiction of colonial society previously discussed. As Yonge regarded the empire as an extension of Britain, it would be reasonable to assume that a character could settle comfortably in any part of the empire, while still retaining access to a place in British society. As the previous examples have shown, this is clearly not the case; emigration to the colonies must involve change and separation and the production of a society that functions independently of Britain. Moreover, emigration implied involvement with the alien and the untamed within that colonial society, with its effects upon the settlers and the possible development of hostility to British laws and authority. Active engagement with colonial society produced the situation outlined by Bhabha in which not only the differences but the similarities between the various groups participating in colonialism were articulated. By Yonge's terms, this was damaging for a man but could have disastrous implications for a woman, particularly as her conduct carried such enormous social implications for her family as a whole. Consequently, Yonge was reluctant to permit a single woman to experience the opportunities that the colonies might offer, as the potentially destabilizing influence of colonial life could undermine all that the female stereotype of conformity and domesticity represented. For those women who did emigrate, the inability to retain a position in British society represents a final stage in the process of acceptance or rejection of this stereotype; in leaving England they have passed beyond the confines of their role, and for Yonge to avoid the threat of instability that this action poses, she must stress the irrevocable nature of such an action.

To a woman of Yonge's temperament and conservative beliefs, emigration involved changes that were dangerous and to be avoided, but as a devout Anglican and loyal subject of the empire, Yonge recognized that the colonies could not be ignored. Events such as the 1854 battle at the Eureka Stockade in Australia typified the threat of lawlessness in the colonies; Yonge recoiled from this lawlessness and regarded it as typify-

ing the alien nature of colonial life. Insofar as such events were alien, with no place in a society regulated by British laws, Yonge did not write about them. This alienation and lawlessness could affect even the apparent stability of English birth and a place in English society, and also prevented Yonge from accessing the metaphor of the empire as part of a greater family. Harnessing the domestic image for political purposes was, at this level, too dangerous because unqualified acceptance of the colonial experience involved a paradox: participation in the affairs of the British colonies was an activity that could render an individual incapable of returning to the very society that apparently upheld that participation.

Notes

1. During the 1850s, Yonge achieved a popularity comparable to that of Dickens (Dennis 2).
2. The full title of this publication was *The Monthly Packet of Evening Readings for Younger Members of the Anglican Church*. Interestingly, both the contents of the periodical and the "Introductory Letter" of volume 1, 1851, indicate that the readership was perceived as female.
3. Violet Martindale (*Heartsease*) was married on her sixteenth birthday; her first child was born before she was seventeen. However, Violet's ability to care for her child is seen as unremarkable, unlike the native women, who, not being British, have not been exposed to the cultural standards that defined English womanhood.
4. See *The American Senator* (1877), *Is He Popenjoy?* and *The Duke's Children*.
5. *The Three Brides* (1876) does offer a partial exception to this in Anne Charnock, a colonial girl from South Africa who marries a British naval officer and finds a new home with his family. Anne wants to become an accepted member of the household but does not achieve this until her husband returns and validates her position. Significantly, Yonge plays down Anne's colonial background, referring to her by her family descent as a "Scotch girl" (107) and emphasizing her ability to assume the conventional role of a wife and daughter of the upper middle class. This process culminates in Anne's own rejection of colonial life in favor of her new responsibilities as the wife of an MP.

Works Consulted

"Bengal Cantonments." *Monthly Packet* 1st ser. 15 (1858): 533–45.
Bhabha, Homi K. "Of Mimicry and Man: The Ambivalence of Colonial Discourse." *The Location of Culture*. London: Routledge, 1994.
———. "Sly Civility." *October* 34 (1985): 71–80.
"Church Bells in New Zealand." *Monthly Packet* 1st ser. 13 (1857): 459–63.
Davidoff, Leonore. *The Best Circles: Women and Society in Victorian England*. 1973. London: Century, 1986.

Dennis, Barbara. *Charlotte Yonge (1823–1901) Novelist of the Oxford Movement: A Literature of Victorian Culture and Society*. New York: Mellor, 1992.

"The Earth As It Is." *Monthly Packet* 1st ser. 13 (1857): 361–68.

Hammerton, A. James. *Emigrant Gentlewomen: Genteel Poverty and Female Emigration, 1830–1914*. London: Croom, 1979.

"The Little Duke in New Zealand." *Monthly Packet* 1st ser. 13 (1857): 552-54.

Mackey, D. J. "Centenary of the Colonial Church." *Monthly Packet* 3rd ser. 14 (1887): 187–92.

"A Maori Haka." *Monthly Packet* 3rd ser. 3 (1882): 76–80.

"Norfolk Island in 1857." *Monthly Packet* 1st ser. 14 (1857): 96–103.

"Notes of a Voyage amongst the Pacific Islands." *Monthly Packet* 1st ser. 15 (1858): 553–60.

"The Rabbit Plague in Australasia." *Monthly Packet* 3rd ser. 12 (1886): 58-69.

Rowbotham, Judith. *Good Girls Make Good Wives: Guidance for Girls in Victorian Fiction*. Oxford: Blackwell, 1989.

Said, Edward. *Orientalism: Western Conceptions of the Orient*. 1978. London: Penguin, 1985.

"St. Andrew's College, New Zealand." *Monthly Packet* 1st ser. 26 (1863): 97–105.

"A Trip to Norfolk Island." *Monthly Packet* 3rd ser. 1 (1881): 486–97.

Yonge, Charlotte M. *The Daisy Chain; or, Aspirations: A Family Chronicle*. 1856. London: Macmillan, 1911.

———. *The Long Vacation*. 1895. London: Macmillan, 1899.

———. *Modern Broods*. London: Macmillan, 1900.

———. *My Young Alcides*. 1874. London: Macmillan, 1889.

———. *Pillars of the House: or, Under Wode, under Rode*. 1873. London: Macmillan, 1875.

———. *Womankind*. London: Macmillan, 1887.

Selected Bibliography

Primary Sources

Chapman, J. "Emigration." *Westminster Review*. 102.40 (1874): 25–38.

Gore, Catherine G. F. "A Bewailment from Bath; or, Poor Old Maids." *Blackwood's Edinburgh Magazine* Feb. 1844: 199–201.

Greg, William R. "Why Are Women Redundant?" *National Review* 14 (Apr. 1862): 434–60.

Grey, Mrs. William. *Old Maids: A Lecture*. London: Ridgeway, 1875.

Hamley. "Old Maids." *Blackwood's Edinburgh Magazine* July 1872: 94–108.

Hatton, Noel. "The Future of Single Women." *Westminster Review* 121 (1884): 151–62.

Herbert, Sidney. *First Report of the Committee of the Fund for Promoting Female Emigration*. London, 1851.

Manochie, Cpt. *Emigration: With Advice to Emigrants Especially Those with Small Capital*. London: Olivier, 1848.

Oliphant, Margaret. "The Condition of Women." *Blackwood's Edinburgh Magazine* Feb. 1858: 139–54.

Orr, A. "The Future of English Women." *Nineteenth Century* 3.181 (1878): 1010–32.

Plant, G. F. *Oversea Settlement: Migration from the United Kingdom to the Dominions*. London: Oxford UP, 1951.

Ross, Adelaide. "Emigration for Women." *Macmillan's Magazine* 1882: 312–17.

Rye, Maria. "Middle Class Female Emigration Impartially Considered." *English Woman's Journal* 10.56 (1862): 73–85.

Tregear, Edward. "Compulsory Emigration." *Westminster Review* 130 (Sep. 1888): 378–88.

Women's Branch of the Oversea Department. "Britain's Call from Overseas: The Need and Scope for British Women in the Dominions and Colonies." *Miscellaneous Institutions*. London, 1929.

Secondary Sources

Auerbach, Nina. *Communities of Women: An Idea in Fiction*. Cambridge: Harvard UP, 1978.

Baines, Dudley. *Emigration from Europe, 1815–1930*. London: Macmillan, 1991.

Barrett, Michele. *Women's Oppression Today: Problems in Marxist Feminist Analysis*. London: Verso, 1986.

Brantlinger, Patrick. *Rule of Darkness: British Literature and Imperialism, 1830-1914*. Ithaca: Cornell UP, 1988.

Brown, Laura. *Ends of Empire: Women and Ideology in Early Eighteenth Century England*. Ithaca: Cornell UP, 1993.

Buzard, James. "Victorian Women and the Implications of Empire." Rev. *Victorian Studies* 36.4 (1993): 443–53.

Carrington, C. E. *The British Overseas: Exploits of a Nation of Shopkeepers*. Cambridge: Cambridge UP, 1950.

Carrothers, W. A. *Emigration from the British Isles*. London: Cass, 1929.

Clarke, Patricia. *The Governesses: Letters from the Colonies, 1862–1882*. London: Hutchison, 1985.

Constantine, Stephen, ed. *Emigrants and Empire: British Settlement in the Dominions between the Wars*. Manchester, Eng.: Manchester UP, 1990.

David, Deirdre. *Rule Britannia: Women, Empire, and Victorian Writing*. Ithaca: Cornell UP, 1995.

de La Campa, Roman, E. Ann Kaplan, and Michael Sprinker, eds. *Late Imperial Culture*. New York: Verso, 1995.

Donaldson, Laura. *Decolonizing Feminisms: Race, Gender, and Empire-Building*. Chapel Hill: U of North Carolina P, 1992.

Erickson, Charlotte. *Leaving England: Essays on British Emigration in the Nineteenth Century*. Ithaca: Cornell UP, 1994.

Fanon, Franz. *Black Skin, White Masks*. New York: Grove, 1982.

Hammerton, A. James. *Emigrant Gentlewomen: Genteel Poverty and Female Emigration, 1830–1914*. London: Croom, 1979.

Hassam, Andrew. *Sailing to Australia: Shipboard Diaries by Nineteenth-Century British Emigrants*. Manchester, Eng.: Manchester UP, 1994.

Hobsbawm, Eric. *The Age of Empire, 1875–1914*. New York: Pantheon, 1987.

———. *Industry and Empire: From 1750 to the Present Day*. New York: Penguin, 1990.

Kaplan, Caren. *Questions of Travel: Postmodern Discourses of Displacement*. Durham: Duke UP, 1996.

Macdonald, Charlotte. *A Woman of Good Character: Single Women as Immigrant Settlers in Nineteenth-Century New Zealand*. Auckland, NZ: Williams, 1990.

Mangan, J. A. *Making Imperial Mentalities: Socialization and British Imperialism*. New York: Manchester UP-St. Martin's, 1990.

McClintock, Anne. *Imperial Leather: Race, Gender, and Sexuality in the Colonial Contest*. New York: Routledge, 1995.

Mills, Sara. *Discourses of Difference: An Analysis of Women's Travel Writing and Colonialism*. New York: Routledge, 1991.

Minh-ha, Trinh. *Woman, Native, Other: Writing Postcoloniality and Feminism*. Bloomington: Indiana UP, 1989.

Monk, Una Barbara. *New Horizons: A Hundred Years of Women's Migration*. London: HMSO, 1963.

Pratt, Mary Louise. *Imperial Eyes: Travel Writing and Transculturation*. New York: Routledge, 1992.

Said, Edward. *Culture and Imperialism*. London: Vintage, 1994.

Sharpe, Jenny. *Allegories of Empire: The Figure of the Woman in the Colonial Text*. Minneapolis: U of Minnesota P, 1993.

Spurr, David. *The Rhetoric of Empire: Colonial Discourse in Journalism, Travel Writing, and Imperial Administration*. Durham: Duke UP, 1993.

Strobel, Margaret. *European Women and the Second British Empire*. Bloomington: Indiana UP, 1991.

Thompson, David. *England in the Nineteenth Century, 1815–1914*. New York: Penguin, 1978.

Trollope, Joanna. *Brittania's Daughters: Women and Imperialism*. London: Pimlico, 1983.

Vicinus, Martha. *Independent Women: Work and Community for Single Women, 1850–1920*. Chicago: U of Chicago P, 1985.

———, ed. *Suffer and Be Still: Women in the Victorian Age*. Bloomington: Indiana UP, 1972.

Woolcock, Helen R. *Rights of Passage: Emigration to Australia in the Nineteenth Century*. New York: Tavistock, 1986.

Contributors

Diana C. Archibald received her PhD from Washington State University in 1997. Her dissertation, *Constructing Home Sweet Home: Domesticity and Imperialism in the Victorian Novel*, analyzes the theme of emigration in the novels of Gaskell, Trollope, Dickens, and Thackeray.

Mark Bevir is Sir James Knott Fellow at the University of Newcastle in England. His research interests include the philosophy of history, British socialism, and Indian nationalism. He has published articles in a number of journals, including *English Historical Review*, *History and Theory*, *Historical Journal*, *History of Political Thought*, *International Review of Social History*, and *Journal of the History of Ideas*, among others.

Nupur Chaudhuri teaches history at Kansas State University. She is coeditor of *Western Women and Imperialism: Complicity and Resistance* (Indiana UP, 1992). She is the coeditor of a special issue on "Gender, Race, Class, Sexuality: National and Global Perspectives" for the *National Women's Studies Journal*. She has written extensively on gender and imperialism. She has published articles in *Journal of Women's History*, *Women's History Review*, *Victorian Studies*, and *National Women's Studies Association Journal*.

Marion Diamond is reader in the history department at University of Queensland. Her publications include two biographies on Australian historical figures, *Ben Boyd of Boydtown* (Melbourne UP, 1988 and 1995) and *Creative Meddler: The Life and Fantasies of Charles St. Julian* (Melbourne UP, 1990). A third biography, on Maria Rye, is forthcoming, and Professor Diamond is now also working on a major study of nineteenth-century Australian trade with Asia.

Carmen Faymonville is a doctoral candidate in the English department at Loyola University of Chicago, where she is completing her dissertation on twentieth-century migrant women writers and transnationalism. She

has published on South Asian women writers, and immigrant writers and the American West, and she is currently writing on representations of ethnic women and on Black German literature.

Emma Floyd (Curtin) has degrees from the University of Birmingham and the University of Calgary. Her PhD in British and Australian History is from La Trobe University, where she is currently teaching part-time. Her publications include "Helen Maria Shaw and Barbara Alice Slater: British Gentlewomen in Alberta before 1914" (*Alberta History*, Autumn 1990) and "Gentility Afloat: British Gentlewomen on the Voyage to Australia" (*Australian Historical Studies*, Oct. 1995).

A. James Hammerton is reader in history at La Trobe University, Australia. His publications include *Emigrant Gentlewomen: Genteel Poverty and Female Emigration, 1830–1914* (London: Croom, 1979); and *Cruelty and Companionship: Conflict in Nineteenth Century Married Life* (London: Routledge, 1992, 1995). He is currently engaged on a study of marriage and masculinity in the lower middle class in England from 1870 to 1920.

Sherrie A. Inness is assistant professor of English at Miami University. She has published articles in a number of journals, among them *American Literary Realism, Edith Wharton Review, Journal of American Culture, NWSA Journal,* and *Women's Studies,* as well as in several anthologies. She is author of *Intimate Communities: Representation and Social Transformation in Women's College Fiction, 1895–1910* (Bowling Green) and *The Lesbian Menace: Ideology, Identity, and the Representation of Lesbian Life* (U of Massachusetts P, 1997). She is editor of *Nancy Drew and Company: Culture, Gender, and Girls' Series* (Bowling Green, 1997) and coeditor (with Diana Royer) of *Breaking Boundaries: New Perspectives on Regional Writing* (U of Iowa P, 1997).

Eva-Lynn Alicia Jagoe is currently at work on her dissertation, entitled "English Cultural Production in Nineteenth-Century Latin America," at Duke University's English department. She has published articles on contemporary Latin-American fiction and nineteenth-century Spanish literature.

Michele Ren holds a BA and MS in English and is a graduate student in the American Studies program at Washington State University. Her aca-

demic interests include literature, ethnicity, and gender in the United States. Her foray into Victorian matters began fairly innocently in a course and grew out of all proportion through numerous discussions with the editor.

Shannon Russell recently completed her PhD at Oxford University. Her dissertation, entitled "Domesticity and Imperialism in the Mid-Nineteenth Century Novel," analyzes works by Dickens, Gaskell, and Charlotte Bronte. She is currently doing editorial work for the unpublished journals of Tennessee Williams and is coeditor of Elizabeth Hamilton's *Translations of the Letters of a Hindoo Rajah.*

Catharine Vaughan-Pow earned her MA at the University of Queensland with a thesis that concerned the role of women in Charlotte Yonge's fiction. Her research interests now center on children's literature, and she is finishing her PhD on the changing roles available to British and Australian adolescent girls in periodicals and magazines from 1890 to 1920.

Index

The Editor

Rita S. Kranidis is assistant professor of English at Radford University. Her interests include Victorian literature and culture, gender studies and material culture. She is author of *Subversive Discourse: The Cultural Production of Late-Victorian Feminist Novels* (St. Martin's, 1995), and is currently at work on a book about Victorian spinsters.

The emigration of Victorian women to the colonies and dominions of the British Empire—and the cultural significance and the social consequences of this phenomenon—are the subjects of the essays collected in *Imperial Objects*. In addition to examining Victorian women émigrés' roles as travelers, teachers, and missionaries, *Imperial Objects* also uncovers the women who emigrated in the role of national commodity. These "superfluous" women—spinsters, destitute girls, and other women who did not fit into the domesticated middle-class Victorian society—were exported to the colonies to alleviate social and economic pressures at home and were encouraged to view their emigration as a service to the empire. The essays in this collection reveal the transformative experiences of the women who emigrated to Canada, Australia, New Zealand, India, South Africa, as well as Latin America and the United States. Other essays address the role of social activists, such as Maria Rye, who promoted emigration for women who would otherwise be reduced to begging and prostitution in order to survive. Rita Kranidis has also included essays that consider the female emigrant in Victorian literature. Emigration in the works of Thomas Hardy, Charles Dickens, and Elizabeth Gaskell provide a narrative solution that reflects the function that female emigration played in Victorian society at large.

Women's emigration raises questions about gender roles, social mobility, and national subjectivity in Victorian England that have been largely unexamined. This important new work collects the most recent reflections of important scholars as well as new voices